Where art and history meet, a story emerges.

—GERT JAN VAN DER SMAN,
LORENZO AND GIOVANNA

Praise for
MONA LISA

"I'm enthralled by every page of Dianne Hales's *Mona Lisa*. The mysteries of the painting remain, but through Hales's portraits of the people and her skilled rendering of customs, politics, and daily habits of the time, you come to know the painting in profound new ways. The great pleasure of her prose brings Lisa Gherardini's world to vivid life."
—Frances Mayes, author of *Under the Tuscan Sun* and *Under Magnolia*

"Combining history, whimsical biography, personal travelogue, and love letter to Italy ... an accessible, vivid examination of women's lives in Florence of the period. ... Entertaining."
—*Publishers Weekly*

"Dianne Hales tracks down the real woman behind one of the world's most famous and enigmatic faces. Expertly sleuthing her way through the treasure troves of archives and palazzos, she offers her own fascinating portrait not just of Lisa Gherardini but also of the vibrant Renaissance world that nurtured both Lisa and Leonardo's painting."
—Ross King, author of *Brunelleschi's Dome* and *Leonardo and The Last Supper*

"It's a joy to follow Dianne Hales's fascinating exploration into what's behind the world's most famous smile—an enchanting mix of fascinating history and passion-filled memoir."
—Susan Van Allen, author of *100 Places in Italy Every Woman Should Go*

"Now, thanks to meticulous research, Hales's biography-memoir-history lesson brings to life Lisa Gherardini (1479–1542), the unforgettable face behind Leonardo da Vinci's *Mona Lisa*."
—*Fort Worth Star-Telegram*

ALSO BY DIANNE HALES

La Bella Lingua

The Mind/Mood Pill Book (with Robert E. Hales, M.D.)

Just Like a Woman

Caring for the Mind (with Robert E. Hales, M.D.)

Intensive Caring (with Timothy Johnson, M.D.)

Depression; Pregnancy; The Family
(three volumes in *The Encyclopedia of Health*)

How to Sleep Like a Baby

Think Thin, Be Thin (with Doris Helmering)

The U.S. Army Total Fitness Program (with Robert E. Hales, M.D.)

New Hope for Problem Pregnancies (with Robert K. Creasy, M.D.)

Fitness After 50 (with Herbert A. deVries, Ph.D.)

The Complete Book of Sleep

An Invitation to Health (16 editions)

An Invitation to Health, Brief (8 editions)

An Invitation to Personal Change (with Kenneth W. Christian, Ph.D.)

MONA LISA

A Life Discovered

DIANNE HALES

SIMON & SCHUSTER PAPERBACKS
New York London Toronto Sydney New Delhi

To Bob and Julia, who remind me every day
that love is the greatest art

Simon & Schuster Paperbacks
An Imprint of Simon & Schuster, Inc.
1230 Avenue of the Americas
New York, NY 10020

First Simon & Schuster trade paperback edition August 2015

SIMON & SCHUSTER PAPERBACKS and colophon are
registered trademarks of Simon & Schuster, Inc.

For information about special discounts for bulk purchases,
please contact Simon & Schuster Special Sales at
1-866-506-1949 or business@simonandschuster.com.

The Simon & Schuster Speakers Bureau can bring authors
to your live event. For more information or to book an event,
contact the Simon & Schuster Speakers Bureau at
1-866-248-3049 or visit our website at www.simonspeakers.com.

Interior design by Paul Dippolito

Manufactured in the United States of America

1 3 5 7 9 10 8 6 4 2

The Library of Congress has cataloged the hardcover edition as follows:
Hales, Dianne M.
Mona Lisa : a life discovered / Dianne Hales.
pages cm
1. Leonardo, da Vinci, 1452–1519. Mona Lisa. 2. Del Giocondo, Lisa
Gherardini, 1479–1542. 3. Artists' models—Italy—Florence—Biography.
4. Florence (Italy)—History—1421–1737. I. Title.
ND623.L5A7 2014
759.5—dc23
[B] 2013042086

ISBN 978-1-4516-5896-5
ISBN 978-1-4516-5897-2 (pbk)
ISBN 978-1-4516-5898-9 (ebook)

CONTENTS

MONA LISA FAMILY TREE

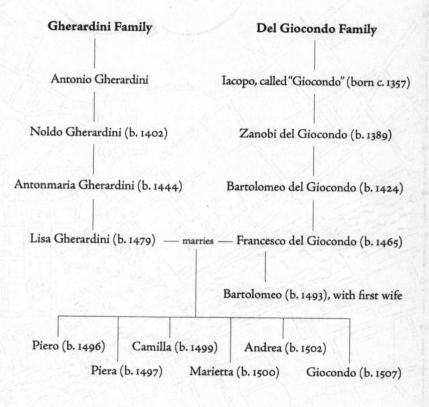

Gherardini Family

Antonio Gherardini

Noldo Gherardini (b. 1402)

Antonmaria Gherardini (b. 1444)

Lisa Gherardini (b. 1479) — marries — Francesco del Giocondo (b. 1465)

Del Giocondo Family

Iacopo, called "Giocondo" (born c. 1357)

Zanobi del Giocondo (b. 1389)

Bartolomeo del Giocondo (b. 1424)

Bartolomeo (b. 1493), with first wife

Piero (b. 1496) Camilla (b. 1499) Andrea (b. 1502)

Piera (b. 1497) Marietta (b. 1500) Giocondo (b. 1507)

SOURCE: Based on research, including recent unpublished
findings, by Giuseppe Pallanti, author of *La Vera Identità della
Gioconda*. Milan: Skira Editore, 2006.

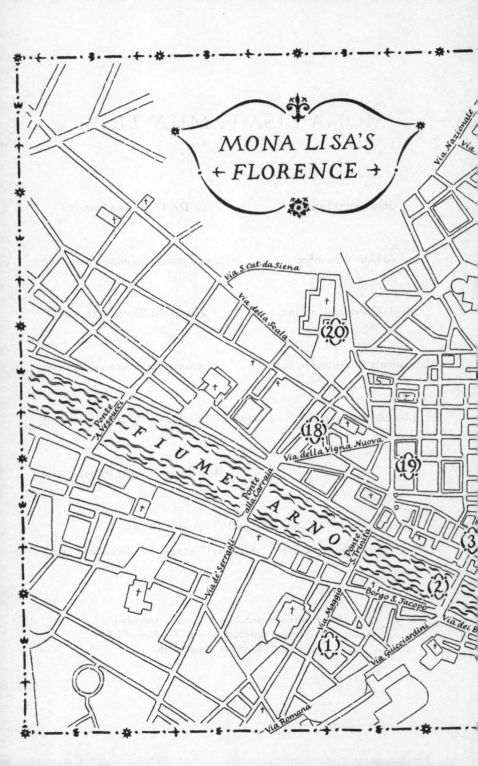

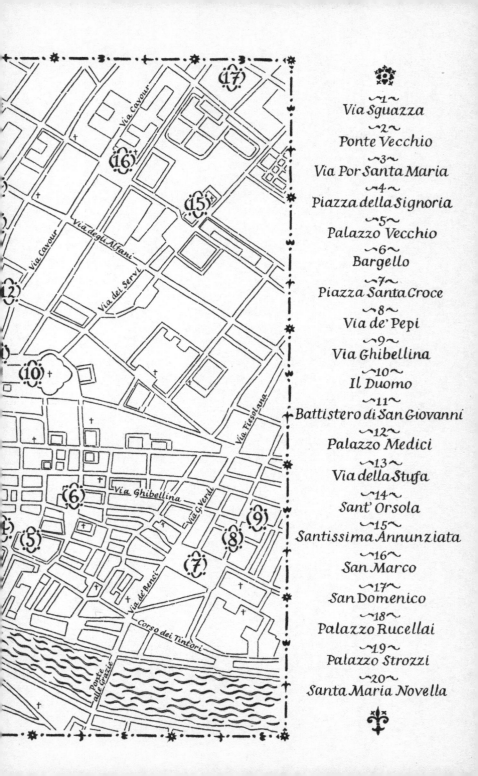

1
Via Sguazza

2
Ponte Vecchio

3
Via Por Santa Maria

4
Piazza della Signoria

5
Palazzo Vecchio

6
Bargello

7
Piazza Santa Croce

8
Via de' Pepi

9
Via Ghibellina

10
Il Duomo

11
Battistero di San Giovanni

12
Palazzo Medici

13
Via della Stufa

14
Sant' Orsola

15
Santissima Annunziata

16
San Marco

17
San Domenico

18
Palazzo Rucellai

19
Palazzo Strozzi

20
Santa Maria Novella

AUTHOR'S NOTE

This book rests on the premise that the woman in the *Mona Lisa* is indeed the person identified in its earliest description: Lisa Gherardini, wife of the Florentine merchant Francesco del Giocondo.

The first time that I heard her name—many years after I first beheld Leonardo's portrait in the Louvre—I repeated the syllables out loud to listen to their sound: LEE-sah Ghair-ar-DEE-nee. Almost immediately the journalistic synapses in my brain sparked, and I felt a surge of curiosity about the woman everyone recognizes but hardly anyone knows.

On the trail of her story, I gathered facts wherever I could find them. I sought the help of authoritative experts in an array of fields, from art to history to sociology to women's studies. I delved into archives and read through a veritable library of scholarly articles and texts. And I relied on a reporter's most timeless and trustworthy tool: shoe leather. In the course of extended visits over several years, I walked the streets and neighborhoods of Mona Lisa's Florence, explored its museums and monuments, and came to know—and love—its skies and seasons.

Facts, I discovered on my journeys, grow fragile with time, especially when laced with the lore of Leonardo. Experts disagree about dates and documents. Aficionados endlessly debate almost everything. Self-styled detectives scurry after clues. Theories flourish and fade. Yet what we do know with any certainty about Leonardo reveals little about his world.

"Great men—geniuses, leaders, saints—are poor mirrors because they rise too far above the common level," the historian Barbara Tuchman once observed. "It is the smaller men, who belong more completely to the climate of their times, who can tell us most."

The real woman named Lisa Gherardini—small by history's measure—lived amid rapid change, political strife, meteoric creativity, and economic booms and busts. At a new dawn for Western civilization,

hers may have seemed an ordinary private existence, but at a distance of more than five centuries, its details create an extraordinary tapestry of Renaissance Florence, at once foreign and familiar.

"Customs change," one of my wise consultants reminds me. "Human nature does not." This book describes the customs—the clothing, the homes, the rituals, the routines—of Lisa Gherardini's life, but I also relate to her as a woman, a daughter, a sister, a wife, a mother, a matriarch, a fully dimensional human being not unlike her twenty-first-century counterparts. This is territory that skirts the realm of the probable and the possible, and I have tried to make the borders clear whenever I cross from confirmed fact to informed imagination.

A few additional notes: The symbol above, used to introduce parts of the book, is the *giglio rosso*, the red lily that has served as the heraldic emblem of Florence since the Middle Ages. Spelling remained arbitrary through centuries of Italian's evolution. On the advice of linguistic scholars, I use modern Italian in the text, although I have kept the original spelling of names like Iacopo (Jacopo in contemporary Italian). I also identify places, such as the Palazzo Vecchio and Bargello, as they are called today rather than by older names.

Dates in histories of Florence, which began its new year on March 25, the Feast of the Annunciation, rather than January 1, are often confusing. I have relied on historical consensus whenever possible. A timeline appears on page 265; a list of key characters, on page 269. My website (www.monalisabook.com) provides additional background information, including a gallery of photos.

Most of Leonardo's works, like many other Renaissance paintings, are unsigned, unnamed, and undated. Perhaps the only point about the *Mona Lisa* on which everyone agrees is that no one other than Leonardo could have created this masterpiece. And, I believe, no one other than the real Lisa Gherardini could have inspired it.

Chapter 1

Una Donna Vera
(A Real Woman)

A genius immortalized her. A French king paid a fortune for her. An emperor coveted her. Poets lauded her. Singers crooned of her. Advertisers exploited her.

No face has ever captivated so many for so long. Every year more than 9 million visitors trek to her portrait in the Louvre. Like most, I stared at the masterpiece but never thought much about its subject.

Then I went to Florence—not once, but again and again. As a tourist, I explored its treasures. As a student, I learned its language. While researching *La Bella Lingua*, the tale of my love affair with Italian, I interviewed its scholars. On visit after visit, I immersed myself ever more deeply in its culture. And almost by chance, I came upon the woman behind the iconic smile.

One evening during a dinner at her home, Ludovica Sebregondi, an art historian who befriended me, mentions that the mother of "La Gioconda," as Italians refer to Leonardo's lady, grew up in this very building on Via Ghibellina. The casual comment takes me by surprise. To me *Mona Lisa* had always seemed nothing more than the painting in the Louvre or the ubiquitous image on everything from tee shirts to teapots, not a girl with a mother and a life of her own.

"Mona Lisa was an actual person?" I ask.

"Sì," Ludovica replies, explaining that *Monna* Lisa Gherardini del Giocondo was *"una donna vera"* (a real woman) who had lived in Florence five centuries ago. *Monna*, spelled with two *n*'s in contemporary Italian,

means "Madame," a title of respect. Like other women of her time, Lisa would have carried her father's name, Gherardini, throughout her life. Italians call the painting "*La Gioconda*" as a clever play on her husband's surname (del Giocondo) and a descriptive for a happy woman (from the word's literal meaning).

Yet the city's most famous daughter is almost invisible in her hometown. No street or monument bears her name. No plaques commemorate the places where she lived. Curiosity leads me, via a typically Italian network of friends and friends of friends, to the world's expert on *la vera* Lisa: Giuseppe Pallanti. Tirelessly pursuing her family's parchment and paper trail, this archival sleuth has unearthed tax statements, real estate transfers, court proceedings, and records of baptisms, marriages, and deaths, published in *La Vera Identità della Gioconda* in 2006.

We meet on a rooftop terrace overlooking Lisa's childhood neighborhood in the Oltrarno, the "other," or southern, side of the Arno River. Pallanti, a soft-spoken, gray-haired economics instructor with a classic and kindly Tuscan face, cannot explain an obsession that has consumed him for decades. His wife has grown weary of her rival for his attention; his children groan at the sound of her name. But from the moment when he came upon her father's signature on a land deed, he fell under Lisa's thrall. Soon I would too.

Unfolding a tourist map of Florence, Pallanti marks an X to indicate the location of the house where Lisa was born, a converted wool shop on Via Sguazza. Once again I feel the electric buzz of an epiphany: Of course, *una donna vera*, a real woman, would have a real place of birth. I can't wait to see it.

The very next day I make my way to a narrow lane off Via Maggio, once a main artery leading to the Porta Romana, the gate south to Siena. Via Sguazza, meaning "wallow," lives up to its squalid name. More than five hundred years after residents complained of the stench from a clogged municipal drain, the street still stinks. The foul smell, I discover as I re-

turn in different seasons, intensifies as temperatures rise and water levels fall.

Graffiti smear the grimy houses that line the dank street. Trash huddles in corners. Wooden doors splinter and sag on rusty hinges. No one lingers in the gloom. No one seems to care about a girl named Lisa Gherardini born centuries ago amid the clattering mills of Florence's cloth trade. Unexpectedly, I find that I do.

Although I make no claims as scholar, historian, archivist, or *Leonardista*, the journalist in me immediately senses that the flesh-and-blood woman born on this fetid block has a story of her own, stretching deep into the past and woven into the rich fabric of Florence's history. Determined to find out more, I begin asking the basic questions of my trade: who, where, what, when, how, and—the most elusive—why.

Who was she, this ordinary woman who rose to such extraordinary fame? When was she born? Who were her parents? Where did she grow up? How did she live? What did she wear, eat, learn, enjoy? Whom did she marry? Did she have children? Why did the most renowned painter of her time choose her as his model? What became of her? And why does her smile enchant us still?

Mona Lisa Gherardini del Giocondo, we now know with as much certainty as possible after the passage of half a millennium, was a quintessential woman of her times, caught in a whirl of political upheavals, family dramas, and public scandals. Descended from ancient nobles, she was born and baptized in Florence in 1479. Wed to a truculent businessman twice her age, she gave birth to six children and died at age sixty-three. Lisa's life spanned the most tumultuous chapters in the history of Florence, decades of war, rebellion, invasion, siege, and conquest—and of the greatest artistic outpouring the world has ever seen.

Yet dates and documents limn only the skeleton of a life, not a three-dimensional Renaissance woman. I yearn to know more about *la donna vera* and how she lived, to time-travel to her world and see it through her eyes. And so I decide to launch my own quest.

"Inhabit her neighborhoods," an art historian advises me. On repeated

visits over the course of several years, I take up residence in various Florentine *quartieri* (districts) and stroll the same stony streets that Lisa Gherardini once did. I genuflect in the churches where she prayed. I linger in courtyards where she too may have breathed the fragrant scent of *gelsomino* (jasmine). As the X's on my map multiply, I venture deeper— into musty cellars, abandoned chapels, antique silk mills, restored *palazzi*, and private libraries so deserted that I consider the dust motes drifting in the air my boon companions.

Each discovery fuels an unanticipated adrenaline surge. My pulse quickens at the touch of a sixteenth-century family history. I whoop in exhilaration when I find Lisa's baptismal record in an ecclesiastic ledger. One day outside the home her husband, Francesco del Giocondo, bought for their growing family, a woman's song floats from an open second-story window. Bells toll. Birds chirp. Centuries fall away. Bit by tantalizing bit, I feel *la donna vera* coming alive.

Now, when I visit or even think of Florence, I see Lisa everywhere: In Santa Maria Novella, eternal resting place of her Gherardini ancestors, once lords of lush river valleys in Chianti. In the Baptistery of St. John, where her godparents swept the newborn through Ghiberti's gleaming bronze doors. In the Palazzo Vecchio, the town hall where her forefathers and later her husband jostled for the highest seats of power. In the Bargello, once the dread hall of justice, where rebellious Gherardini met a grimmer fate.

Renaissance Florence was indeed, as the researcher Pallanti reminds me, "*un fazzoletto*" (a handkerchief), with everyone within walking and talking distance of each other. Around the corner from Lisa's grandparents' *palazzo* on Via Ghibellina stands the house where the silk merchant Francesco del Giocondo may have come to pay court to the budding beauty. The rambunctious brood of Ser Piero da Vinci, a well-connected legal professional who worked for Florence's most powerful and prominent citizens, lived just steps away. His illegitimate firstborn son Leonardo trained in a *bottega* (artist's workshop) farther down the street.

Crinkled map in hand, I trace the route that Lisa may have ridden on her wedding day in 1495 when, astride a white charger, she crossed the heart

of Florence into "Medici country," the neighborhood clustered around the Basilica of San Lorenzo. There, in a cat's cradle of streets, I find the original beams and an inner courtyard of one of several del Giocondo properties, now home to the Studio Art Centers International (SACI).

On nearby Via della Stufa, extensively rebuilt over the centuries, I join Silvano Vinceti, a self-styled *cacciatore di ossa* (bone hunter) spearheading a controversial campaign to identify Lisa Gherardini's skeleton. A city engineer leads us to No. 23, the approximate location of the home that was the probable destination for Leonardo's portrait.

With a Parisian television crew filming footage for a documentary, Vinceti, a chain-smoking, spindly-limbed, garrulous showman, rings the doorbell. A chic young Frenchwoman in spiky heels and pale green scarf emerges. She is merely renting an apartment, she explains, and knows nothing of the painting she calls *La Joconde*. I furtively snap a photo of the entrance hall.

Early one morning I walk through a leafy neighborhood where monasteries and abbeys once clustered to the former convent of San Domenico di Cafaggio, now a military forensic medicine institute. Peering through the wrought-iron fence, I imagine my way back to the long-ago time when shocking scandal and tragic loss rocked this tranquil site—and Lisa's family as well.

Another day brings me to a cherished Florentine shrine, the Basilica of Santissima Annunziata (Most Holy Annunciation). Heart pounding in fear of trespassing (more so of being caught and ejected), I heed an art restorer's tip and slip through an unmarked door next to a confessional and make my way along a semicircular row of private chapels. The dark one just to the right of center houses the remains of Lisa's husband and two of his sons. I kneel to trace the Latin words *"familiae iucundi"* ("of the Giocondo family") on a marble floor stone.

Lisa's mortal remains should lie here with her husband's, but she defied his wishes and chose a different resting place: the Monastero di Sant'Orsola, just a short block from her home on Via della Stufa. Once an exclusive finishing school for the daughters of Florence's elite, Sant'Orsola has suffered centuries of neglect. Its bleak walls are blotched with ugly graffiti, peeling posters, rusted grates, and rows of bricked-up

arched windows. Jagged beams jut from the parapets; nets suspended along the roof snag crumbling stones before they crash onto the sidewalk. Dodgy characters—drug dealers, I'm told—linger in the shadows. Passersby avert their eyes and speed up their pace.

"*La vergogna di Firenze*," an editorial writer branded the blighted block. "The shame of Florence." Several years ago the city announced plans to rebuild the site as a neighborhood cultural center, perhaps named for the woman who epitomizes culture itself. On my most recent visit, I see no signs of progress, just a desolate bookend to a forgotten existence.

Although much has changed over the centuries, the heart of Lisa's hometown has not. Hers was the urban masterpiece that thrills us still, the city of Brunelleschi's sky-skimming Cupolone (big dome), Giotto's graceful Campanile (bell tower), the sacred spaces of Santa Croce and Orsanmichele, the slender spire of La Badia Fiorentina. In Lisa's lifetime, a galaxy of artistic stars—Michelangelo, Botticelli, Raphael, Perugino, Filippino Lippi—rivaled the heavens with their brilliance. None outshone the incandescent genius of Leonardo, who emerges from the fog of history as more of a cultural force than a mere human being.

Nothing about this artist and architect, musician and mathematician, scientist and sculptor, engineer and inventor, anatomist and author, geologist and botanist was ever ordinary. The consummate Renaissance man sketched, designed, painted, and sculpted like no one else. He looked like no one else, with carefully curled locks in his youth and a prophet's chest-long beard in age. He wrote like no one else, in his inimitable "mirror script" that filled thousands of pages. He rode like a champion, so strong that a biographer claimed he could bend a horseshoe with his hands.

During Leonardo's and Lisa's lifetimes, larger-than-legend characters strutted across the Florentine stage: Lorenzo de' Medici, whose magnificence rubbed off on everything he touched. The charismatic friar Savonarola, who inflamed souls before meeting his own fiery death. Ruthless Cesare Borgia, who hired Leonardo as his military engineer. Niccolò Machiavelli, who collaborated with the artist on an audacious scheme to change the course of the Arno River.

"*Maledetti fiorentini!*" (Accursed Florentines!), their enemies jeered. Sometimes admired, often feared, never loved, Lisa's fellow citizens were vilified for—in one historian's inventory of their vices—greed, avarice, inconstancy, faithlessness, pride, and arrogance, not to mention "peculiar sexual proclivities." Even its native sons derided their hometown as a veritable cauldron of suspicion, mistrust, and envy—"a paradise inhabited by devils," as one Florentine wrote to an exiled compatriot.

Leonardo would have had reason to agree. In Milan, where he spent more than a third of his life, he was known as "*il fiorentino*," but he was born in 1452 in rural Anchiano, a hamlet near the town of Vinci. The illegitimate son of an unmarried country girl, he might have passed an anonymous life amid the birds and horses and streams that fascinated him from boyhood. Instead his father, Ser Piero, an honorary title for a *notaio*, a keeper of records, inscriber of transactions, and maker of wills, brought his preternaturally talented son to the booming city of Florence to apprentice as an artist.

Despite some major commissions, Leonardo never carved a niche for himself in Lorenzo de' Medici's favored circle. But in Milan, under the patronage of its ambitious Duke Ludovico Sforza, his genius bloomed. For almost two full and fulfilling decades, Leonardo delved deep into mathematics, hydrodynamics, physics, and astronomy; orchestrated breathtaking theatrical spectacles; designed prototypes for a helicopter, armored tank, and submarine; and brought to painting such remarkable verisimilitude that Christ and his apostles seemed to breathe as they gathered for their last supper together.

Then history turned on a ducat. A French invasion of Milan forced Leonardo to flee to Florence in 1500. Over the next few feverish years, he would join the employ of the infamous Cesare Borgia, collaborate with Niccolò Machiavelli, spar with the upstart sculptor Michelangelo, mourn his father's death, attempt unparalleled artistic feats, and suffer ignominious failures. Through these years and beyond, he lavished time and attention on the one portrait he would keep with him for the rest of his life—Lisa Gherardini's.

Why her? Why did the "divine" Leonardo, at the height of his talent and renown, choose to paint someone with no title, no fortune, no claim to power or prestige? Soon after I begin pondering these questions, a friend gives me a holographic postcard of the *Mona Lisa*. With the slightest motion, the evanescent image shifts from Leonardo's portrait to another view of the model, face turned to the left rather than the right, both hands raised as if to push back a veil. The second, oddly disconcerting image portrays a more spontaneous woman, as if captured the moment before settling into position before the artist's easel.

Holding the card, I flick it gently to watch this other woman morph almost magically into Leonardo's Lisa and back again. If I steady the card in mid-transformation, I see two faces simultaneously, two Lisas—one the familiar icon and the other the less recognizable *donna vera*. I wonder if Leonardo, the master of *"sapere vedere"* (knowing how to see), might have glimpsed more than what met others' eyes in this seemingly ordinary woman—a flicker perhaps of the indomitable spirit that family members referred to as their *"Gherardiname,"* their essential, proud Gherardini-ness.

Could this be why he chose Lisa as his model? Not, or not just, for money. Not, or not just, because of a possible friendship with her husband. Not, or not just, as a virtuoso display of innovative painterly techniques.

Outspoken members of what I think of as the "anyone-but-Lisa" league argue that the woman we see in the Louvre is not the Florentine merchant's wife, but the victim of art's most egregious case of mistaken identity. The nominees for alternative sitters include a bevy of more or less unlikely candidates, including a warrior duchess, a marchioness, a countess, and a courtesan or two.

Others contend with equal vehemence that Leonardo's model is no lady at all. Mathematicians, citing his fascination with their field, "read" her as a transcription of equations and logarithms. An Egyptologist alleges that *Mona Lisa* represents the goddess Isis, with the ancient se-

cret of the Giza Pyramids encrypted in her image. Or she could be a reincarnation of Leonardo's mother (Freud's theory), a transgendered self-portrait (a twentieth-century view), or a depiction of a longtime male companion nicknamed Salaì (a consistent headline-grabber).

Yet the evidence that Lisa Gherardini was indeed Leonardo's model has mounted steadily. A margin note in a sixteenth-century volume, discovered in the last decade, specifically describes and dates the portrait of the wife of Francesco del Giocondo. Some remain skeptical. Others dismiss the model's identity as an irrelevant detail that simply doesn't matter in consideration of a great work of art.

The *Mona Lisa*, I agree, ultimately remains what it is: a masterpiece of sublime beauty. And yet my quest to discover the real Lisa Gherardini has added new dimensions to my appreciation of the portrait. Once I saw only a silent figure with a wistful smile. Now I behold a daughter of Florence, a Renaissance woman, a merchant's wife, a loving mother, a devout Christian, a noble spirit. Lisa's life beyond the frame opens a window onto a time poised between the medieval and the modern, a vibrant city bursting into fullest bloom, and a culture that redefined the possibilities of man—and of woman.

By the time of Lisa Gherardini's death in 1542, Florence's golden age had ended. Within decades her family faded into the recesses of time—or so historians assumed. But the family tree continued to sprout.

Lisa's granddaughter gave birth to a new generation, which begat another, and another, then more. Over five centuries her descendants married into a *Who's Who* of distinguished families, including a count of the Guicciardini clan (best known for the historian Francesco Guicciardini, a colleague of Machiavelli), a *principessa* of the Strozzi dynasty, and an ancestor of Sir Winston Churchill. But it wasn't until 2007 that genealogist Domenico Savini meticulously traced fifteen generations of Lisa's heirs to identify her last living descendants: the real-life princesses Natalia and Irina Guicciardini Strozzi.

On a cloudless June morning, my husband and I weave through Tuscany's postcard-pretty hills toward the towered town of San Gimignano.

Skirting this self-proclaimed "medieval Manhattan," we ascend a steep lane under a canopy of leafy green to a tenth-century *castello* straight out of a fairy tale, home of the Guicciardini Strozzi family, its winery, and its tasting rooms.

Two radiant young women in their thirties greet us with toothy, megawatt smiles—completely unlike *Mona Lisa*'s sly grin. Blue-jeaned Natalia, a stunning actress who trained and danced as a professional ballerina in Russia, bubbles with energy and enthusiasm. Her more reserved younger sister, Irina, elegant in white, studied at Milan's distinguished Bocconi University before joining her father in managing the family's wine business.

"We always knew," they tell me when I ask if they were surprised by the documentation of their family tie to Lisa Gherardini. As little girls, their paternal grandmother had regaled them with tales of a beautiful relative painted by Leonardo—twice, once on the wood panel in the Louvre and again in another portrait passed down in the family for centuries.

As we chat and tour the labyrinthine wine cellars, I wonder aloud if the sisters' effervescent charm might mirror Lisa's high-spirited *Gherardiname*. They are dubious.

"It's amazing to feel that something in our blood, in our DNA, connects us to the woman in the most famous of paintings," says Irina, "but it doesn't affect who we are in today's world."

Yet it may affect how they look. In addition to brown eyes and long dark hair—generic Italian traits—there is something Lisaesque around the princesses' eyes and in the oval of their cheeks and jaws.

"But not in our smiles!" Natalia jokes, flashing her mile-wide grin. "Our father—he's the one who smiles like *La Gioconda*." Unfortunately, he is tied up in meetings. And so in a flurry of hugs and *arrivedercis*, we take our leave.

⌇

"What delightful young women!" my husband enthuses as we walk to our car. "Do you think they really are related to Mona Lisa?"

"*Chissà!*" I shrug. Who knows? The odds of ever finding out with anything approaching certainty range from nonexistent to minuscule.

Then I realize that I have left my sunglasses behind. Dashing back to the *castello*, I burst into a courtyard where a tall, silver-maned man stands, his back toward me.

Startled by my unexpected entrance, Principe Girolamo Guicciardini Strozzi turns slowly. His forehead crinkles in curiosity. His eyes lift. And then I see it, appearing on his lips as if it had migrated directly from Leonardo's portrait: the same demismile that has been beguiling the world for five hundred years.

It is the smile of *la donna vera*, the real woman who just might be his ancestral grandmother.

The smile of a Gherardini.

Part I

GHERARDINI BLOOD

(59 B.C. – 1478)

Chapter 2

Fires of the Heart

The Gherardini blazed out of the mists of myth and history. In a time before time, the Trojan prince Aeneas, son of the goddess Venus, fled his besieged city with his aged father on his back and his young son by his side. His band of loyal followers wandered for years before arriving at the kingdom of Latium on the Italian peninsula. After marrying its monarch's daughter and succeeding to the throne, Aeneas divided the kingdom among his descendants. "Etruria," the land we know as Tuscany, went to "Gherardo," who passed it along to his sons and the sons of his sons—the "little Gherardos," or Gherardini.

So one legend goes.

Is it true? Perhaps we shouldn't even try to pry genealogical fact from fantasy. Historians have long accused Italy's earliest chroniclers of creating "a golden legend" to enhance the glories of the past and embellish the achievements of the present.

"If they were great enough to create these myths," the German poet Goethe observed, "we should be great enough to believe them." The romantic in me wants to believe. The journalist craves something more.

This much is certain: In Italy lineage matters. In the homes of Italian friends I behold great, multibranched, thick-trunked family trees—veritable genealogical redwoods—that often date back a millennium or more. Ancestry tells Italians not only where a person came from but also the type of character the generations have forged.

<div align="center">~</div>

In search of Lisa Gherardini's forebears, I head to the Archivio di Stato di Firenze (Archive of the State of Florence), a bleak, utterly unromantic bunker that squats in busy Piazza Beccaria near the market of Sant'Ambrogio. Within its thick concrete walls lies the patrimony of Tuscany—its *memoria storica* (historical memory), a staggering forty-six miles of decrees, manuscripts, registries, charters, drawings, maps, tax records, and other artifacts, some dating back to the 700s. In addition to official documents, the Archive houses letters, diaries, and hundreds of *ricordanze* or *ricordi* (family record books) of a populace of obsessive takers of notes and makers of lists.

Guiding me through this labyrinth is Lisa Kaborycha, author of *A Short History of Renaissance Italy*. In the reverential hush of the dim reading room, dozens of heads bend over documents propped on wooden holders. You can take notes, cautions Kaborycha, a Berkeley-educated historian with the California sun still in her smile, but only in pencil. Laptops are allowed, but there is no Internet access. Transgressions such as dangling a pencil too close to a manuscript provoke a sharp rebuke. Don't even think of smuggling in a snack.

In a whisper, Kaborycha identifies scholars, famed in their fields, who have spent entire careers deciphering the intricate calligraphy of anonymous scribes. These unsung heroes of academia have pulled off a myth-worthy accomplishment: bringing the dead back to life. Thanks to their painstaking research, we know intimate details about the lives of the fanatically self-documenting Florentines: how they earned and lost fortunes, how they arranged marriages and bore children, how they celebrated in victory and plotted vengeance in defeat.

Powerful personalities emerge from the sea of statistics. "Men who wish to show their superiority over other animals," reads the inscription in one memory book, "should make every effort not to pass through this life silently, as do sheep."

The Gherardini, I quickly discover, were no sheep.

I begin my quest by exchanging my passport for the oldest book I have ever touched: a history of the Gherardini written by a family member,

Don (Reverend) Niccolò Gherardini, in 1586. The oversize volume, 30 inches high and 20 inches wide, feels both heavy and fragile.

"Is this parchment?" I ask.

Kaborycha rubs a page between her fingers.

"No, it's paper," she says, explaining that parchment was made from animal skin, so one surface is smooth and the reverse (*verso*) slightly rougher and dotted with hair follicles. (The finest-quality "uterine" vellum came from the tender skin of a fetal calf or lamb.) Paper was cheaper, concocted from a pulpy mulch of used undergarments, animal parts, and hemp, boiled in a huge cauldron and then dried. As I turn the brittle pages, the ink, blotched in places, still sparkles in the light.

We focus on the author's feathery penmanship, particularly his way of writing *s*'s and *f*'s horizontally rather than vertically. With practice I begin to make out familiar Italian words. When a recognizable name, Naldo Gherardini, leaps out at me, I squeal—and immediately apologize for the unseemly outburst in such a hallowed chamber.

Soon I am caught up in a sweeping saga of dastardly deeds and deadly vendettas. One Gherardini, betrayed by a coconspirator in a daring plot to overthrow the government of Florence, is imprisoned, tortured, convicted, and sentenced to death. The entry ends with the chilling word "*decapitato.*"

"Beheaded?" I ask. Kaborycha shrugs. The bloody history of the Gherardini strikes her as fairly typical in a city with violence encoded in its civic DNA.

~

As I learn from the oldest chronicles of Florence, Roman legions, attacking rebel forces holed up in the hillside town of Fiesole around 59 B.C., were pushed back to the banks of the Arno. There they made their stand, fighting in the river into the night and refusing to yield another inch.

The following morning, led by their captain, Fiorino, the Romans crushed the Fiesoleans. After the imperial forces returned home in triumph, a small group of soldiers remained with their commander at the outpost. One night a band from Fiesole crept into the camp and murdered Fiorino, his wife, and their children.

Julius Caesar himself swore revenge. After sacking Fiesole, his troops returned to the bend in the Arno to create a new city, first known as "*piccola Roma*" (little Rome), with a forum, aqueducts, public baths, fine villas, and marble temples, including one dedicated to its patron, the war god, Mars. In its first two centuries, Fiorenza (Firenze in modern Italian)—a name that evoked Fiorino and the Latin for "blossom," translated in the vernacular of the time as "flowery sword"—grew to about 10,000 inhabitants.

In the third century, blood still stained its stones. A Christian preacher named Minias, arrested for propagating the forbidden new religion, was thrown into the Florentine amphitheater with a panther. When the beast refused to attack him, Minias was decapitated before a cheering crowd. With true Tuscan stoicism, the martyr picked up his truncated head, replaced it on his shoulders, and marched across the Arno and up the hill to his cave, the site where the Basilica of San Miniato now stands.

So this legend goes.

Through the calamitous Dark Ages, waves of invaders—from Byzantines to Ostrogoths—destroyed the once thriving settlement. The population of Fiorenza dwindled to just a thousand residents. In the early ninth century, according to another mythic tale, Charlemagne restored the primitive church of San Miniato and underwrote the city's rebirth.

By the Middle Ages, as a historian simplified the social hierarchy for me, Tuscans fell into three broad categories: men who prayed, men who worked, and men who fought. Women, all but invisible in the scant historical records, bore children.

~

The Gherardini, among the most ancient, wealthy, and bellicose of feudal warlords, were fighters. Their gold-spurred *cavalieri* (knights) seized possession of a vast swath of the rugged Greve and Elsa valleys in the Chianti countryside and lorded over hamlets, villages, turreted watchtowers, parishes, mills, and acres of fields, vineyards, olive groves, and forests.

In the twelfth century three adventurous Gherardini brothers wielded their swords in the service of Britain's King Henry II in his conquest of the island of Hibernia. Richly rewarded, they settled in the country we know as Ireland and established the dynasties of the Geraldines and the

Fitzgeralds (from "son of Gerald"), which claim President John Fitzgerald Kennedy as their most illustrious American son.

Tuscany in the Middle Ages was no Camelot and its *cavalieri* no gallant Galahads. Scarcely able to write their own names (as deeds signed with an *X* attest), the Gherardini charge across the pages of even the driest historical tomes like semisavage brigands. Sweeping down from their fortress castle at Montagliari, they warred against rivals, ransacked the countryside, and plundered abbeys and convents. If merchant caravans on the market road between Siena and Florence refused to pay hefty tolls for safe passage, the Gherardini would slash the heel tendons of the donkeys and confiscate the merchandise they carried.

Such brazen daylight robberies, widespread in the region, outraged the young Commune of Florence, run by guilds of tradesmen determined to safeguard their supply routes. In 1135, Florentine troops marched into Chianti to wrangle the rural robber barons into submission.

Razing castles and torching lands, they forced the landed gentry, including the Gherardini, to move to Florence. The vassals of the feudal lords joined the migration and became *popolani* (common people, or citizens) in a boomtown in dire need of bakers, barbers, bricklayers, butchers, carpenters, cobblers, saddlemakers, tailors, and, above all, carders, washers, combers, trimmers, spinners, dyers, and weavers for its immense wool industry.

"And thus," the fourteenth-century historian Giovanni Villani reports, "the Commune of Florence began to expand, either by force or by argument, increasing its territory and bringing under its jurisdiction all the country nobility and destroying the castles."

Not quite. "Citified" did not translate into "civilized." Forced out of their mountain lairs, the *magnati* (magnates, as they were designated), still lusting for dominion, marked their new territory by building armed towers linked by spindly bridges to the houses of allied families. Florence sprouted a forest of 150 such spikes, some higher than 225 feet, all hated symbols of the arrogance and insolence of the glorified gang leaders who smugly towered over the city.

In a history of Florence, I come upon a sketch of the main Gherardini tower, a tall, skinny, stark, almost windowless slab of stone in the White Lion *quartiere* (district) of Santa Maria Novella. Barricaded in this stronghold, kinsmen from as many as eighteen Gherardini households would have fired giant crossbows and heaved rocks or red-hot pitch from the ramparts onto assailants.

I think of them when I read a passage from the poet Dante Alighieri (1265–1321), who lived at the height of the magnates' mayhem and belonged to the same political faction as the Gherardini: "Pride, envy, avarice—these are the sparks that have set on fire the hearts of all men."

The Gherardini flamed with all three. No grudge could be forgotten, no insult unavenged, no adversary untoppled. Their honor—as descendants of Roman warriors, as conquerors of Chianti, as golden-spurred knights, as natural-born masters of all they surveyed—demanded no less.

Florence's pugnacious magnates found new reason to brawl in the early thirteenth century, when conflict between the Holy Roman Emperors and the supremely powerful popes convulsed all of Italy. Most of the Gherardini sided with the pro-papal forces known as the Guelphs, drawing swords against the Ghibellines, who supported the emperor. Almost daily street battles erupted, often trapping residents in crossfires of arrows and reducing entire neighborhoods to rubble and ashes.

The magnates "fought together by day and by night, and many people perished," Villani records, adding a heartfelt lament: "May its citizens weep for themselves and for their children since by their pride and ill will ... they have undone so noble a city."

"How did Florence survive?" I ask historian Lisa Kaborycha.

The way all civil societies do, she explains: by rule of law.

Despite the unending urban unrest, the Commune managed to weave a fragile overlay of governing committees such as the Twelve Good Men (Dodici Buonuomini) and the Sixteen Gonfaloniere (Standard Bearers). In theory, a lottery selected officeholders from all debt-free, taxpaying members of the guilds. In practice, various magnate coalitions made sure the official leather *borse* (large bags) contained only supporters' names.

Although the incorrigible street fighters didn't sheath their swords, the Florentine magnates took up the mantle of church protectors and civic leaders. In addition to swashbuckling warriors, the Gherardini family history duly records upstanding vicars, governors, ambassadors, and patrons of churches and charities. Gherardini men regularly ascended to the highest political posts, including terms (limited to two months to prevent power grabs) as priors and *gonfaloniere* of the Signoria, Florence's chief executive and deliberative body. In religious processions Gherardini gallants proudly marched "*armati di tutto punto*" (armed to the teeth) behind the Bishop of Florence.

By the middle of the thirteenth century, the magnates' hold on the city began to weaken. With trade expanding, money exchange emerged as a lucrative industry of its own. Florence's family-owned banks, which pioneered the use of checks, letters of credit, and treasury notes, financed (at high interest rates) the extravagant ventures of Europe's kings.

The profits from banking and commerce, accumulating quietly year after year, transformed Florence into the greatest commercial market in Europe and its "lords of the looms" into medieval Midases. Without king or court, Florentines bowed to only one ruler: "*Messer Fiorino*," the gold florin, first minted in 1252, with the city's patron saint John the Baptist on one side and its symbolic lily on the other.

Yet even prosperity didn't bring peace. The newly rich *popolo grasso* (literally, the fat people) and the *popolo minuto* (the little people) united to bring down—literally—the nobles they assailed in judicial proceedings as "wolves and rapacious men." A decree in 1250 ordered the magnates' fortress towers reduced by more than half to a maximum height of about 98 feet.

In a deafening citywide demolition, parapets and bricks cascaded into the streets. The stones were used to construct a new set of protective city walls extending south across the Arno. Symbolically the mighty also were falling, but the Gherardini unyielding spirit not only endured, but became the stuff of new local legends.

⁓

I uncover some of these sagas in a thoroughly modern medium: digitized Google e-books such as *Miscellanea Storica della Valdelsa* (Historic

Miscellany of the Elsa Valley). In their scanned pages, I meet a thir-
teenth-century family hero whose bravado Lisa Gherardini's relatives
would have extolled when they swapped stories around a winter hearth:
Cece da' Gherardini, the valiant military captain of one of Florence's
quartieri.

In 1260, after a rare decade of peace, the Commune's Guelph lead-
ers set their sights on their longtime nemesis Siena, a Ghibelline strong-
hold. Gathering in the Piazza della Signoria as they traditionally did to
debate war plans, citizens voiced unbridled support for an attack. Then
Cece da' Gherardini spoke out against what he saw as a rash and fool-
hardy offensive.

The presiding consuls ordered him to be silent. When Cece kept
talking, they slapped him with a hefty fine. Cece paid the fee and resumed
his diatribe. The magistrates doubled the sum; Cece again paid up and
continued arguing. Once more they doubled the amount.

"Speak again," the consuls declared when he threw them more coins
and resumed his tirade, "and we will cut off your head." The outspoken
commander held his tongue, although he muttered that if he had two
heads, he would gladly have sacrificed one to stop the rush to war.

For thirty days a huge bell called the Martinella rang from the great
arch of Por Santa Maria, warning enemies that the Florentines were pre-
paring for battle. On the appointed day, Cece da' Gherardini dutifully led
his men south toward Siena. Accompanying them was the ornate Floren-
tine *carroccio,* or war chariot.

Drawn by four pairs of stately white oxen draped with red cloth, with
the Commune's emblematic lily on a splendid standard waving from
two tall masts, the wagon carried the Martinella in a wooden tower. Its
peals led a force of 3,000 knights and 30,000 foot soldiers, at least one
man from every household, toward Siena. In battle, the tolling of the bell
would help wounded soldiers find the priest accompanying the army so
they could receive last rites before dying.

The Florentines weren't anticipating many casualties. Two friars had
agreed to unlock one of Siena's gates to allow easy entrance. Instead, in
a stunning double cross, as the great doors creaked open on Septem-
ber 4, the Sienese, reinforced by imperial troops, roared forward. At the

same time, pro-Ghibelline Florentines, who had marched into battle with the Guelphs, suddenly switched sides and attacked their countrymen. One cut off the hand of the Florentine standard bearer, adding to the confusion.

Some 2,500 Florentines, Cece da' Gherardini among them, died in the ill-fated Battle of Montaperti. No family—magnate or merchant—was spared. The Gherardini and their vanquished allies, exiled from Florence, packed their possessions and headed tearfully to Lucca, a Guelph stronghold, to bide their time until the political pendulum swung back in their favor.

For decades power surged back and forth in violent bursts between the factions. Finally, in 1289, the Gherardini and other Guelphs decisively routed the Ghibellines. But victory on the battlefield didn't stop the carnage in the streets. The Guelph magnates split almost immediately, with the Gherardini joining the "Whites" against the more adamantly propapal "Blacks." When they weren't attacking other magnates, the Gherardini—singled out by historians as "troublemakers" with a reputation for being "warlike and uncivilized"—terrorized the *popolani*, beating and robbing working-class Florentines with impunity.

Tougher laws, the town fathers reckoned, were needed to corral its toughest citizens. From 1290 to 1295 the Signoria clamped down with a series of draconian restrictions called the Ordinances of Justice ("the Ordinances of Iniquity," sniped the magnates). Their undisguised goal: "to make life as miserable as possible" for 150 hated magnate families, identified not just on the basis of ancestry and wealth, but also for their dangerous propensity for violence. The Gherardini qualified on all counts.

Nobility became as much a curse as a blessing. No longer could the Gherardini and other despised magnates receive honors or hold the high offices that had allowed them to manipulate the system for their benefit. Each male had to swear an oath of allegiance to the Commune and put up a sort of security bond as a pledge of peace. Boxes called *tamburi* (drums)—nicknamed *buchi della verità* (holes of truth)—were set up outside civic buildings to collect denunciations from anonymous informers.

Unlike other Florentine citizens, magnates could be arrested solely on the basis of accusations by two witnesses, without any corroborating evidence. Once convicted, they faced steeper penalties than *popolani*, including confiscation of their property, exile, and execution. And not only the transgressors but all of their kinsmen were compelled to pay exorbitant fines for every offense.

As another tangible assertion of its dominance over its unruly citizens, the Commune erected a fortress tower of its own, the formidable Palazzo dei Priori, now known as the Palazzo Vecchio. Its raised fist of a tower, the highest in town at more than 300 feet, incorporated an old magnate stronghold known as La Vacca (the cow) that gave its name to the Republic's official bell. Its low mooing tones summoned all males over the age of fourteen to the Piazza della Signoria, the civic soul of Florence, in times of crisis.

One crisis hit Florence like a tsunami, shattering the lives of the Gherardini and also of Italy's greatest poet. In 1302, when Dante Alighieri, a thirty-six-year-old White Guelph, was serving a two-month term as prior, civil war erupted. The Black Guelphs raged through Florence, slaughtering Whites and burning their homes. Dante, in Rome on a papal mission, escaped the bloodbath, but the Blacks sentenced him and 350 other Whites to lifetime exile.

These *fuorusciti* (refugees) would face immediate execution if they were to return. Dante, who never went back to his hometown, would compose his literary masterwork, *The Divine Comedy*, while wandering "like a boat without sail or rudder" for two decades around the Italian peninsula.

The exiled Gherardini retreated to their rural estates, but they couldn't escape the wrath of their enemies. Naldo Gherardini, a clan leader with a reputation as an aggressive "hothead," and his banished relatives barricaded themselves within the family castle at Montagliari in Chianti. The Black Guelphs pursued them, and the two sides raged against each other with unrelenting ferocity for months. Ultimately, the Blacks razed the Gherardini stronghold and declared the site a place of *perpetua inedificabilità* (perpetual "unbuildability").

Some of the defeated Gherardini migrated to Verona and Venice. Others continued to defend their properties in Chianti's Val d'Elsa. Their leader, Cavaliere Gherarduccio Gherardini, who died in 1331, is buried in the oldest knight's tomb in Tuscany, within the simple stone parish church of Sant'Appiano in Barberino Val d'Elsa.

One branch of the family was granted permission to build a new villa a few miles away on the other side of the Greve River—with the stipulation that it never be fortified. The Gherardini named this unarmed oasis Vignamaggio (May Vineyard).

On a crisp fall day, my husband and I drive through a patchwork of tall cypresses, terraced vines, and gnarled olive trees to the 400-acre Vignamaggio estate near Greve in Chianti. The Gherardini sold the property, which once included a mill and olive press, to another, more prosperous Florentine family, the Gherardi (no relation), in 1422. After that the property changed hands several times before Gianni Nunziante, an international corporate attorney based in Rome, took possession in 1988.

In the years since, he has lavishly restored the villa's eighty-plus rooms and Renaissance gardens. A cozy inn offers guest accommodations. A large *cantina* processes Vignamaggio's grapes and stores wood barrels of its prize-winning wines. In 1993, Kenneth Branagh set his film *Much Ado About Nothing* in these magical surroundings.

Part of Vignamaggio's lore is the fanciful notion that Lisa Gherardini was born there, although a land deed confirms its sale almost sixty years before her birth. Some even claim that Leonardo painted Lisa against the backdrop of the sun-dappled terrace, where we eat lunch with the genial owner. Just across the river and through the trees, we can make out the castle ruins and a family chapel, rebuilt in the seventeenth century and still decorated with the Gherardini coat of arms.

As we linger in the idyllic setting, I imagine Lisa's ancestors on this same spot, gazing across the valley at the silent testimony to all that they had lost. As the magnates' power and prestige ebbed, income from lucrative

church patronages called "benefices" and stipends from honorary offices dried up. Some dynasties had to sell off lands to pay creditors. More than a few descended into the ranks of what a historian calls "the shame-faced poor."

Florence offered one alternative to nobles willing to change with the times: a sort of familial divorce. A magnate could renounce his title, denounce his *"grandi e possenti"* (great and powerful) relatives, change his name and coat of arms, and become an ordinary *popolano*, entitled to a citizen's protections and privileges, including the right to join a guild and hold political office. The rich Tornaquinci, who owed their wealth to exclusive building and fishing rights on a stretch of the Arno, became the even richer Tornabuoni. The proud Cavalcanti disavowed their illustrious past and christened themselves the Cavallereschi. More than a hundred noble clans did the same.

The Gherardini, singled out by historians as among "the most intransigent and reactionary" of magnates, refused even to consider such an affront to their family honor. The diehard aristocrats, clinging to the trappings of past glory, comforted themselves with pride in never falling "so low that they had to pursue a base occupation or a trade" and never marrying beneath them to a bride or groom whose family "had no claim to antiquity or nobility."

These consolations wore thin as the Gherardini plunged into bitter infighting. As I labored through a scholarly history of the Florentine magnates in Italian, a single sentence stopped me in mid-page: *"I Gherardini si odiavano di cuore."* The Gherardini hated each other with all their hearts—with each of the three principal branches despising the others *in egual misura* (in equal measure). While many families harbor grudges, the sparring Gherardini had elevated what we would call "dysfunction" to a level worthy of historical record. I soon understood why.

By the mid-fourteenth century, one disgruntled Gherardini, Cece di Bindo di Sasso, had had enough. In a petition to disown his unruly tribe, he presented himself and his brother Cione, known as Il Pelliccia (the

Furry One), as upright and loyal citizens and protested the heavy fines levied against them for the misdeeds of their errant relatives.

In a single five-year period, Cece told the court, ten Gherardini had been condemned under the Ordinances. One stole a mule; others engaged in armed brawls or beat up local *popolani*. The most villainous killed two men, including a prior, in a single day. The government was demanding a fortune in fines, while Cece's relatives were threatening the lives of the turncoat, his wife, and his son.

The court allowed Cece and his brother to declare their independence and to add "da Vignamaggio," for their Chianti homestead, to the Gherardini name. Yet even these alleged model citizens could not stay out of trouble. Cece's son Bindo—no *"stinco di santo"* (shin of a saint), as a chronicler puts it—caroused through the countryside with his friends vandalizing the property of hardworking peasants. Yet his transgressions paled compared to the disgrace that his uncle Pelliccia Gherardini would bring to the family name.

In 1360 a coalition of six magnate families and several disgruntled *popolani*—"men of aggressive spirits and passions," Villani writes—banded together to overthrow the Commune's leaders. The conspirators recruited an inside man, a friar who would unlock a door while spending a night within the palace of the Signoria so the rebels could seize control.

Before they could act, one of the plotters—Bartolomeo de' Medici, of the dynasty that was just beginning its political ascent—confided in his brother Salvestro. Immediately recognizing the peril to the entire family, Salvestro de' Medici rushed to the priors, who agreed to pardon his brother if he identified the ringleaders.

The traitors included the "upstanding" citizen Pelliccia Gherardini da Vignamaggio and his son-in-law Domenico Bandini. Most of the accused fled, but the police arrested Bandini and a *popolano* implicated in the plot. Under torture, the two men confessed. All twelve conspirators were sentenced *in absentia* to death for planning to topple the government and "disregarding the peaceful and serene state of the city, which

thrives on tranquility, prosperity, and justice." The common citizen was hung. As a noble entitled to a more dignified execution, Domenico Bandini was beheaded.

His father-in-law, Pelliccia Gherardini da Vignamaggio, was punished in effigy with a *pittura infamante*. As was the custom with dastardly criminals, the Commune ordered a sort of glorified mug shot painted on the exterior wall of the hall of justice (now known as the Bargello) for all the town to see and mock. The dishonored exile, wandering through Europe for years, bombarded Florentine leaders with protests of innocence and petitions for a pardon. In 1378, long after his portrait had faded, Pelliccia's death sentence was commuted.

The reversal came too late to change the fate of Pelliccia's daughter, Dianora Gherardini. The widow of the decapitated traitor Domenico Bandini gave birth to their seventh child, a girl named Margherita, in 1360, the same year that her husband was executed. With her spouse slain, her father disgraced, and their property seized, Dianora fled *senza una lira in tasca* (without a penny in her pocket), as a family history records. She eventually joined her two sisters, who, along with many other Florentine political refugees, had settled in Avignon, the prosperous French commercial center that served as home to the exiled papacy through much of the fourteenth century.

Dianora was the first female Gherardini—and the most sympathetic soul—whom I encountered in months of trolling through family and municipal annals. Yet I might never have known of her existence if not for a clue I spied during our visit to Vignamaggio. On the wall of its *cantina* (which sells a full-bodied Chianti called Castello di Monna Lisa) hangs a copy of a letter written by the manor's last Gherardini owner, Amidio.

In the warm, informal note, dated October 26, 1404, he sends greetings to Francesco di Marco Datini, the entrepreneurial tycoon famed in Italian history as "the merchant of Prato." Complaining about how busy he has been, Amidio urges Francesco to drink the wine *inbotato* (placed in barrels) at Vignamaggio that he has sent.

"What is mine is yours," he writes, ending with a greeting for Datini's wife, Margherita.

———

Struck by the warm, familiar tone, I wonder if there might have been more than a business relationship between the Gherardini and the medieval mogul Datini. In the digital archives of Chianti's Val d'Elsa, I come across local histories that help me connect the dots. Amidio, it turns out, was a son of the notorious traitor Pelliccia Gherardini—and an older brother of Dianora. Her youngest daughter, Margherita, Amidio's niece, married the rich Tuscan merchant Francesco Datini in 1376.

Little "Bita," as her family called her, should have faded into obscurity. Instead, we know more about this Gherardini daughter than any other woman of her time, thanks to her husband's compulsive preservation of almost every piece of paper that crossed his hands. During his long life, Datini copied the letters that he wrote and saved those that he received, including the one from Amidio Gherardini da Vignamaggio and those exchanged with his "rebellious and singularly outspoken young wife," as the historian Barbara Tuchman describes her.

"I can feel the Gherardini in my blood," Margherita declares in one of more than two hundred candid notes she sent to her husband. In their pages, I come to know this Tuscan *donna vera*—vivacious, intelligent, practical, energetic, devout, iron-willed. Her words reveal both what it was like to be a woman and a wife in fifteenth-century Tuscany and how it felt to have the Gherardini fires of the heart—their *Gherardiname*—raging within her. Perhaps learning more about Margherita, I speculated, would lead to a fuller understanding of her kinswoman Lisa Gherardini.

There was only one way to find out.

Chapter 3

A Voice Without a Face

"We have to go to Prato," I say to my husband on a steamy morning in Florence.

"Why?" he asks with justifiable weariness.

"There's a house I want to visit."

"Did Mona Lisa live there?"

"No," I concede. Lisa Gherardini, born fifty-six years after Margherita Datini's death in 1423, might never have set foot in the sleepy textile town west of Florence.

"Is it worth a trip?" he asks.

"Absolutely," I assure him. Even before I made the connection between the Gherardini and the Datini, scholars had urged me to learn more about the exceptionally forthright merchant's wife whose letters shattered the silence that had long shrouded women's lives. But what intrigues me most about this medieval Everywoman is the "Gherardini-ness" she shares with Leonardo's model.

Lisa Gherardini, who left not a single word on paper, forever remains a face without a voice. Margherita, the prolific correspondent, haunts me as a voice without a face.

This turns out to be literally true. In the formal living room of the pale stone Casa Datini on the corner of Via del Porcellatico and Via Mazzei in central Prato stand two life-size mannequins, dressed in reproductions of the luxurious robes the prosperous couple once wore. Black cloth covers their featureless heads. The Datini come alive only in the words they wrote, part of an archival treasure trove of some 150,000 letters, over 500 account books and ledgers, 300 deeds, and thousands of bills, receipts,

and checks—the largest cache of private papers from a single source to
have survived in Italy prior to the eighteenth century.

⌒

Once or twice a week for about sixteen years, missives from one spouse to
the other traveled on the backs of mules, along with laundry and baskets
of bread, eggs, and fresh-picked vegetables from the Datini farms. Often
composed or dictated in the heat of the moment, these unpolished let-
ters, dealing with the small change of everyday life, provide an intimate
portrait of a troubled marriage.

Reading many of their letters in Iris Origo's landmark *The Merchant
of Prato*, I feel that I am watching a medieval version of a television real-
ity show, peeking into the Datini kitchens and wardrobes, meeting their
friends and relatives, eavesdropping as they grapple with timeless issues
such as infertility and infidelity. I begin to see Francesco Datini (1335–
1410) and Margherita (1360–1423) as a couple perhaps not unlike Fran-
cesco del Giocondo and his wife, Lisa Gherardini—and not unlike some
contemporary spouses as well.

Ambitious, avaricious, and opportunistic—as was Lisa Gherardini's
husband—Datini wheeled, dealed, blustered, bargained, and strained
laws and commandments to their breaking points and sometimes be-
yond. The workaholic merchant lived in a state of angst he called *malin-
conia*, often translated as "melancholy." However, in Datini's day, the term
also referred to a "black humor," or thoughts and forebodings that cause
constant anxiety.

I can imagine the stressed-out businessman as a character in a Woody
Allen film—perhaps a neurotic, death-obsessed Wall Street trader, with
a therapist on speed dial, antacids in his pocket, and Xanax in his medi-
cine cabinet, ranting at his assistant and flinging his cell phone across the
room when it drops a call.

"*Sappiti temperare!*" (Learn to temper yourself!) Margherita would
enjoin her choleric spouse. No stereotypically meek medieval helpmate,
she evolved from a quick-tempered girl into a confident and competent
woman, fully capable of soundly berating her husband when he behaved
badly, which was not infrequently.

When the *Gherardiname* rose in her—as it sometimes did a dozen times a day, she confessed—Margherita pulled no punches. Yet in her determination to make her husband and her life better, she stretched and grew in unexpected ways.

Francesco Datini's rags-to-riches saga began in tragedy. The Black Death of 1348 killed his tavern-keeper father, his mother, and two siblings. Two years later the sixteen-year-old sold the land he had inherited, wrapped himself in a scarlet cloak—the color symbolizing wealth and authority—and set off from Prato to make his fortune in Avignon.

In this thriving trade center the exiled Pope Clement VI reigned in splendor over the most corrupt court in Europe, so sybaritic that not only dinner plates but horses' bits were cast in gold. Enterprising young Datini sold whatever this moneyed market desired: arms and armor (supplied without bias to both sides in any conflict), wool, silk, spices, silverware, candlesticks, bowls, basins, chalices, sapphires, emeralds, linens—plus a selection of inexpensive religious figurines. In time, he set up a money-changer's counter, a wine tavern, a draper's shop, even a bank. His ledgers bore on their frontispiece the dedication "In the Name of God and of Profit."

Living in an unabashedly material world, Datini acquired a reputation as, in a friend's words, "a man who kept women and lived only on partridges [an expensive delicacy], adoring art and money, and forgetting his Creator and himself." He may have fathered a child during one of his youthful liaisons, but the baby did not survive infancy.

Finally, at age forty, with a sizable fortune in the bank, the consummate self-made man and confirmed bachelor decided to start a family. More than anything, he wanted to beget heirs to whom he could leave his riches "in love and delight." But the shrewd merchant was finicky about a bride.

"Methinks," he wrote to the kindly Prato woman who had sheltered him after his parents' death, "God ordained at my birth that I should take a Florentine as my wife."

Florence might not have touted Margherita di Domenico Bandini, daughter and granddaughter of traitors, as a prime candidate. The girl, though fetching, noble, and, as one of seven children, of obviously staunch breeding stock, did not qualify as premium marriage material. With her grandfather, the treasonous Pelliccia Gherardini, still in exile and her mother, Dianora Gherardini, living off her relatives' charity, there would be no dowry. (According to Datini's will, one may have been promised, but it was never paid.)

Friends may have cautioned Datini that all too soon Margherita's siblings were sure to leech on to their new kinsman for money and favors. Furthermore, one of the casualties of Margherita's turbulent childhood was her education. Unlike her mother and most girls of her class, Margherita could not read or write. And then there was the matter of the fiery Gherardini spirit.

Nothing deterred Datini. For once, he looked beyond the bottom line to the girl's other assets: youth, good looks, and aristocratic blood. Lisa Gherardini would offer her equally venal suitor Francesco del Giocondo similar gifts—and little else.

Like other girls of the time, sixteen-year-old Margherita didn't choose her husband; he was chosen for her. In her mother's eyes the mercantile mogul might have seemed quite a catch. When I try to imagine what the teenager might have thought of her groom—a quarter-century older, described as plump by contemporaries but gaunt and grave in memorial statues—the kindest image I can conjecture is an urbane father figure.

After an extravagant wedding during Carnevale in Avignon in 1376, the newlyweds eagerly awaited their first child. Weeks, months, then years passed, but Margherita didn't conceive. The merchant's Italian friends blamed France and reminded Datini that Tuscan lands were *maschili e moltiplicativi* (male and fertilizing). Niccolò dell'Ammannato Tecchini, married to Margherita's sister Francesca in Florence, faulted "Bita," who, he argued, should "strive harder, not with *Gherardiname*, but with coaxing and wiles," to bring her husband back to his native land.

Only after the papacy relocated to Rome in 1383 did Datini finally return to Prato—no mere local boy made good but the most spectacular success the town had ever seen. The middle-aged tycoon transported his

young, pretty trophy wife to a town as flat as its name ("lawn") implies, a place of narrow streets and even narrower minds.

Prato's 12,000 hardworking, God-fearing, straightlaced citizens, almost all employed in the cloth business, faced each day with such glum resignation that a former resident described them as feeling "shame to be alive." Within the city's austere walls, every man's business was his neighbor's, but none stirred more curiosity than "*Francesco ricco*" (rich Francesco), as the townspeople quickly christened Datini.

⁓

The gossip started months before Datini's arrival, with the construction of the most ostentatious home ever built in the city, "the finest castle in the world," as his closest friend, the *notaio* Ser Lapo Mazzei, described it. Unlike most Prato residences, Casa Datini was built of stone rather than wood, with a handsome pillared loggia on the top floor. The moment I stepped inside, I imagined twenty-three-year-old Margherita wandering from room to room, amazed to find herself mistress of a medieval mansion.

Her domestic domain included two kitchens—one upstairs and one down, vaulted ceilings (some painted with blue stars that still twinkle in a sky of gold), polished brick floors, halls hung with shields decorated with the Datini crest (a status symbol commissioned by the merchant), a large living room, a small home office, several guest rooms, and two stone fireplaces. The master bedroom housed the couple's most expensive piece of furniture: a hand-carved bed about twelve feet wide, with curtains, a canopy, a striped mattress, two pillows of cloth-of-gold, six more with embroidered cases, and a coverlet stuffed with downy feathers, under which the Datini slept naked, as was the custom of the day.

Outside, rather than a practical vegetable plot, Datini designed what he admitted was an unheard-of folly, a "pleasure garden," costing a small fortune, where oranges, roses, violets, and other flowers bloomed. Every week more luxuries—rare foods, vintage wines, plush fabrics for the couple's wardrobe, and rare creatures such as a monkey, two peacocks, a seagull, and a porcupine in a cage—arrived at the Datini door.

Margherita's new neighbors, taking note of every delivery and de-

tail, may have developed grudging admiration for her husband's obvious prosperity but no affection for the imperious businessman and his foreign-seeming wife.

Almost as soon as he unpacked, the restless Datini relocated to Pisa to set up a new branch of his trading business. The separation was only temporary, he assured Margherita, emphasizing in his very first letter to her, written around 1382, that without her "I should have poor comfort here, and you but little there. . . . Were you here, I would be more at ease."

Margherita replied with fervent affection, swearing that she would "go not only to Pisa, but to the world's end, if it please you." Touched by the sincerity of her pledge, I feared that the naive young wife was headed for heartbreak. Again and again, her hopes to live at Datini's side like a true spouse would be dashed. For the better part of the next two decades, the merchant would live mainly in Pisa and Florence, where he opened another annex, and travel to outposts as far as Spain and Majorca, returning periodically to check on his Prato properties.

With her spouse away, Margherita became in effect a "deputy husband," in charge of the grand house, country farms, garden, warehouse, livestock, servants, and whatever crises came her way. From a distance Datini obsessively micromanaged every task with step-by-step instructions, which he directed his scribe to read repeatedly, as if he himself were standing over her shoulder.

In many of his memolike notes, sentence after persnickety sentence begins with the word "Remember":

"Remember to wash the mule's feet with hot water, down to her hoofs, and have her well fed and cared for."

"Remember to draw a little of that white wine every day."

"Remember to send to the mill the sack of grain."

Often Datini added a final patronizing admonition, such as "See to it that I do not have to scold." In another note, he carped, "Strive to be a woman and no longer a child. Soon you will be entering your twenty-fifth year."

When Margherita was twenty-five, in 1385, Prato buzzed with the

rumor that she was pregnant, but it was a false hope. Her sister and brother-in-law in Florence, parents of five children, peppered her with advice—and half-jokingly offered to lend her one of their offspring since she obviously didn't know "how to make one" herself.

Apply a powerful (but putrid) poultice to your belly, they suggested. Recruit a virginal boy to "gird" a belt on your naked flesh while reciting three Pater Nosters and Ave Marias. Pray to Prato's beloved patroness, the Madonna della Cintola (Our Lady of the Girdle, the miraculous belt that the Virgin Mary entrusted to an apostle when she ascended into heaven).

In her letters, dictated to various Datini employees, Margherita complained of *doglie* (pains) before each menstrual period. Modern gynecologists have speculated that endometriosis, a common female malady, may have caused both cramping and infertility. But how could any woman conceive when night after night she slept alone in the marital bed?

As time passed and her grievances mounted, I could hear the edge in Margherita's voice sharpen. "You have left me so much to do that it would be too much if I were a man and had the secretary of a lord," she protested. When her husband nagged her about tending to his pampered mule, she exploded: "Would God you treated me as well as you do her!"

Time and again Margherita couldn't resist trumping Francesco with her one unimpeachably superior asset: her noble lineage.

"I have a little of the Gherardini blood," she declared, "but what *your* blood is, I know not." Datini, who sighed to his friend Ser Lapo that he wished his wife "were as meek as she is shrewd," resigned himself to her tongue-lashings.

"What you say," he wrote on one occasion, "is as true as the Lord's Prayer."

Then came the first betrayal. Other men of Datini's day may have indulged in extramarital dalliances—but not with a fifteen-year-old servant who had come into their home at age twelve. When Margherita first noticed the girl's widening waist, she may have assumed the father was a

village lad or one of the roguish traders who cajoled young innocents into their beds.

I wonder how Margherita learned the truth. Did the terrified girl confess in a torrent of tears? Did Datini confirm his paternity with a cold matter-of-factness? Regardless of how the revelation came, her husband's adultery must have stabbed Margherita's heart.

Datini dealt with the situation expediently. The girl was quickly married off to a merchant who occasionally worked for him, accompanied by a large dowry and two *cassoni* (wedding chests) brimming with clothes, linens, and household goods. When the baby arrived, the new father arranged a series of wet nurses for the son he named after himself and called "*il fanciullo mio*" (my little boy). The infant died of what Datini called "the accursed sickness" within just five months. The devastated father buried the tiny body at the foot of the family tomb, the place reserved for a man's legitimate children.

As tongues wagged in Prato's shops and streets, Margherita drew on her Gherardini pride and kept her head high. When scandalous accusations would rock her family in Florence, Lisa Gherardini would have need of similar reserves of internal fortitude.

A few months after the birth of her husband's illegitimate son, Margherita decided to attempt something unheard-of for a woman of her day: to teach herself to write. Although she may have comprehended some words, Margherita had never mastered the daunting mechanical skills of cutting a quill pen, mixing ink, applying it evenly, and placing words on a page in a straight line.

Why did she want to learn? Although Margherita complained about having to rely on scribes to communicate with her husband, I suspect a motive beyond a desire for privacy: a determination to express herself, to demonstrate her intelligence and competence, and to present herself as the free-thinking, free-spoken woman she had become.

Margherita's oldest surviving "autograph" letter, written in 1388 when she was twenty-eight, testifies to the difficulty of the challenge. A facsimile I come across in a scholarly article reveals the sheer effort she put into

it. Nearly illegible lines meander across the page, sometimes squeezed to-gether and sometimes far apart, with blots of ink scattered everywhere.

Yet from the start Margherita, although obviously forming each let-ter slowly and laboriously, wrote with a decisive hand, the ink dark, the letters upright. As the words flowed more smoothly, Margherita's person-ality—and her Gherardini-ness—emerged more fully. "I am not a boor just because I live in the countryside," she protested to her relatives. "The boor is the one who does boorish things."

Despite her soured marriage, Margherita created a satisfying life in Prato, surrounded by a merry "*brigata*" (company) of friends her own age, who addressed her fondly as "*sirocchia*" (sister), and a gaggle of giggling village girls who helped with the endless chores. Any event—christening, wedding, birthday, festival, even daily church services—turned into a merry outing with what Datini called her "great pack" of *femmine*.

Margherita's needy Gherardini relatives remained more problematic. Like hungry sparrows, her mother and siblings constantly chirped for crumbs from her rich husband's table, and complained of never getting enough. When Datini opened an office in Florence in 1386, Dianora Ghe-rardini offered her son-in-law the house she still owned in the city—at an exorbitant rent that she urged Margherita to convince him to pay. Datini secured cheaper quarters instead.

Yet when Margherita's brother-in-law Niccolò went bankrupt, Da-tini covered his debts. Then her brother Bartolomeo, the black sheep of the family, began beseeching Margherita for money. She pleaded with her husband, arguing that "he is after all my brother, and I cannot but love him." In her letters, she nonetheless berated her brother and mother for their shameless demands. When Bartolomeo died, Datini felt obliged to pay his doctor's bills and to buy mourning cloaks for the entire family at a considerable expense. Francesco del Giocondo would end up doing even more for his Gherardini in-laws.

Margherita appreciated her husband's generosity, however grudging it may have been. "Lo, see how many burdens Francesco bears for my sake," she reflected. Yet money couldn't restore her trust or stop the bickering that echoed through the grand rooms of their manor house whenever Datini returned home.

"I am in the right," she wrote after a bitter argument, "and you will not change it by shouting."

~

In 1392, at the age of fifty-seven, Datini fathered another illegitimate child—this time with the family's twenty-year-old slave, Lucia.

A slave? In Tuscany?

Taken aback by this revelation, I turn to historian Fabrizio Ricciardelli, director of Kent State's Palazzo dei Cerchi in Florence, who has extensively researched the topic. After the Black Death had decimated the population in 1348, he explains, the Commune of Florence sanctioned the ownership of slaves—provided they weren't Christians. Most were young girls bought or snatched from the Balkan countries known as Schiavonia (Slaveland), Greece, or North Africa and sold in Venice or Genoa for considerably less than the price of one of Datini's velvet cloaks.

Although they worked mainly as household help, slave girls routinely satisfied the sexual urges of their masters. The esteemed Cosimo de' Medici (1389–1464), who would preside over Florence like an uncrowned monarch, fathered a son, Carlo, with a family slave. The boy grew up in the Medici *palazzo* in Florence before entering the priesthood and eventually becoming the Bishop of Prato.

Once again Margherita's husband had humiliated her in the most personal yet public of ways. Although she may have raged and wept in private, her Gherardini pride would have kept her from revealing her innermost feelings in public. For a while, she may not have communicated with Datini in any form, written or spoken.

With his usual efficiency, the pragmatic businessman plucked yet another husband from his work force, granted Lucia her freedom, and provided a hefty dowry. The baby, a girl named Ginevra, was, as was customary, handed over to a *balia* (wet nurse) in the countryside. But rather than the usual eighteen months to two years, she stayed with her caregiver for about six years. Margherita must not have wanted any part of her—or of her faithless spouse.

~

Cheating husbands haven't changed much over the centuries. Datini, like many a philandering mate before and since, tried to appease his wife with an exorbitantly expensive gift. Margherita's extensive wardrobe already included hats of beaver and samite, a luxurious silk with a satinlike gloss (supposedly banned by sumptuary laws), silver buckles and belts (also prohibited), ivory combs, two fans of peacock feathers, and hand-tailored dresses of blue damask and taffeta lined with ermine or hemmed with miniver. Margherita also owned more than a dozen rings, popular with both women and men, who sometimes wore two on a finger.

One item in an inventory from 1392, the year of Ginevra's birth, caught my eye: an order for a cloak of heavy silk embossed with velvet, the most highly prized and priced fabric of the time. "As good and fine as may be," Datini specified. "If it be not excellent and most beautiful, then I will not spend the money." Cost was no object—not this time. Whatever it took to buy his way back into his wife's good graces, Datini was willing to pay.

Margherita demanded more than finery. She wanted to live in Florence. In 1395, Datini finally relented. Then he began spending more time in Pisa and Prato. She was furious.

"One day I shall pack up my things in a bundle and set forth home again," she threatened. This was unthinkable for a woman of her day, too bold even for Ser Lapo, Margherita's most ardent defender, to condone. He reminded his lifelong friend Datini that Margherita was "a woman who has had much to bear," with "a great turbulence of spirit, which most women are not afflicted by." Her Gherardini-ness, perhaps.

Yet in 1395 when her sixty-year-old husband fell gravely ill, Margherita nursed him dutifully. Datini's health improved, but his gloom deepened.

"Fate has so willed that, from the day of my birth, I have never known a whole happy day," he lamented, fearing an eternity of even greater torment. Datini's conscience plagued him, not for adultery, but for usury. Like other moneylenders, he feared punishment for sinning *contro natura* (against nature) by selling what belongs to God alone: the interval of time between making a loan and collecting its principal and interest.

In hope of saving his soul, Datini donated generously to local churches and charities and once trudged in white robe and pointed cap on a penitential pilgrimage through Tuscany. Other wealthy men relied on sim-

ilar soul-saving strategies, including Lisa Gherardini's husband. Twice charged with usury, Francesco del Giocondo would underwrite the decoration of chapels in a Florentine convent and a church.

Prayers were on every tongue in 1397, when invading forces from Milan descended into Tuscany, looting, burning, slaughtering cattle, and killing peasants. Fearful of abandoning his business, Datini remained in Florence and directed Margherita to secure and defend their home in Prato. In what may have been her most heroic hour, Margherita did so with such calm proficiency that she earned rare words of praise from her captious husband.

"That you have ordered the house in a fashion to do you honor pleases me," he wrote. "The wise may be known in times of need." The danger passed, but life in the Datini household changed dramatically. In 1398, the wet nurse who had served as an unofficial foster parent for Datini's illegitimate daughter, Ginevra, brought the six-year-old to Prato.

"She is fearful, and we love her dearly and therefore we beseech you, be gentle with her," she entreated in a touching letter. I imagine Margherita, reconciled at age thirty-eight to never having a baby of her own, taking these words to heart as she welcomed the girl into her home. Like Lisa Gherardini, who would acquire a stepson when she married, Margherita developed a deep affection for her husband's child.

Over the years she bought Ginevra blouses, shoes, shifts, stoles, and silver buttons for a purple dress of her own that she cut down for her to wear. When the little girl developed a sore throat, Margherita reassured her husband not to worry and regretted even telling him "because I know that you are certain that I look after her better than if she were my own; indeed, I consider her to be mine."

After a fatal illness struck her sister Francesca, Margherita brought her niece Tina (Caterina) to Casa Datini. The spirited youngsters seem to have softened Datini's dour disposition. His account books record a payment for a tambourine that took one of his clerks an entire day to find—just "so that the little girls may be happy."

Datini provided well for his daughter's future with a 1,000-florin

dowry, more than that of many daughters of the great merchant houses of Florence at the time. For a groom he selected the son of one of his most trusted partners.

At her wedding in 1406, Ginevra Datini wore the most extravagant dress Prato might ever have beheld—a gown of lustrous crimson samite with a long train, a little collar of white ermine, a silver-gilt belt, and a high, elaborate headdress called a garland. At the end of a sumptuous feast, Margherita placed a baby boy in the bride's arms and a gold florin in her shoe, old Tuscan traditions designed to bring fertility and riches. Lisa Gherardini's mother would do the same at her wedding.

As she got older, Margherita, like many women of her time—and perhaps like Lisa Gherardini as well—increasingly devoted herself to religious practices. Despite his wife's pleas that he too seek comfort in piety, Datini spent the last years of his life entertaining distinguished guests in his *palazzo* and obsessing about money and business. He breathed his last on August 16, 1410, not in the arms of his wife but in those of his dear old friend Ser Lapo, who observed that "it seemed very strange to him that he should have to die."

In his will Datini left his grand home and entire fortune—an enormous sum of 70,000 florins (more than $10 million)—to a foundation he created for abandoned children. To his wife—"*sua donna diletta*" (his beloved woman)—he set aside a modest annual income of 100 florins a year as well as a "suitable" house with two beds (one for her maid) for use during her lifetime, any household goods that she needed, and both her own and Francesco's expensive clothes to give "in charity, for the good of our souls." His daughter Ginevra inherited 1,000 florins and dowries for any daughters she might bear.

At fifty the widow Datini was finally free from her domineering spouse. No letters from this time survive, and we do not know how or even where she chose to live. Some claim that she became a lay Dominican nun, but historians generally believe that Margherita moved to Florence to live with Ginevra, her husband, and their daughter.

In 1423 plague struck. After decades surrounded by the most refined

luxuries money could buy, Margherita died at age sixty-three, with no recorded possessions, among the poor and the wretched in Santa Maria Nuova, a Florentine charity hospital that often crowded ill patients two to a bed. Rather than spend eternity at Datini's side in Prato, as he had stipulated, she chose to be buried with her Gherardini ancestors in Florence's Basilica of Santa Maria Novella.

Ultimately this anything-but-ordinary *donna vera* had the last word on her final resting place. So would Lisa Gherardini.

～

During the half-century or so between Margherita's death and Lisa's birth, three families—the Gherardini, the da Vinci, and the del Giocondo—would reshape their futures in a town that proudly declared itself "the new Rome." As the fifteenth century unfolded, Florence, a magnet for the brightest and the best of innovators and thinkers, basked in its own *bellezza* (beauty): 108 churches "with marvelous choirs and chapter houses and refectories and sacristies and libraries and bells and towers"; 50 *piazze*; hundreds of shops (270 for wool, 83 for silk, 84 for woodworking, 54 for stone and marble); 33 major banks; and 23 large *palazzi*, or mansions, "where live the lords, officials, chancellors, stewards, suppliers, notaries, functionaries, and their families."

"Venetians, Milanese, Genoese, Neapolitan, Sienese," taunted the clerk who compiled this inventory, "try to compare your cities to this one!" None could come close.

A new financial and political dynasty had ascended to power: the Medici. Called God's bankers, they collected money from every country in Europe on behalf of the papacy, their biggest client, and amassed a fortune greater than most European monarchs. Under the astute rule of Cosimo de' Medici, Florence grew into the richest city in Europe, "a blazing sun of affluence," a diarist writes, "set within a dark, nearly destitute rural space."

Lisa's grandfather Noldo di Antonio Gherardini, born in Chianti in 1402, would have been eager to move into this urban light. In 1434— eleven years after his kinswoman Margherita Datini's death—he and his brother Piero took a step that her grandfather, the traitor Pelliccia Gher-

ardini, would have considered unthinkable: They accepted Cosimo de'
Medici's offer to the once feared and fearsome *magnati* to join the ranks
of the *popolani* and enjoy the full rights of Florentine citizens.

Despite this change in political status, Noldo Gherardini never came
close to basking in the glow of prosperity enjoyed by Florence's eco-
nomic elite, the 20 percent of its citizens who controlled 80 percent of its
wealth. Despite extensive landholdings in the countryside, he struggled
to maintain—or even appear to maintain—the standard of living that
the honor of his noble blood demanded.

The only house Noldo could afford to buy for his wife, Lisa (whose
name would pass to their first granddaughter), and their four children
was a half-ruined shack on a narrow, closed street called Parione Vec-
chio (today Via del Purgatorio), not far from the Gherardini's medieval
fortress tower. A nearby wool-washing facility, he complained in his tax
statements, discharged a stench so unbearably foul that the family had to
move from the dismal hovel into a rented home. These days, as I discover
in an evening ramble, the air smells of cigarettes, as waiters from nearby
restaurants gather in the dead-end lane to smoke during their breaks.

Noldo Gherardini, like Margherita Datini, died on the wretched wards
of the charity hospital of Santa Maria Nuova. He willed one of the fam-
ily farms to the institution, perhaps in gratitude, perhaps—like Francesco
Datini—in an attempt to redeem his eternal soul. His other properties
went to his oldest son, the melodiously named Antonmaria di Noldo Ghe-
rardini. The family's fortunes and fate would rest on his elegant shoulders.

～

Neither ancient nor aristocratic, another Tuscan family, the da Vinci, of
the town of the same name, boasted several generations of the legal pro-
fessionals known as *notai*, including one who had served in the presti-
gious post of *notaio* to Florence's chief governing body, the Signoria. His
grandson took his name (Piero) and followed in his professional foot-
steps to earn a *notaio's* honorary title of *Ser*.

Early in his career Ser Piero da Vinci (1427–1504) traveled a circuit
of villages in rural Tuscany to record deeds, file wills, draw up contracts,
and handle other commercial and legal transactions. But he had far more

ambitious goals, and fathering an illegitimate child with a lowly servant would not get in his way. When a country girl, named Caterina, gave birth to his son on April 15, 1452, they christened the boy Leonardo. Soon thereafter Ser Piero moved to Florence and wed a socially suitable bride: sixteen-year-old Albiera Amadori, daughter of another *notaio*.

Ser Piero's father, a local landowner, may have provided a dowry for Caterina and arranged a marriage to a local kiln worker. Within a few years, according to tax records, she had borne other children, and young Leonardo, listed as "*non legittimo*," was living with his paternal grandparents and his uncle Francesco.

Families routinely accepted illegitimate children—so common in Italy that a foreign visitor at the time considered them one of the country's defining characteristics. Nevertheless, "bastards" were penalized for being born out of wedlock. Leonardo, for instance, would not be able to attend university or to pursue professions such as medicine and law. Nor could he become a *notaio* like his father and great-grandfather.

In Florence, a city so litigious that *notai* and lawyers outnumbered doctors and surgeons by ten to one, Ser Piero da Vinci quickly set himself apart. Within months of opening an office near the hall of justice (now known as the Bargello), he paid an official visit to the Medici *palazzo* on Via Largo (today Via Cavour). In a career that would span six decades, the skillful *notaio*, whose duties shaded from a mere keeper of records into those of accountant, attorney, investment broker, and all-around "arranger," would oil the wheels of commerce and bureaucracy for Florence's wealthiest merchants, most influential families, and most illustrious religious institutions. "If destiny bids you take the best man of law," wrote a Florentine poet in tribute, "look no further than da Vinci, Piero."

Ser Piero's first wife, Albiera, reportedly fond of fair-haired, sweet-tempered Leonardo, died in childbirth in 1464. His second wife, Francesca Lanfredini, also described as affectionate toward his son—"lovable as a love child," in Stendhal's words—suffered the same cruel fate in 1473.

As a boy in Vinci, Leonardo would have learned to read and write Italian, memorized long sections of the Bible and Dante's *Divine Comedy*, and

studied the fundamentals of math and science. However, he never mastered Latin, the hallmark of a well-educated Renaissance man, nor did he learn to write with his right hand, as a tutor would have demanded of a left-handed pupil.

Since his childhood, nature served as Leonardo's greatest classroom. I picture the boy, pockets crammed with stones and leaves and feathers, alone but never lonely. "When you are alone, you are completely yourself," he would write in his notebooks. "If you are accompanied by even one other person, you are but half yourself."

Roaming through forests and fields, the curious lad must have peppered his uncle Francesco, just sixteen years older, with questions about the animals and creeks that fascinated him with their every move: How did birds fly? Why did water spin into a vortex as it cascaded over rocks? How did horses, one of his lifelong loves, gallop so fast that their hooves seemed to fly above the ground? He would spend a lifetime searching for answers—and sketching whatever caught his eye and ignited his imagination.

Leonardo's uncle Francesco may have shown the boy's drawings to his father. At some point in the 1460s, Ser Piero brought his son's sketches to the owner of the busiest *bottega* (workshop) in Florence. Maestro Andrea del Verrocchio immediately recognized Leonardo's astounding potential and urged Ser Piero to bring the boy to train with him.

For the first of many times, life as Leonardo had known it changed in a blink. The teenager would leave Vinci to forge his future in Italy's foremost commercial and cultural hub. There would be no turning back.

~

Among the many families in Florence's thriving thread trade were four brothers named Antonio, Bartolomeo, Amadio, and Giovangualberto del Giocondo. These successful *setaiuoli* (silkmakers) owned two shops on the busy street of Por Santa Maria, several other commercial properties, and assets totaling 5,000 florins, including cash on hand as well as bolts of premium cloth. For years they lived with their wives and children—some twenty *bocche* (mouths, or dependents) in all—in a large *palazzo* they had converted from two houses purchased from the great humanist and architect Leon Battista Alberti on Via del Amore.

The del Giocondo clan, like many of Florence's *nuova gente* (new people), could trace their family histories back only a few generations to a humble, hardworking grandfather—in their case a brawny barrelmaker. In a town whose residents quaffed 70,000 quarts of wine a day, Iacopo di Bartolomeo (born around 1357) had amassed a tidy sum crafting one of Florence's essential commodities. As he molded wooden staves and iron rings, the jovial Iacopo never stopped smiling and joking. The customers in his noisy shop on Via dei Vecchietti called the jolly soul "Giocondo" (the happy one), a nickname so indelible that it passed on to his descendants.

The shrewd barrelmaker had reason to smile. Investing in real estate, Iacopo bought a second house in his working-class neighborhood, which he rented to a cloth weaver, and acquired several farms in the surrounding Tuscan countryside, including one with a fine villa from an aristocratic family crunched for cash. His earnings catapulted his sons, Zanobi and Paolo, into the thriving mercantile class by providing money for an *entratura*, a sort of license, to join the prestigious silk guild.

In 1463, Bartolomeo del Giocondo, one of Iacopo's upwardly mobile grandsons, moved out of the family homestead on Via del Amore. By connecting three narrow medieval houses near the Piazza San Lorenzo, not far from the Medici *palazzo*, he constructed a residence worthy of his status as a successful merchant. His street, Via della Stufa, notorious for the brazen prostitutes at a raucous municipal brothel, remained stubbornly ungentrified—typical of many Florentine neighborhoods, often a mix of mansions, cottages, monasteries, cloth factories, apothecaries, parish churches, shops, and taverns.

Less scruffy these days, Via della Stufa remains far from upscale.

On my first visit I have trouble finding the entrance to the narrow lane in the jumble of vendors in the Piazza San Lorenzo, site of a congested street market across from the Medici parish church. Squeezing around stalls piled high with leather products, from wallets to belts to boots to briefcases, I zigzag past boxes of handbags and row upon row of jackets. As I breathe in the pungent smell of leather, I realize that Bartolomeo

del Giocondo would feel right at home in his old neighborhood, still a beehive of the perennial Florentine pursuits of bargaining, buying, and selling.

The first of the merchant's children to be born on Via della Stufa was Francesco di Bartolomeo di Zanobi del Giocondo, his third son, on March 19, 1465. Francesco seems to have inherited his great-grandfather Iacopo's ambition and acumen but not his amiable temperament. This enterprising entrepreneur would not only increase the family's profits and political prestige, but also lift the del Giocondo—a family *s.nob* (*senza nobilità*, without nobility, as "common" citizens were categorized in a Florence census)—into a higher social rank by marrying a daughter of the ancient Gherardini clan.

When I recount the story of the merry barrelmaker and his prosperous heirs to a friend over a glass of wine, he smiles and tells me an old Tuscan adage: A barrel of wine can work more miracles than a church full of saints. Iacopo, the jovial patriarch of the del Giocondo clan, would have roared with laughter to think of himself as testimony to its truth.

"Who Would Be Happy ..."

One Sunday morning in Florence, I awaken in an apartment I've rented on the Lungarno della Zecca Vecchia (the riverside street near the Old Mint) to the exultant sounds of drums and trumpets. I dash from one window to another, trying to locate the source—away from the Arno, it seems, toward Santa Croce. After quickly wriggling into a dress and sandals, I join excited groups of people rushing through the neighborhood.

From every direction musicians—competitors from all of Tuscany for a regional prize, a bystander informs me—are converging in the Piazza Santa Croce. As I scramble up the steps in front of the Franciscan basilica for a better view, the bands strut into formation behind their hometown banners. A sea of bright colors and high-flying flags surges before me, and my imagination carries me back in time to another thrilling spectacle that Florentines once beheld in this square.

On February 7, 1468, nineteen-year-old Lorenzo de' Medici, grandson of Cosimo de' Medici and a prince in all but title, hosted a *giostra*, a ceremonial joust in honor of both a recent military victory and his engagement to a Roman princess (who was not in attendance).

His father, Piero de' Medici, dubbed "the Gouty" for the malady that would soon claim his life, and his mother took seats of honor in front of Santa Croce's then unfinished brick facade. Lucrezia Donati, a young married beauty rumored to be their son's ladylove, may have sat not far from my perch. According to French chivalric tradition, Lorenzo fastened her scarf to his lance.

On that long-ago morning, crowds squeezed onto benches set up

along the piazza, while hundreds craned from the windows of the surrounding buildings. A thick layer of white sand covered the great rectangle, divided lengthwise with wooden rails so galloping horsemen could heave lances at each other at breakneck speed. In a splendid procession young men from the best families in town—scions of the Pazzi, Pitti, Vespucci, and Tornabuoni among them—cantered slowly into the piazza on horses festooned with a king's ransom of precious stones, silk, velvet, and ermine, a display so brilliant that the radiance seemed to one observer "enough to block out the sun."

With a roll of drums and blare of trumpets, a white charger entered, bearing the unmistakable figure of Lorenzo de' Medici, supremely yet seductively ugly, in a white silk mantle bordered in scarlet and a black velvet cap encrusted with rubies, diamonds, and pearls. At the center of his shield gleamed the famous Medici diamond known as Il Libro (the Book), reportedly valued at the equivalent of a million dollars.

Above Lorenzo's head fluttered a gorgeous "standard of white taffeta," decorated—in a poet's description—"with a sun above and a rainbow below and in the middle a lady standing in a meadow, wearing a robe . . . embroidered with gold and silver flowers," with a bay tree (*lauro* in Italian, a pun on "Lorenzo") in the background and a quote from Virgil inscribed in gold. This was the creation of the wizardly artists and artisans in the *bottega* of Medici favorite Andrea del Verrocchio.

The maestro's most talented apprentice, the slim teenager named Leonardo, would almost certainly have stood amid the cheering throng.

The youth's bucolic life in Vinci must have seemed long ago and far away. From the moment that Florence's massive iron-studded gates creaked open at dawn, Leonardo would have been swept into its rollicking street life. Heralds on horseback blew a treble blast on their trumpets before announcing banishments, fines, and other official decrees. Minstrels sang. Criers called out for wet nurses and day laborers. Couriers on horseback rushed to deliver satchels of urgent documents. Flocks of priests, bishops, monks, and friars flapped their way from churches to monasteries. Peasants trundled carts of just-picked cabbages or bleating pigs.

Traders hauled leather from Córdoba, armor and steel blades from Spain, spices from the East, saffron from Majorca, wheat from Sardinia and Sicily, salt from Ibiza, oranges and dates from Catalonia, everything and anything to feed the desires and fill the bellies of the city's 50,000 residents. Animals—dogs, goats, pigs, geese, the occasional recalcitrant donkey—roamed everywhere.

In 1469, Lorenzo de' Medici—statesman, scholar, athlete, swordsman, writer, musician, poet, collector—succeeded his father at the city's helm. In the Camelot years of his reign, Florentines, giddy with their own good fortune, reveled in the glorious moment. Besotted with beauty, they elevated everything—a shoe's turned-up toe, a sleeve's jewel-bright lining, a dagger's hand-carved sheath—into a work of art.

Life was short, just thirty-five to forty years on average, but fully savored. In the seize-the-day spirit of his time, Lorenzo raised revelry almost to the point of art with torchlit parades, processions, festivals, "lion-hunts" in the Piazza della Signoria, and lightning-fast horse races from one city gate to another.

"Who would be happy, let him be," Lorenzo urged in his best-known canticle.

Leonardo da Vinci, young, handsome, and extravagantly talented, had every reason to comply.

Even before the Florentines sensed the immensity of his genius, the boy from Vinci dazzled everyone he met with his remarkable good looks. Tall and wiry, with long golden locks, dawn-blue eyes, and fair skin, the young Leonardo, as the sixteenth-century art historian Giorgio Vasari puts it, "displayed great physical beauty, which has never been sufficiently praised." With an amiable personality that rivaled his appearance, he entertained friends by singing in an "exceptionally harmonious" voice and playing the lyre with skill.

As part of an informal group of Renaissance rap artists called poets *alla burchia* (which translates as "in a hurry, higgledy-piggledy"), Leonardo improvised verses in a ribald, satirical style called *burchiellesco*. He recorded jokes in his notebooks and wrote wry essays, including one on

"Why Dogs Willingly [the Italian translates into "Gladly"] Sniff One Another's Bottom." (The reason: The smell lets them know whether the dog is being fed meat by a powerful and rich master.)

Only Leonardo's relationship with his stern father, whom he referred to as "Ser Piero" throughout his life, seemed neither light nor easy. Although he could have gone through the legal process of changing Leonardo's illegitimate status, Ser Piero never did so. A telling anecdote from Vasari's *Le Vite* (as his *The Lives of the Most Excellent Italian Architects, Painters, and Sculptors* was known) suggests some strain between father and son.

When a peasant in Vinci asked Ser Piero to arrange for a painting on a small round shield he had fashioned, the *notaio* assigned the task to his son. Leonardo decided to concoct an image that would terrify anyone who encountered it. Delving into a pile of dead reptiles, lizards, snakes, bats, and other such creatures—a collection only an unsqueamish boy could assemble—he combined their limbs, Frankenstein style, to create a hideous hybrid, "a most horrible and frightening monster with poisonous breath that set the air on fire . . . emerging from a cleft in a dark rock, vomiting fire from its gaping jaws, its eyes blazing, and poisonous vapors emanating from its nostrils."

Before allowing Ser Piero into the room, Leonardo positioned the shield on his easel and shaded the window so the light fell directly on the gruesome image. At first glance, his startled father thought he had encountered an actual beast and jumped back in fright.

"This work has served the purpose for which it was made," Leonardo said, perhaps with a satisfied smile.

A shaken Ser Piero took the shield but never gave it to the peasant, whom he mollified with an inexpensive substitute. More pragmatic than paternal, he sold Leonardo's creation to some merchants in Florence for 100 ducats. They, even wilier, charged the Duke of Milan three hundred for the piece.

Surrounded by the soaring works of Giotto, Brunelleschi, Donatello, Masaccio, and so many other masters, young Leonardo breathed in the

big ideas and grand visions that circulated in the air like cerebral oxygen. In Verrocchio's *bottega*, he saw them emerge in tangible form.

The small-scale art factory turned out everything from paintings and statues to gilded baskets, wood chests, coats of arms, armor, candelabra, bells, headboards, and special commissions, such as a two-ton bronze globe hoisted, amid the fanfare of trumpets and choral chants, atop the cathedral dome. I get a sense of how such a workshop might have looked by peering into surviving structures in the artisans' neighborhood around the church of Sant' Ambrogio, many now occupied by laundromats and parking garages.

A cavernous room, noisy and dusty, smelling of paints and varnishes, would have opened onto the street. Apprentices clustered around easels, workbenches, turntables, grindstones, and kilns. Supplies were stacked on shelves, with sketches, plans, and models of works in progress perched in clear view. Chickens, whose eggs were mixed with dyes to make tempera paints, clucked underfoot.

Here, under the scrutiny of his thin-lipped and keen-eyed maestro, Leonardo learned the technical skills of an artist's trade: how to make a pen from a goose quill, how to carve wood, draw figures, master perspective and proportion, hammer metal, grind stone, mold plaster, chisel marble, sculpt clay, select dyes, and meticulously prepare a wood panel for painting—as well as the fundamentals of chemistry, metallurgy, and engineering. Here he would also imbibe the spirit of a generation of innovators, the first to approach art from what we would call a scientific point of view. And here he would develop the habit of carrying a *libriccino*, a pocket-sized notebook not much bigger than a pack of cards, so that whatever his eyes observed, his fingers immediately translated into images.

At Verrocchio's insistence, Leonardo would have worked for years with a metal-point stylus before picking up a paintbrush. When he did, his talent astounded even his teacher. According to Vasari, the luminous wide-eyed angel that Leonardo added to Verrocchio's *Baptism of Christ* (now in Florence's Uffizi Gallery) so surpassed anything from the painter's own hand that he "never touched colors again, angered that a young boy understood them better than he did."

Leonardo realized that this was the natural order of things. "He is a poor pupil," he wrote, "who does not progress beyond his master."

In 1472, Leonardo progressed, along with Sandro Botticelli and Perugino, to membership in the Compagnia di San Luca, the guild of artists named for the apostle believed to have painted a portrait of the Virgin Mary. Not long afterward, the twenty-year-old scrawled a rare expression of emotion on the back of a drawing of the Arno Valley: "*Sono contento*" (I am happy).

━━━

An official document describes Antonmaria di Noldo Gherardini, who turned twenty-eight in 1472, simply as a *vir nobilis* (noble man). As such, he would have learned Latin, which he would use when serving from time to time as an arbiter in judicial proceedings, and at least enough mathematics for the transactions required for managing his holdings.

As was "the custom of gentlemen," he had no other occupation. Like an estimated third of the members of Florentine elite families, Antonmaria collected rents and earnings from his rural estates, including a country house (*casa signorile*) in San Donato in Poggio, a small village about twenty miles south of Florence.

I could find no portraits of Antonmaria himself, but if he bore any family resemblance to the Francesco Gherardini painted by the Venetian artist Tintoretto in 1568, Lisa's father would have looked every inch the aristocrat, with high cheekbones, a long nose, an arrogant mouth, neatly trimmed goatee, and an erect, broad-shouldered frame. As a cultured gentleman, he would have been expected to display "great artistry" in the three things the humanist Leon Battista Alberti considered paramount: "walking in the city, riding a horse, and speaking."

These skills would have served Antonmaria well in securing his family's best hope for financial security: an advantageous marriage. Fortunately for him, the ancient Gherardini pedigree—scorned during the era of the detested magnates—now qualified him as an eminently eligible suitor for an aspiring middle class eager to gild a plebeian family tree. The merchants and bankers who fancied themselves Florence's new aristocrats coveted the one thing money could not buy: a noble lineage.

In 1465, at age twenty-one, Antonmaria wed Lisa di Giovanni Filippo de' Carducci, from a solid, well-established Florentine family. She died in childbirth—a tragic and shockingly common occurrence. One in four Tuscan women—daughters and wives of the rich and the poor, the powerful and the pious—suffered this tragic fate. Parents lost the child whom they had watched over from birth; husbands, the mates with whom they had hoped to build a family and a future. But young widowers were expected and exhorted to move on and marry again.

In 1473, Antonmaria's eye turned to one of "*i più bei fiori*" (the most beautiful flowers) of Florence, Caterina Rucellai. Centuries earlier the arrogant Gherardini magnates might have sneered at her ancestors as pretentious *nuova gente* (new people) flaunting their recently acquired riches with gaudy baubles and ostentatious homes. But by Antonmaria's day, few families could boast a greater fortune or a grander house than the Rucellai.

I think of Antonmaria the first time I visit the imposing Rucellai *palazzo* on Via della Vigna Nuova to attend a book presentation—and not only because I spot the chic Gherardini shop (no relation to Lisa's descendants) selling the brand's high-end handbags across the street. As I climb to the *piano nobile*, or second floor, I wonder if he would have been as impressed as I by the magisterial staircase and immense carved coat-of-arms.

Wandering through vast, highly ornamented chambers, I chat with a fellow guest, who asks in Italian if I realize that the original architect was the renowned humanist Leon Battisti Alberti.

"No," I reply.

Not only did he design the house, she informs me, but the Rucellai hired Alberti to create the dramatic geometric facade for their parish church of Santa Maria Novella. In what she clearly considered commoner crassness, they insisted that the Rucellai name be chiseled into the multicolored marble front in letters three feet high.

"Do you know how they made their money?" she inquires.

Again, I shake my head no. With a mischievous grin, she regales me with the tale of a Florentine merchant named Alamanno, who was re-

turning from the Middle East in the early thirteenth century. One day while he "*faceva pipi*" (was making peepee), as she puts it, Alamanno noticed that a spray of urine altered the color of a particular lichen called *uricella*, which grew in the Canary Islands. The new shade was a remarkable red, deeper than scarlet, richer than purple, brighter than rose.

When Alamanno brought the plant home to Florence, his clever relatives devised a way to use the chemicals in urine to dye fabric—"*all'oricello*"—and produce a crimson that became the most exclusive and expensive of hues, the prized favorite of cardinals, kings, and the pope himself. Jealously guarding their secret and establishing a money-churning monopoly, the family became known as the "*oricellai*," a name that morphed into Rucellai.

By the fifteenth century, the head of the family, Giovanni di Paolo Rucellai (1403–1481), ranked as the third-richest man in Florence and one of its greatest philanthropists, as proud of spending his money as of earning it.

"There are two principal things men do in this world," he once declared. "One is procreating; the other is building." The Rucellai, who spawned twenty-six households, did both extremely well. Giovanni also mastered the art of cultivating strategic marital alliances as deftly as Tuscans tended their orchards and vineyards. In 1466 he managed to heal a breach between the two families by marrying one of his many offspring into the Medici *parentado* (kinship network), the most exclusive in Florence.

For the wedding of his son Bernardo to Lorenzo de' Medici's sister Nannina in 1466, Giovanni Rucellai built an elaborate pavilion (now home to a trendy shop on Via della Vigna Nuova). Under its gracious loggia, "the finest and most beautiful ever to grace a wedding banquet," some five hundred guests danced and ate not one but two gargantuan feasts, a midday repast and an evening banquet—almost twenty dishes in all. The extravaganza, one of the most elaborate and expensive in a generation, violated almost every provision of the sumptuary laws, from the limits on guests to the number of courses that could be served. The bill came to a whopping 1,185 florins, but the investment paid off.

"Since I became the relation of Piero di Cosimo de' Medici [father of Nannina and Lorenzo]," Giovanni Rucellai wrote, "I have been honored, esteemed, and well-regarded." He wasn't the only one to benefit.

In 1473, Giovanni's son Bernardo Rucellai requested a favor of his brother-in-law Lorenzo de' Medici on behalf of a cousin. Mariotto di Piero Rucellai (1434–1520) was hoping for a seat as a prior on the governing Signoria "in order to improve the marriage prospects" of his daughters. Lorenzo made it happen.

Three weeks after his cousin Bernardo's intercession, Mariotto began a two-month term of office as a prior. In the same year this highly regarded public servant, who would be appointed to numerous government posts throughout Tuscany, bestowed the hand of his daughter Caterina on one of the marital prospects he had hoped to attract. The suitor, Antonmaria Gherardini, would bring a touch of class to a dynasty that had parlayed a plant and *pipì* into a commercial empire.

Antonmaria could have anticipated many potential benefits from the match. With entry into the Rucellai *parentado*, doors might open, debts might be forgiven, lucrative appointments might be made. The wedding, although less spectacular than the Medici nuptials, would have feted the young couple with merry exuberance.

When Caterina soon became pregnant, the future glowed even brighter. Antonmaria and his extended family delighted in the welcome news. But their all-too-fleeting joy soon turned to sorrow. Caterina died in childbirth. The teenager, clad in sumptuous fashions every day on earth, entered the Great Sea of eternity in a plain white muslin gown. The law allowed no adornments—no silk, silver, or gold, not even some fancy ribbons.

The death of another young spouse may have devastated Antonmaria. "I am so oppressed by grief and pain for the most bitter and unforeseen fate of my most sweet wife," one of his contemporaries wrote to Lorenzo de' Medici after a similar loss, "that I myself do not know where I am." For the second time, Antonmaria sadly donned a *mantello grande*, a great mourning cloak that fell to the ground with a hood to cover the face.

As he stood among weeping relatives in the Rucellai Chapel in Santa Maria Novella, Antonmaria Gherardini could never have anticipated how curiously the future would unfold. In two decades the extended Rucellai kin would again gather to mourn another of Mariotto's daughters. Born two years after the death of Caterina Rucellai Gherardini, young Camilla Rucellai would die just as unexpectedly as the older sister she never knew, leaving behind an eighteen-month-old son and another grieving widower, Francesco del Giocondo.

~

In 1473, Lisa Gherardini's future husband was behaving—and occasionally misbehaving—like any eight-year-old Florentine boy. Along with his two older brothers, Francesco del Giocondo would have raced through alleyways, swam and fished in the Arno, and pummeled other boys in bruising street games, including a precursor of soccer played, as one chronicler described it, "more with the fists than the feet."

When a winter blizzard blanketed the city in white, Francesco and other Florentine lads clamored out of houses, schools, and workshops to carve snow lions—either in the shape of the living beasts once kept in a "lion-house" on the Via del Leone (Lion Street) or of the Commune's emblematic Marzocco, a regal seated lion with one paw resting on a shield. Florentine troops carried a stone statue of the Marzocco with them into battle and often forced defeated foes to kiss its backside. At times the townspeople would set a crown on the statue's head as a sign that freedom was the only king Florentine citizens would ever accept.

For merchants' sons like Francesco and his brothers, learning to be good citizens of Florence meant learning to be good businessmen. A tutor probably taught the del Giocondo boys reading, writing, and basic arithmetic. At about age ten they went to a *scuola d'abaco* to learn to work the abacus, a prototype of the calculator, essential for currency exchanges and other financial transactions. The brothers acquired a deeper understanding of the trade from their father and uncles in the family shops—a commonplace experience in Florence, but shocking to outsiders.

"The highest citizens who govern the state go to their silk *botteghe* and work the silk for all to see," marveled Marco Foscari, a visitor from

Venice. "Their children are in the *bottega* all day, in their smocks, carrying sacks and baskets of silk."

——

Even after finishing his own professional apprenticeship, Leonardo continued to work with Verrocchio. Around 1474 (a date, like so many in his career, still in dispute) the young artist began his first portrait—and his first masterpiece. Its subject, Ginevra de' Benci (c. 1457–1520), another *donna vera* of Florence, was born about twenty years before Lisa Gherardini into immense wealth and privilege. Her grandfather had served as general manager for the bank of his friend Cosimo de' Medici. Her father, a humanist intellectual and art patron as well as a banker, reported a fortune second only to that of the Medici.

In the stately Benci *palazzo*, Ginevra and her six brothers received a superb education in literature, mathematics, music, Latin, and perhaps Greek. At ten, after her father's death, Ginevra continued her studies as a boarding student at one of Florence's exclusive convents, Le Murate (for the "walled-in ones"), renowned for its nuns' exquisite embroidery and angelic singing.

At about age sixteen, Ginevra left the convent school to marry a cloth trader. Young humanists, including Lorenzo de' Medici, wrote verses in praise of her beauty and wit. She also attracted a devotee whom she may or may not have welcomed: Bernardo Bembo, the married, middle-aged Venetian ambassador to Florence, who first beheld the young beauty at a Medici joust.

Despite a wife and son in Florence and a mistress and love child elsewhere, Bembo threw himself into a public courtship of Ginevra—a not uncommon and completely platonic Renaissance diversion. He, rather than Ginevra's husband, may have hired Leonardo to capture her allure in a painting. (Many years later, some believe, a similarly smitten admirer of Lisa Gherardini—none other than the youngest son of Lorenzo de' Medici—may have urged Leonardo to paint her portrait as a similar tribute.) Bembo also commissioned ten poems in Ginevra's honor by members of the Medici literary circle.

Like only a few women of her day, "La Bencia" wrote poetry her-

self, but only one enigmatic fragment survives: "I beg for mercy, and I am a wild tiger." Leonardo's unsettling painting captures the tigress's mystique: a proud and perfect head, heavy-lidded feline eyes, an icy and unflinching gaze, a brooding expression, skin smoothed into perfection by his own hand. Masses of the ringlets that would become his trademark twirl around her pale face, set against the background of a juniper tree—*ginepro* in Italian, a play on her name and perhaps her prickly character as well. On the portrait's reverse, Leonardo painted a "device," an emblem of laurel and palm enclosing a sprig of juniper—a poetic representation of Bembo entwined with Ginevra—and an inscription, VIRTUTEM FORMA DECORAT (She adorns her virtue with beauty).

When I think of Ginevra de' Benci and Lisa Gherardini, the two Florentine women who grace Leonardo's portraits, their differences strike me first. Although both married successful merchants, Ginevra's husband hardly merits a mention in accounts of her life. Unlike Lisa, who would care for a stepson and give birth six times, Ginevra had no children—by choice, some suggest. A note from a gentleman complimenting her poetry chides Ginevra, who "from excessive haughtiness . . . refuses to present us mortals with descendants."

The aloof, pale beauty may have suffered a chronic illness or a breakdown of some sort that compelled her to leave Florence. Lorenzo de' Medici mentions her tears, sighs, and "blessed madness" and commends her for fleeing the city, "aflame with every vice."

Years ago, when I first beheld Ginevra's portrait, the only painting by Leonardo in the United States, at the National Gallery of Art in Washington, D.C., I admired its style but not its subject. But as I learned more about Ginevra, I detected hints of an indomitable spirit, perhaps not unlike Margherita Datini's, behind her frosty features. As feminist scholars observe, she may have represented a new, independent-minded breed of Renaissance woman.

After her husband's death in 1505, Ginevra reportedly became a "tertiary," or lay nun. When she died around 1520, she was "vested," or dressed in a nun's habit, a special privilege reserved for pious laywomen, and bur-

ied in Le Murate. I began to wonder if she and Lisa had more in common than I had assumed. Or could it be mere coincidence that the two young Florentines captured by Leonardo's brush chose to spend eternity in nunneries?

However different their subjects, the paintings share unmistakable similarities. In both works, Leonardo breaks the rules of traditional portraiture. Rejecting the conventional profile pose used in earlier, stylized works, he presents both real women in a three-quarter view. Rather than looking demurely downward, they gaze directly at or almost through an observer. Although both undoubtedly owned fancier gowns and impressive jewels, they appear in plain, even somber, dress. In Ginevra's portrait, Leonardo merges shades together in a suggestive technique called *sfumato*, literally "evaporated into smoke," that he would perfect in the *Mona Lisa*. And he sets both women against a dreamlike landscape that suggests psychological as well as physical depths.

In 1475, at age forty-eight, Leonardo's father, the twice-widowed Ser Piero da Vinci, married his third wife, seventeen-year-old Margherita Giulli. The following year Leonardo, after twenty-four years as an only child, acquired a half brother—and lost any possible claim to his father's estate. Perhaps even more unsettling, psychologists suggest, might have been his sense of losing a favored place in Ser Piero's life.

Within a few years the prospering *notaio* moved to a large *palazzo* on Via Ghibellina, near the home of Lisa Gherardini's grandparents. Its rooms filled rapidly. Although he had not lived under his father's roof for years, Leonardo may well have shaken his head in dismay at the arrival of baby after baby after baby after baby. Decades into the future he would find himself locked in a bitter legal battle with these step-siblings and others young enough to be his own grandchildren.

Leonardo's first run-in with the law came in April of 1476. Florence's vice squad—the detested Office of the Night and Conservers of the Morality of Monasteries—investigated an anonymous denunciation in one of the *tamburi*, the boxes originally set up to snare troublemaking magnates like the Gherardini. Along with three other young men (one re-

lated to Lorenzo de' Medici), Leonardo was accused of having sex with a seventeen-year-old apprentice goldsmith named Iacopo Saltarelli, who, according to the complaint, "pursues many immoral activities and consents to satisfy those persons who request such sinful things from him."

Sex between men was so common in Renaissance Florence that "*Florenzer*" had become German slang for a homosexual. The intensely masculine city displayed unabashed appreciation for male as well as female beauty, for the bulge of a muscular thigh in tights as much as the curve of an ivory bosom in a low-cut dress. Many artists and humanists were widely believed to be homosexual, as their works sometimes revealed. A Florentine contemplating young Michelangelo's sculpture of an alluring Bacchus commented, "Buonarroti could not have sinned more with a chisel."

Yet the Commune created a judicial magistracy—the Office of the Night, one of the few such criminal agencies in Europe—solely to pursue and prosecute sodomites. Every year from 1452 to 1502 anonymous accusers denounced an average of 400 men and boys; some 55 to 60 were convicted of sodomy. Punishments ranged from a fine for an initial arrest, to flogging through the streets, to death by burning for a fifth offense.

Leonardo and his friends may have been jailed briefly, although the only evidence is a sketch he made of "a device for unhinging a prison door from the inside—imagined while sitting amidst the stinking, vermin-ridden straw." The court dismissed the charges against the young men two months later for lack of a witness, perhaps with some deft string-pulling by an embarrassed Ser Piero or the powerful Medici.

Was Leonardo gay? He never married or had children, surrounded himself with handsome young men, and doted on comely protégés, but we know little else. The artist veiled the intimate details of his life with a curtain of discretion so impenetrable that no historian or psychologist has ever pulled it open—although many have tried.

Early biographers presented the artist as asexual. "Leonardo would marry no mistress but painting," one wrote, "nor beget any children but

the works he performed." Some quote Leonardo's own words as evidence for his abstinence. "The act of copulation and the organs that serve therein are distinguished by such hideousness," he observed, "that were it not for the charms of the faces, the ornaments of the participants, and the power of lust, humankind would cease."

Perhaps the question shouldn't be the nature of Leonardo's sexual orientation but whether it made any difference in his works. When I ask the opinion of a gay art historian in the San Francisco Bay Area, he pauses before answering.

"It may have mattered with a painting like *Mona Lisa*," he says slowly. "In Leonardo's eyes, she wasn't someone to be desired. He looked at her in a different way than other men. This may be one reason why he could see—and paint—Lisa Gherardini, not as an object or an ideal but as a fully realized human being." It was a perspective on *la donna vera* that I had never considered.

As a human being, Leonardo, already stigmatized by his illegitimacy and lack of a classical education, may have felt stung by the sodomy accusation. Whether by choice or circumstance, he seems to have become increasingly isolated. In a cri de coeur from this time, Leonardo lamented, "I am without any friends."

By the middle of the 1470s, Lorenzo de' Medici had reason to reflect on another line from one of his canticles: "Of tomorrow, who can say?" The future seemed uncertain at best. The prince of pageantry had proved disastrously inept as a banker. With the loss of hundreds of thousands of florins in bad loans, several branches of the family bank were hemorrhaging money. Lorenzo sparred openly with Pope Sixtus IV, who canceled the Medici's lucrative Vatican account.

In 1478 some disgruntled Florentines, led by the Pazzi, a rival banking clan, decided that the time was ripe for a coup. The Pope offered covert support—on the condition that no one be killed. Despite this caveat, Archbishop Francesco Salviati of Pisa, nursing a deep contempt for the Medici, helped hatch a brazen assassination plot.

Antonmaria Gherardini, far removed from Florence's internecine pol-

itics, would have known nothing of such stratagems. Focused on family concerns, the widower had taken a third bride. Lucrezia del Caccia, from another well-established Chianti family with holdings near the Gherardini lands, was, at twenty-one, pushing the upper age of desirability. Despite his tragic marital history, thirty-two-year-old Antonmaria may have seemed her best—if not her last—chance to wed.

Settled with his wife in the little low-rent house on smelly Via Sguazza, Antonmaria never could have anticipated an impending cataclysm. In one of history's minor unforeseeable consequences, the Pazzi conspiracy and the war it triggered would devastate his family's finances and jeopardize the Gherardini's future.

On the morning of April 26, 1478, in Florence's immense Duomo, the cathedral of Santa Maria del Fiore, Lorenzo de' Medici took a place just to the right of the high altar for Sunday Mass. His brother Giuliano, who came in late, stood some twenty or thirty yards farther back. The dashing bachelor may have decided to sleep in after a night of carousing, but two of his pals—the banker Francesco de' Pazzi, so tiny he was called Franceschino (little Frankie), and a ne'er-do-well gambler named Bernardo di Bandino Baroncelli—thumped on his door and practically yanked him out of bed and into his clothes. As they scurried along the streets, Pazzi wrapped an arm around Giuliano to check for protective armor under his doublet. He wasn't wearing any.

Just before the holiest moment in the sacred liturgy, a hand bell chimed to herald the elevation of the host. At this signal, as Lorenzo and Giuliano bowed their heads, four men pulled out their daggers.

"Die, traitor!" cried Bernardo, plunging his blade into Giuliano's chest. Little Francesco de' Pazzi began slashing at Giuliano in such a frenzy that he stabbed his own thigh. Two priests just behind Lorenzo lunged at him with their knives, but the agile athlete, only slightly grazed, spun away. Wrenching off his cloak, he swirled it over his arm to form a shield and drew his sword. His friends rushed toward Lorenzo, swept him into the sacristy, and barred the door.

"*Popolo e libertà!*" (For the people and liberty!) the Pazzi and their

supporters yelled, expecting the confused congregation to rally to their rebellious cause. Instead, as Lorenzo showed his face, the Florentines shouted their support for the Medici with cries of *"Palle! Palle!"* (for the balls on the family coat-of-arms). Francesco de' Pazzi fled to his uncle's house, where a rabid crowd snatched and kicked him, then brought him, naked and bleeding, to the Palazzo Vecchio. There Archbishop Salviati, who had led a band of mercenaries to the town hall to confront the priors, was already in restraints.

When the great bell tolled, the mooing of La Vacca drew all of Florence's men into the Piazza della Signoria. Ser Piero da Vinci would have rushed the few blocks from his home on Via Ghibellina. Leonardo may have arrived with some fellow artists. Antonmaria Gherardini would have taken more time to make his way across the Arno. As the square filled, an executioner slipped a noose over Francesco de' Pazzi's head, tied the other end to the strong metal transom dividing one of the windows, and hurled the pint-sized banker into the air.

Archbishop Salviati, still in his purple ecclesiastic robes, soon joined him. Eyewitnesses reported that, either in rage or a crazed attempt to save himself, the prelate bit into Pazzi's naked body as it swung next to him. As the rope tightened, he kept his teeth clenched and died with a huge lump of flesh in his mouth. The artist Michelangelo Buonarroti, just three at the time, recalled his father hoisting him onto his shoulders for a better view of the dangling bodies.

A raging mob dragged other conspirators through the streets, slit their noses, and hacked off their hands and genitals. At one point 16 corpses hung from the Palazzo Vecchio windows; another 68 disemboweled bodies swelled and rotted in the piazza below. In all, 270 Florentines died. The patriarch of the Pazzi family was killed, thrust into a hole, dug up again, and then dumped in the Arno. Lorenzo confiscated the Pazzi property and exterminated the family name, forbidding anyone even to pronounce it.

Leonardo might have hoped to paint the large *"pittura infamata"* on the Bargello wall of the eight leading Pazzi conspirators, seven with nooses around their necks, and Bernardo, who managed to escape, dan-

gling by his foot. Instead the prized commission—like so many others—went to the Medici favorite, Sandro Botticelli.

Pope Sixtus IV's retribution for the execution of his archbishop was swift and merciless. Calling Lorenzo "a suckling of perdition," he excommunicated him and the entire city of Florence and ordered the seizure of all Medici assets in Rome, including the family bank. Under the Pope's edict, anyone anywhere who bought a bolt of Florentine cloth or even accepted or exchanged Florentine coins would become a moral leper. The bishops of Tuscany defiantly issued a decree of their own excommunicating the Pope.

Sixtus IV decided that it was time to topple the arrogant Medici once and for all. Since his Vatican forces were too small, he formed an alliance with King Ferdinand I of Naples, whose son Alfonso marched a combined army of papal and Neapolitan troops into Chianti, south of Florence. The invading troops set fire to fields of crops, plundered houses, and slaughtered livestock. As they trampled across the Gherardini estates, they sacked the mill and stole the harvest.

"For love of war," Antonmaria Gherardini scrawled angrily on his tax statement, "I have no income. Our houses have been burned, our possessions smashed, and our workers and livestock lost."

When his wife Lucrezia became pregnant later that year, Antonmaria would have had a new reason for worry. If the child survived and turned out to be a girl, he would face the stinging humiliation of not having enough money to set aside a dowry at her birth.

At first I didn't understand the implications of such a default. Even if a girl couldn't snare a husband, I figured that an "old maid" could surely remain at home. No, a friend from an old Florentine family explained to me. A spinster—*zita, zitella,* or *zitellona* in Italian—had no place in Renaissance society.

Unless a father could provide a dowry and "lead a daughter to honor"—a sacrosanct responsibility—a girl of the upper classes would descend into a social limbo. No groom would want her; no clan would welcome her. Her own family couldn't keep her. The very existence of an

unmarried daughter, even if she retreated to the upper floor of her father's *palazzo*, would jeopardize her relatives' honor and status. Among the "best people," as a historian bluntly comments, families did not include females over the age of twenty who were not married.

"*Maritate o monacate!*" (Marry or become a nun!) Tuscans exhorted their daughters. Once convents had been reserved for the least desirable of girls—the ugly, infirm, deformed, or disabled, those a preacher derided as "the scum and vomit of society." But by the late fifteenth century, nunneries had become dumping grounds for undowered virginal girls from respectable homes. Elite families were more likely to confine their daughters within convent walls than allow them to marry downward. As many as half of upper-class girls, by some estimates, ended up in the fifty or so local convents, with reputations ranging from spiritual to salacious.

However alluring his daughter's face, however fetching her figure, Antonmaria Gherardini might have feared that without a dowry she would have to live out her days—as his own sister did—in eternal anonymity behind convent walls. He could not have been more mistaken about the fate awaiting his Lisa.

Part II

UNA FIORENTINA

(1479–1499)

Chapter 5

Daughter of the Renaissance

On a mid-June day in 1479, a midwife—called a *levatrice* for her "lifting" (*levare*) of a baby into the light—gently washed the newborn daughter of Antonmaria and Lucrezia Gherardini with warm white wine and swaddled her tightly in white linen. Only her pink rosebud face peeked out from her wrappings when her father took the priceless bundle in his arms. Like all Christian fathers in Florence, thirty-five-year-old Antonmaria faced a sacred duty: to whisk his newborn to the Battistero di San Giovanni (Baptistery of St. John) before dangers or devils could snatch her eternal soul.

The walk from dank Via Sguazza to the spiritual heart of Florence usually takes twenty to thirty minutes. I know. I've trekked it at different times and different seasons. But on this glorious day of days, Antonmaria's was no ordinary stroll. In an age when birth swept mother and child perilously near death, Florentines welcomed each new life with unbridled exultation.

Dressed in gaily colored brocade gowns and cloaks, with banners fluttering in the air, a high-spirited crowd of *amici, parenti, e vicini* (friends, relatives, and neighbors) accompanied the town's youngest citizens on the first journey of their brand-new lives. Only the exhausted mother remained at home in the care of an aptly named *guardadonna* (literally, "lady-watcher").

Antonmaria Gherardini would have led his merry troupe past the humming looms of the giant wool houses on Via Maggio, along scruffy Borgo San Jacopo, nicknamed Borgo Pidiglioso (Louse Place), into the noisy crush of the markets and shops on the Ponte Vecchio. House-

wives haggling over the price of tripe may have turned to smile. Butchers paused, razor-sharp blades in midair, to shout congratulations. Some well-wishers would have spontaneously joined the parade.

Crossing the Arno, Antonmaria could have glimpsed the stump of the Gherardini medieval fortress tower. On Por Santa Maria, then as now a main commercial street, he passed the textile shops of the del Giocondo brothers, where fourteen-year-old Francesco, the boy who would become his son-in-law, was learning the fundamentals of the family silk business.

~

Ahead loomed the domed cathedral, a great clay-bricked, white-ribbed hump of a mountain towering above the knot of city streets. Across from its unfinished facade stood the Baptistery of St. John, Florence's oldest and holiest monument. Antonmaria Gherardini, like other Florentines of his time, would have believed that the Baptistery was an ancient temple of Mars converted to Christian use. Not so, I learn from local historians, although the ancient Romans may have buried their dead nearby.

To Florentine Catholics, who baptized all newborns here by law until well into the twentieth century, this blessed site celebrated life. Constructed in the eleventh and twelfth centuries, its octagonal shape represented eight days: the six during which God created heaven and earth and all that inhabits them, the seventh when He rested, and the eighth, the eternal day that never ends.

As Florence prospered, the ancient rite of baptism had evolved into yet another opportunity for over-the-top ostentation. Status-craving citizens bought so many candles, designated so many godparents, and presented such extravagant gifts that the city fathers clamped down on every excess, including the number of courses to be served at the postbaptism banquet. Dismissing the laws as an attack on their right to assert family honor, indignant Florentines generally ignored the restrictions.

~

Antonmaria Gherardini's newborn daughter, nestled in the arms of one of her godparents—probably two godmothers and a godfather, as the Church recommended for a girl—could not enter the Baptistery's hal-

lowed interior with an uncleansed soul. On the entrance steps a priest exhorted any unclean spirits to flee and the Holy Spirit to come in their stead. Her godparents, bound to her almost as closely as blood relatives, pronounced the infant's second, or middle, name: Camilla.

The Gherardini party, modest compared to many, entered the vast open hall, an awe-inspiring testament to the splendor of God's grace— and to Florence's wealth. Overhead shimmered the celestial ceiling, painted in gold and then covered with glass mosaics to form a huge Italo-Byzantine image of Christ the King and Judge. To His left a hideous horned demon with serpents writhing out of its ears devoured sinners; to His right devout souls soared heavenward.

Also on display were a relic of Christ's true cross, believed to be a gift from Charlemagne; gleaming silver candlesticks atop a silver altar; and Florence's greatest military treasures, including the *carroccio*, the war chariot that accompanied its troops, and battle standards captured from enemies. In this civic church, Florence crowned poets, vested magistrates, blessed soldiers before battle, and honored troops returning from war.

At the octagonal marble font, the godparents of the youngest Gherardini renounced Satan and declared belief in God in the baby's name. In the chill of the towering hall, the priest sprinkled holy water on the infant. With this blessing, her soul, otherwise doomed to what Dante described as "untormented gloom" in a limbo of endless sighs, entered the kingdom of God, perhaps the only residence Florentines of the time would choose over their city.

When the priest asked how the child would be called, her godparents intoned her first name, "Lisa," a tribute to Antonmaria's mother, who had died a few years before.

⁓

Although Lisa's baptism has been well documented, I feel a compelling urge to see the actual record for myself.

"Don't waste your time looking through baptismal ledgers in Florence," an archivist advises. "You can find it online when you get back home."

With some trepidation, on my return to California I take up the challenge, still daunting to me, of digging through Italian digital archives. As

I position myself before my computer, my apprehension intensifies. With trembling fingers, I search for the Opera di Santa Maria del Fiore di Firenze. A few clicks bring me to the cathedral's *"risorse digitali"* (digital resources) and its *"registri battesimali"* (baptismal registries). Zeroing in on the ledger for June of 1479, I hit the key to *visualizzare* the list—and hold my breath.

With an abracadabra swiftness, a page of names, written in the small, florid script I'd first encountered in the Archive of the State of Florence, materializes on my screen. Six lines below the bold heading of *"Martedì Adi XV di Giugno 1479"* (Tuesday the fifteenth day of June 1479), I spot the names Lisa & Camilla di Antonmaria Gherardini di San Pancrazio (an old Gherardini neighborhood in Florence).

Leaping out of my chair, I dance in excitement. More than 530 years later, at a distance of some 6,100 miles, in a country yet to be discovered at the time of her birth, I have found the original record of Lisa Gherardini's entry into the world.

The *donna vera* had never seemed more real to me.

━━━━

Lisa's addition to the rolls of Florentine citizens may have been marked less formally. As new fathers had for centuries, Antonmaria Gherardini would have selected a bean—white for a girl rather than black for a boy—and dropped it into a designated receptacle, possibly at or near the Baptistery. Sometimes fathers didn't bother to acknowledge the birth of a daughter. In this patriarchal society, families exulted more in the arrival of a son, who could continue the male line, take over the business or farm, and increase a clan's prestige and wealth by acquiring a well-bred bride with a sizable dowry.

Yet as their letters and *ricordanze* reveal, many Florentine fathers adored their little girls. After two heart-wrenching losses of wives and babies, Antonmaria must have looked down on his newly baptized daughter and swelled with an emotion he had never before experienced. At least for the moment, relief and joy would have washed away worries about his finances and her future. The new *babbo* (daddy) might not even have been able to find words for what he felt.

"Who would believe, except by the experience of his own feelings, how great and intense is the love of a father toward his children?" asked the humanist Leon Battista Alberti in his classic treatise *On the Family*. "No love is more unshakeable, more constant, more complete, or more vast than the love which a father bears his children."

Antonmaria's household would have celebrated for weeks. The new mother, Lucrezia, would have held court in the bedroom. Some visitors may have tucked coins into baby Lisa's swaddling clothes to bring her riches. Others could have brought a branch of coral or a dog's tooth, believed to ward off evil, for her to wear on a little gold chain around her neck. As the women chatted and fussed over mother and child, the men—most dressed in the simple *lucco*, the long, well-cut robe of the old nobility—would have talked of darker things.

It had been a terrible year. Lorenzo de' Medici's war with Pope Sixtus IV and his Neapolitan allies was crippling the city's commerce and draining its coffers. Branches of the major Florentine banks throughout Europe closed. The textile industry shuttered mills and warehouses. Supplies no longer streamed into the city.

Even the rich were suffering. The tycoon Giovanni Rucellai, who had declared 60,000 florins in taxable assets (mainly real estate) in 1473, just six years earlier, was plunging toward bankruptcy. The news from the countryside was even worse. The papal troops that had invaded Chianti like locusts were ransacking nearby estates. Antonmaria Gherardini's wheat fields lay fallow, his livestock untended, his vines unpicked.

I catch up on the news of these day-to-day developments through an observant diarist named Luca Landucci (1436–1516). From his apothecary shop at the Canto de' Tornaquinci, near the mansion of the Rucellai (to whom he paid rent for years), the sharp-eyed onlooker watched the comings and goings of his fellow citizens, jotted down their comments, and catalogued the events of the day in pithy notations that strike me as the Renaissance equivalent of tweets.

"Chianti was pillaged," reads one entry from 1479. After a seven-month siege, Landucci reports, invading troops conquered Colle di Val

d'Elsa near the Gherardini estates and laid waste to more of the neighboring lands. But then came reason for hope. In a daring move, Lorenzo de' Medici traveled to Naples to negotiate face-to-face with King Ferdinand I, whose son Alfonso had led the invasion of Tuscany.

Several weeks later, "a herald arrived in Florence with an olive branch," symbolizing that peace talks had begun. When Lorenzo returned home with an agreement, the city hailed him as a triumphant hero.

"There were great rejoicings with bonfires and ringing of bells," Landucci records. Lorenzo de' Medici, who had been addressed along with the most elite Florentines as *La Magnificenza Vostra* (your Magnificence), became the one and only Il Magnifico (the Magnificent).

For Lorenzo, vengeance was even more gratifying than his diplomatic triumph. Through the long arm of the Medici enterprises, he set in motion a manhunt for Bernardo di Bandino Baroncelli, one of the Pazzi conspirators. On the fatal April morning in 1478, after stabbing Giuliano de' Medici, the assassin had lunged toward Lorenzo but was intercepted by Francesco Nori, head of the Medici bank in Florence. Bernardo skewered the banker with a thrust to his stomach.

In the chaos and carnage that followed, Bernardo jumped on his horse and galloped as fast and as far as he could. Eventually, he made his way to Constantinople, where he was arrested by order of Lorenzo's ally, the Sultan of the Grand Turk, and hauled back to Florence. On December 28, 1479, the executioner tied a noose around his neck and flung the traitor from a window of the Palazzo Vecchio.

We find a sketch of the limp body in Leonardo's notebooks, along with these notes:

A tan-colored small cap.
A doublet of black serge.
A black jerkin with a lining.
A blue coat lined with fur of foxes' breasts and the collar of the jerkin covered with black and red stippled velvet.

Bernardo di Bandino Baroncelli;
black hose.

───

The young artist had grown from a beautiful boy into a *bell'uomo*, a stunning twenty-seven-year-old looking as if he'd stepped out of a fresco in his favored pink, rose, and purple robes, cut short to showcase his muscular legs even after fashion dictated longer lengths. An early biographer described him as "very attractive, well-proportioned, graceful, and good-looking," with a "beautiful head of hair, curled and carefully combed in golden ringlets that fell to the middle of his chest."

Leonardo's father Ser Piero, widowed again, this time with four young sons and a daughter, may have orchestrated some lucrative commissions, including an altarpiece for the chapel in the Palazzo Vecchio, which Leonardo never completed. From the very beginning of his career, the artist acquired a reputation for not meeting deadlines or delivering promised works—although not for lack of ability or ambition.

In his notebook Leonardo copied these lines from Dante:

> . . . *he who uses up his life without achieving fame*
> *Leaves no more vestige of himself on earth*
> *Than smoke in the air*
> *Or foam upon the water.*

Leonardo was determined to become more than mere smoke or foam. "I wish to work miracles," he once wrote. But his miraculously creative designs were often so complex and technically demanding that he never could complete them. "In his imagination," the art historian Vasari explains, "he frequently formed enterprises so difficult and so subtle that they could not be entirely realized and worthily executed by human hands."

Leonardo, who may still have felt a bit like a small-town boy gussied up in big-city finery, never won over the town's highbrow humanist intellectuals. To them, he may have seemed a gifted but unschooled ignora-

mus, incapable even of conversing in Latin. Then Leonardo suffered what might have seemed to him a galling snub.

Pope Sixtus IV, reconciled with Lorenzo de' Medici, requested a list of the best artists in Florence to work on the Vatican chapel that would be named "Sistine" for him. On Il Magnifico's recommendation, Botticelli, Perugino, and a string of lesser painters packed their brushes and decamped to Rome for lucrative commissions. One man was conspicuously left behind: Leonardo da Vinci.

Il Magnifico sent the artist on a mission to Milan, a dangerous enemy during its centuries under the rule of the Visconti dukes. In 1450 a fierce warlord named Francesco Sforza, a family name derived from *sforzare* (to force), seized control of the city-state. Cosimo de' Medici, Florence's leader at the time, cultivated a mutually advantageous friendship.

By 1481, Francesco Sforza's illegitimate son Ludovico (1452–1508) emerged as the victor in a hard-fought power struggle and became acting regent of Milan. As a tribute or token of friendship, Lorenzo de' Medici commissioned Leonardo to create a special gift for the cosmopolitan ruler: a silver lyre in the shape of a horse's head. The artist, who played the violin-like instrument "most divinely," in Vasari's words, delivered it personally.

Il Moro (the Moor), as burly, big-chinned Sforza was nicknamed, was impressed, but Leonardo was even more captivated by Milan, a prosperous big city of more than 80,000 residents that pulsed with energy and an invigorating spirit of intellectual innovation. Under Ludovico's aegis, the duchy attracted a rich medley of scholars, scientists, architects, poets, artists, and musicians. In their admiring eyes, Leonardo possessed such an impressive wealth of talents that painting seemed just one.

When he applied for a ducal appointment, Leonardo didn't present himself as just another dime-a-dozen artist. A hyperbolic résumé emphasized his expertise as a military engineer who could dig underground tunnels "without noise and following tortuous routes," make "large bombards, mortars, and fire-throwing machines," and create weapons of mass destruction that would "penetrate enemy ranks with their artillery and destroy the most powerful troops."

Almost as an afterthought Leonardo mentioned his peacetime capabilities: "I can carry out sculpture in marble, bronze, and clay; and in painting can do any kind of work." He proposed completion of a stunning memorial to the Duke's father, a gigantic bronze statue "that will be to the immortal glory and eternal honor of the lord your father of blessed memory and of the illustrious house of Sforza."

Although he didn't win an immediate position on the Sforza payroll, Leonardo, convinced that his destiny lay in Milan, left Florence around 1482. Lorenzo de' Medici did nothing to stop him.

~

Lisa Gherardini turned three in 1482. Like other little girls of the upper classes, she would have learned to curtsy before she could count. Through a thousand reprimands and reminders, she would have mastered the knack of eating daintily with three fingers of the right hand and dabbing her lips with the edge of the long tablecloth.

Bathed in rose water and rubbed with scented oils, Lisa smelled like a flower and dressed like a miniature adult. Over a *camicia* (underblouse), she donned smaller cuts of her mother's clothes—indicated by diminutive endings meaning "little": a *gamurrina* (little at-home dress), *cioppetta* (little smock with wide sleeves), *farsettino* (little quilted vest), *cintoletta* (little belt), *cappuccetto* (little hood), and *mantellino* (little cape). If she was at all like my daughter, she may have delighted in twirling round and round so her full skirts billowed around her.

Soled *calze* (stockings) covered her legs, while *cuffie, berrette,* or *cappellini* (varieties of caps, bonnets, and little hats) protected her head. On her feet Lisa wore cloth or leather slippers (*pianelle*), although probably not a pair with heels, which were considered scandalous for a young girl; wooden-soled sandals; and boots. In the fall and winter, wooden clogs (*zoccoli*) protected her from muddy streets.

In her arms little Lisa would have cuddled her "*bambino*," a terra-cotta figure of the infant Jesus dressed in velvet and brocade. Girls so treasured such "devotional toys," as priests referred to them, that they tucked them into their wedding chests when they moved into a husband's home.

Like other Florentine kids—called *putti,* a term adopted for cheru-

bic infants in paintings or sculptures—Lisa would have played with balls, wooden horses, cymbals, artificial birds, gilded drums, "a thousand different kind of toys," according to a priest who warned parents not to give children banks lest they foster avarice or dice lest they encourage gambling. Following clerical advice, Lisa's mother would have brought her daughter to church, where she learned "to stand respectably and ornately" and to recite the Ave Maria and Pater Noster.

In 1483, at age four, Lisa became a big sister with the birth of her brother Giovangualberto, followed by Francesco, Ginevra, Noldo, Camilla, and Alessandra. Each arrival must have increased the pressure on Antonmaria Gherardini to squeeze more revenue from the six large properties he managed in Chianti, his own and several others rented from the hospital of Santa Maria Nuova. Their wheat, grape, and olive crops, together with earnings from livestock, provided his principal income—"hardly enough," economist Giuseppe Pallanti observes, "to give him the dignified life" expected of the landed gentry.

Despite the financial strain, as a family with growing children, the Gherardini may not have been so different from other Florentines, including the richest of all. We get a charming inside peek at Lorenzo de' Medici's domestic life from a letter that seven-year-old Piero, his oldest son, wrote to his father in 1479 about his six siblings:

"Magnificent father mine," he begins. "We are all well and studying. Giovanni is beginning to spell. By this letter you can judge where I am in writing. . . . Giuliano [an infant] laughs and thinks of nothing else. Lucrezia sews, sings, and reads; Maddalena knocks her head against the wall, but without doing herself any harm, Luisa begins to say a few little words, Contessina fills the house with her noise . . . nothing is wanting to us save your presence."

In privileged households like that of the Medici, tutors taught sons and daughters grammar, math, logic, literature, and Latin, which humanists considered "the finishing touch to a girl's charms." Lisa's education would have been more limited: reading (mainly psalters and inspirational books such as the *Little Book of Our Lady*), writing, simple arithmetic, poetry (to

be recited by heart), singing, and mastering an instrument such as the lyre. Like girls of every class, she would have spent hours at needlework and embroidery, considered a display of skill and gentility—and a healthy substitute for the work the devil might otherwise find for idle hands.

Florentine children like Lisa also learned certain self-evident truths, accepted by all beyond doubt or discussion: The sun revolved around the earth. Their home planet was shaped like a sphere, just as Dante described in his *Divine Comedy*. Males by their very nature were dry and warm; females, wet and cool. Girls and women were also unquestionably, intrinsically inferior—in body, mind, and morals—and therefore in lifelong need of male direction.

If Florence reared its sons to be as fierce and fearless as its mascot lions, its daughters were groomed to be as elegant as its other state symbol—the lily, the epitome of the attributes that the city most valued in a woman: grace, purity, and beauty.

Lisa would have been admonished to walk, not run, and to keep her back straight, head up, and eyes down. The growing girl would acquire ways of investing every gesture with feminine sweetness and of presenting herself in the most fetching possible way—lifting her robe slightly in front to show her dainty feet, for instance, and pulling her mantle open from time to time "as a peacock spreads its tail." And she would have learned to dance—whether a solemn and stately pavane or an exuberant jig with leaps and jumps. On May Day, dressed in a pretty spring frock with a garland of flowers on her head, Lisa would have joined the city's other maidens sashaying with leafy branches in Piazza Santa Trinita.

Lisa's mother would have initiated her in all aspects of domestic life, including how to cook, clean, shop, keep accounts, haggle with vendors, and manage servants. As the big sister in a household that could afford little help, she undoubtedly did a full share of daily chores, such as dusting, waxing, sweeping, and lending a hand in the kitchen.

Along with having more responsibilities, Lisa might have enjoyed more freedom than the daughters of Florence's elite, some so closely monitored that they rarely left their homes except for religious services. Only

in summers on a family's country estates, amid the rasp of cicadas and the flicker of fireflies, could girls romp freely through fields of sunflowers, sing around evening bonfires, and wish upon a falling star on August 10, the Feast of San Lorenzo.

As I stroll through Florence's historic *centro*, I imagine young Lisa dwarfed by its rusticated walls and mammoth *palazzo* doors, high and wide enough for horse and carriage. Like other Florentines, she would have learned to tell time by church bells—so many and so loud that the town enforced a strict schedule for their ringing. As she ventured into the jostling crowds, Lisa might have wrinkled her nose at the urban scents of horse dung mixed with straw, seldom washed bodies, and stale blood from butchers' shops.

Her mother may have cautioned Lisa to keep an eye overhead for slop-pots being hurled from upstairs windows onto city streets. (Citizens regularly demanded recompense for ruined clothing.) Everywhere she went, she would have overheard the voluble Florentines bantering, gossiping, swearing (practically a local art form), swapping *battute spiritose* (witty remarks), and airing complaints on the platform called the "harangue" site in front of the Palazzo Vecchio.

As Lisa walked past the foreboding Bargello on the way to her grandparents' house on Via Ghibellina, she might have passed a felon in a huge two-pointed dunce cap, riding backwards on a donkey on his way to public mockery and whipping in the market square. Occasionally she would have spotted a more solemn procession of black-hooded friars chanting as they led a condemned soul along the Via dei Malcontenti (Street of the Wretched) to the gallows. Outside the Basilica of Santa Croce, she would have seen the hungry poor in grubby tunics lined up for steaming bowls of *minestra* (soup) and chunks of bread.

Florence's nonstop revels—parties, festivals, plays, games, ceremonies, processions—dazzled its youngest residents. Lisa may have marveled at sword-swallowers, acrobats, dancing bears, storytellers, and traveling actors, who would beat an iron pot to signal a performance. At the miracle plays performed on holy days, she would have watched saucer-eyed as a

heavenly angel in a snow-white gown glided from a church ceiling or a martyr's hands were magically cut off and then refastened.

In 1488, when Lisa was nine, a Middle Eastern sultan sent Lorenzo de' Medici a remarkable gift that everyone in town crowded to see: a giraffe—"very large, very beautiful and pleasing," Luca Landucci reports. Unfortunately, the gangly animal caught its head in some stable rafters and died of a broken neck. When excavation for the Strozzi *palazzo*, the largest in Florence, began in 1489, ten-year-old Lisa and her siblings, like many of their friends, may have tossed medals, flowers, and coins into its foundations to become part of the history of an edifice so monumental that Landucci predicted it would last "for the better part of eternity."

While Lisa Gherardini was still playing childhood games, Francesco del Giocondo would have traveled to Rome and Lyon, where the family operated branches, to learn the daunting complexities of international trade. As Florence's mercantile masters of the universe could—and did—rightfully boast, only the best-trained minds could set, monitor, track, and adjust prices, tariffs, exchange rates, inventories, and trade routes. And only the most stalwart of spirits could weather the constant risks of, well, weather—along with pirates, packhorses, plagues, highway robbers, political upheavals, bank failures, shipwrecks, and disasters of every natural and unnatural variety.

"Whoever is not a merchant and has not investigated the world and seen foreign nations and returned with possessions to his native home," Gregorio Dati wrote of his fellow Florentine businessmen, "is considered nothing."

Francesco and his relatives definitely amounted to something. Almost eighty del Giocondo men would serve in Florence's highest public offices (forty in the four decades from 1480 to 1520)— a privilege open to only an estimated 5 percent of the population. Francesco himself, like ten other relatives, would don a prior's ceremonial gold chain and a splendid cloak tailored of the best crimson wool and move into the Palazzo Vecchio for the standard two-month term on the Signoria, the very pinnacle of power—not just once, but twice.

Such success could have been woven only in Florence, a town that pursued both profit and beauty like drugs.

Once, I asked a Florentine friend why her hometown, of all possible places, became the cradle of the Renaissance. Without a word, she carefully extracted a strand from a shawl tossed over her shoulders and held it before me.

"*Il filo*," she declared. The thread.

Wool, the first fiber to enrich Florence, dominated the cloth market for centuries. Then the city swooned for *seta* (silk), worn by Chinese emperors a thousand years before Moses was born, light as a breeze, smooth as a petal, iridescent as sunshine, with a sheen that danced with every movement. Catholic missionaries may have smuggled the first silkworms into Italy in hollow canes in the twelfth century; others say a Chinese bride brought them in her trousseau. Florence's prize weavers—many exiled from Lucca in various political paroxysms—transformed raw silk into tactile fantasies by working thousands of ultrathin fibers into intricately patterned taffeta, damask, brocade, and velvet.

Florentine silk, epitomizing the elegance and refinement of the city itself, became the most coveted Renaissance luxury, more expensive even than precious gems. With the courts and clerics of Europe and the sultans of the Middle East clamoring for fabric, the city's silk business grew into a 400,000-florin ($60 million) enterprise.

Curious about what the del Giocondo silk shops might have looked like, I visit the Antico Setificio Fiorentino (Old Florentine Silk Mill), a combination showroom and factory set among flower gardens in the old cloth-making neighborhood south of the Arno. As I enter, the inebriating perfume of raw silk floods my nostrils. All around me, bolts of cloth ripple from ceiling to floor in rivers of reds, purples, and indigos. Their luscious names tantalize the tongue: pink sapphire (*rosa di zaffrone*), Apollo's hair (*capel d' Apollo*), throat of the dove (*gorgia di piccione*), peach blossom (*fior di pesco*).

Modern technology cannot replicate these handwoven cloths and colors, Sabine Pretsch, the Setificio's director, tells me. Lifting a piece of silk

with weft and warp threads of two different hues, she swirls it back and forth so it changes color as if by magic in light and shadow. I have to resist a sudden urge to touch, press, stroke, rub, crinkle.

The clients in the del Giocondo shop, Pretsch notes, would have favored *ermesino*, a heavy taffeta used today for draperies, and thick velvets (*velluti*), highlighted with curlicues of fine gold or silver foil, "voided" with a pattern showing through, or "figured" with a combination of cut and uncut pile against a satin or brocade background.

Despite its high price tag, more cloth was unquestionably more desirable. While servants and slaves dressed in skimpy, ill-fitting outfits, prosperous Florentines wrapped themselves in reams of richly worked silk. A lady's gown, falling in deep folds with a small train behind, enveloped her in some 35 *braccia* (an arm's length, about two feet)—at 5 florins or more per *braccia*—of plush fabric. Even a simple house dress required 8 *braccia*, enough for a modern ball gown.

Although most Renaissance garments have disintegrated over time, Florentine silks survive in the paintings of the artists who "dressed" Madonnas, saints, nobles, and well-to-do patrons in rich brocades and intricately worked velvets. "The value of the cloth," Pretsch explains, "made the paintings more valuable."

In the adjacent mill, where hand-operated looms click and clack as regularly as a heartbeat, she shows me a large still-functional cylindrical warping machine, based on a sketch by Leonardo, who filled page after page of his notebooks with knots, braids, and patterns. When I learn that the multitalented artist had designed fabrics, I can't help speculating that during his years in Florence, Leonardo may have consulted with its artisan weavers, perhaps even those in the del Giocondo shops—an unlikely but not unthinkable possibility.

❧

When Leonardo left Florence in 1482, his list of belongings did not contain a single book. Within a few months of his arrival in Milan, a magnet for erudite scholars from the great universities of northern Italy, he recorded five books in his possession. Eventually, he would amass a library of more than two hundred volumes, a substantial number for a professor,

let alone someone who defiantly declared himself "*un uomo senza lettere*" (an unlettered man).

The insatiably inquisitive artist—"the most relentlessly curious man in history," in the influential twentieth-century art critic Sir Kenneth Clark's description—plunged into a universe of new fields: anatomy, architecture, astronomy, geography, geology, mathematics, medicine, natural history, optics. But Leonardo soon ran into what seemed an insurmountable barrier: his lack of a formal education, particularly his limited knowledge of Latin, the language of science and scholarship. And so he embarked on what one historian describes as an "obstinate attempt of cultural emancipation" to learn what he needed to know in order to learn more.

With a flinty determination that reminds me of Margherita Datini's dogged quest to achieve literacy, the thirtysomething student laboriously copied *vocaboli latini* (Italian words derived from Latin) into his notebooks, filling page after page of the *Codex Trivulzianus*, his earliest manuscript, which he referred to as "my book of words." Even as Leonardo neared age forty, he was still working at conjugations, copying "*amo, amas, amat*" as diligently as a schoolboy.

As usual, Leonardo was juggling many other tasks at the same time—painting, teaching, making maps, entering an architectural competition, designing stage sets, and winning the admiration and affection of the Sforza court. In time, Leonardo secured his dream appointment as court painter and "*Ingeniarius Ducalis*" (ducal engineer), a job that entailed everything from supervising shipping routes to tinkering with the hot water supply in a royal residence.

Leonardo and his ever-present entourage set up living quarters and a workshop in a wing of the Corte Vecchia, the old ducal palace next to the cathedral. Here he would create sets, floats, banners, and costumes; carry out scientific experiments; sketch his first flying machines; design a dome for the Milan cathedral; and begin work on a clay model of the huge equestrian monument to Francesco Sforza, Ludovico's father, that would surpass in size all other such statues since antiquity.

Ludovico Sforza's first request was simpler: a portrait of his mistress, Cecilia Gallerani.

Leonardo might never have met a woman quite like Cecilia in Florence. The daughter of an ambassador from Siena who died when she was seven, the bright little girl, along with her six brothers, received an outstanding education. At age ten she was pledged to the son of a prominent family. Although part of the dowry was paid and the couple was officially betrothed, the union was never consummated, and the arrangements eventually dissolved.

Cecilia, an accomplished poet, musician, and singer and a clever conversationalist who could deliver orations in Latin, caught the eye of Ludovico Sforza. With a wave of his royal hand, he set the teenager up in a bucolic love nest. Before long the girl, lauded as *"bella come un fiore"* (beautiful as a flower), relocated to a suite of rooms in the immense Castello Sforzesco. By 1489 the pregnant sixteen-year-old had ascended to *"dominatrice della corte di Milano"* (the woman who dominated the court of Milan).

In a not-at-all-minor complication, Duke Ludovico happened to be engaged to Beatrice d'Este, the daughter of an important ally, the Duke of Ferrara. When he repeatedly postponed his nuptials with the young woman he described as *"piacevolina"* (just a bit pleasing), a polite way of saying "plain," the lords and ladies of the court blamed *"quella sua innamorata"* (that beloved of his).

Caught in the middle of this love triangle, Leonardo would have had to rely on his ample reserves of charm and discretion while painting Cecilia's portrait at the same time that he was planning spectacular festivities for several weddings, including the Duke's marriage to Beatrice in 1491.

As with his portrait of the self-proclaimed tigress Ginevra de' Benci, Leonardo chose an unconventional three-quarter view, with Cecilia's appraising eyes looking outside the frame of the picture as if her lover had just entered the room. Rather than appear demure or drab, she makes a bold fashion statement. Her gold frontlet, tied veil, black forehead band, and draped necklaces, art critics observe, suggest the restrained captive status of a concubine.

Unlike the antiseptic Ginevra, Cecilia sizzles with an erotic charge. With her right hand, in a curiously suggestive gesture, Cecilia strokes a sleek ermine (white weasel), a symbol of Il Moro, whose many titles included the honorary Order of the Ermine, and a play on the Greek word for ermine, similar to her name. The animal cradled in Cecilia's arms also captures the essence of the man to whom she is bound, sexually and socially—a predator with a vigilant eye and menacing claws splayed against her red sleeve.

Leonardo's almost photographic portrayal of an animated moment in this woman's life represented something radically new among painters of the time. Milan's court poets praised "the genius and the hand of Leonardo" for so adeptly capturing "beautiful Cecilia, whose lovely eye / Makes the sunlight seem dark shadow."

To me, Cecilia's story casts a different sort of light on Lisa Gherardini's life. In Italian city-states with kings, dukes, and princes, women (granted, an uncommon few) could inherit or acquire power and influence either directly or through their fathers and consorts. Not so in the macho Florentine republic. The city of artistic geniuses, great merchants, and brilliant humanists ranked, as a historian observes, "among the more unlucky places in Western Europe to be born female."

Florentine women, second-class citizens in their hometown, could not buy property, vote, hold office, attend university, study medicine or law, join a guild, run a business, or live independently. They could not even set foot in the halls of government or justice. Women called as witnesses or charged with crimes had to present their testimony at the entrance door.

From birth to death, the fate of a *fiorentina* like Lisa Gherardini depended on men: first her father, whose primary duty was to find a mate who would most benefit the family's circumstances, and then her husband, whose primary duty was to produce heirs. Eve's daughters—"walking wombs" typecast as virgins, wives, mothers, or crones—never escaped the dark shadow of her original sin.

Even poets and philosophers who savored feminine wit and intelli-

gence believed that women's place was unquestionably subservient to men. The humanist Marsilio Ficino, an inveterate romancer, relished female charms but dismissed women as "chamber pots," meant "to be pissed in and thrown away."

Scholars, looking back on history from a modern perspective, paint a bleak picture of life for daughters of the Italian Renaissance. Girls, devalued as products of "inferior" conceptions, were abandoned and left at foundling hospitals more often than boys, unmentioned on many tax forms and census documents, weaned sooner and more abruptly (often to save money), and fed less in times of famine.

Poverty shackled many female lives. Malnourished, illiterate, dressed in tattered dresses and thin cloaks, poor women toiled in houses, at looms, or in the fields alongside their men. Many bred early and died young. If their families fell on hard times, they could quickly plunge into servitude or prostitution.

Middle-class women, with less backbreaking burdens, were confined to the microcosm of their families, dedicating all their energies to homes, husbands, and children. Wealthier girls were practically kept under lock and key to safeguard their chastity, married off very young as pawns in their fathers' ambitious strategies, or relegated to convents so they would not be a social embarrassment or an economic drain. Most upper-class women married men almost twice their age; almost a quarter became widows.

"Did women have a Renaissance?" historian Joan Kelly-Gadol asked in a classic essay in 1977. No, she concluded, arguing that, if anything, they lost power—legal, social, moral, sexual, physical. In the decades since this provocative essay, scholars have arrived at a somewhat more positive perspective. Even if little changed in their social condition, "something changed in women's sense of themselves."

What about Lisa's sense of herself? How might she have felt about growing up female in a world made by and for males? At the suggestion of a mutual friend, I pose the question to Angela Bianchini, an esteemed author, literary critic, and grande dame of contemporary Italian literature.

In her book-crammed apartment in Rome, the nonagenarian and I discuss one of her nonfiction works, *Alessandra e Lucrezia: Destini Femminili nella Firenze del Quattrocento* (Alessandra and Lucrezia: Feminine Destinies in Florence in the 1400s), an account of two remarkable Renaissance women: Alessandra Macinghi Strozzi, best known for the hundreds of letters she wrote to her exiled sons, and Lucrezia Tornabuoni de' Medici, an admired poet and astute political observer, as well as the mother of Lorenzo de' Medici. (Her father-in-law, Cosimo de' Medici, called Lucrezia "the only man in the family.") As wives, mothers (Alessandra of eight children; Lucrezia of six), and widows, both wielded an unusual amount of influence in Florence, but neither ever overstepped the boundaries of her sex.

"*Non erano femministe*" (They were not feminists), Bianchini says thoughtfully. "*Non volevano cambiare il mondo*" (They didn't want to change the world). Renaissance women felt no urge to try. Florentines of both sexes saw themselves and everyone else as having an immutable place in the social hierarchy. Words like feminism, women's rights, or equality would have had no meaning to them. Born female, Lisa Gherardini would no more have yearned to trade lives with her brothers than with the fish in the Arno.

From a feminist perspective, Bianchini acknowledges, the women of Renaissance Florence can seem no more than "slaves or anonymous objects." But this view ignores their singularity, their individuality, and the unspoken but significant influence they had on their times. The women of Lisa's time, she emphasizes, were very much creatures of the society in which they lived.

Although not liberated in our sense of the word, Renaissance women were strong—and constituted the very center of the most important social institution of the time: the family. Wives and mothers not only held up half the sky; they functioned as the glue that held all aspects of Florentine society together. The impression they made on the men of their day remains indelible.

"When most people think of the Renaissance, what comes to mind?" Bianchini asks. Not the moguls, power brokers, and pontificating intellectuals who have long since slipped into obscurity. The images enshrined

in our collective imagination are the female faces in the paintings and statues created by Florentine artists—none more recognizable than Lisa Gherardini's.

"*Guardi!*" she exhorts me. Look!

⌇

And so I do. Following Bianchini's counsel, I return to the Gherardini parish church of Santa Maria Novella and its splendid *cappella maggiore* (main chapel), funded by the wealthy Tornabuoni family. Adorning its walls are some of the most astounding visual chronicles of the fifteenth century, frescoes dedicated to scenes from the life of the Virgin Mary and St. John the Baptist by Domenico Ghirlandaio (1449–1494).

The son of a goldsmith nicknamed for the garlands (*ghirlande*) of rare beauty that he created for the town's girls and women, young Ghirlandaio would sketch everyone who walked by his father's *bottega*, deftly capturing each likeness in a few quick strokes. He grew into a prolific painter who never turned down a commission—because, he explained, he didn't want anyone to leave his shop disappointed.

Ghirlandaio won his greatest renown for frescoes that seem like works of photojournalism in their detailed realism. The scenes, though biblical, are set in his contemporary Florence, which he bathes in golden light. (Ghirlandaio so loved his hometown that he complained of a longing he called "Duomo sickness" whenever he left it.)

In his panels, preening merchants and bejeweled patricians strut in velvet cloaks and elaborate hats. Their wives and daughters—women Lisa would have recognized in a glance—glide across the walls in floorlength gowns of intricately patterned brocades with gems adorning their heads, shoulders, necks, and fingers, every thread and trinket testifying to their honor, virtue, and dignity.

As Bianchini urged me, I look at the women's faces: regal, proud, self-possessed, with what she terms a *misteriosa interiorità* (mysterious interiority) that we still find *inquietante* (unnerving). They are indeed no one's victims, no passive creations of the male gaze, but rather part and partakers of, as she puts it, "*la grandezza del secolo*" (the greatness of the century)—a greatness they personify.

After completing his luminous fresco cycle in Santa Maria Novella, Ghirlandaio added an inscription: "In the year 1490, this most beautiful city, renowned for its abundance, power, and wealth, for its victories, for its arts, and its noble buildings, enjoyed great prosperity, health, and peace."

None of the Florentines, male or female, who shared this self-satisfied pride in their city could have guessed that the bubble was about to burst. The Medici bank was teetering on the edge of collapse. In just a few years Florence would lose its magnificent Lorenzo, fall under the sway of a fanatical friar, surrender its forts without firing a shot, and open its gates to a foreign invader.

Lisa, in 1490 a lively eleven-year-old on the cusp of her future, could never have guessed how these political upheavals would buffet her life. Against all odds, she would marry—and, by the strictly commercial standards of the day, marry well—and quickly become a mother. More, young Lisa could never have imagined, not even in her wildest dreams, that, in one of the unique ways that daughters of the Renaissance created beauty, she would also inspire an immortal work of art.

Chapter 6

Money and Beauty

T his is the closest I will ever come to a Renaissance banquet," I think to myself on a soft September night as I enter the colossal courtyard of Florence's Palazzo Strozzi.

Banners cascade from balconies. Ceremonial flags wave overhead. Torches and candles blaze. Wine flows freely. Stunning floral and fruit arrangements adorn long tables piled with platters of food, including whole roast suckling pigs with apples in their mouths. Throngs of Florentines glitter in beaded dresses, statement jewelry, and (of course) fabulous shoes.

The festivities mark the opening of a major exhibition of art and artifacts on the two forces that forged the Renaissance, *Denaro e Bellezza* (Money and Beauty), based on an oft-ignored fact: Money did more than talk in Florence; it bellowed the prestige of the patrons who underwrote great artworks. Without funding from the town's merchants and bankers, the beauty created by its artists would never have existed.

"*Eccolo!*" (Here it is!) the man beside me exclaims as we inch our way up a stone staircase to the exhibit entrance. "The most beautiful thing ever created in Florence!"

Suspended within a gleaming sheet of glass, a nickel-sized gold florin shimmers in a perfectly positioned spotlight. For centuries the shiny coin, containing 3.5 grams of 24-carat gold (worth $135 to $150 at today's exchange rates), reigned throughout the Western world.

In their hometown, florins could buy anything: a mule for 50, a slave for 60, a church altarpiece for 90, a gentleman's cloak lined with the soft

fur of squirrel bellies for 177, a great mansion for 30,000. Everything had a price—including a prospective husband.

~

"*Chi to' donna, vuol danari*" goes an old Tuscan dialect saying. He who takes a wife wants money. As fathers in Antonmaria Gherardini's time realized, grooms and their families were demanding more *denaro* (money in modern Italian) than ever. Dowry amounts escalated steadily from an average of 350 florins in 1350, to 1,000 florins in 1401, to 1,400 florins in the last quarter of the fifteenth century. An aristocratic family, anxious to avoid the disgrace of marrying below their rank, could end up paying upward of 2,000 florins (the equivalent, depending on exchange rates, of as much as $270,000 to $300,000).

Fathers were getting desperate. "Nothing in our civil life is more difficult than marrying off our daughters well," historian Francesco Guicciardini groused. Even well-paid senior civil servants, lawyers, and university professors couldn't afford the exorbitant sums, especially with more than one daughter at home.

The city that had practically invented banking came up with an ingenious solution: a savings fund, called the Monte delle Doti (literally, Dowry Mountain), in which citizens made an initial investment that grew substantially over time.

An Italian economist I meet at a group dinner explains to me how the system worked: A father deposited an amount, ranging at different times from 60 to 100 florins, when his daughter was five (the average age) or younger, with exceptions up to age ten. Florence, which used the fund for its debts and operating expenses, paid interest at variable rates, depending on how long the money remained in the account. A deposit of 100 florins, for instance, would yield a dowry of 500 florins over fifteen years or 250 florins over seven-and-a-half years.

"It sounds like an old-fashioned Christmas club," I say, fondly recalling how as a young girl I had taken $20 to the bank in June and collected what seemed like a whopping sum to spend on presents six months later.

"*Forse*" (Maybe), replies the economist, looking both baffled and bemused by my comparison.

Florentine dowry financing, established in 1425, underwent extensive modifications over the years to allow for different contingencies. If a girl died, the Monte delle Doti repaid the deposit "one year and one day" after her death. If "spurning carnal wedlock," she entered a convent to "join the celestial spouse in marriage" and vowed to be "perpetually cloistered," the Monte turned over a much lower "monastic" dowry to the nunnery.

Nearly one-fifth of the heads of Florentine households invested in the dowry fund—two-thirds from upper-crust families such as the Tornabuoni and Strozzi. There is no record that Antonmaria Gherardini ever deposited a florin on Lisa's behalf. Perhaps, with the return of peace to Chianti, he was confident that he could reverse his losses and extract cash from his country properties. Perhaps he feared that Florence, constantly waging costly wars, would default and not honor its commitments (which sometimes happened).

Personally, I blame Gherardini pride. The arrogant magnate clan that had resisted every pressure to behave like ordinary folk would have balked at partaking of commoners' cash. For Antonmaria, refusing to invest may have seemed a matter, like so much else, of family honor. Nonetheless, he may have begun to worry as Lisa approached adolescence.

Affluent parents of preteens began sending discreet signals to the families of prospective suitors, often via an intermediary—either a *sensale* (professional matchmaker) or a *mezzano* (a relative of one of the families). Like other fathers, Antonmaria would have wanted to finalize a betrothal by the time Lisa reached fifteen or sixteen. Once an unmarried girl passed seventeen, she risked being written off as "a catastrophe."

Love had nothing to do with this harsh reality. What mattered, as always in Florence, was *denaro*. Without enough money, Lisa's future might depend on a currency more valuable but more volatile than florins: beauty.

Lisa Gherardini may or may not have been born beautiful. As a daughter of the Renaissance, she certainly learned how to become so. In a culture

that reviled ugliness as a reflection of evil, sin, and social inferiority, a girl's appearance was too important to leave to genetics or luck. Beauty, the visible expression of interior goodness, had to serve as a lure to attract a man to the deeper qualities hidden within a girl's heart and mind.

The obsessive Florentines spelled out precise standards for ideal beauty in verses, essays, and treatises: A forehead smooth and serene, broader than it was high, with a good space between the eyes (large and full, preferably dark, the whites slightly blue). A face bright and clear, the chin round (ideally with "the glory of a dimple"), the mouth small, the lips red. A neck long and white. Hands plump and creamy. Breasts firm and round with rosy nipples. Torso slender and willowy.

A popular treatise listed thirty-three female "perfections," including:

Three long: hair, hands, and legs.
Three short: teeth, ears, and breasts.
Three wide: forehead, chest, and hips.
Three narrow: waist, knees, and "where nature places all that is sweet."
Three large ("but well proportioned"): height, arms, and thighs.
Three thin: eyebrows, fingers, lips.
Three round: neck, arms, and . . .
Three small: mouth, chin, and feet.
Three white: teeth, throat, and hands.
Three red: cheeks, lips, and nipples.
Three black: eyebrows, eyes, and "what you yourself should know."

Did Lisa match up with these expectations? If not, her mother, godmothers, and aunts would have set about changing what could be changed, including the discreet use of *trucco*, the Italian word that doubles for "trick" and "makeup." Elixirs of ground peach stones, bean flour, camphor, borax, or white lily bulbs ensured that a girl's skin glowed a creamy white—the color of chastity, purity, delicacy, and the gleaming feminine moon. A bit of rouge would have enhanced the rosiness in her cheeks.

Then there was the matter of eyebrows, which underwent aggressive plucking, sometimes entirely and sometimes just enough to make two

thin, wide-spaced arcs. Lisa Gherardini's may be the most analyzed *sopracciglia* in all of art history. None appear on her portrait, even though Vasari, in the first description of the painting, commented on Leonardo's skill in portraying them. (A French researcher using an ultrahigh-resolution camera has detected a single brow hair, an indication that Lisa's original eyebrows may have disappeared in an unfortunate cleaning in centuries past.) Her eyelashes remain a mystery. Women of Renaissance Florence, who considered lashes unaesthetic, either left them unadorned or plucked them out.

Lisa's hair appears much darker than the Renaissance ideal of golden locks, laboriously achieved by a combination of bleaching agents and hours on sunny terraces, a broad-brimmed hat called a *solana* shading a girl's delicate face. However, according to historians tracking style trends, as Florence's economy soured and a fanatical monk began preaching against human "vanities" in the final decade of the fifteenth century, the more natural look that we see in Lisa's portrait came into vogue.

Money bought beauty in wearable forms, and few peacocks have preened more gloriously than Renaissance Florentines. Both sexes swathed themselves in thick-piled velvet, brocades shot with silver tinsel, gold-filigreed scarves, and cloaks lined and trimmed in exotic and expensive ermine, lynx, or sable. On average, affluent families invested 40 percent of their resources in clothing. Men, as personal account books verify, spent as much as women on exquisitely tailored garments—the priciest dyed a deep crimson, which Florentines considered "the noblest color and the most important that we have."

With business booming, the del Giocondo silkmakers enlarged their workshops, expanded their offerings to include finished products such as decorative tablecloths, opened more retail stores, and extended trade to Rome, the rest of Europe, and the land of the Grand Turk, the best market for the most opulent artisan silks. The Medici became clients of the del Giocondo, who in turn used the Medici banks, with sixteen branches from London to Constantinople, for financial transactions.

As the family enterprises grew, young Francesco del Giocondo leap-

frogged over his older brothers to take the reins. Giuseppe Pallanti, who has devoted endless hours to sifting through the del Giocondo receipts, proxies, contracts, and other commercial records, categorizes him as "a typical Florentine businessman—intelligent, sharp, and enterprising."

Francesco's forceful handwriting testifies to his strong personality. A trail of judicial filings reveals a darker side. In one court proceeding, the Otto di Guardia, the officers in charge of public order, referred to Francesco del Giocondo as "an argumentative type"—almost certainly an understatement. Pallanti describes him as "bold, and confident, intolerant of rules and those who enforced them . . . [with] a business sense and lack of scruples that often bordered on illegality."

In a city whose citizens prided themselves on being *colti, benestanti e litigiosi* (cultured, well-off, and quarrelsome), Francesco's questionable business ethics and general tendentiousness in no way hampered his commercial success. Nor did they detract from his desirability as a potential husband. Despite his plebeian origins, the well-to-do young merchant could have paid suit to many of Florence's most desirable maidens.

In 1491, Francesco, at age twenty-six, arranged a marriage with sixteen-year-old Camilla Rucellai, the daughter of one of the del Giocondo silk company's long-standing customers. At first the choice didn't strike me as remarkable. The families of Florence were as interwoven as the threads of their ornate fabrics, and I knew from my research on Antonmaria Gherardini's marital history that the Rucellai were exceptionally prolific. Then I came upon the complete name of Francesco del Giocondo's first wife: Camilla di Mariotto Rucellai.

Could she be related to the ill-fated Caterina di Mariotto Rucellai who had married Antonmaria Gherardini in 1473, almost two decades earlier?

In a nineteenth-century genealogy, I find a Rucellai family tree that includes Caterina Rucellai's birth and her marriage to Antonmaria but nothing about Camilla. Online, I again dive into the digital archives of the Opera di Santa Maria del Fiore di Firenze. There I find the official record of Camilla di Mariotto Rucellai's baptism on April 9, 1475, two years after

her older sister Caterina's demise. At the time, their father, Mariotto, was forty-one. Five years later he reported fourteen *bocche* (dependents) living in his home, including Camilla and a newborn son younger than his latest grandchild.

The unexpected connection uniting the Rucellai, the Gherardini, and the del Giocondo intrigues me. The two men who played the most significant roles in Lisa Gherardini's life—her father, Antonmaria Gherardini, and her husband, Francesco del Giocondo—had both married Rucellai sisters. In the overlapping social circles of Renaissance Florence, this may well have been coincidental, but it clears up a minor mystery for me.

The odds of an undowered girl like Lisa finding a husband in Florence's overheated marriage market were almost nil. So, I kept asking, how did Antonmaria land a groom for a daughter who was essentially unmarriageable?

The answer could lie in the kinship bond that wove families together. Regardless of the fates that befell their wives, Antonmaria Gherardini and Francesco del Giocondo had married into the same *parentado*. And in a Florentine family tapestry, this counted for something.

In the spring of 1492, the year after Francesco del Giocondo's marriage to Camilla Rucellai, dreadful omens chilled all of Florence. She-wolves howled at the moon. Strange lights flickered in the sky. Two of the city's prized lions mauled each other to death in a fight in their cage. That same night lightning struck the lantern atop the cathedral dome and dislodged one of the marble balls supporting it. The ball crashed to the pavement below and smashed into pieces.

"In which direction did it fall?" asked Lorenzo de' Medici, so debilitated by excruciating gout that he could no longer walk or even hold a pen.

"To the northwest," he was told, toward his house.

"This means I shall die," he said.

The illness had already ravaged Lorenzo's body, "attacking not only the arteries and veins," his friend the humanist Poliziano wrote, "but

also his organs, his intestines, his bones, and even the marrow of his very bones." His healers tried an exotic concoction of pulverized pearls and other precious stones, but Lorenzo entered death's Great Sea on April 8, 1492. His doctor threw himself down a well in despair.

The succession to his oldest son, Piero, was so smooth and greeted with such great goodwill "on the part of people and princes," reports historian Guicciardini, "that had Piero had even an ounce of wit and prudence, he could not have fallen."

Fall he did—and sooner than anyone might ever have anticipated. The impetuous and violent-tempered youth, just twenty when Lorenzo de' Medici died, quickly earned the nickname "*Lo Sfortunato*" ("the Unfortunate"). His father would not have been surprised.

With a leader's dispassionate scrutiny, Il Magnifico had once appraised his three sons: Piero, who would succeed him, was stupid; Giovanni, who would become pope, smart; his youngest child, Giuliano, born the same year as Lisa Gherardini, sweet. A tutor described the baby of the family as "vivacious and fresh as a rose . . . kind and clean and bright as a mirror . . . merry, with those eyes lost in dreams."

Did Giuliano and Lisa Gherardini know each other as children? The dreamy-eyed boy could have made her acquaintance as they curtsied and bowed through the town's intertwined social spheres during his father's reign. Their families were linked by marriages to Rucellai kinsmen: Giuliano's aunt Nannina had wed Bernardo Rucellai; Lisa's father, his cousin Caterina. Novelists, weaving tales more of fancy than fact, have conjured a friendship between Lisa Gherardini and Lorenzo de' Medici's daughters, who were close to her in age, and a secret adolescent romance with Giuliano.

Lisa would certainly have seen Lorenzo's sons. The Medici brothers—sweet Giuliano, luckless Piero, and chubby Giovanni, appointed the youngest-ever cardinal in 1492 at age thirteen—regularly appeared at civic festivals and the grandiose processions of Il Magnifico's final years. As she had been taught, Lisa would have cast down her eyes in their—or any male's—presence, but she might have snatched quick glimpses at Giuliano, the striking lad who had inherited his father's charismatic charm and his namesake uncle's good looks.

Did he notice her? If Lisa was indeed *bellissima*, as Vasari described her, all the young men would have. Steeped in humanist romanticism, Renaissance swains loved loving fair maidens—if only from afar. Regardless of whether he and Lisa met as teenagers, Giuliano would later forge a tie both to Lisa's husband, Francesco del Giocondo, and to Leonardo da Vinci.

———

As Il Magnifico's era ended in 1492, another began. The Italian explorer Christopher Columbus discovered what he thought were islands off the coast of India and launched the Age of Exploration. The del Giocondo silkmakers also were looking to new horizons.

On October 26, 1492, Francesco, his older brothers, and two partners formed a new *compagnia* (partnership) "to deal in silk, both wholesale and retail, in Florence and Lyon and any other place they might wish." In their document of incorporation, they invoked, with a typical Florentine eye to both piety and profit, "the immortal and omnipotent God, His glorious Mother, the Virgin Mary, and all the Saints so that their business affairs might enjoy a good start, better continuation, and excellent conclusion."

Dividing operations between Florence and Lyon, the partners pledged "to work day and night for the good of the company." Francesco kept his vow. Amid the click of abacus beads and the murmur of looms, the zealous merchant met with customers, supervised cloth production, checked accounts and payments, negotiated contracts, and monitored the progress of caravans and ships.

Francesco's personal happiness soon paralleled his professional success. On February 24, 1493, his wife, Camilla, "brought to the light" a healthy son. The delighted couple named their baby boy Bartolomeo in honor of Francesco's father, who had recently died. After a jubilant christening, the family would have hung tapestries on the walls, passed out confections to visitors, and celebrated for weeks.

Streams of well-wishers bustled along Via della Stufa bearing birth trays piled with presents. As was the tradition among Florence's prominent families, Francesco and Camilla would have selected a unique fabric design and named it for their firstborn son for his exclusive use throughout his life.

Eighteen months later Camilla was gone. The nineteen-year-old died on July 24, 1494, perhaps of a miscarriage, perhaps of one of the age's ubiquitous infectious diseases. Once again neither power nor privilege could protect a young wife. The funeral in the Rucellai Chapel at Santa Maria Novella drew a huge crowd that would have included the city's most important families, business associates such as Ser Piero da Vinci, and the noble man who had also married and mourned a Rucellai bride, Antonmaria Gherardini.

The aftershocks of Lorenzo de' Medici's death reverberated for years. The unthinkable was happening: The Medici banks were running out of money. On Lorenzo's not-at-all-vigilant watch, millions of florins had been spent, lost, or loaned to monarchs unable or unwilling to repay them. As secret accounting books revealed, Lorenzo had diverted money from a family trust as well as from state funds. At the time of his death, many of the Medici accounts were in the red. The family owed the del Giocondo silkmakers some 4,000 florins, a hefty sum that Francesco resolutely set out to collect.

Money problems continued to plague Antonmaria Gherardini, who hopscotched from one shabby rental to another. In 1494 his in-laws, the prosperous del Caccia, arranged for their daughter's growing family to move into the *palazzo* of a rich widower who lived alone around the corner from them on Via de' Buonfanti (now Via de' Pepi). Ser Piero da Vinci, who had remarried for the fourth time in 1485, lived steps away with his still-growing ménage.

As big sister of the Gherardini brood, fifteen-year-old Lisa would have tried her best to corral her boisterous little brothers and sisters. Nonetheless, the reluctant landlord, despite the high rent he collected, complained on his tax statement about the "great inconvenience" caused by the invasion of unwanted tenants.

Florence soon would face a much greater and graver invasion. Once again Europe's monarchs were playing a dangerous game of thrones. When the Neapolitan king Ferdinand I died in 1494, his son Alfonso succeeded to the crown—one that the new French king, Charles VIII,

was determined to snatch on the basis of a hereditary claim. King Alfonso reached out for support to Pope Alexander VI, the ruthless Spaniard Rodrigo Borgia, who had risen to St. Peter's throne in 1492. Young Piero de' Medici edged closer to their orbit.

From Castello Sforzesco in Milan, Ludovico Sforza watched this potentially threatening new alliance with a wary eye.

For the Duke's court artist and engineer Leonardo da Vinci, these were wonder years. Nothing seemed impossible. With supreme self-confidence, the ultimate Renaissance man was ready to tackle any project.

Planning his equestrian monument, Leonardo prowled through Milan's stables in search of the noblest steeds and sketched their eyes, heads, hooves, and legs. In 1493, during the wedding festivities of the Duke's niece to the Holy Roman Emperor, Maximilian, Leonardo unveiled an imposing clay model of the great horse, more than 20 feet high. The Duke requisitioned some 80 tons of bronze for the largest single-cast statue ever—a technical challenge so daunting that no other artist would even attempt it.

Leonardo, who oversaw a bustling *bottega* of apprentices and salaried artisans, had settled cozily into a refined court that shared his appreciation of physical beauty, stylish clothes, good manners, and fine horses. "Although without fortune," Vasari notes, "he always had manservants and horses, which he loved dearly, as well as all sorts of animals." So great was his affection for creatures great and small that Leonardo became a vegetarian—a rarity among the meat-relishing men of his day.

A brilliant impresario, Leonardo staged stunning musical productions—one featuring performers costumed as rotating planets—that delighted the Milan court. Duchess Beatrice d'Este, Ludovico's wife, so enjoyed these entertainments that, as her secretary recorded, barely a month went by without "some idyll, comedy, tragedy, or other new spectacle," all infused with Leonardo's incomparable flair.

With almost manic energy, Leonardo continued his quest to penetrate the secrets of light, water, air, dreams, madness, even the nature and location of the soul. He calculated the ideal proportions for a human figure, based on the geometry of the ancient architect Vitruvius. With

the spirit of the adventurous Vinci lad still racing through his blood, he dreamed of flying like an eagle and drew plans for gravity-defying "flying machines." True to his mantra of *saper vedere* (knowing how to see), he filled notebooks with lists, diagrams, and pithy observations, set down without punctuation as his fingers flew across the pages.

The person whom Leonardo wrote more about than any other human being during these years in Milan was a ten-year-old named Gian Giacomo Caprotti da Oreno who joined his household, presumably as a servant, in 1490. The mischievous scamp, whom he nicknamed Salaì or Salaino from a Tuscan word for "little devil," stole money from Leonardo, silverpoint pens from his pupils, and a purse from a Sforza groom. At one dinner the naughty boy "ate for two, made mischief for four, broke three bottles, and knocked over the wine."

A thief and a liar, obstinate and greedy—these were among the faults Leonardo catalogued in his notebook. Yet rather than chastise or dismiss the wayward lad, he doted on Salaì, dressing him in costly pink and rose tunics and buying him a bow and arrow and other toys and trinkets. Leonardo also couldn't resist drawing the boy Vasari describes as having "ravishing grace and beauty, with a mass of curly hair which his master adored."

A more mysterious figure entered Leonardo's life at the time, a woman named Caterina. All that Leonardo writes of her is this record: "16 July Caterina came, 16 July 1493." Some believe she was his mother, who would have been about age sixty-six. Others suggest that she may have been a housekeeper, a "maternal substitute," who somehow, through her age or name or appearance, reminded Leonardo of his mother.

Perhaps Leonardo, financially secure at last, sent for his mother, probably widowed, and took satisfaction in providing her with comfort in her old age. About a year or so after her arrival, the *notaio*'s son meticulously recorded payments for Caterina's funeral costs, including fees for pallbearers, gravediggers, four priests, and three pounds of wax for candles—an amount biographers have judged generous for an employer but paltry for a son.

Another mystery revolves around a painting called *La Belle Ferron-nière* (the beautiful ironmonger's wife), which Leonardo painted on a panel cut from the same tree used for Cecilia's portrait. Art historians at first thought the model was a French king's lover, who happened to be married to an ironworker. Later she was identified as Lucrezia Crivelli, a married lady-in-waiting to Duchess Beatrice of Milan, who became another of the Duke's mistresses.

Some still question the attribution, despite such Leonardo hallmarks as the three-quarter pose and the intricately patterned and ribboned dress, a testament to the artist's wondrous way with fabrics. But what captivated me when I saw the portrait in the Louvre was the sitter's unflinching gaze. What was it about Leonardo and the ladies he chose to paint that brought out such intensity? Was it the way Leonardo looked at women or the way women looked at him?

⁓

An intense new voice began to echo through Florence in the final decade of the fifteenth century: the charismatic Dominican friar Fra (Brother) Girolamo Savonarola (1452–1498). Gaunt and gangly, with sunken cheeks and an enormous hooked nose, the young Savonarola had studied with his esteemed grandfather, a physician to the d'Este court in Ferrara. Allegedly smitten with an illegitimate daughter of the Strozzi family who was living in exile in Ferrara, he was coldly rebuffed by the young woman. Even a Strozzi bastard, she scoffed, would never lower herself to wed a Savonarola.

Some say this rejection sparked the young man's antipathy toward women, vile creatures tarted up in frills who put on airs and taunted men with their devil wiles. Savonarola began to see evil in everyone around him. When he slipped out of his family home to join the Dominican order, he wrote, "I can no longer bear the wickedness of the people of Italy."

During his initial assignment as a "lecturer" in the 1480s in Florence, the ugly little friar showed no aptitude as a preacher. Stumbling, mumbling, stuttering, he delivered sermons so ineffectual that, as he admitted, they wouldn't have "frightened a chicken." Then the visions of the hor-

rors awaiting the damned inflamed his mind, and he started to preach like a human firebrand. When Savonarola returned to Florence in 1490 as prior of San Marco, he unleashed horrifying harangues that envisioned in gruesome detail the apocalyptic fate awaiting a town awash in sodomy, usury, and decadence of every sort.

His timing was extraordinary. Encouraged by Milan's Duke Ludovico, King Charles VIII of France decided to invade Italy in order to seize the throne of Naples. In the autumn of 1494 the French army crossed the Alps and marched south through the Italian peninsula. As town after town yielded without a fight, some 30,000 soldiers and mercenaries advanced on Florence.

Fear infected the city like a plague. It found its voice in Savonarola, who told his growing congregation that he had seen "a fiery cross hanging in the dark clouds above Florence." God was unleashing his terrible sword to punish a city of sinners, including the purveyors of decadent luxury goods. To many his diatribes sounded like the *vox Dei* (voice of God) warning of the horrors that awaited Florence—perhaps at the hand of the invading king.

"Behold!" the friar cried when the French, with artillery more powerful than any ever seen in Italy, massacred the entire garrison at the Tuscan fortress of Fivizzano. "It is the Lord God who is leading on these armies."

When the invaders set up camp in the hills outside Florence, young Piero de' Medici, without consulting the priors, attempted the sort of diplomatic ploy only his father Lorenzo might have pulled off: He tried to negotiate a peaceful settlement. King Charles's demands were outrageous—a huge cash payoff plus almost all the cities and lands, including three fortresses and the prize port of Pisa, that Florence had conquered over the last century.

Without a single shot being fired, Piero de' Medici, whom the French mocked as "the Great Money Changer," acquiesced. The priors were so infuriated by his humiliating concessions that they locked the gates of the Palazzo Vecchio and refused to meet with Piero.

La Vacca began to ring. When he reached the Piazza della Signoria, Francesco del Giocondo would have found a crowd shouting insults and throwing stones at Piero de' Medici. His younger brother Giovanni, the boy cardinal, tried to rally the people with cries of *"Palle!"* (for the Medici's symbolic balls), but the jeers grew louder. At nightfall Lorenzo de' Medici's three sons, along with Piero's wife and two young children, fled the city with as many jewels and valuables as they could carry.

At word of their flight the priors decreed that the Medici be banished forever and confiscated their assets. From his home on nearby Via della Stufa, Francesco del Giocondo would have heard a mob break into the Medici *palazzo*, fling the family stone crests to the ground, and haul off a fortune in medallions, coins, manuscripts, tapestries, and priceless artifacts.

The next morning Florence's citizens awoke to a new reality. In a shockingly sudden collapse, the Medici reign had ended. Savonarola declared Jesus Christ the Florentines' new leader. Along with city officials, the friar met with French commanders to negotiate their entry into the city.

Charles VIII sent his lieutenants as an advance party to mark the choicest dwellings for his officers. (Machiavelli later quipped that the French monarch had conquered Italy "with a piece of chalk.") The Medici *palazzo* would serve as the king's headquarters. Anxious fathers like Antonmaria Gherardini quickly tucked their daughters into convents or remote rooms. Only men, boys, and old women ventured onto the deserted streets.

———

On November 17, 1494, Charles VIII, wearing gilt armor, a cloak of cloth-of-gold, and a crown, rode into Florence under a stunning embroidered canopy held over his head by four knights. The del Giocondo brothers would have watched glumly as his entire army—foot soldiers, archers, crossbowmen, cavalry, officers in helmets trimmed in thick plumes—marched through their streets.

"A truly beautiful sight," Guicciardini records, "because of their great numbers, the appearance of the men and the beauty of the arms and the

horses, with their rich coverings of cloth and gold brocade . . . but little enjoyed by the people, who were filled with fear and terror."

Then King Charles dismounted from his enormous black warhorse, and the Florentines nearby had to resist the urge to snicker. The red-bearded, big-nosed, ugly little monarch—"more like a monster than a man," Guicciardini reports—limped on feet so huge they were rumored to have a sixth toe. The French king's bluster lost its clout during the eleven days of occupation. When the city magistrates offered him a lesser sum than Piero de' Medici had promised, King Charles threatened to call his men to arms.

"If you sound your trumpets," the Florentine statesman Piero Capponi responded in what became a civic rallying cry, "we will ring our bells!" Charles, wary of rousing the volatile citizens to arms, took what he was offered and marched south.

The Florentines watched the French depart on November 28 with a mix of humiliation, anger, and relief. Lisa Gherardini and other young girls emerged from their hiding places, but fathers like Antonmaria still had plenty of reason to fear for their daughters' futures.

~

"The year 1494 was a most unhappy year for Italy," writes Guicciardini, "and in truth was the beginning of our years of misery, because it opened a door to innumerable horrible calamities." After decades of the prosperity and peace they saw as the just rewards of their intelligence and hard work, Florentines no longer felt in control of their destiny. In the leadership vacuum that followed Piero's departure, the voice that rang out loudest was that of Savonarola.

I could almost hear the friar's chilling words when I entered the final room of the *Denaro e Bellezza* exhibit in the Palazzo Strozzi in 2011 and stood in front of the nineteenth-century Bavarian artist Ludwig von Langenmantel's painting of Savonarola "preaching against luxury" in a richly ornamented church.

Actual Florentines—Niccolò Macchiavelli, Sandro Botticelli, and Andrea della Robbia among the recognizable faces—appear in the congregation. Women in elaborate gowns and headdresses gather luxurious

objects, such as fabrics and bowls, into a pile. But it is the preacher stand-ing high atop a pedestal in a white robe, a black hood over his head and shoulders, who dominates the painting. His outstretched left arm, hand open, fingers extended, points diagonally and dramatically to the upper right, as if to a new place, a new world, a new day.

Francesco del Giocondo couldn't wait for its arrival. As history raged around him, the impatient widower wanted a wife—and as quickly as possible. His professional and political status demanded no less, and his son, who would soon return from his wet nurse's care, would need a mother.

Chapter 7

The Business of Marriage

Why, of all the Florentine girls he could have married, did Francesco del Giocondo choose Lisa Gherardini?

I put this question to the man who may best understand her appeal: the dedicated archival explorer Giuseppe Pallanti. We meet at Le Oblate (from the Latin for "offers"), a convent in Lisa's day, now a library and meeting center popular among students and scholars, for another conversation about the woman he refers to as "*la nostra donna*" (our lady).

What does he think attracted the mercurial merchant to this particular teenager? Was it her beauty? Her pedigree? Something special that set her apart from other bridal prospects?

Pallanti pauses for a moment as if contemplating the so-close-you-feel-you-can-touch-it view of the Duomo. Then he smiles and pronounces two Latin words: "*mulier ingenua*."

The phrase appears in Francesco del Giocondo's will, drawn up in 1537, the year before his death. Initially, Pallanti had translated the words as "noble wife," a seemingly standard appellation from a husband's last testament. But as he perused other such documents, he never again came across this specific word pairing.

Within the limitations of his English, my Italian, and our elementary Latin, we struggle for a better translation for *ingenua* (*mulier* means "wife"). Although it serves as the etymological root of the French *ingénue*, absorbed intact into English, *ingenua* did not mean "ingenuous" or "naive" in the Latin of ancient Rome. The Latin scholars I consult say the best

definition is "free born" or "noble," a term used for the upper echelons of the Roman Empire.

"Could it mean 'independent?'" I ask Pallanti.

No, definitely not. "Independent wife" would have been an oxymoron.

"Feisty?"

No, not a quality to engender fondness in a Renaissance husband.

"Free spirit?"

"*Potrebbe darsi*," (It could be), he says after a few moments' contemplation—if I mean a woman of quality and presence, not only pretty but with a noble spirit.

Yes, I say, realizing that Lisa is taking tangible form in my imagination. This is exactly what I mean.

Was there more to it? Perhaps. Florentines viewed prospective brides as *mercanzia* (merchandise) and marriage itself as a commercial transaction involving a long negotiation process, legal documents, social rituals, and, of course, money. The dowry, the sine qua non of the deal, almost always mattered most, if only because of its impact on both families' bank accounts. Typically a payment diminished—sometimes significantly—the net worth of a bride's kin while boosting her husband's family fortune.

Francesco del Giocondo knew the math. His own sisters carried respectable dowries of 1,000 florins into their unions. Given the financial and symbolic ramifications, he might never have considered a dowryless girl if not for the Rucellai bond he shared with Antonmaria Gherardini. Yet in a groom's market, with his pick of girls equally fetching, even younger, and certainly richer, Francesco didn't have to settle for the daughter of a cash-strapped family of long-faded glory.

Perhaps, like the Prato merchant Francesco Datini, who had wed a penniless Gherardini descendant, Francesco del Giocondo could afford to look beyond the bottom line. According to a tax record of the time, his assets included a quarter of the two family silk workshops, a third part of another store on Por Santa Maria, two farms with *case da signore* (manor houses), and a small part of another farm. A large dowry, however ap-

pealing, might have mattered less than an ancient pedigree. Even Michelangelo would advise his nephew to choose a wife of high birth rather than one with more money but common blood.

The humanists of Florence's intellectual elite might have been content to admire a beauty like Lisa Gherardini from afar and pen Petrarchian verses about her ivory brow and blossom cheeks. No-nonsense Francesco did what he always did: He went after what he wanted. And he clearly wanted Lisa.

I pose another question to Pallanti, based on published accounts alleging that Francesco had a second wife, a certain Tommasa Villani, who also died in childbirth. But in his exhaustive archival research, Pallanti found "not even the slightest reference" to such a union.

"There was no time for another marriage," he tells me, explaining that just eight months passed between the death of Camilla Rucellai in the summer of 1494 and the merchant's marriage to Lisa Gherardini in the spring of 1495.

At some point brash Francesco del Giocondo and proud Antonmaria Gherardini would have had a man-to-man conversation, perhaps in the Piazza della Signoria, where Florentine men gravitated to discuss, debate, gossip, and negotiate. Antonmaria may have worn his best scarlet ankle-length *lucco*, the old-fashioned type. Francesco might have chosen a more stylish calf-length mantle dyed with the richest of reds and lined in downy fur.

What went unsaid between the two men may have been more revealing than the words they actually exchanged. Francesco, who had every right as a suitor to expect money as a sort of down payment for a lifetime of financial support for his future wife, knew that Antonmaria had none—no lump sum set aside at Lisa's birth, no deposit from her early childhood quietly accruing interest in the city's dowry fund. This alone might have sealed Lisa's fate. "A marriage without a dowry," observes a Renaissance scholar, "seemed more blameworthy than a union unblessed by the Church."

But as Antonmaria would have realized, Francesco didn't need cash.

His family businesses were prospering, and he had pocketed a hefty dowry from the Rucellai when he married their daughter. Francesco, with a Florentine's hypersensitivity to appearances, might well have balked at settling for nothing, but like other widowed fathers, he might have been open to accepting a token amount for the sake of acquiring a mother for his child.

Florentines generally preferred that property remain with the male kin, but Francesco may have recalled his merry great-grandfather Iacopo, who had propelled the del Giocondo family out of the working class with shrewd real estate investments. Curious about the Gherardini holdings in the Chianti countryside, he might have ventured into the densely wooded hills south of Florence to inspect them for himself.

The one that seems to have caught his fancy was a farm called San Silvestro, set on a steep slope planted with olive trees and grapevines in a scenic valley where Michelangelo would one day purchase properties for his heirs. Compared to the high dowries of the day, its value wasn't great—an estimated 400 florins—but it was something. The furnishings, livestock, and various other valuables attached to the farm, Giuseppe Pallanti calculates, would have added another 170 florins (an amount often erroneously reported as Lisa's cash dowry).

From Antonmaria's perspective, Lisa's suitor might as well have asked for an arm or an eye. His ancestors had shed blood to win and defend their Chianti territory. Generation upon generation had been born on Gherardini turf. Even when his cash flow all but dried up, Antonmaria's father Noldo had never sold a hectare of their estates. How could he turn over even a square meter to a sweaty barrel builder's great-grandson?

But the down-at-heel noble would have had to consider the fat cat seated before him, dressed in a merchant's bespoke finery—gold-threaded sleeves, calf-leather shoes, rings with hefty gemstones. His little Lisa, in contrast, would have grown up in frayed cuffs and worn-down slippers with scarcely a jewel to her name. The darling girl, with her inimitable Gherardini spirit and bearing, would have deserved a better life than he had ever been able to provide. Antonmaria, swallowing his family pride, agreed to sign over the deed.

The two men would have sealed their initial understanding with a

handshake, called an *impalmamento* or *toccamano*, a commitment so binding that violations could set off lifelong feuds. With a well-justified sigh of relief, Antonmaria could announce that he had *impalmato* his oldest daughter.

Did Lisa Gherardini have any say in selecting her spouse? The answer from every scholar and source is the same: absolutely not.

The formal dance of a Florentine courtship began. I got my first sense of its elaborate variations in an exhibit called *Virtù d' Amore: Pittura Nuziale nel Quattrocento Fiorentino* (Virtue of Love: Nuptial Painting in 15th-Century Florence) at the Galleria dell'Accademia in 2010. Paintings, *cassoni* (wedding chests), platters, and other decorated objects—along with clever animated videos—evoked the splendor and symbolism involved in a Florentine wedding.

The complex rituals, as Ludovica Sebregondi, one of the curators, explains, involved many people—grooms, parents, family members, *parentado* (relatives by marriage)—but much less the brides-to-be. "*Poco più che bambine*" (little more than babies), as she puts it, girls like Lisa Gherardini were treated as "*mera merce di scambio*" (mere goods of exchange).

Even so, the rituals of courtship offered girls of the merchant and moneyed classes a rare chance to shine—beginning with the first time a suitor came calling. Wooing a beloved from the street below her balcony wasn't a dramatic literary device that Shakespeare invented for his Romeo and Juliet, I learn, but an old Italian tradition. Soon after exchanging a formal handshake with his future father-in-law, Francesco del Giocondo may have made his way along Via Ghibellina and turned on what is now Via de' Pepi to stand below the Gherardini windows.

Beelining to another X on my Florence map, I stand in the narrow lane and crane my neck upward to what might have been the Gherardini living quarters on the second floor. There Lisa, excited and more than a bit nervous, could have caught her first glimpse of the man who wanted her for his wife.

What did the teenager see?

An upstanding citizen and merchant of Florence, as stated in the

marriage contract. Although we have no portrait, it's safe to assume that, not quite thirty, Francesco del Giocondo was not—or at least not yet—fat or bald.

I base my impression of Francesco on another Ghirlandaio work, the *Adoration of the Magi* in the Ospedale degli Innocenti, the foundling home with a graceful facade designed by Brunelleschi, where the del Giocondo commercial records lie in a seemingly untouched-by-time archive. I come upon the large 7-by-9-foot painting in the adjacent museum, one of Florence's lesser-known gems.

Ghirlandaio painted the sweeping scene of the ultrarich Magi (favorite subjects of the Medici and the Florentine merchants and bankers who emulated them), presenting gifts to the Madonna and Child, between 1485 and 1488, when Francesco del Giocondo was in his early twenties. On the right side stand three men Francesco surely would have known, leading members of the Silk Guild, the Ospedale's principal source of support.

The older two silk merchants, gray-haired and jowly, wear plush cloaks and elaborate hats festooned with pearls and other jewels, while a younger man in a plain black cap, also extravagantly robed, stands between them. I peg him as a Francesco del Giocondo type: neither handsome nor ugly, clean-shaven, with a wistful expression, sallow skin, and downcast eyes. Clustered at the side of the fresco, the trio seem to be edging their way into the frame as if they too wanted to go down in history. And they did—the banal part always occupied by smallish men.

A clutch of women—mother, aunts, godmothers—would have coached Lisa for her initial presentation. With her long hair falling loosely on her shoulders, she would have worn her best dress, modest but pretty, with stylish sleeves. Her mother may have prompted her on where to stand so the light glowed on her face. In her initial encounter with her suitor, Lisa may have smiled, laughed, coyly cast her eyes downward, perhaps tossed a ribbon or flower as a keepsake.

I can imagine her father Antonmaria hovering nearby, nervously pacing as he eavesdropped. Her mother may have rounded up Lisa's squealing little brothers and sisters in a back room, while their ornery landlord harrumphed himself into his *studiolo*, the door slammed behind him.

Soon, Francesco del Giocondo would have returned to pay a formal

call and offer presents, most likely a jewel for Lisa and some bolts of silk from his shops for her parents. They would have invited him to dinner. Rather than their usual *minestra* with Tuscany's ubiquitous beans, they may have served a festive dish like savory stuffed partridge, washed down with wine from one of their Chianti vineyards. Francesco may have toned down his usual contentiousness at his first meal with his future in-laws. Lisa, casting furtive glances at the stranger, might not have eaten at all so that, when it came time to dip her hand in the small bowl of water provided at the end of the meal, her fingers remained immaculate.

As negotiations continued, a groom and his prospective father-in-law typically established specific terms. Usually, these included payment arrangements and dates, with guarantors and arbiters chosen to ensure that each party fulfilled the promises made during the negotiations. The father of the bride also agreed to gain his daughter's consent to the union, which, at least in theory, could not otherwise take place. Only rarely did a girl refuse—and then at risk of sparking a bloody vendetta for the insult to her suitor's honor.

Lisa would have known what was at stake. Although she wasn't privy to the details of the family's finances, she would have grown up wearing patched house dresses in a string of threadbare rooms. A well-off man like Francesco could offer her and her family a more secure life. And marriage, she had always been told, was a girl's destiny, her duty, her future. Not all of her friends—and none of her sisters—would be fortunate enough to enter the ranks of honorably married young matrons of Florentine society. Lisa would have had every reason to accept.

An ever-indispensable *notaio* drew up the official public announcement of an intended marriage, and the couple became formally engaged. Three to six months commonly passed before a wedding, but given the merchant's impatience, the timetable may have been considerably shorter.

Lisa and her mother would have hurried to fill her *cassone*, the large painted wedding chest that carried the material part of a girl's dowry from her father's house to her husband's. As soon as a girl was born, a mother typically began putting aside items: embroidered undergarments,

head scarves, and aprons; linen handkerchiefs and towels of various sizes; silk hairnets; house caps of very soft fabric; ribbons, small silk purses, cord belts, an ivory or mother-of-pearl comb and brush; house dresses of woolen cloth with silk sleeves; socks and stockings; woolen and silk shoes; skeins of silk; pincushions; gloves; a writing portfolio and inkstand; scissors; mirror; basket; a tabernacle with painted images of saints; some small devotional books; perhaps her beloved *bambino* (infant Jesus) or a Santa Margherita doll dressed in brocade (a popular fertility charm). *Cassoni* once were pulled through the streets of Florence as part of the wedding procession, but by Lisa's day, a bridal chest was delivered more discreetly to the groom's family home before the ceremony.

———

The parents of an engaged couple meticulously recorded nuptial expenses, with the value of every item in the *donora* (trousseau) appraised independently by two professional evaluators. On average, a bride's family spent about 110 florins for her wedding gowns, headpieces, and shoes. However, since marriage was supposed to be an equal exchange, neither family wanted to feel too greatly in each other's debt. The practice developed of the groom's bestowing a *contra-donora* (countertrousseau) of jewels (often pearls, symbols of purity and the most valuable of gems) and clothing. The gifts generally amounted, according to scholars' calculations, to between a third and two-thirds of the value of the bridal dowry.

Symbolically, a husband-to-be's adorning—"marking," some social historians prefer—of a bride with her new family crest and colors served as a rite of passage. This sartorial initiation signaled the rights he would acquire over her and introduced her to her new role as a married woman. Ultimately, like so much in Renaissance Florence, the display reflected family honor.

"You have honor in other things, you don't want to be lacking in this," observed the Florentine matron Alessandra Macinghi Strozzi, whose letters provide an insider's view of marital arrangements. "Get the jewels ready, and let them be beautiful," she wrote to her son Filippo when she informed him of his future bride. "We have found a wife. Being beautiful and belonging to [you], she needs beautiful jewels."

When the time came to orchestrate the engagement of her daughter Caterina, Alessandra observed with pride that Marco Parenti, the prospective groom, spent over 560 florins on the countertrousseau, which included a cloak lined with almost two hundred tiny furs called *lattizi*, a fringed embroidered cowl, a gown of crimson velvet, a silk overcoat, a pearl-studded hat, and a crimson silk belt.

Why such extravagance? "Because she's so beautiful and he wants her to look even more so," the prospective mother-in-law declared in approval. The discerning *fiorentina* estimated that her daughter would leave her house wearing "more than 400 florins on her back"—and, in her mother's opinion, she was worth every one of them.

So was Lisa Gherardini, an undeniable trophy for the commoner Francesco del Giocondo. Like all grooms of lower social status, he was expected to offer extravagant tokens of appreciation and respect. Legally, whatever finery a husband purchased before the wedding remained his property, not his wife's. Faced with financial crises, many a spouse pawned or sold the nuptial gifts he'd bought for his bride. Francesco did not. In his final will, he formally signed the valuable bounty over to Lisa.

Her wedding was the single biggest event in the life of a Renaissance woman, but for many a bride, then as now, the celebration was all about the dress. In a public display of family honor, a girl made the visual statement of her life. Regardless of sumptuary laws (universally disregarded by brides), no fabric could be too costly, no skirt too full or flowing, no flourish too flamboyant. One thirteen-year-old was so weighed down by her bridal attire that she could not move. A constable had to carry her into the wedding ceremony in his arms.

Lisa's dress would have been the most stylish she had ever worn, created with fabrics from the del Giocondo workshops and sewn by local tailors in the latest fashion. Many brides of the day favored a crimson cut-velvet overgown intricately embroidered with pine cones and pomegranates (symbols of fertility and eternity), with sleeves worked with gold and silver thread. Around her waist Lisa may have worn another gift

from Francesco, a girdle or belt elaborately decorated with silver medallions. Atop her head she may have worn a headdress, perhaps of feathers and pearls, held in place with finely crafted pins.

In a ceremony variously called the *matrimonio, anellamento, giuramento,* or *giure,* Lisa's relatives and close friends and Francesco del Giocondo's kin would have assembled in her parents' home. A *notaio* would have asked a series of questions.

First, their ages: Lisa, fifteen; Francesco, just shy of thirty, a fairly typical difference for an upper-class union.

Did each give free consent?

Yes.

Had they made prior commitments to another?

No.

Had they been married previously?

The *notaio* would have noted the death of Francesco's first wife.

In their vows, called *verba de praesenti* (words of the present) or sometimes *verba de futuro* (words of the future), Francesco pledged to take Lisa as his wife, to love her, honor her, keep her, and protect her, in health and in sickness, as a husband should his wife, and to keep from all other women except her as long as their lives should last. Lisa repeated these promises but also vowed "to obey and serve."

The *notaio* pronounced Francesco and Lisa man and wife. In some ceremonies the groom slid a ring onto the bride's finger. (In one Ghirlandaio fresco, the groom does so with one hand while reaching for his promised payment with the other.) The guests would have cheered and drunk toasts to the newlyweds. This wholly civil ceremony would be followed at a later date with a priest's blessing in or on the steps of a church. It wasn't until 1563 that the Council of Trent drew up the first systematized requirements for a proper Catholic wedding.

Sometimes hours, sometimes days, weeks, or even months after the exchange of vows came the triumphal procession, the *ductio ad domum* or *domumductio* (leading [of a woman] home) from her parents' to her husband's residence, a bride's moment of public glory. Since the marriage was

not yet complete, Lisa did not have to wear a matron's cloak (*mantello*) but could show off her wedding apparel to the entire town.

As portrayed in paintings and accounts of the time, brides led a jubilant parade of sisters, cousins, in-laws, friends, musicians, and merrymakers through the streets of Florence. I trace Lisa's possible routes past landmarks that still stand in central Florence: the Bargello; the Duomo; the Campanile; the Battistero. I picture shopkeepers calling out congratulations, children skipping alongside, *nonne* waving branches from their windows.

These days when I encounter real-life brides in fluttery white dresses posing for wedding pictures at various scenic spots around the city, I wonder whether each feels, as Lisa Gherardini may have, that at least for one brief shimmering moment, she has become the belle of Florence.

The festivities would have continued at the del Giocondo home, with a guest list extending beyond the immediate families to various kin groups. Everyone dressed as beautifully as possible as a way to "*far onore*" or contribute honor to the event. The wedding feast may have featured expensive treats, such as spiced veal, roast kid, peacocks' tongues, and sweetmeats. Honeyed almonds were popular confections for the guests, with musicians, singers, and jugglers entertaining well into the evening.

The eating, dancing, toasting, and singing might have seemed to go on forever yet passed as quickly as a flash of summer lightning. As the bride, Lisa, imbued with the special authority of a queen for a day, could have invited young men and women to dance as couples. In the old Tuscan wedding ritual, her mother would have placed a baby boy in her arms as a harbinger of future sons and slipped a gold coin in her shoe for prosperity. Outside, a few young men may have lingered to shout and sing in a raucous *mattinata*, a tradition whenever an older man "stole" a young girl for his bride. Some coins tossed through the window for drinks would have persuaded them to leave.

Finally, Lisa was alone with Francesco. Their union would not be considered "*perfetta*" (complete) until she passed a night in his bed.

What happened next? In one fanciful account of a wedding night, bride and groom approach the marriage bed, strewn with rose petals, with can-

dles in their hands and kneel to pray that God would bless them with many sons before they slip naked under the covers. Historians—one of whom reminds me that their research "stops at the bedroom door"—say only that a husband like Francesco, more mature and experienced than a hot-blooded youth, would have been expected to be gentle with an innocent teenage girl.

The cleric Bernardino da Siena, famed for his widely circulated sermons, exhorted mothers to instruct their daughters about what to expect of a marital consummation—sometimes referred to as *rendere il debito* (to repay the debt). Even so, I can imagine how overwhelmed and frightened a girl like Lisa, not yet sixteen, would have felt alone with a much older man who had complete power over her.

Not surprisingly, many a wedding night triggered what one scholar calls "*crisi di pianto*" (attacks of crying), touchingly captured in a fifteenth-century woodcut in which a groom escorts the bride's friends out the door as she lies weeping in their bed. Mother Mary—the Madonna whose image typically hung on a bedroom wall, holding the perfect son they aspired to bear—would have offered brides their only comfort.

The morning after his wedding night, Francesco del Giocondo may have slipped a gold ring on Lisa's finger as a sign that he was pleased with her. By Tuscan law he also would have had to pay a *donatio propter nuptias*, for the gift of Lisa's virginity. Some accounts refer to this amount as a *mancia*, now the Italian word for a "tip."

The newlywed Lisa awoke in a house filled with people she barely knew: Francesco's mother, his siblings and their spouses, his two-year-old son Bartolomeo, plus various servants, maids, and cooks. In what might have been an awkward encounter, her new in-laws would have fed Lisa the traditional postwedding breakfast of eggs (for fertility) and sweetmeats (for love).

That day or the next, Lisa's married del Giocondo kinswomen would have played "the ring game" and presented her with rings, symbols of the new concentric circles of relatives surrounding her, to welcome her into the household. The rings themselves were hand-me-downs—or heirlooms, depending on your perspective—first given to the older women when they were young wives. Husbands selected a specific ring for a new

bride, depending on the meaning of its stone: a fiery red ruby for a heart burning with love; a diamond, for harmony between man and wife; sapphires and pearls for peace, piety, and chastity.

According to sumptuary statutes, brides like Lisa could wear the rings for only a few years before the jewels were recycled as gifts to other brides in a continuous exchange that symbolized and solidified family ties.

Dowries were paid only after a marriage was consummated, often in a series of payments or when the funds in the Monte delle Doti had matured. As Lisa Gherardini began her life within the del Giocondo household, her father kept his part of the bargain. On March 5, 1495, Antonmaria Gherardini, in the office of his *notaio*, signed over the San Silvestro farm in Chianti to Francesco del Giocondo.

Although he might have rued the loss of any family property, I can see the father of the bride walking home through the streets of Florence and reflecting on what a coup he had pulled off. As a hard-nosed businessman, Francesco del Giocondo would have considered himself the craftier negotiator, but the *vir nobilis* had struck the better bargain. In exchange for a penniless daughter and a modest farm, Lisa's father had bagged one of matchmaking's biggest jackpots: a wealthy son-in-law.

Perhaps a sly grin inched onto his lips—the telltale smile of a Gherardini.

Chapter 8

The Merchant's Wife

*F*ai la castellana!" (You are playing the lady of the manor!) an Italian friend teases when she visits us in a villa we are renting in the Tuscan countryside.

It is a role that I inexplicably love. Minimally domestic in the United States, I am transformed in Italy. I brew espresso in a stovetop Moka, snip flowers for bouquets, fuss over table settings, sweep the terrace with a broom made of bundled twigs, and derive inordinate satisfaction from hanging our laundry on rickety lines in the summer sun.

Perhaps the spirit of centuries of Italian *casalinghe* (housewives) takes possession of my soul. Or perhaps, as my friend, a university professor, suggests, Italy brings out my inner Renaissance woman. According to the nineteenth-century scholar Jacob Burckhardt, this historical period ushered in the first attempts "consciously to make of the household a well-regulated matter, nay, to make it a work of art."

This lofty description almost surely would have not applied to the large and lively del Giocondo household that Lisa Gherardini entered as a teenager. Some sociologists have lamented the plight of such "child brides," forced to marry much older men and take up residence with several generations of meddling in-laws. But the fate of girls like Lisa might not have proved as dismal or daunting as we might assume. For brides from financially strapped households like the Gherardini, marriage to a wealthy man may well have provided what one historian describes as a "first taste of opulence, leisure, and freedom."

"Opulence" would have been an overstatement of the del Giocondo family's status, but Lisa, emancipated from the daily drudgery of menial chores, undoubtedly had moved up in the world. Rather than share a mat on the floor with her siblings, she would have slept on cotton sheets atop a wool-stuffed mattress, warmed by a coverlet filled with goose feathers in a canopied bed with inlaid bedposts and soft pillows embroidered with delicate needlework. Herbs may have burned slowly in pierced globes suspended from the ceiling to keep the air sweet, while mulberry twigs placed under the bed attracted the fleas that otherwise tended to infest mattresses. Servants toted braziers to warm beds at night and carried away smelly chamber pots in the morning.

Compared to the spare meals of the Gherardini household, the del Giocondo table would have boasted more expensive and exotic foods, such as liver sausage, capon, peacock, thrush, and turtledove, along with the perennial Tuscan favorites of beef and pork, all strongly flavored with ginger, cinnamon, cloves, pepper, nutmeg, and other spices. If Lisa had a sweet tooth, she might have relished treats like *berlingozzo*, a cake made with flour, eggs, and sugar; rice cooked with almonds, sugar, and honey; *pinocchiato*, a pudding made of pine nuts; and little jellies of almond milk colored with saffron and molded into animal shapes. Men, women, and children of every class drank wine, but the del Giocondo would have served finer vintages than the Gherardini.

Thanks to the countertrousseau she received from her husband, Lisa's wardrobe could have expanded to some twenty or more pieces of clothing (typical for a merchant's wife). Her *camicia* (underblouse), always a natural unbleached shade or pearly white, would have been sewn of deluxe silk or fine linen rather than the inexpensive cotton she once wore. We don't know which of the various words for house dress—*gonna, gonnella, sottana, gamurra,* or *cotta*—Lisa would have favored, but the garment would have been simply cut, either ankle- or floor-length, of a basic fabric like cotton, linen, or thin wool. At home she would have tied her hair back in a kerchief or bonnet of sorts (*il capo fasciato*) and tucked her feet into soft cloth shoes, slipped inside larger wooden clogs for walking in the streets. For festive occasions, she might have donned elevated dress shoes, called chopines, trimmed in embroidered fabric.

In all but the most domestic of settings, Florentine women of Lisa's time wore an overdress of silk or fine wool in rich colors—crimson, scarlet, violet, purple—made with expensive dyes. In the summer Lisa would have donned a sleeveless *giornea*, often of damask or silk brocade. In the winter, she would wear a warmer *cioppa* with sleeves of silk brocade or figured velvet, oversewn with pearls or metallic embroidery. I can almost hear the rustle of Lisa's skirts in this most opulent of garments, accented with all sorts of *frasche* (decorations or frills) and serving no utilitarian purpose other than to reflect honor on herself and her family. A *mantello*, a matron's full-length cloak with a matching cowl, or *cappuccio*, would have kept her face *coperta e nascosta* (covered and hidden) from the eyes of men when she left the house.

Young wives like Lisa enjoyed the greatest fashion freedom in the first years of marriage, when everything from the buttons on their sleeves to the jewels embroidered on their bodices testified to a husband's prosperity and prestige. By the time Leonardo began his portrait, Lisa, married for more than eight years, would have presented herself in public in more understated but nonetheless elegant and expensive attire.

In the museum shop of the Costume Gallery of the Pitti Palace in Florence, I find a paperback version of a fashion history classic, *Vecellio's Renaissance Costume Book*, with woodcut illustrations of outfits that Lisa and her contemporaries might have worn. Mature Florentine ladies, according to these drawings, cultivated a distinctive over-the-top look, heavy on brocades, beading, padded shoulders, fancy collars, intricate sleeves, and veils. Enveloped in layers of handwoven silks and crowned with a bulbous headpiece, a *fiorentina* of the highest rank would have swayed through the streets looking, in a scholar's words, like "a rather large, sedately moving, imposing mass of fabric."

❦

Marriage, like other Florentine social institutions, involved rules for comportment as well as clothing. Regardless of class or income, husbands ruled and wives obeyed. A man, according to the day's conventional wisdom, commanded a household like a king reigning over a kingdom or a captain steering a ship. As women were repeatedly reminded, a wife's role

was to aid and assist her mate in every aspect of his life, public or private, and to do nothing that might displease her sovereign commander in word, deed, or gesture.

Laugh at his jokes, the advice-mongers urged. Do not be joyful if he is sad or sad if he is joyful. Serve his favorite dishes—and if your tastes do not agree, do not show it. Keep yourself clean and appetizing. Do not prattle when he craves quiet or turn silent when he prefers merriment. Do not pry into his business affairs. Be like the moon, rather than the sun, and shine only in his reflected light.

Wives may have accepted these admonitions in principle, though not always in practice.

"O do not be born a woman if you want your own way!" fumed Nannina de' Medici, sister of Lorenzo Il Magnifico, in a letter to their mother, Lucrezia, after losing an argument about their children's tutor with her husband, Bernardo Rucellai. Husbands, absolute rulers of their domestic domains, always had the last word—or so they thought. Clever women often found ways to get what they wanted. Nannina, for instance, arranged for her favored teacher to move in with her mother.

As a teenager in a house full of strangers, Lisa may not have dared to employ such wifely wiles—at least not yet. Within her new extended family, the first person she would have tried to win over was little Bartolomeo, probably just weaned from his rural wet nurse. With a slew of younger siblings, his teenage stepmother would have known how to comfort, coddle, and cajole a toddler. Like her kinswoman Margherita Datini, who took in her husband's illegitimate child, Lisa might have quickly come to love Francesco's son as her own. She would name a daughter after his mother and remain close to him throughout life.

Lisa's tenderness toward Francesco's son may have melted her husband's anything-but-tender heart. Although love was not considered a prerequisite for a successful Renaissance marriage, the merchant of Florence seems to have developed a genuine fondness for his spouse. Despite his general churlishness, Francesco ultimately acquiesced to Lisa's every desire. Over the years he lent money to her father, built a home of their own so she no longer had to board with her in-laws, and eventually pro-

vided for her impoverished siblings. In his will, he wrote touchingly of his lifelong affection for his noble-spirited wife.

Lisa alone evoked such sweet sentiments in her cantankerous husband. As the del Giocondo records reveal, Francesco quarreled incessantly with his brothers, cousins, neighbors, and just about anyone who dared cross him. And he never failed to pounce on a potentially profitable venture. When an artisan neighbor was drowning in debt, Francesco promised to pay off the creditors in return for purchase of his house at a greatly reduced price. For four years he rented out the property, waited for the right buyer, and doubled his investment.

Francesco may have been no more greedy or grasping than many of his contemporaries, historians remind me. Nonetheless, I can't help but wonder what the venal opportunist might have been like in the most intimate of settings.

<p style="text-align:center">~</p>

"So how was Mona Lisa's sex life?" I ask Professor Sara Matthews-Grieco, an expert on medieval and Renaissance sexuality, in her office overlooking Piazza Savonarola at the Syracuse University in Florence campus.

"Probably not very exciting," the silver-haired, warmly maternal scholar responds, chuckling at the sheer incongruity of the question.

Yet sexuality, as she and her colleagues have assiduously documented, was a very serious matter in Renaissance Florence. Clerics—including the stern friar whose statue glared at us through her window—raged against its perils. Poets rhapsodized about its pleasures. Humanist philosophers, living in the heat of seemingly perpetual erotic arousal, exulted in sex as the consummate expression of the individual man.

"Man" is the operative word. Rather than mere double standards for men and women, Florence provided two distinct varieties of sexual experience: recreational and procreational. The former was reserved primarily for educated and affluent young Florentine men, considered by their elders to be sex-obsessed, hot-tempered "idiots," not yet intellectually mature, emotionally sensible, or politically responsible.

The town's bachelors enthusiastically engaged in what we might call

"casual" sex, hooking up with whatever partners were available and more
or less willing: servants, slaves, working-class wenches, comely youths, or
prostitutes at municipal brothels, maintained by the town as a more so-
cially acceptable alternative to sex with boys. Once they had sown several
fields of wild oats, Florentine men were expected to assume the steadying
yoke of marriage and fulfill their fundamental sacred and civic duty of
procreation—although they didn't necessarily forgo recreational pursuits.

No such equivalent existed for women. From her early teens, a girl's chas-
tity became a family's most fiercely guarded asset. Only virginity before
marriage, like fidelity afterward, could guarantee the purity of a husband's
lineage, the legitimacy of his heirs, and the reputation of his family. Any
aspersion on a daughter's or sister's honor—let alone an actual violation—
could and regularly did trigger bloody retribution from her kinsmen.

The prudent course for fathers was to marry a daughter off as soon
as possible so she could launch her procreational career. From menarche
(between the ages of twelve and fifteen) to forty, according to historians'
calculations, a typical Florentine woman became pregnant every thirteen
to fourteen months.

A bit of recreation may well have snuck into a couple's reproductive
endeavors. The Dowager Duchess of Urbino, a woman of acknowledged
refinement, burst into her niece's bedroom the morning after her wed-
ding and trilled, "Isn't it a fine thing to sleep with the men?"

Sensual pleasures weren't confined to the educated upper classes.
Merchants like Francesco del Giocondo, Professor Matthews-Grieco tells
me, were not "the prudes we might assume businessmen to be." They en-
joyed drawings of naked women and couples copulating (a tame precur-
sor of Internet porn). In their youth many frequented municipal brothels.
Those who could afford it sometimes kept or shared mistresses.

Wives also indulged in some ribaldry in mildly suggestive parlor
games and bawdy songs. As printed books became more widespread
during the Renaissance, the salacious tales of the former monk Matteo
Bandello (1480–1562), which featured randy nuns and comic cuckolds,
became a guilty pleasure of literate Florentine women. A frisson of eroti-

cism also invaded the boudoir. The underside of the lids of bridal *cassoni* were sometimes decorated with seductive scenes, presumably to inflame erotic passions and incite procreative urges.

By the sixteenth century, these paintings migrated to the walls of the master bedroom. I found evidence of this in an unabashedly romantic apartment I rented in Florence on Costa San Giorgio. Above the four-poster bed hung a large portrait of a nude woman lying back in eager anticipation of a lover's embrace. Fittingly, the apartment was named Amore.

If couples like Francesco and Lisa del Giocondo had need or desire for expert counsel on any aspect of intimate relations, Renaissance physicians, preachers, and philosophers readily dispensed it. Prototypes of self-help manuals, instantly recognizable by their size and print font (most books didn't yet have covers), became widely, even wildly popular. Their audience, reports history professor Rudolph Bell, author of *How to Do It: Guides to Good Living for Renaissance Italians*, consisted mainly of folks much like Lisa and Francesco—"the well-to-do, joined as often as not by their wives, in town and in the countryside—lawyers, doctors, merchants, master craftsmen, substantial landowners, and rich peasants."

In their pages, curious Florentines could have found information on everything from the best setting (the marital bed, in a room sprayed with the must of civet cat, amber, or aloe) to the ideal time (early morning, after a good night's rest and a well-digested meal) to the weather (strong, dry northerly winds favored the conception of sons) to position (wife facing the heavens, husband the earth) to taboos (no kissing other than the mouth, no unnecessary touching, and above all no release of sperm anywhere other than in the vagina, its divinely determined destination).

Except for nightcaps on their heads to warm essential fluids for their voyage to the genitals, married couples slept naked. Spouses were duty-bound to engage in intercourse at the other's request—as long as desire didn't conflict with the times when the Church explicitly banned intimacy, including Fridays and Sundays, feast days, all of Lent, and during menstrual periods and pregnancy.

For men, the humanist Leon Battista Alberti counseled restraint and consideration. "Husbands should not couple with their wives in an agitated state of mind or when they are perturbed by fears or other like preoccupations," he advised, "for such emotions . . . disturb and affect those vital seeds which then must produce the human image." Another timeless recommendation: "Make yourself intensely desired by the woman."

Although I would have considered Leonardo da Vinci an unlikely couples counselor, he offers this perspective: "The man who has intercourse aggressively and uneasily will produce children who are irritable and untrustworthy, but if the intercourse is done with great love and desire on both sides, the child will be of great intellect, and witty, lively, and lovable"—an idealized fantasy, psychologists suggest, of his own conception and its genial outcome.

The premier sex expert of the day had a famous last name: Savonarola. Giovanni Michele Savonarola (c. 1385–c. 1468), a distinguished teacher of medicine at the University of Padua and physician to the d'Este court in Ferrara, was also the grandfather of the Dominican preacher Fra Girolamo Savonarola.

A pioneer in popularizing medical knowledge, this *scrittore fecondissimo* (very productive writer) penned what may have been the first sex manual for couples, its tone practical rather than prurient. To conceive a son, for instance, he recommends careful positioning to ensure that "hotter" sperm from a man's right testicle makes its way to the warmer right side of a woman's uterus—a rather complicated maneuver that involves tying the left testicle in a tourniquet and hoisting the woman's right flank onto a pillow during coitus.

Acknowledging that writing about such matters could bring accusations of crudeness, the erudite physician nonetheless dispenses advice that sounds surprisingly modern in some ways. Unlike clerics who cautioned against touching the lips to "dishonest" parts of the body, he advocates foreplay, clitoral stimulation, and caressing a woman's breasts and nipples in order for her to achieve orgasm (his word is *spermatizare*), which he considers essential for conception. After her partner "shoots his

seed," he directs a woman to elevate her buttocks high in the air, thighs, legs, and feet squeezed tightly together, so the sperm can descend deeper into her uterus. One of his contemporaries adds a caution: "Don't sneeze!"

With or without erotic inspiration or step-by-step instruction, Francesco and Lisa figured out the fundamentals. Within a year of their marriage, Lisa was anticipating the greatest honor a Renaissance wife could aspire to: bringing forth a new life.

~

"Praise God for the good news!" reads the first line of a popular Tuscan pregnancy guide that provided rudimentary lessons on female anatomy and fetal development to "please the gentlewomen who are anxious to know about such matters." If Lisa Gherardini were so inclined, she could have learned that after conception her uterus shuts itself so tightly that not even the point of a needle could pass through its mouth. Like good soil, the warmth of her husband's sperm allows the seed planted within her to expand and form a protective coating around itself, much like the membrane of an egg.

The spirit emanating from the sperm's heat in the uterus forms the soul, the vital force that drives everything else. If the spirit is strong, it stretches the spermatic material to allow space to form "the thing he has in front" (i.e., a penis). If the sperm happens to be warm enough to procreate but not quite hot enough to form a boy, the result is a girl.

Nourished by menstrual blood, the seed gradually takes human shape—in about thirty days for a boy and forty for a girl. Regardless of sex, the fetus positions itself in the womb like Christ on the Cross: feet down, arms outstretched, head forward. When its internal lodgings become too tight, the baby somersaults to face backward with head and shoulders pressed against the mouth of the uterus, ready to be born.

During this mystical process, Lisa reigned as the queen of the del Giocondo household. According to the highly superstitious Tuscans, a mother-to-be had to be pampered and protected from any upset. Although I laughed the first time I heard it, Florentines of Lisa's day took seriously the widespread cautionary claim that a woman had given birth to a mouse after being frightened by one during pregnancy.

Authors of popular advice books tried to be more scientific. Addressing expectant mothers with *tu*, the familiar form of "you," the good doctor Savonarola writes, "You understand me, woman reader, eat three meals a day, with a diet based on the finest bread baked from flour ground from kernels of pure wheat." Choose veal, beef, kid, milk-fed lamb, young mutton, or pork. Stay away from excess salt and venison, which provokes melancholy. Avoid fish, which are cold and humid and could make the blood phlegmatic. But do indulge in wild boar, roasted hare, chicken, capon, pullet, young grouse, pheasant, partridge, and pigeon—all such delicacies that the author cannot resist exclaiming, "Oh, woman reader, who wouldn't want to get pregnant just to be held to a diet like this?"

Drink only wine that is well aged, he adds, and stay "as far away as you can from white wine, woman reader, even though it's true that white wine looks better in your hand." Cold water is not good at all—better to drink red wine until the ninth month, when white wine will "open you up and facilitate childbirth."

~

As her belly bulged in the final weeks of pregnancy, Lisa would have been advised to take warm baths in order to "gently dilate the abdominal passages and prepare for an easier delivery." Her female relations would have proffered a variety of talismans for childbirth: coral, mandrake root, coriander seeds, pulverized snake skins, rabbit milk, crayfish.

When contractions began, Dottor Savonarola urged a mother-to-be to sit on a chair with her legs extended for about an hour, then lie on the bed "to see if the baby knocks at the door." If not, he suggested some gymnastic maneuvers that strike me—as they would any woman who has ever been in labor—as nothing less than ludicrous:

> Climb onto a dresser or other high piece of furniture and jump to the floor, repeating this several times. If all this climbing and jumping becomes too tiring, get hold of a pair of stilts, stand on them on the points of your toes, kick your legs in the air, and jump down to the ground landing on your heels. Then take very deep

breaths and close your mouth and nose for as long as possible so
the air descends to your abdomen.

If labor continued for many hours, the esteemed physician recom-
mended light nourishment for the mother, some spiced wine for her to
sniff, and pleasant conversation to distract her. Screaming, he noted,
serves a double purpose: It helps to get the baby out and to "arouse the
husband's compassion." It also may have intensified the anguish of the ex-
pectant fathers waiting just outside the bedchambers.

The husband of another Gherardini—Margherita Datini's sister Fran-
cesca—described the helplessness he felt when, after five harrowing days of
labor, six women had to hold down his wife to keep her from killing herself.
The shrieks of laboring women echoed so often through Florence's stony
canyons that a historian described them as part of "the normal cacophony."

Lisa would have heard these cries herself—and would have heard of
the women and babies whose ordeal ended in death's eternal silence. But
while she had much to fear, she also could draw on the comfort of the
women who surrounded her. A midwife would have anointed her with
herbs and poultices. The *guardadonna* would have wiped her brow and
moistened her lips. One of her godmothers may have read the legend
of St. Margaret, who was swallowed by a dragon and emerged safe and
sound. Her mother may have prayed the Rosary. Her kinswomen would
have propped her up as the pains grew more frequent and intense.

Finally, Lisa pushed her first son into the light. Francesco, surrounded
by an elated throng of godparents and well-wishers, proudly bore the in-
fant to the Baptistery. On Tuesday, May 24, 1496, he was baptized Piero
Zanobi del Giocondo. At the del Giocondo home on Via della Stufa,
Lisa's *guardadonna* would have washed her gently, changed her clothes,
brushed her hair, and fed her a meal of poultry with extra salt.

Just as on her wedding day, Lisa occupied a position of highest honor.
Bright tapestries were hung from the walls. Visitors presented her with
deschi da parto (wooden childbirth trays), often decorated on both sides,
which she and Francesco would later hang on the bedroom wall. Oth-
ers brought *maiolica* childbirth bowls known as *scodelle da parto*, painted
with frolicking infants and piled with candies, nuts, special breads, and

marzipan cakes. At least one may have displayed the popular motif of naked baby boys and cherubs urinating streams of silver and gold.

Like other Florentine fathers, Francesco would have recorded the day, hour, and minute of Piero's birth and commissioned an astrological chart for his son. For Lisa, he would have expressed his gratitude with the traditional gift of jewelry. His cousin Bartolomeo had presented his wife with a special present—a precious stone, a string of pearls, a gold bracelet—at the birth of each of their children. Never one to be outdone, Francesco undoubtedly endowed Lisa with a suitably impressive bit of bling.

Soon such "vanities" would incur clerical wrath.

〜

Fra Girolamo Savonarola, grandson of the physician and author, continued preaching his fearsome sermons to larger-than-ever throngs in the vast Duomo. Lisa, their son entrusted to a wet nurse in the countryside, may have accompanied Francesco to listen, but she would have had to stay on the other side of a curtain that separated male and female worshippers.

From their home on Via della Stufa, Francesco and Lisa del Giocondo would have heard Savonarola's followers, called the Piagnoni (weepers or snivelers), parading through the streets yelling *"Viva Cristo!"* and singing tunes like "Crazy for Jesus," with a chorus of *"Sempre pazzo, pazzo, pazzo"* (Always crazy, crazy, crazy). Savonarola's equally fervid opponents (the Arrabbiati, or Angry Ones) smeared his pulpit with grease and dung, hung the putrid skin of a donkey around it, and drove great spikes along the rim where he would hammer his hands for emphasis.

During the pre-Lenten celebrations of Carnevale in 1497, Savonarola's battalions of *fanciulli* (little boys) fanned out through the city, knocking on every door and demanding that residents turn over their "vanities"— jewels, furs, pagan books, wigs, perfume, cards, dice, fans, cosmetics, decadent works of art. Canny householders like Francesco would have set aside cheap trinkets and outdated fashions to mollify them.

On February 7, the last day of the pre-Lenten celebrations, an enormous, 50-foot-high scaffold in the form of a pyramid rose in the Piazza della Signoria. That night the Piagnoni stacked the collected "vanities" above piles of sticks and straw, crowned the mountain with an image of

Satan, and set it ablaze. As flames rose to the sky, choirs chanted, trumpets blared, and church bells pealed. According to a diarist, "almost all the populace" participated, but "only the friar's followers praised it as something well done and commendable, while the others criticized it severely." Francesco del Giocondo would surely have been among the latter.

The clashes between the friar's followers and foes intensified. Savonarola, claiming that God was speaking through him, attacked the Borgia pope Alexander VI's "cesspool" of a *curia*. When the Pope excommunicated him, the wild-eyed preacher called upon the "defenders of Christianity" to depose the pontiff. But Florence was tiring of Savonarola's rants. A second Carnevale bonfire in 1498 did not draw crowds as large or ardent.

The faith of the Florentines would prove to be, as Savonarola predicted, "like wax—a little heat is enough to melt it."

On April 8, 1498, a band of Arrabbiati stormed San Marco and hauled Savonarola through jeering mobs to prison. Francesco del Giocondo could have heard details about the friar's excruciating torture from his fellow Florentines as they clustered in the Piazza della Signoria.

A dreaded instrument called the *strappado* (from *strappare*, to rip or tear) suspended Savonarola, arms tied behind his back, high in the air and then dropped him until a pulleyed rope abruptly halted his descent inches above the ground. The force of such a fall could tear tendons, wrench arms out of their sockets, and dislocate shoulders. After repeated drops, the friar, broken in every way, signed a confession of heresy.

Over the next few weeks, Francesco del Giocondo would have watched the construction of a wooden drawbridge leading from the Palazzo Vecchio into the Piazza della Signoria. On a spring night, I stand by the plaque that marks this site and conjure up the hellish scene of May 13, 1498.

An executioner led Savonarola and two of his compatriots, in white tunics, iron collars, and chains, along the walkway and up a narrow ladder to a raised scaffold.

"O prophet, now is the time for a miracle!" a voice called out from the crowd. "Prophet, save yourself!"

There would be no miracle. As the nooses tightened around their necks, the three bodies jerked and then dangled limply in the air. The tinder surrounding the scaffold was set ablaze. With flames engulfing the trio, the townspeople hurled rocks until, one by one, the friars' blackened limbs fell to the ground. Deputies scooped the ashes into carts and threw the clumps into the Arno to remove every trace of the heretics. The most devoted of Savonarola's followers, the diarist Luca Landucci reports, skimmed the last bits of charred bone from the surface of the river to preserve as relics.

For days afterward Francesco and Lisa del Giocondo would have smelled the acrid smoke in the air. The tensions lingered even longer. Fires were set in churches throughout the city. Goats were let loose in Santa Maria Novella. At Christmas Mass in the Duomo, someone released a wild-eyed horse that reared and charged through the nave until it was hacked to death.

These were also tense years for Milan's Ludovico Sforza. After his initial support of the French king's incursion into Italy, the Duke switched sides and joined the "Italian League," a loosely cobbled-together confederation of city-states, duchies, and papal troops that united to drive the French out of Italy. In desperate need of weapons, he ordered the bronze intended for Leonardo's *Il Cavallo* melted down for cannons.

"Of the horse, I say nothing," a disappointed Leonardo wrote, "because I know times are bad." The Duke commissioned another memorial—a painting of Christ's last meal with his followers for the Dominican friars of Santa Maria delle Grazie in Milan, where his father was buried. Rather than the conventional depiction of the consecration of the communion bread, Leonardo focused on the shocking moment when Jesus says, "One of you will betray me," and the words register like a slap on each apostle's face.

We get an eyewitness report on the artist's creative process from the writer Matteo Bandello, then a novice at Santa Maria delle Grazie. Some days, he reports, Leonardo "would arrive early, climb up the scaffolding, and set to work [on *The Last Supper*] from dawn to sunset, never

once laying down his brush, forgetting to eat and drink, painting without pause." On other days, laboring on different projects but struck by a sudden inspiration, he would stride across the city, even in the midday sun, and "clamber up on the scaffolding, pick up a brush, put in one or two strokes, and then go away again."

As he walked, Leonardo may have scanned the people in the streets to find real faces to serve as models for the twelve apostles: an angry Peter, a stunned James, a swooning John, a doubting Thomas. By 1497 he had made considerable progress, but not enough to satisfy the monastery's prior, who complained to Duke Ludovico about Leonardo's seeming procrastination.

Summoned before the Duke, Vasari tells us, Leonardo explained that he had indeed been working on *The Last Supper* at least two hours a day—but mostly in his mind. Slyly, he added that he had finished all the heads but one—that of Judas. If he could not find a suitably reprehensible face soon, he would give the biblical villain the features of the impatient prior. The Duke, if not the prelate, was amused.

When Leonardo did paint his Judas, he placed the traitor in shadow, his elbow on the table, his head lower than anyone else in the painting, clutching a small bag, perhaps containing the silver given to him as payment to betray Jesus. With a combination of such gestures and astutely rendered facial expressions, Leonardo came closer than anyone ever had to capturing the emotional subtleties that he called the "movements of the soul."

While creating a work that would be hailed as "the keystone of European art," Leonardo did not use the standard fresco technique of painting directly on fresh plaster. Instead he experimented with different binding agents and an unusual white ground base. Within months, flecks of paint began to fall from the damp wall.

The sky itself soon seemed to be falling over Milan. In January 1497, Duchess Beatrice d'Este died dancing—or so the court gossips put it. Duke Ludovico's wife had so reveled in courtly pageants and parties that even her third pregnancy couldn't keep her off her feet. When she collapsed at a banquet and went into labor, a midwife and birth attendants quickly surrounded her. A doctor rushed to the Castello Sforzesco. It was

too late. The baby was stillborn. Beatrice, just twenty-two, died shortly thereafter. Her husband was inconsolable.

As the fifteenth century lurched through its final years, tears would also fall in Florence. Lisa Gherardini brought her first daughter, Piera, into the light in 1497. The little girl, like as many as half of Florentine youngsters, did not survive childhood. Piera del Giocondo died on June 1, 1499, at just two years of age and was reportedly buried in Santa Maria Novella. We do not know which of the many scourges of the Renaissance—plague, influenza, tuberculosis, a nameless fever—claimed this child, but her parents would have forever carried the sorrow of her loss in their hearts.

As they mourned, Francesco and Lisa had to keep moving into the future. In 1499 the merchant served a two-month term on the Dodici Buonuomini (Twelve Good Men), one of the city's highest councils. Just months after burying their first daughter, Lisa gave birth to another little girl, their cherished Camilla, on September 9, 1499.

History's kaleidoscope shifted again. The French king Charles VIII, who had led the invasion of Florence, died after striking his head on a door lintel in one of his castles in France. His successor, Louis XII (1462–1515), had descended from the Visconti, the previous dukes of Milan. Determined to reclaim the city he saw as his ancestral birthright, he marched French troops across the Alps, this time with Milan in his crosshairs.

With French shells hammering nearby towns, Duke Ludovico fled on September 2. Four days later the Milanese opened their gates in surrender. Leonardo, immersed in projects, commissions, ideas, and intrigues, seemed to have been taken by surprise.

On October 6, 1499, the French victors marched through Milanese streets strung with white banners emblazoned with their country's fleur-de-lis. Heading the triumphal parade were two men who would play significant roles in Leonardo's future: the French king Louis XII and his ally Cesare Borgia (1475–1507), the son and military captain of the infamously corrupt Pope Alexander VI.

At first sight of Leonardo's stunning *Last Supper*, King Louis XII or-

dered the masterpiece transported to France. "His Majesty failed to have his way," Vasari notes, only because the mural could not be removed from the wall. Leonardo did not await further dictates. Transferring his life's savings to the bank at Santa Maria Nuova (a trusted institution also used by his father Ser Piero da Vinci, Michelangelo, and Antonmaria Gherardini) in Florence, he headed out of town.

"Sell what you cannot take with you," Leonardo wrote in his notebook. Together with Salaì and the mathematician Luca Pacioli, his longtime companion and collaborator, he left Milan in December of 1499 with a cart piled with unfinished paintings, drawings, and sheaves of paper covered with designs and sketches.

In Mantua, the trio stopped briefly at the court of Isabella d'Este, the Marchioness of Mantua. The sister of the late Duchess of Milan welcomed Leonardo warmly but immediately began entreating him for a portrait. Leonardo placated her with a chalk drawing and promises of a future painting. Moving on to Venice, under threat from the expanding Ottoman Empire, Leonardo offered advice (unheeded) on military defenses.

When word reached him of Sforza's capture after betrayal by his Swiss mercenaries, Leonardo scrawled some lines on the back of a notebook: "The Duke has lost his state, and his possessions, and his freedom, and he did not complete any of his projects." A grim fate awaited the deposed ruler of Milan. After being paraded like a wild animal in a cage, Ludovico Sforza was imprisoned in a wretched, dank underground dungeon in the Loire Valley. Half mad from captivity, he died there eight years later.

Leonardo also had lost much. French soldiers, aiming their crossbows at his towering clay model of *Il Cavallo*, smashed it to pieces. His transcendent *Last Supper* was already disintegrating. His handful of panel paintings were scattered to various private owners.

"A defeated man nearing fifty," a biographer summarizes, "had given the richest years of his life to a second-rate tyrant with a passion for power."

The coming years would bring unforeseen turns of fate. The gentle

soul who ate no animal flesh and bought caged birds only to set them free would work for a cold-blooded warrior whose very name inspired terror. The self-taught engineer with a lifelong fascination for the force of water would take on the Herculean feat of changing the course of Tuscany's Arno River. The seasoned painter who disdained sculpting would compete head-on with a brash young sculptor who derided painting. And the lifelong bachelor who surrounded himself with beautiful boys would devote years to the portrait of an enigmatic young woman.

For now there was nowhere for Leonardo to go but home—to Florence.

Part III

A NEW CENTURY

(1500–1512)

Chapter 9

New Beginnings

Lisa Gherardini and her family welcomed the new century, not on the first of January, 1500, but on Florence's traditional New Year's Day of March 25, the Feast of the Annunciation. This holy day celebrates the angel Gabriel's descent from heaven to announce to a teenage girl in Nazareth that God had chosen her to be the mother of His son. With Mary's acceptance of divine will, the Holy Spirit "moved in her womb," and nine months later Jesus Christ was born. Every year exultant Florentines swarmed into the piazza of La Nunziata, the nickname of the Basilica of Santissima Annunziata (Most Holy Annunciation), built by the Servites (Servants of Mary) in the thirteenth century, for an annual New Year's festival.

In the early years of the sixteenth century, the lives of three men would converge in this beloved shrine: Francesco del Giocondo, thirty-five, who supplied altar linens and vestments and handled currency exchanges for the friars; Ser Piero da Vinci, seventy-three, who managed the richly endowed church's complex financial and legal affairs; and Ser Piero's son Leonardo, forty-eight, who arrived in Florence on April 24, 1500, with no job and no place to live, ready for a new beginning.

Ser Piero da Vinci and his son had never lost contact. "Dearly beloved Father," Leonardo begins in the only surviving fragment of their correspondence, "I received the letter that you wrote me and that in the space of an instant gave me pleasure and sadness. I had the pleasure of learning that you are in good health and give thanks to God, and I was unhappy to hear of your trouble."

We don't know the nature of Ser Piero's woes. At their *palazzo* on

Via Ghibellina, the seemingly robust patriarch presided with his fourth wife over a boisterous brood of eleven youngsters—nine boys and two girls, ranging in age from twenty-four to barely two. The masterful pull-er-of-strings may well have had a hand in arranging accommodations at Santissima Annunziata for his acclaimed son, who was to paint a Madonna with St. Anne for the main altar. The Servites, anticipating the glory this would bestow on their church, rushed to order an elaborate frame of about 10 feet by 6 feet for what would be Leonardo's largest panel painting.

The town where artists reigned like rock stars greeted Leonardo as a living legend. Few Florentines had seen the works he had created in Milan, but everyone had heard of their brilliance—and of Leonardo's scientific and mathematical pursuits, which magnified his reputation as a universal genius. Even unfinished pieces, such as the giant model of *Il Cavallo* pierced by French arrows, embellished his mythic reputation, as did his arresting appearance. Artisans rushed to the doors of their workshops and women leaned out second-story windows to catch a glimpse of the tall man in rose-colored robes, his thick wavy hair now more silver than gold.

As Leonardo settled into Santissima Annunziata, the Servites would proudly have shown him their most precious possession: a "miraculous" portrait of the Virgin Mary. I heard its story from a chatty friar I met years ago when I was studying the history of Italian at the Società Dante Alighieri, a language school in a former cloister around the corner. Almost every day after class I would stop to light a candle before the shrine to the Madonna for my ailing mother.

An anonymous thirteenth-century artist began the painting, the friendly friar told me, but despite one botched attempt after another could not capture Mary's exquisite face. Collapsing in exhaustion, he awoke to discover that someone—an angel, he had no doubt—had completed the portrait with a skill beyond any human hand.

Shrouded within an elaborate bronze tabernacle underwritten by Lorenzo de' Medici's father, Piero, the breathtaking work attracted pilgrims from all of Christendom. When unveiled and carried in procession

through Florence's streets for special celebrations, the painting inspired such awe that the faithful would fall to their knees before it. Even today hundreds of ex-votos (wax or metal symbols of gratitude for answered prayers) testify to the Madonna's miraculous powers.

Finding it hard to imagine Leonardo, the Milanese dandy, taking up residence in a monastery, I return to Santissima Annunziata. A gaunt, tonsured friar with firefly eyes approaches me with an assortment of postcards, calendars, and medallions. I buy the lot for 10 euro and ask about Leonardo's long-ago stay. Walking fast and talking faster, he sweeps me through the cavernous marbled nave to an inner courtyard, a green oasis of calm and quiet.

Catching his breath, the friar points vaguely in the direction of an adjacent structure now occupied by the Instituto Geografico Militare of Florence. There, he tells me in rapid-fire Italian, is the studio where Leonardo worked on the *cartone*, the actual-size preliminary drawing for the altarpiece that the Servites had commissioned. Just a few years ago workers demolishing a wall for an Institute renovation had come across a secret stairwell and some small rooms that have since been linked with Leonardo and his assistants.

"Guess what they found on the walls?" the friar asks with a rhetorical flourish.

Clueless, I shake my head.

"*Uccelli!*" (Birds!) he exclaims—drawings, perhaps by Leonardo himself (doubtful), of the very same sort of little birds flitting about the courtyard where we stand.

As we stroll under a graceful loggia, the friar's crude sandals, mere slabs of wood fastened with leather straps, make me think of the hand-sewn buckled velvet shoes that Leonardo fancied. What had the humble friars and their eminent guest made of each other? The ascetic Servites wore rough robes tied around their waists with rope. The worldly courtier's wardrobe included Catalan gowns in pink and dusty rose, a dark purple cape with big collar and velvet hood, a crimson satin overcoat, and two pink caps. How had the Milan cosmopolitan, long ensconced in a grand

ducal palace with its ballroom for a workshop, adjusted to a monastic cubicle and a daily routine marked by bells and blessings?

We know little of Leonardo's faith. Despite the beauty and profundity of his religious works, he never displayed any conventional devotion. He did, however, feel a sort of professional kinship with God, since, as he noted, painters also could create all things, from idyllic landscapes to mighty mountains to raging oceans. "The divine character of painting," he wrote, "means that the mind of the painter is transformed into an image of the mind of God."

The Church, on the other hand, provoked undisguised disdain. Leonardo criticized clerics "who produce many words, receive much wealth, and promise paradise," and decried the selling of indulgences, liturgical pomp, and the cult of the saints. Art historians credit him with "uncrowning the Middle Ages" by not putting halos on his religious figures and portraying them as flesh-and-blood fallible humans rather than heavenly beings.

In Vasari's depiction, Leonardo emerges as a self-taught, clear-eyed dispassionate scientist who relied on observation and reason and could not be "content with any kind of religion." But perhaps to Leonardo in 1500, Santissima Annunziata seemed—as it did to me as I paused in its tranquil courtyard—a heaven-sent haven offering serenity and stability when he needed them most.

In 1502, during Leonardo's residence at Santissima Annunziata, Francesco del Giocondo, one of the church's regular suppliers, had a particular bone of contention to discuss with Ser Piero da Vinci, who represented the Servites. The friars were contesting one of his bills of exchange. Francesco, a man of business, and Ser Piero, a man of law, could have worked together at least once before, when the *notaio* got involved in another matter concerning the del Giocondo enterprises and the Servites.

The dispute over Francesco's handling of a currency exchange was not his first. Always trying to skim an extra profit from a transaction, Francesco tended to tip the fluctuating exchange rates in his favor. But he and Ser Piero would not have resorted to legal proceedings. In an out-

of-the-way corner in the sprawling Santissima Annunziata compound, they could have negotiated their way to a reasonable settlement. In typical Italian fashion, the two fathers also might have chatted of more pleasant matters, including their veritable tribe of children.

Francesco del Giocondo had happy news to share. After giving birth to Camilla, their third child, in 1499 and Marietta, their fourth, in 1500, his wife, Lisa, was pregnant again. Ser Piero, who for more than twenty years had lived just *due passi* (two steps) away from Lisa's grandparents on Via Ghibellina, would have extended best wishes. He might have watched Lisa grow from a darling child skipping down the block to an adolescent girl of striking beauty to a young matron with toddlers of her own. Ser Piero may well have been the one who presented her husband to his celebrity son, perhaps as a potential patron.

Despite the warmth of his welcome in Florence, Leonardo seemed restless. Flitting from one pursuit to another, he began a small (now lost) painting called the *Madonna of the Yarnwinder*, offered advice on repairing the foundation of a church near Florence, and consulted on the construction of a *campanile* (bell tower) for San Miniato, as well as visiting Rome to study ancient works of art and architecture. He also acquired several pupils, two working on drawings or copies. "From time to time," a contemporary reports, Leonardo "put a touch on them."

There was no sign of progress on the altarpiece. "He kept them waiting a long time without even starting anything," writes Vasari. In 1502, Leonardo finally had something to present to the friars: a *cartone* (preliminary drawing), since lost, so brilliant that it silenced any grumblings about the delay. According to the descriptions that have come down to us, the design was classic Leonardo, with a dramatic composition of Mary, her mother Anne, and the infant Jesus, their faces portrayed with a melting softness. The first public viewing—a one-man, one-painting show—ignited as much excitement as the opening night of a theatrical blockbuster.

"For two days," Vasari recounts, "it attracted to the room where it was exhibited a crowd of men and women, young and old, who flocked there as if to a great festival to gaze in amazement at the marvels he had created." Florentines, Vasari reports, were "stupefied by its perfection." Fran-

cesco del Giocondo would surely have been among them. We can't be sure about the pregnant Lisa, who would give birth to her fifth child and second son, Andrea, on December 12, 1502.

—

Perhaps Leonardo's impressive *cartone* sparked Francesco's interest in acquiring a painting by the acclaimed artist. Vasari, in the earliest account of the origins of *La Gioconda* (literally "the Giocondo woman"), provides only this minimal description: "For Francesco del Giocondo, Leonardo undertook to paint a portrait of his wife, Mona Lisa."

The arrangement would have made sense. Leonardo needed income. And the affluent merchant, who would commission other works from well-regarded painters in the future, would have been proud to acquire a work by the acclaimed artist. Some have speculated that Ser Piero, as he had done with other artists, might have commissioned his son to paint Lisa as a gift for Francesco del Giocondo, but no evidence supports this theory.

A historical document from the French curator Père (Father) Dan, who first catalogued the *Mona Lisa* as part of the royal art collection in the seventeenth century, suggests another possibility: that the portrait was Leonardo's idea. According to the scholarly prelate, head of the monastery at the royal palace of Fontainebleau, Leonardo asked Francesco del Giocondo, a "close friend," for permission to paint his wife.

Whoever instigated the project and whatever the nature of the agreement, the conversation may well have taken place at Santissima Annunziata. However, no works were ever completed there. Leonardo never finished the altarpiece for the Servites—or any other painting.

When the persistent Marchioness of Mantua, Isabella d'Este, badgered Fra Pietro da Novellara, her contact in Florence, to press the artist to accept a commission to paint any subject he chose, at any price he set, she was informed that "the existence of Leonardo [is] so unstable and uncertain that one might say he lives from day to day." His fascination with mathematics, mechanics, and science had intensified into an all-consuming obsession. Fra Pietro described the genius as so deeply immersed in postulates, axioms, and theorems that he seemed to have grown *"impaziente sino al pennello"* (impatient even with the brush).

Perhaps he was indeed just plain sick of painting, but I think Leonardo also may have wanted to try something a modern middle-aged man might consider: reinvent himself. This may be why he took on one of the most unlikely assignments of his career—a stint as military engineer for the notorious Cesare Borgia.

~

The two may have first met in Milan in 1499, when Cesare Borgia rode in triumph with the French king Louis XII into the conquered city. There he could have beheld Leonardo's masterpieces, including his imposing model for *Il Cavallo*, his matchless *Last Supper*, and his designs for fortresses and weaponry. For his part, Leonardo would undoubtedly have heard of the Borgia pope's son Cesare and his reputation as "a bloodthirsty barbarian" who once had the tongue of a Roman satirist who insulted him cut out and nailed to his severed hand.

Tall, with massive shoulders tapering to a wasp waist, the warrior prince merged a sophisticated intellect with a sociopath's penchant for unspeakable violence. Appointed a cardinal as a teenager, he renounced his crimson robes at age twenty-two to replace his murdered brother as *gonfaloniere* and captain-general of the Papal States. (He remained the prime suspect in the assassination.)

For help in winning a papal annulment of his first marriage, King Louis XII bestowed upon Cesare one of his royal cousins as a bride, a small army, an income, and the title Duke of Valentinois. At twenty-seven, Il Valentino, as the Italians called him, set out to conquer central Italy in the name of his father, Pope Alexander VI. His motto: *Aut Caesar aut nihil* (Either Cesare or nothing).

As the diarist Landucci reports, all of Florence followed reports of Cesare's campaign against the Renaissance's feistiest female ruler: Caterina Sforza (1463–1509), the Duchess of Forlì. Leonardo may have met this niece of his former patron Duke Ludovico Sforza in Milan. He certainly would have heard tales of her exploits. Once, fending off enemies from castle ramparts, the auburn-locked beauty had dared the soldiers holding her children hostage to go ahead and kill them. Lifting her skirt, she shouted, "See, I have the equipment to make more."

In her final heroic battle, the *"tigre"* (tigress) of Forlì, wielding a sword and fighting side by side with her men, managed to hold Cesare's forces at bay for several weeks. In January of 1500, Cesare prevailed and took the virago duchess captive. After reportedly brutalizing Caterina as his private prisoner, he dispatched her to the foul dungeons of Rome's Castel Sant'Angelo.

"If I were to write the story of my life," she confided to a monk after her release in 1501, "I would shock the world." Some have argued, on the basis of similarities with a portrait of Caterina painted by Lorenzo di Credi, a colleague of Leonardo's, in 1487, that she was also the model for the *Mona Lisa.* The fabled tigress would certainly have been a fascinating subject, but there is no convincing evidence that Leonardo ever painted her.

At his first meeting with Cesare Borgia in 1502, in a candlelit chamber in the ducal palace of Urbino, his latest conquest, Leonardo coolly appraised the man once hailed as the most handsome in Europe. Three red chalk sketches capture his first impressions of his new patron: a jowly face, coarsened features, heavy-lidded eyes. A thick beard covered the pustules caused by syphilis, the "French disease" that had spread through the peninsula after Charles VIII's invasion. By day Cesare took to wearing a black mask.

It's not clear exactly how Leonardo ended up in Cesare's employ. Perhaps the Florentine Republic volunteered his services as a token of goodwill to a predatory tyrant who posed a constant threat to its security. Perhaps Il Valentino simply demanded the expertise of the man he considered the most brilliant engineer of his day.

Leonardo would not have needed much persuasion. Although he had never set foot on a battlefield, war had fascinated him since youth. The self-taught engineer had filled pages in his notebooks with sketches of ingenious fortifications and killing machines. To Leonardo, indifferent to his patrons' political agendas, the assignment represented an opportunity—one he'd hoped to have under Milan's Duke Ludovico—to put his designs for military machinery to a real-life test.

The packing list that the fifty-year-old Leonardo composed in the

summer of 1502 makes me think of the high-spirited boy from Vinci. Among the must-take items for his next adventure: boots and extra soles for them, a compass, a sword belt, a leather jerkin, a light hat, a "swimming belt," a book of white paper for drawing, some charcoal, and a single concession to time's passing—a frame for holding spectacles, the first reference to the vision problems that would plague him in old age.

The morning after their meeting in Urbino, Cesare Borgia disappeared.

"Where is Valentino?" Leonardo asked in his notebook.

The dark prince had absconded to Asti to meet with King Louis XII of France, leaving a letter, a passport of sorts, that opened all doors to "our most excellent and most dearly beloved friend, the architect and general engineer Leonardo da Vinci . . . commissioned to inspect the buildings and fortresses of our states." In a sartorial tribute, Cesare presented him with one of his capes, long and green, cut "in the French style."

Wrapped in this smart cloak, Leonardo threw himself into his assignment with the vigor of a man half his age. Rising with the dawn, he rode through Cesare's newly occupied territory. At each thick, castellated fortress wall, he held up his quadrant to measure its height and peered through his thick-rimmed round spectacles to record his observations more precisely. The meticulous engineer paced out the length of moats and inner courtyards and checked with his compass the direction of nearby towns. Every now and then he paused to make a quick sketch in a palm-sized notebook hanging from his belt.

In October 1502, the priors of Florence's ruling Signoria, anxious for news, dispatched their most adept diplomat to Borgia headquarters in Imola: thirty-three-year-old Niccolò Machiavelli, a small-boned man with short chestnut hair, a pert nose, and a smirk he couldn't quite disguise. Like many, I had thought of Machiavelli solely as a writer whose name served as a byword for political cunning. But for fourteen years, the devoted civil servant held various diplomatic and administrative roles in his hometown, including Second Chancellor of the Florentine Republic.

Machiavelli, the political mastermind, and Leonardo, the polymath ge-
nius, holed up for the winter truce in Imola's ducal palace. I imagine the
two *cervelloni* ("big brains" or intellectuals) passing long evenings before a
blazing fire, glasses of *vin santo* in their hands, talking late into the night
about all manner of things. Leonardo, his eyes weary after a day of work-
ing on an intricate map of Imola, would have appreciated Machiavelli's
sharp eye and even sharper tongue.

Perhaps the satirist regaled Leonardo with some of his oft-told *barzel-
lette* (amusing stories). In one a newly rich man in Lucca invites a friend
named Castruccio to dinner at his house, which he has just remodeled in
the most ostentatious manner possible. During the meal Castruccio sud-
denly spits in his host's face. Rather than apologize, he explains that he
did not know where else to spit without damaging something valuable.

Inevitably, the conversation would have turned to Cesare Borgia,
the leader who so fascinated Machiavelli that he would cast him as the
cunning protagonist of his classic treatise *The Prince*. Although neither
Leonardo nor Machiavelli rode to battle with Cesare's forces, both men
witnessed his gruesome handiwork.

In a particularly grisly episode, the townspeople in the nearby town
of Cesena woke on a December morning to find Il Valentino's cruel and
much-hated Spanish "enforcer" Ramiro de Lorqua lying in the piazza in
his finest brocade cloak, his kid-gloved hands at his side and his decap-
itated head stuck on a lance nearby. Beside him lay the blood-spattered
blade and the butcher's wooden wedge used to dismember him.

"All the people have been to see him," Machiavelli wrote. "No one is
sure of the reason for his death except that it pleased the Duke [Cesare],
who by so doing demonstrated that he can make and unmake men as he
wishes, according to their deserts." A few days later Cesare lured some
former rebels, including a close friend of Leonardo, into a local castle for
a banquet and barricaded the doors. Some of the men were garroted in
their seats; others, jailed and executed later.

Leonardo did not record any such scenes in words or images, but he
did reflect on the brutality he had witnessed. "The most wicked act of all
is to take the life of a man," he wrote. "He who does not value [life] does
not himself deserve to have it."

Back in Florence, Francesco del Giocondo was getting his financial affairs in order. After the senior generation of the family of silkmakers had died off, Francesco and the other heirs decided to define and separate their respective portions—perhaps, Giuseppe Pallanti suggests, because they no longer trusted Francesco, who "was no angel and tended to overpower the others." Two arbiters—one, Francesco's father-in-law, Antonmaria Gherardini—recommended an equal division of the family assets.

With his inheritance defined, Francesco made financial arrangements for his own children. In the presence of several friars at the church of San Gallo, he signed papers prepared by his *notaio* to divide *"omnia et singula bona mobilia et immobilia"* (all of his movable and immovable goods) among his sons—Bartolomeo (from his first marriage), nine; Piero, seven; and the infant Andrea—and to set aside dowries for his daughters. A month later, in a deed signed on April 5, 1503, Francesco bought a house on Via della Stufa next to the del Giocondo family homestead.

When I peer inside the apartment building that stands in its probable location, I realize that all traces of the original design have long disappeared. And so I head to Palazzo Davanzati, now the Museo della Casa Fiorentina Antica (Museum of the Antique Florentine House), built in the mid-fourteenth century by a prosperous merchant. Unlike the renovated residences on Via della Stufa, the *palazzo* retains the feeling of a genuine home of *Firenze com'era* (Florence as it was).

I enter a ground-floor courtyard, similar to the one where the del Giocondo family would have stabled horses and stored supplies. Climbing a stone staircase to the second-floor residence, I step into spacious reception rooms with windows facing the street, a huge stone fireplace, and walls painted in warmly colored geometric patterns. Lisa's new home might also have featured parqueted wood floors, imported Persian rugs, gold-framed mirrors, sculptured moldings, embellished ceilings, Venetian glassware, colorful ceramics, and a private bathroom under the stairwell, with a "close stool," a chair with a chamber pot inside, and a basin with water drawn up from a well. Windows of leaded glass rather than glazed linen would have let in light and kept out cold.

The master bedroom, the heart of the house, would have contained the standard furnishings: a large wood-posted bed, with Lisa's *cassone* at the foot and storage chests underneath; a *guardaroba* (wardrobe), and, in a corner set aside for prayer, a kneeler in front of a painting of the Madonna. Only one item in this room, I later learn, is out of place: an elaborate cradle.

Like other Florentine women of her station, Lisa would have had little need for one. As was the standard practice of the day, she would have handed her babies—Piero, Piera, Camilla, Marietta, and Andrea—over to a *balia* (wet nurse), usually a sturdy country lass with plenty of milk to spare. Modern scholars, citing the high infant mortality rate at the time, have criticized this practice as almost a form of maternal neglect.

Curious about any possible grounds for this assertion, I ask the opinion of Kristin Stasiowski, a Yale-educated Italian scholar, when we meet for lunch at a Florentine trattoria to discuss Renaissance family life. "Parents then were the same as parents are now," she observes. "They wanted what was best for their children." The countryside seemed a safer place than Florence, and robust country girls were assumed to produce higher-quality milk than the city's delicate young mothers.

Prato's *balie* won particularly high praise. The advice of Lisa's kinswoman Margherita Datini, who often located local wet nurses for her husband's Florentine associates, would still have held true in Lisa's day: Try to find a woman who resembles the child's mother a little, with good color, a strong neck, and breasts that aren't overly large, so the baby won't get "a flat nose" when pressed against them.

Because they didn't nurse, the ladies of Florence's upper classes returned more quickly to their marital beds and procreational duties—one reason they produced many more offspring than poorer women. Lisa was a prime example. In the first seven years of her marriage, she gave birth five times. Particularly after the birth of his second son, Francesco may have thought that a portrait would be a fitting tribute to the mother of his children—as well as the crowning glory of their new residence.

After eight months with the Borgia campaign, Leonardo made his way back to Florence. By March 4, 1503, he was withdrawing money from his account at Santa Maria Nuova—an indication that he never was paid for his stint as a military engineer. The experience with Cesare Borgia drained more than his savings. No longer did Leonardo take pride in designing impregnable fortresses and diabolical killing machines. Never again did he tout his skills related to military operations.

In August word came that the Borgia reign of terror had spiraled to a grotesque end. In the scorching summer heat, Pope Alexander VI and his son, Cesare, dined in a cardinal's villa outside Rome. A week or so later both became feverishly, violently ill—possibly poisoned by wine meant for their host or stricken by a virulent form of malaria. The Pope died and "was buried in hell," as a contemporary put it, his corpse so black and bloated that it was hardly recognizable as human.

Cesare slowly recovered but eventually fled Italy for Spain. He died, sword in hand, in an ambush in 1507 at the age of thirty-one. Three assailants, stealing his shining armor, well-cut cloak, and plush leather boots, tossed aside his butchered naked body, bleeding from more than two dozen wounds, a flat stone covering his genitals. Another of Leonardo's patrons ended up losing everything, including his life.

Basta! Leonardo might have had enough. Enough death. Enough violence. Enough wickedness and wretchedness. Enough *"pazzia bestialissima"* (madness most bestial), as he had come to think of war. Leonardo's bruising experiences with the Borgia campaign may have heightened his appreciation for the preciousness of human life—and rekindled his passion for art.

No longer "impatient even with the brush," Leonardo was ready to paint again.

The Portrait in Progress

If I could freeze-frame one day in Lisa Gherardini's life, it would be her twenty-fourth birthday, June 15, 1503. At this sweet moment in time she would have had every reason to smile. She had married into a secure and comfortable life. In the eight years since her wedding, she had embraced a stepson as her own and given birth to five children. Although she could hold Piera, swept away at age 2, only in her heart, she would have given thanks for her seven-year-old son, Piero, growing fast as summer wheat; Marietta and Camilla, her three- and four-year-old *bambole* (dolls); and Andrea, her darling baby boy. Her husband, Francesco del Giocondo, who had already gifted her with gowns and jewels, had purchased a new home for their growing family. And now this: an unexpected moment in the sun.

Leonardo da Vinci, most biographers agree, was working on his portrait of Lisa in 1503 (some believe he may have begun a year or two earlier), perhaps most intensely between his return from the Borgia campaign in the spring and a major new civic commission in the fall. Lisa might not have known the details of the arrangements; these were matters men negotiated. Regardless of the when and where of their first encounter, the manners of the day would have dictated what happened when a Florentine *signora* was formally presented to a distinguished elder, old enough (at age fifty-one) to be her father.

As a proper matron, Lisa would have extended her hand for Leonardo to raise almost but not quite to his lips. Even with her eyes cast demurely downward, she may have sensed the painter looking at her in a way no other man ever had, studying the contours of her face as if breaking her bones into bits and reassembling them in his mind. Leonardo's

voice, so melodious that a sentence could sound like a song, would have soothed any nervousness. Bemused by the unlikely intersection of their lives, Lisa may have unconsciously let her lips curve into the slightest of smiles. As she dared to glance upward, Leonardo would have caught his first impression of her eyes, those "mirrors of the soul."

Something in the depths of Lisa's eyes ensnared Leonardo, although no one knows exactly what. "Something inherent in his vision," the art critic Sir Kenneth Clark observed. How else, he asked, could one explain the fact that "while he was refusing commissions from Popes, Kings, and Princesses he spent his utmost skill . . . painting the second wife of an obscure Florentine citizen?"

Maybe Lisa's obscurity was part of her appeal. Rather than mollifying a vain monarch, Leonardo could bring to bear every technique he had honed, every theory he had developed, every insight he had acquired to capture *una donna vera*, a fully dimensional human being rather than someone's pawn, property, or fantasy. And perhaps with his discerning eye Leonardo saw more than an ordinary young wife and mother caught up in the delights and distractions of small children, with a blustering husband and a big quarrelsome blended family.

"Give your figures an attitude that reveals the thoughts your characters have in mind," Leonardo advised young painters. "Otherwise your work will not deserve praise." Perhaps what intrigued Leonardo was Lisa's "attitude," her own personal variant of Gherardini-ness: a spirit large-hearted enough to love another's child as her own; tender enough to tame a temperamental spouse; determined enough, as she would prove in the decades ahead, to make wrenching choices; and flinty enough to sustain her family through the dark years of upheaval that the future would bring. Beyond the girl Lisa once was, Leonardo might have glimpsed the essence of the woman she was still in the process of becoming.

Leonardo's entire career had led him to this point—and this portrait. Through years of advanced mathematical calculations, he had worked out the perfect proportions for a human head. In experiments with optics, he had observed a pupil's response to the play of light and shadow.

By dissecting cadavers, he had isolated the muscles that curve a finger or draw the lips into a smile. All that sixteenth-century science could offer—as well as some pioneering insights others had yet to acquire—would sharpen his eye and guide his hand.

In the process of creating the *Mona Lisa*, Leonardo would revolutionize art in never-before-seen ways. Using the so-called golden ratio (which he had studied with the mathematician Pacioli), he would calculate the ideal distances between neck, eyes, forehead, nose, and lips. He would highlight Lisa's supple hands like a magnificent work of nature and immerse objects in air and light—termed aerial or "atmospheric" perspective—so they appeared crisply defined in the foreground but less so in the distance. And he would position Lisa against a fantastical background in such a way that the coiling road, arched bridge, rocks, water, and mountains seem as much a part of her as she is part of them.

Like Prometheus, Leonardo would breathe life into his creation. Lisa would become *una cosa viva* (a living thing), almost human yet at the same time something more elusive: "poetry that is seen," his ultimate goal.

———

In Milan, Leonardo had painted his portraits of Ludovico Sforza's mistresses on walnut, a dense, hard wood. But in Florence, he stuck with the local artists' preference: poplar. (Canvas had not yet become popular in Italy, except in Venice.) The thin-grained plank he selected, sawn lengthwise from the center of the trunk, was trimmed to about 30 inches high by 21 inches wide. To prevent warping, Leonardo painted on its "outer" rather than "inner" face. Instead of the standard primer of *gesso*, a mix of chalk, white pigment, and binding materials, he applied a dense undercoat with high levels of lead white (detected in modern chemical analysis).

From his favored apothecaries, Leonardo would have purchased precious dyes, such as cinnabar, red as dragon's blood, and brilliant blue ultramarine from the exceedingly rare and costly lapis lazuli stone. As he preferred, he would mix the rich colors with oil, slower to dry than the eggs he had used for tempera paints in Verrocchio's studio and more suited to the subtle shadings that he alone among Florentine painters had mastered.

At the very center of the composition, Leonardo would place Lisa's heart, framed in the pyramid of her torso rising majestically from the base of her folded hands and seated hips to the crown of her head. As he did for his portraits of the self-proclaimed tigress Ginevra de' Benci in Florence as well as for Il Moro's mistresses in Milan, Leonardo chose a forward-facing three-quarter pose. Firmly grounding Lisa in a *pozzetto* ("little well"), a chair with a stiff back and curved arms, he instructed her to twist into a *contrapposto* pose, her right shoulder angled backward and her face turning in the opposite direction.

According to beneath-the-surface scans of the painting, Lisa may initially have grasped the chair arm with her left hand, as if about to push herself upward. Changing his mind, Leonardo brought both of her arms in front of her body, the left leaning on the chair, the right hand resting atop the left (a sign of virtue), her supple fingers gently fanning over her sleeve. This startlingly original position would create the illusion that Lisa's hands are nearer the viewer than the rest of her body.

If I had been in Lisa Gherardini's hand-sewn slippers, I might have donned my fanciest frock, perhaps a gown with a voided velvet bodice, styled from the finest fabrics in the del Giocondo shops. And I would have looped pearls, the most impressive gems, around my neck and slid a ring set with a sizable stone, maybe two, on my fingers. This would have been the image that a pretentious Florentine merchant would have wanted to project. But even if he did commission the portrait, Francesco del Giocondo seems to have had no say in his wife's attire. At this stage in his career no one told Leonardo how or what to paint.

Although he dressed his Madonnas with what one scholar calls "fashion plate elegance," Leonardo stripped Lisa of all embellishments: no beaded bodice, no brocaded overgown, no jewels, not even a wedding ring. I began to understand his motives only when I came across a comment in his notebooks about "peasant girls in the mountains, clad in their poor rags, bereft of all ornament, yet surpassing in beauty women covered with adornments." Lisa, though no rural ragamuffin, didn't need gaudy *frasche* (trimmings) to snare a viewer's attention.

Leonardo presented the merchant's wife as *una donna vera* in understated but refined garments appropriate to her role as a respectable, respected married lady. Her *gamurra*, dulled by time and layers of lacquer, would originally have been a lighter green, woven of the highest-quality silk. A skilled embroiderer would have crafted the intricate knotting and needlework around the neckline, cut just low enough to reveal a hint of the dip between her breasts. The velvet sleeves, now a coppery shade, drape in the "artful artlessness" of deep folds and seem somehow to glow from within.

Scouring Renaissance fashion histories, I learned that women often wore veils, light and sheer, more "to enhance than hide" their looks. Lisa's transparent veil, almost invisible to the naked eye, floats from the top of her head over her shoulders. The lighter-than-air accessory may have come from a French hairstyle, "*la foggia alla francese*," popular at the time or from the "Spanish look" popularized by the Borgia pope's daughter, the fashionista Lucrezia Borgia.

Some commentators have categorized this as a *guarnello*, a gossamer gown particularly popular during and after pregnancy, but Lisa's billowy garment lacks a hem and other characteristic touches. No one has definitively identified the piece of material rolled over Lisa's left shoulder (also hard to detect without close examination)—perhaps a shawl, a scarf, an extension of the veil over her head, or a theatrical flourish Leonardo may have invented.

With his typical zest for silky ringlets, Leonardo twirled tendrils of angel-fine hair against Lisa's pale neck. But while her hair may look as loose as a young girl's, modern imaging techniques have revealed a more elaborate coif, with locks gathered gently at the back of her neck, perhaps in a bun or bonnet of sorts, and long curls undulating on either side of her face—a style seen in other portraits of the day. At some point, according to the under-the-surface scans, Lisa may have freed more strands to cascade softly onto her left shoulder.

Biographers suggest several possibilities for where Lisa might have posed for Leonardo. The artist could have begun his original sketch in his

bottega at Santissima Annunziata, where he was living at the time. When he later moved to the Santa Maria Novella compound, Leonardo might have set up his three-legged easel there. Wherever he worked, Leonardo, obsessed with light, might have rigged up shades to filter the sun or, as he suggested in his advice to painters, taken advantage of cloudy or hazy days or the evocative glow of dusk.

Leonardo would have started by drawing his model with either chalk or pen on paper. Like other artists of the day, he could have completed a sketch in just a single sitting and transferred its outlines via pinpricks and chalk to a prepared wood panel. But in the earliest account of the portrait's creation, Vasari describes a far more prolonged and complex process.

Leonardo, he recounts, hired performers "who played or sang, and continually jested, who would make [Lisa] remain merry, in order to take away that melancholy which painters are often wont to give to their portraits." Many scholars deride this dramatic scenario, but Leonardo may have needed more than the usual amount of time with his model. The reason: He was attempting something that had never been done before.

"Leonardo wanted to portray the complex psychological life of a real person," explains Monsignor Timothy Verdon, director of the Museo dell'Opera di Santa Maria del Fiore, who teaches a course on women in Renaissance art at Stanford University's Florence program. "He may have wanted to see the play of different feelings and responses to different stimuli on her face. The emotions, the intelligence, the obvious wit that he captured are what makes Lisa's face so alive and so fascinating to us."

What about Lisa? What did she behold when she returned Leonardo's penetrating stare? She would never have met anyone like him. Few people had. She doubtlessly knew the lofty reputation of the silver-maned painter who swept through the town in modish cloaks with boys as bewitching as angels in his wake. She would have appreciated the immense honor of the grand master's prized attention to herself and her family. Like other Florentines, always proud of their grasp of *cose dell'arte* (things of art), she would have recognized the power of an artist of his stature to confer an eternity of fame on a model. But perhaps she would have dismissed this daunting possibility and thought of herself as simply a prosperous man's wife posing for a portrait relatively few might ever view.

Sitting just so before Leonardo's attentive gaze, Lisa may have sensed the qualities that made him appealing as a man as well as an artist: warmth, kindness, gentleness, a wisdom deeper than knowledge, a childlike playfulness that he would never outgrow. Perhaps, in the harmony that a shared focus breeds, the maestro and his muse forged such an intense connection that all else seemed to fall away in a moment suspended in time.

The notion of Lisa in a state of communion with a paternal figure makes me think of my own father. In his final years we would sometimes just sit together, not saying anything, looking up at a rambling cloud, sharing the same space and the same moment, wrapped in the warmth of feeling totally accepting and being totally accepted. The memory brings a bittersweet smile to my lips.

As Leonardo worked on Lisa's portrait, another local artist was finishing his latest masterpiece. Michelangelo Buonarroti (1475–1564), twenty-three years Leonardo's junior, could not have been more different from the refined court painter. Affable Leonardo won over even casual acquaintances so effortlessly, Vasari writes, "that he stole everyone's heart." No one ever accused Michelangelo of such larceny.

A short child who never grew tall, Michelangelo was squat and bony, with a low brow set on a large head, coarse curly hair, big ears that jutted from the sides of his skull, and small, searing eyes. Unlike fastidious Leonardo, who washed his hands with rose water and "flower of lavender," Michelangelo dressed in splattered tunics and often didn't remove his dogskin underboots until they reached such a state of disrepair that strips of flesh came off with them. His fearsome temper matched his grizzled looks.

In 1503, the twenty-eight-year-old sculptor had been working for almost two years on a discarded marble slab more than 16 feet tall. A local artist attempting to carve a statue of a young David had bungled the work so badly that the huge stone, dubbed "Il Gigante" (the Giant), had seemed unusable. But Michelangelo's gifted hands had brought the shepherd boy back to life.

On June 23, the eve of the annual Feast of St. John the Baptist, the

directors of the workshop of the Opera del Duomo (Cathedral Works) opened their gates and invited Florentines to a preview. If Lisa Gherardini and her husband were among the throng—as seems likely—they wouldn't have known what to make of the astonishing statue. No one did. Unlike Leonardo's figures, drawn in perfect proportion, David flaunted disproportion. The hands and feet were too large, the thighs too massive, the chest too muscled, the head overwhelming. Everything about Michelangelo's marble teen titan seemed new and unnerving—including the intensity of his gaze.

I know one person who has looked directly into David's piercing eyes: Contessa Simonetta Brandolini d'Adda, president of the board of the Friends of Florence, which funded the most recent cleaning of Michelangelo's giant-killer. While the statue was encased in scaffolding, the petite American, transplanted to Florence decades ago, had the privilege of climbing up to look at David eye-to-eye.

"What did you see?" I ask.

"Determination," she replies. Michelangelo embodied the very word.

Leonardo missed the debut. That June, Machiavelli summoned him to the front line of Florence's war with Pisa, which then had access to the sea. For almost a decade, their landlocked city had been fighting to regain possession of the port. During the long winter evenings they had shared at Cesare Borgia's fortress in Imola, Leonardo and Machiavelli may have envisioned a scheme for diverting the Arno, the river that runs through Tuscany, into canals that would give Florence sea access and force Pisa to surrender.

When a key fort above the Arno east of Pisa fell to the Florentine forces in June, Leonardo inspected the site and began to formulate a plan. In time, his calculations would lead to a bold attempt to change the river's course. Of Leonardo's many grandiose schemes, this strikes me as the most ambitious—and the most foolhardy.

~

Returning to Florence, Leonardo may have resumed work on Lisa's portrait. By autumn he had made significant progress—a fact that remained unknown until a fortuitous discovery in 2005.

A manuscript expert named Armin Schlechter was cataloguing an early-sixteenth-century edition of *Epistulae ad Familiares*, the Latin letters of the Roman orator Cicero, written in the first century B.C. and a favorite tome of the humanists of Renaissance Florence. Flipping through its pages as he prepared an exhibit at the University of Heidelberg in Germany, the sharp-eyed scholar spotted a note in the margin.

In the annotated pages' text, Cicero had described how the renowned Greek painter Apelles rendered the head and shoulders of his subjects in extraordinary detail before continuing with the rest of a painting. Next to this paragraph a comment in erudite Latin stated that "Leonardus Vincius," the Apelles of the day (the highest praise a Renaissance humanist could bestow on an artist), was using a similar approach for a new work, a portrait of "Lise del Giocondo" as well as for Anne, "mother of the Virgin," in his still-uncompleted altarpiece. The marginalia included the date, October 1503, and a bit of speculation about Leonardo's newest commission: "We will see how he is going to do it regarding the Great Hall of the Council."

Most journalistic accounts identify the commentator as Agostino Vespucci, a cousin of the explorer Amerigo Vespucci, who was serving as a secretary for Second Chancellor Machiavelli. Not so, says Rab Hatfield, a retired professor of art history at Syracuse University in Florence and such a fastidious fact-finder that he's been hailed as the "Sherlock Holmes of Renaissance art." The respected researcher identifies the author of the note as the *notaio* Ser Agostino di Matteo da Terricciola, the book's owner, whom Leonardo, apparently in a reference to Machiavelli's valued assistant, called "my Vespucci."

The serendipitous discovery electrified the academic world. For the first time, a verified historical document set a specific time frame—in and around 1503—for the *Mona Lisa*'s creation, refuting the contention, once widely held, that Leonardo painted the work at a much later date in Rome. Everything about the marginal note—the ink, the paper, the specificity of the observations—has held up to the closest scrutiny.

A letter from 1503 provides less authoritative confirmation of the timing of Lisa's portrait. At some point in the summer or fall, Machiavelli must have visited Leonardo with his pal Luca Ugolino. If he came when

Leonardo was sketching, Lisa Gherardini might have made the acquaintance of another Florentine whose name would become almost as famous as hers.

That autumn Machiavelli's wife, Marietta, gave birth to their first son while her husband was in Rome on state business. "Congratulations!" Ugolino wrote in a note to his "very dear friend." "Obviously Mistress Marietta did not deceive you, for he is your spitting image. Leonardo da Vinci would not have done a better portrait."

The only portrait Ugolino might have seen on Leonardo's easel was Lisa's.

⁓

The long-unknown marginal note reveals not just when Leonardo began painting, but also how the portrait must have emerged: face-first. Lisa's smile may have been one of the first of her features that Leonardo drew—and the last one that he touched.

Vasari, in his description of *La Gioconda*, first published in 1550, lauds Lisa's "*ghigno*," a word that translates as both "grin" and "mocking smile," as "a wondrous thing, as lively as the smile of the living original . . . so sweet that while looking at it one thinks it rather divine than human." So much has since been said that some experts have wearied of talking about Lisa's lips—as I discover when I bring up her smile during an interview in a trattoria in the neighborhood where Leonardo trained as a teenager.

"Ask your husband!" Marco Cianchi, a professor of art history at the prestigious Accademia di Belle Arti in Florence, thunders.

"But he's a psychiatrist," I respond, startled by the amiable Florentine's uncharacteristic outburst.

"I know," he says with an emphatic shake of his head, and I begin to understand.

Let therapists hatch theories about what thoughts might have danced behind Lisa Gherardini's enigmatic gaze, what emotions tugged at those labile lips. Art historians know better.

As Cianchi explains, most Renaissance artists, whose attempts at grins ended up looking like grimaces, viewed the smile as an elusive Holy Grail, a consummate technical challenge. Leonardo himself spent years

experimenting with similar expressions until, with the gentle slope of Lisa's mouth, he elevated his skills to an incomparable new level.

"If you asked Leonardo what the smile meant, he would have said, 'What are you talking about? Why are you asking? I was painting her face,'" says Cianchi.

My psychiatrist husband, for the record, can offer no insights. However, Sigmund Freud saw shadows of Leonardo's childhood. Lisa's expression, he asserted, "awakened something in him which had slumbered in his soul for a long time, in all probability an old memory." Perhaps his mother, separated from him as a boy, "possessed that mysterious smile which he lost and which fascinated him so much when he found it again in the Florentine lady."

I run another psychological theory by my husband: What about a sort of transference—the redirection of emotions originally felt in childhood to a substitute? Rather than her smile reminding Leonardo of his mother, perhaps Lisa's maternal warmth elicited loving feelings that Leonardo would have "transferred" to the painting. This may be why millions of people feel an almost visceral connection with the *Mona Lisa* that they cannot fully explain.

His response is a classic therapist's: "What do you think?"

I have no grand theory, but the one I copied word for word in my notes comes from an emeritus professor at Oxford University, Martin Kemp, a preeminent Leonardo scholar. "No image," he observed, "has ever been more particular in the way it engages us with a specific human presence."

Consciously or not, Leonardo created an exquisite prototype of a Rorschach test, an image that each of us can "read" in a unique way. We see in Lisa what we want to see—mother, lover, daughter, fantasy, soother, seductress.

"What do you see when you look at the *Mona Lisa*?" my husband inquires.

"A real woman," I reply.

"Like you," he says.

I open my mouth to protest, but then I realize that this may indeed be why her smile enchants: the sense that Lisa is somehow like us. In that

face, in those eyes, and especially in that smile, we see a reflection of se-
crets locked within our souls.

❧

As Leonardo was sketching the smile that would spark centuries of spec-
ulation, workers were finishing construction of the Sala Grande del Con-
siglio, or Great Hall of the Council (now the Salone dei Cinquecento, or
Hall of the Five Hundred) in the Palazzo Vecchio. As it neared comple-
tion, Machiavelli may have presented the town priors with an inspired
suggestion: Who better to decorate one of its bare walls than the venera-
ble artist hailed as "Painting Incarnate"? In the fall of 1503, Gonfaloniere
Piero Soderini, who had been appointed chief magistrate for life, and the
Signoria asked Leonardo to "leave a memento" of his time in Florence in
the form of a painting in the hall.

It was the commission of a lifetime: a grand mural in the most im-
portant civic building in the artistic epicenter of the Western world. Be-
yond all-but-assured glory, the sheer scope of the project—a painting
some 15 to 20 feet high and perhaps as long as the entire wall—would
have thrilled Leonardo.

On October 24, the artist took possession of the keys to the Sala del
Papa (Hall of the Pope) in the compound at Santa Maria Novella, the
lodgings once reserved for a visiting king or pope (reportedly somewhat
run-down at the time), and began work on the immense *cartone*. No one
doubted Leonardo's genius, but as Gonfaloniere Soderini kept griping,
the artist had a bad reputation for procrastination.

Leonardo, ideas exploding onto the pages of his notebooks, seemed
eager to get to work. At least for the time being, Lisa's elusive smile may
have been set aside.

❧

In January of 1504, Leonardo had to turn his attention to another art-
ist's work. At a public meeting, he and a blue-ribbon panel of fellow dis-
tinguished Florentines—among them Sandro Botticelli, Andrea della
Robbia, and Filippino Lippi—debated the best location for Michelan-

gelo's bold new statue. Most tourists, myself included, cannot imagine the David (even if only a replica) anywhere else but on a pedestal in front of the Palazzo Vecchio. But if Leonardo had had his way, Michelangelo's young shepherd would have been sequestered almost out of sight.

Some of the committee members, worried about exposing the "delicate and fragile" marble to the elements, suggested a spot in the covered loggia in the Piazza della Signoria. Echoing their concerns, Leonardo further advised against a "conspicuous and obtrusive" position under the central vault. A more obscure setting "on the parapet where they hang the tapestries on the side of the wall," he suggested, would ensure that the distracting statue "not spoil the ceremonies of the officials."

Michelangelo would have seethed. As the Republic's leaders ultimately decided, his monument to the human spirit, a supreme incarnation of Florentine independence, deserved to stand "proudly in the blaze of the piazza," directly in front of the Palazzo Vecchio.

One day around that time the world's reigning painter and its reigning sculptor clashed face-to-face in Florence's Piazza Santa Trinita. Some out-of-town visitors, disputing a passage in Dante, asked Leonardo's opinion. Spying Michelangelo entering the square, the elder artist replied by calling out that the Florentine native might offer some insight.

Michelangelo took the comment as an insult. "*Volendo mordere Leonardo*" (wishing to "bite" Leonardo), as a chronicler of the time put it, he responded with a scathing reference to Leonardo's aborted equestrian statue for Milan's Duke Ludovico.

"Explain it yourself—you who designed a horse to cast in bronze, and couldn't cast it, and abandoned it out of shame," he snapped. "The stupid people of Milan [*caponi*, or fatheads, he called them] had faith in you?"

Michelangelo abruptly spun around—"turned his kidneys," in an observer's words—and stomped off, as Leonardo's face reddened.

～

Florence's petty bureaucrats also pushed Leonardo's patience to the limit. One day, while collecting his monthly stipend, the clerk paid the usually unflappable artist in piles of *quattrini* (small change).

"I am not a penny painter," Leonardo indignantly protested, push-

ing back the coins. When Gonfaloniere Soderini denounced him as insolent, the artist, with help from his friends, gathered a huge mound of *quattrini*, the equivalent of all the money he had been paid, and tried to return it. The priors ended up begging Leonardo to keep his wages and continue his work.

Leonardo had a bigger battle to contemplate: his painting of the defeat of Milan in 1440 at the Tuscan town of Anghiari for the Sala Grande. In one of the artist's notebooks, Machiavelli's secretary, Agostino Vespucci, recorded a blow-by-blow account of the confrontation between 40 cavalry squadrons and 2,000 foot soldiers, crowned by a miraculous appearance of St. Peter in the clouds.

Leonardo ignored the grandiose historical depiction. As we can see from his many preparatory drawings, he wanted to capture war's bestial madness in anguished faces, snarling mouths, hacking weapons, and thrusting spears. At one focal point, soldiers strike and scream in a fierce struggle for a battle standard while half-wild horses, teeth bared and hooves raised, rear and plunge in a furious vortex amid clouds of dust and smoke.

"It would be impossible to express the inventiveness of Leonardo's design," writes Vasari. "Fury, hate, and rage are as visible in the men as in the horses."

On May 4, 1504, the duly impressed priors issued a formal contract, reportedly negotiated by Machiavelli, for Leonardo to complete the mural by the following February, "no exception or excuse accepted."

Leonardo might have banished all thoughts of mercurial Michelangelo from his busy mind—until the day the *David* rolled through town.

～

On May 14, workers smashed the arch over the gate to the Opera del Duomo workshop to remove the statue, which they had encased in a wooden frame, as the diarist Landucci describes it, "in an upright position and suspended so that it did not touch the ground with its feet." More than forty men, using techniques dating back to the construction of the pyramids in ancient Egypt, turned fourteen greased rollers hand-to-hand to transport the 6-ton sculpture a distance of about a third of a mile.

"It went very slowly," Landucci reports without comment—or exaggeration—as he records its four-day journey. Florentines, always the keenest of spectators, watched the snail's-pace procession with awe and apprehension. Artisans left their lathes and workbenches. Cobblers put down their hammers. Tailors gaped with needle and thread in hand. Lisa and Francesco del Giocondo might have told their wide-eyed youngsters—particularly eleven-year-old Bartolomeo and eight-year-old Piero—that they were witnessing a historic sight.

Michelangelo's acclaimed *David* transformed the artist into both a celebrity and, with the receipt of a handsome commission, a rich young man. Not yet thirty, he would soon accumulate more money in his account at Santa Maria Nuova than Leonardo did in his lifetime.

What did Leonardo, who had spent sixteen years laboring on his giant horse in Milan, think of the colossus that Michelangelo had created in little more than two years? In the corner of a page in a notebook from that time, we find a pen-and-ink sketch of a figure very similar to the *David*. Some historians see it as an homage; others as "a graphic critique."

As for sculpting itself, Leonardo dismissed the process as dirty, dusty, exhausting labor, "a most mechanical exercise often accompanied by great sweat, compounded with dust and turning to mud," certainly unfit for gentlemen. Discoursing on the superiority of painting, he conjured up a contrasting scene of an artist, "at perfect ease . . . [who] adorns himself with the clothes he fancies . . . often accompanied by music or by the reading of various beautiful works"—perhaps an apt description of himself painting the portrait of Lisa Gherardini.

～

On July 9, 1504, came the news no child—not even a mature man in his fifties—is ever fully prepared to hear: Leonardo's father, Ser Piero da Vinci, had died.

"He left ten sons and two daughters," Leonardo wrote with an oddly matter-of-fact lack of emotion. While he included himself in this total, Leonardo's father calculated differently. In his will, Ser Piero bequeathed his estate to his nine legitimate sons and two daughters, with no mention

of his firstborn. In death, as in life, Ser Piero never officially acknowledged his bastard child.

Florence's foremost families, members of the religious orders Ser Piero represented, and his vast network of connections gathered in the church of Badia Fiorentina to mourn a venerable pillar of the community who had devoted more than half a century to its service. The gaggle of Leonardo's stepsiblings and his shrill fourth stepmother would have clustered close to the altar. Leonardo remained off to the side, seemingly lost in thought.

Francesco del Giocondo, who had worked with Ser Piero for years, would have offered Leonardo condolences, as would Lisa, perhaps the most sympathetic face of all.

After much bluster about not-to-be-missed deadlines, in the summer of 1504, Gonfaloniere Soderini interrupted Leonardo's work on *The Battle of Anghiari*. Desperate to end the long and costly Pisan war, he revived the proposal that Machiavelli may have presented to him: the diversion of the lower Arno River to cut the port of Pisa off from the sea.

The engineer in Leonardo, as avid as his inner artist, enthusiastically rose to the challenge. Filling page after page of his notebooks with maps and charts of the terrain, he developed a plan for a channel a mile long, 30 feet deep, and 80 feet wide at its mouth. In late August 1504, the Signoria gave the order for 2,000 men with shovels to start moving a million tons of earth. As costs and complications mounted, they all but choked on every coin.

The on-site crew, despite Leonardo's objections, departed from the original plan by digging two canals instead of one. In October a cloudburst filled the newly dug ditches, and the water flowed backward faster than the Florentines could dig. The walls collapsed, flooding the plain and destroying homes, farms, and fields.

The Arno project ended as an ignominious and expensive fiasco. Dozens of workers died from infection or accidents; huge amounts of money and resources were squandered. The blame fell on the project's initiators. Soderini, although guaranteed job tenure, lost considerable political sup-

port. Machiavelli reportedly fell ill from shame and grief and took—or was ordered to take—leave from his post. Leonardo, still valued as a military engineer, was dispatched to Piombino to consult on its fortifications.

In Florence, Gonfaloniere Soderini, perhaps staring at the bare walls of the Sala Grande, hatched a plan that strikes me as cunningly Machiavellian. By cosmic good fortune, his city could lay claim to two artistic supernovas of unmatched brilliance. Rather than having Leonardo alone contribute a major work (if he ever managed to complete anything), what if a civic competition of sorts—practically a Florentine blood sport—pitted the world's premier painter against its premier sculptor?

The bad blood between the two—"*sdegno grandissimo*" (greatest disdain), as Vasari put it—could only fuel their creative fires and goad them into speedy completion of the project. And what chamber could be more suited to showcasing the oversize talents of these titans than the vast new Sala Grande del Consiglio? The priors formally commissioned Michelangelo's mural as a companion piece to Leonardo's, but everyone recognized the head-to-head duel for what it was: a "battle of the battles" between the fifty-two-year-old grand master and the twenty-nine-year-old giant-slayer.

In the autumn of 1504, Michelangelo assembled scaffolding, paper, paints, and other supplies in the Sala dei Tintori (Hall of the Dyers), a large room once used to unwind bolts of cloth in the old wool-dyers' hospital. No one was permitted or invited to enter.

Depicting the Battle of Cascina, a victory over Pisa in 1364, Michelangelo focused on the moment when the Florentine captain, seeing his troops swimming in the Arno to escape the summer heat, sounds a false alarm that brings the soldiers running from the river to prepare for battle. In Michelangelo's depiction of war as a noble, manly exploit, heroic warriors (who just happen to be naked) scramble to pull themselves out of the water, climb onto land, and dash for dusty clothes and sun-scorched armor. Together his complex and graceful figures—standing, kneeling, crouching, leaning forward—represent, as one art historian put it, an apotheosis of "the godlike character of the male body."

Working in a nonstop frenzy for about four months, Michelangelo submitted the preliminary drawing for his mural on the last day of October 1504. On his return to Florence from Piombino in December, Leonardo made no public comment on Michelangelo's work. However, his notebooks contain a brief criticism of drawings of exaggeratedly muscular torsos that make the human figure look like *"un sacco di noci"* (a sack of walnuts).

Michelangelo never even touched a brush to the wall of the Sala Grande. After sprinting to catch up with Leonardo, his progress slowed and then stopped. The following spring he would leave for Rome, where Pope Julius II had summoned him to design his tomb.

As word of the clash of the giants spread, artists from *botteghe* throughout Italy flocked to Florence. Michelangelo shrugged them off with his usual surliness, but Leonardo, reveling in the role of dean of the local artists, welcomed the new admirers. The painter we know as Raphael (1483–1520) was so impressed by the esteemed maestro's consummate skill that he swore to forget everything he had learned and imitate him.

The twenty-year-old from Urbino, who won over his colleagues—as Leonardo had—with charm and physical beauty, provides us with a sort of progress report on the portrait of Lisa Gherardini. A small pen-and-brown-ink sketch (now in the Louvre), believed to have been done around 1504, depicts a big-eyed girl in Leonardo's innovative three-quarter pose, with her head tilted slightly forward and hands loosely crossed, set against a flat landscape framed by columns.

In 1506, Raphael produced another copycat composition: the wedding portrait of Maddalena Strozzi Doni, the sister of one of Francesco del Giocondo's business associates, Marcello Strozzi (a work now in the Pitti Palace). Lisa and Maddalena—contemporaries, almost certain acquaintances, possible friends—share the same trendy look, with high foreheads, plucked brows, and long hair escaping from a bonnet of sorts at the back of their necks.

Maddalena, a recent bride dolled up in a showy dress of rich blue and red with an ostentatious nuptial pendant and three rings on her fingers,

sits in the same three-quarter pose as Lisa. Yet when I compare reproductions of the two works side by side, Lisa, despite her muted attire, seems infinitely more enticing—visual poetry compared to the eternally prosaic Maddalena.

In February 1505, the Signoria arranged for the delivery of stacks of sheets of sturdy paper and hundreds of pounds of flour for glue to the Palazzo Vecchio. Carpenters assembled an ingenious scaffolding apparatus designed by Leonardo so he could easily work at different heights. Paperhangers glued the sheets together into a single immense *cartone*, and assistants transferred the design to the wall with pinpricks. Experimenting with different binding agents and pigments, Leonardo came upon a formula, reportedly from ancient Rome, for a compound that produced hues more intense than any he had ever seen.

On June 6, Leonardo recorded in his notebook that he "began to paint in the palace." Things immediately went wrong.

"I was just picking up my brush when the weather took a turn for the worse. . . . The *cartone* began to come apart. The container of water broke, spilling water. Suddenly the weather grew worse still, and the rain bucketed down until evening, turning day into night."

Despite the bad omens, Leonardo persevered, trying to hasten the absorption of the colors with heat from a coal fire on iron braziers. This approach worked for the lower wall, but one evening a large section near the top remained damp. As some biographers imagine the scene, wet colors began to drip down the wall, dirtying and disfiguring the portions that had already dried. Leonardo may have ordered wood thrown on the fire so that the flames would reach higher. In near-panic his assistants might have flung everything they could find—perhaps even boards and benches—onto the blaze. As the heat intensified, the paints may have streamed inexorably downward like lava from a volcano. Leonardo could only watch helplessly.

The extent of the damage is unknown, as is its cause. Chroniclers have blamed the poor quality of the undercoating, the unproven technique, the

makeup of the oils mixed with the pigments. Payments for various materials continued through October, but then Leonardo seems to have abandoned the project.

Copies by his contemporaries indicate that the artist had completed only the knot of men and horses fighting for the military standard. Although some write that he quit "out of dissatisfaction," the word strikes me as a gross understatement for his disappointment. Leonardo may simply not have had the heart to clean off the remnants of his first attempt and start again.

The "battle of the battles" ended without a clear victor but nonetheless proved an artistic triumph. For generations of painters, Michelangelo's preliminary sketch and Leonardo's fragment, copied and circulated throughout Europe, served as *la scuola del mondo*, "the school of the world," inspiring art's next big leaps forward.

During one of my stays in Florence, I learn of a tangible link between Leonardo's huge, violent, tempestuous battle scene and its opposite in every possible way: the small, sedate portrait of Lisa Gherardini. For more than three decades Maurizio Seracini, an Italian bioengineer who heads the Center of Interdisciplinary Science for Art, Architecture, and Archaeology at the University of California, San Diego, searched for remnants of the "lost battle," now masked by a massive mural by Giorgio Vasari, in the Sala Grande del Consiglio. In 2012, Seracini's research team, using tiny surgical probes, extracted samples from a hidden wall just millimeters behind the Vasari painting. Laboratory analysis identified one pigment as identical to a black glaze used in the *Mona Lisa*.

One day I stood in front of the scaffolding Seracini's researchers had assembled in the hall and reflected on the masterpiece that might have been. Even in the midst of the artistic battle of his life, I wondered: Was Lisa always on Leonardo's mind?

⌒

An English translation of *The Lives of the Artists* describes Leonardo as "toiling" over Lisa's portrait for four years, but Vasari used the more evocative Italian word, *penare*, which also can mean "to strive, to labor, to take pains"—fitting verbs when describing the artist's meticulous tech-

nique. For each square yard that Michelangelo covered in painting the entire ceiling of the Sistine Chapel, Leonardo, in just as much time, painted only about a square inch. The painter "permitted no arbitrary, random stroke of the brush," Goethe observed. "Everything had to be both natural and rational."

Leonardo may have felt no compunction to hurry. Perhaps his feelings about this seemingly straightforward assignment changed over time. Perhaps the portrait became his chance to showcase the mastery he had honed over his entire career. Building ever so delicately upon the bright white base with his extremely fine silk brushes, Leonardo dabbed layer upon almost evanescent layer so the previous one shone through, creating the *fumo*, or smoke, of shadows.

His very, very thin glazes conceal as well as reveal, creating *chiaroscuro*, the play of light and dark, that heightens the drama and impact of the work. According to a computer-generated relief map of the portrait, the shaded areas around Lisa's mouth and eyes have the thickest layers of paint, yet so gentle is Leonardo's touch that even close examination cannot detect a single stroke on the surface of the panel.

Almost daily for more than two years I have contemplated a reproduction of the *Mona Lisa* with increasing appreciation as well as affection. The details mesmerize me: Lisa turning gently as if inviting conversation. Her warm brown eyes glistening, one pupil ever so slightly more dilated, a split second behind the other in adjusting to a change in light. Her blood pulsing just beneath the translucent skin of her neck. Leonardo's *sfumature* (subtle shadings) blurring into an uncertain look at the corners of her eyes and mouth. Her lips rising but stopping on the very cusp of an asymmetrical smile.

The face of *una donna vera* stirs before my eyes. Centuries before the invention of the camera, Leonardo captured the immediacy of a photograph in a portrait of life itself.

In 1506 a court summoned Leonardo to Milan to complete a long-disputed commission. This ruling freed the artist from what might have come to feel like indentured servitude to the Signoria, although the re-

prieve was meant to be temporary. At the insistence of Gonfaloniere Soderini, Leonardo signed a notarized promise to return within ninety days or face a 150-florin fine.

Yet even though he may have been eager to leave Florence, Leonardo was not finished with Lisa. After so many years of work, the portrait still remained, at least in his eyes, "*imperfetto*" (incomplete and imperfect). Even after thousands upon thousands of brushstrokes, he had not yet realized his vision.

Was Lisa disappointed? Was her husband Francesco, if he had indeed commissioned the painting, upset that he couldn't claim possession?

With his inimitable charm Leonardo may have reassured them that he wasn't leaving permanently. He would come back to Florence. After all, he had sworn to return. While the court dithered in Milan, he might have time enough to finish the portrait. They would have to be patient, to wait and see.

Francesco del Giocondo knew that he could do nothing to compel the artist to do anything he chose not to do. The Servite friars at Santissima Annunziata would have sympathized. They were still waiting for their altarpiece.

Chapter 11

Family Matters

O ne day in Florence, a princess invites me to lunch.

I didn't realize she was royalty—just a childhood friend of a friend who had given me the name and number of a "P/ssa" (which I wrongly assumed stood for *professoressa*) and insisted I call.

"Come today," the cordial voice urges when I introduce myself. As the taxi pulls in front of the address on Via del Parione, the driver asks if I am planning to rent the place for a wedding or banquet. "They shoot movies here too," he tells me.

I can see why. Staring up at the imposing Baroque facade of the Palazzo Corsini, I remind myself not to let my jaw fall open. When I exit the elevator onto the *piano nobile*, I feel that I have fallen back centuries in time.

Following my hostess, Principessa Giorgiana Corsini, an agelessly, effortlessly elegant *fiorentina*, through a series of ballroom-sized chambers, I gape at sky-high ceilings, silk-covered walls, faded velvet chairs, imposing paintings in gilded frames, and a concert hall where her choral group practices and performs. At the end of yet another grand salon, she pulls open heavy drapes triple her height to reveal a balcony overlooking a hidden oasis: a sweeping Renaissance garden with geometric patterns of shrubbery, manicured paths, stately oaks, and dozens of lemon trees in terra-cotta vases. The statues that adorn the main avenue stand upon graduated pedestals of different heights, adding another grace note to the intricate design.

I marvel at yet another way in which Florentines have long sur-

rounded themselves with beauty. When I meet several generations of today's Corsini—the dignified patriarch, two engaging daughters, a teenage grandson with a face from a Ghirlandaio fresco, and a winsome granddaughter, some living within the *palazzo* compound and others dropping by from country estates—I marvel at the family as well.

I should have realized that the many generations of Corsini and Gherardini would intertwine in some ways. Both clans originally came from the area around Poggibonsi in southern Tuscany, but the Corsini, with bankers, bishops, cardinals, a pope, and a saint adorning their family tree, long ago eclipsed the Gherardini.

During the decoration of the Baroque mansion in the seventeenth century, a Corsini count commissioned a painting by the artist Andrea Gherardini, perhaps a descendant of Lisa's relatives. Less than a century ago, a Corsini relation was living at Vignamaggio, the bucolic former Gherardini estate in Chianti.

Listening as a half-dozen Corsini weave stories like so many fine silk threads into the tapestry of their past, I realize—not for the first time—that one can understand Italians only in the context of their families. I keep this in mind as I piece together the events of the years after Leonardo da Vinci left Florence in 1506, when family issues, disputes, sorrows, and scandals swirled around the painter, his model, and her husband.

Leonardo, mired for years in messy lawsuits, arbitrations, and negotiations, eventually managed to create a gratifying "family" life in the court of Milan's French rulers. In Florence, Lisa Gherardini devoted herself to domestic duties, while Francesco del Giocondo blustered about town hounding creditors. All around them, foes and friends of the exiled Medici jockeyed for influence. Plots were hatched. Alliances shifted. Amid ever-shifting political currents, Florentines struggled to navigate through treacherous times. But one thing endured: *la famiglia*.

<center>~</center>

Lisa's family life revolved around her children, her days a blur of cuddling, comforting, laughing, drying tears, fretting over coughs and fevers, giving and getting thousands of good-night kisses. By 1507, the oldest boys—

Bartolomeo in his early teens and eleven-year-old Piero—had grown to strapping lads who were mastering the abacus and learning the intricacies of the silk trade from their father.

Tutors would teach eight-year-old Camilla and seven-year-old Marietta the basics of reading, writing, and arithmetic along with music and dancing. Lisa, like other Florentine mothers, would have taken charge of almost everything else they needed to know. As Andrea, her youngest son, turned five, she might have begun teaching him the alphabet by forming letters out of "fruits, candies, and other childish foods," as a humanist tutor advised.

No longer sharing a residence with her in-laws, Lisa had become the *donna governa*, or lady in charge, of a busy household. With a ring of keys dangling from her belt, she managed every detail—overseeing servants, planning meals, ordering supplies, supervising repairs and renovations, keeping a close inventory of silver, jewels, and other valuables, inspecting linens (washed in a solution of ashes and perfumed with quince apples), hemming dresses for her daughters and jerkins for her sons. Every season brought special tasks, whether preparing for summers in the country or organizing banquets for holiday celebrations.

Of course, Lisa couldn't neglect her many social obligations, as historian Sara Matthews-Grieco of Syracuse University in Florence points out during our conversation about Renaissance women's lives. She would have made frequent calls to women linked to her by blood or marriage and welcomed them into her home as well. As her husband prospered, his colleagues and clients would have asked her to serve as their children's godmother—which would mean more birthdays and name days, christenings and weddings, feast days and festivals. And more giggles and gossip and girl time to brighten Lisa's days, much like her kinswoman Margherita Datini's merry band of *femmine* did in Prato.

In 1507, the year Lisa turned twenty-eight, she discovered that she was expecting another baby. This time, older and busier, she may have felt wearier than she remembered in her previous pregnancies. In December of 1507, she gave birth to a third son. Perhaps Giocondo, as he was named, was born too soon or too small. Perhaps he developed a stubborn fever or difficulty breathing. Francesco would have summoned a doctor.

Anxious relatives would have offered fervent prayers. But little Giocondo del Giocondo lived only about a month. Once again Lisa and Francesco would have felt the stab of a parent's greatest grief.

We don't know if the sad news reached Leonardo in Milan.

Despite his pledge to return quickly to Florence, Leonardo da Vinci didn't come back—not in the agreed-upon three months, not after the extension the Republic granted, not after the Florence ambassador protested and Gonfaloniere Soderini denounced Leonardo as a "debtor to us." The artist, he ranted, had not "behaved as he should have done toward the Republic because he has taken a large sum of money and only made a small beginning on the great work he was commissioned to carry out."

Leonardo, basking in more acclamation than Florence ever offered, showed no desire to leave Milan. The city's French governor, Comte Charles d'Amboise, young, intelligent, and indulgent, reputedly "as fond of Venus as of Bacchus," provided a generous stipend to the prized jewel of the court. The French king Louis XII himself expressed his "necessary need" of the artist. However much Soderini fumed, the Signoria had no choice but to agree to this "gracious request" from an invaluable ally.

To a remarkable extent, Leonardo, in his mid-fifties, managed to re-create the rich and rewarding life he had enjoyed under Duke Ludovico Sforza's patronage. Revitalized, he tackled a full range of intriguing new projects. For the Comte's proposed summer villa, he sketched porticos, loggias, and big airy rooms opening onto a fantastical Arabian Nights garden of sweet-smelling orange and lemon trees, a bower filled with songbirds, a small canal with flasks of wine cooling in the water, and the pièce de résistance: a little mill with sails like a windmill to "generate a breeze at any time during the summer."

When King Louis XII visited Milan in June 1507, Leonardo choreographed a stupendous welcome, with soaring arches of greenery, banners of Christ and the saints, a triumphal chariot, masques, dances, and fireworks—all more fantastic than any the city had ever seen. As a token of appreciation, the French king granted "our dear and well-beloved" Leonardo a lifelong income from the fees paid by users of a stretch of Milan's canals.

In September, Leonardo learned that his uncle Francesco da Vinci, the genial companion of his youth, had died and named him his sole heir. About this time the youth who would become Leonardo's main heir and guardian of his flame entered his life: Francesco Melzi. This *bellissimo fanciullo*, a most beautiful, almond-eyed boy of about fourteen or fifteen, may have first joined Leonardo's household as a pupil. Soon he became personal secretary to the official "Painter and Engineer-in-Ordinaire" (the title of a salaried employee) to the French government. Melzi's neat italic hand would appear throughout Leonardo's notebooks and papers for the rest of the painter's life.

Well born, well educated, and well behaved, Melzi strikes me as the opposite of Leonardo's longtime favorite, Salaì, then about age twenty-seven or twenty-eight. Perhaps inevitably, personalities clashed and tempers flared. In a notebook from this time, Leonardo scrawled that he wanted to make peace with Salaì. "No more war," he entreated. "I give in."

A different feud pulled Leonardo back to Florence sometime around September 1507. His stepsiblings, led by their brother Ser Giuliano, who had become a *notaio* like their father, were challenging their uncle Francesco's will. Leonardo fought for what was rightfully his. His *fratellastri* (half brothers), he charged in sharply worded letters, had always wished "the utmost evil to [their uncle] Francesco during his lifetime" and treated Leonardo himself "not as a brother but as a complete stranger." The case would drag on for months before finally being resolved in Leonardo's favor.

Both the French governor of Milan and the French monarch sent urgent missives to the Signoria asking the priors to expedite the matter as swiftly as possible. Leonardo tried pulling another string by writing to Cardinal Ippolito d'Este, brother of the Marchioness of Mantua, Isabella d'Este, still chafing for a painting.

In Florence, the avuncular artist—beard graying, eyesight failing, shoulders stooping—took up residence with a group of younger guests in the *palazzo* of the wealthy mathematician and linguist Piero di Braccio Martelli. As a typical diversion, the lively crew amused themselves by improvising still lifes, portraits, and landscapes with the components of their nightly dinners—chickens, sausage, cheese, roast meat, and other edibles.

Martelli's residence stood within blocks of the del Giocondo home. Leonardo would, at the very least, have heard of the death of Lisa's infant son. Did he write a note or pay a condolence call? Might he have encountered Lisa on the street as she walked with her little girls? We get only one tantalizing clue.

Night after night, Leonardo, a pioneering anatomist, descended into the morgue of the hospital of Santa Maria Nuova, a dreadful place filled, as he recorded, with "dead men, dismembered and flayed and terrible to behold." His sketches from the time include a sheet with a cross-sectional view of a woman's uterus in early pregnancy, drawings of male and female genitalia, and a study of a cow's placenta and uterus with a small fetus in it.

On the *verso*, the rougher opposite side, are studies of the mouth and its muscles, including a pair of lips that seem almost to have floated from the face of the *Mona Lisa*. Maybe, just maybe, Leonardo had seen this haunting smile once more.

In 1510 tensions that had simmered for decades in the del Giocondo workshops erupted, and Francesco's brothers and cousins ousted him from at least one family *compagnia*. I do not imagine he went quietly.

Selling his shares, Francesco formed a new partnership with his sons, the teenage Bartolomeo and Piero. He also shrewdly began to diversify his holdings. Like his great-grandfather Iacopo the barrelmaker, Francesco invested in real estate, selling off some low-yielding farms, enlarging the family properties in Chianti, and acquiring land in the countryside around Pisa. Perhaps at Lisa's urging, he took over management of her father Antonmaria Gherardini's estates and recouped some of their losses.

Both Francesco and his eldest son, Bartolomeo, ran into trouble with the law in 1510. In May, the Otto di Guardia, charged with keeping order in the Commune, confiscated a large quantity of wheat in the farmland around Florence. For no seeming reason other than assuming he could get away with it, Francesco sent an agent to claim it.

The infuriated rightful owner of the wheat filed charges with the Otto

di Guardia. In official documents, he attacked Francesco as an extremely confrontational man "warped by sin" and suspected of usury by practically every office in town. Even some of his relatives, the complaint noted, had distanced themselves from their "corrupt and unreliable" kinsman. Francesco, no stranger to conflict, might have shrugged off the diatribe.

This would not have been true of sixteen-year-old Bartolomeo, who was accused of sodomy, a charge that would have been devastating for the youth and disturbing for his stepmother and the rest of the family. According to a *tamburazione* (anonymous denunciation), Bartolomeo engaged in illicit activities with a certain Piero, who, according to the vice squad, "often allowed himself to be embraced like a whore."

There are no records of sentencing, and the charges probably were dropped. Beyond the public embarrassment, Bartolomeo's life continued on course. He would eventually marry, start a family, and carry on his father's business.

~

However upset Francesco would have been by his son's troubles, he might have been more preoccupied with the shifting political climate. Florentines were tiring of their tax-levying leaders. Rumors from Rome hinted of the possible return of the town's former ruling dynasty: the Medici.

Lorenzo Il Magnifico's successor and oldest son, Piero de' Medici, had drowned in 1503 crossing a river with French troops around Naples, but his younger brothers, Giovanni and Giuliano, never abandoned their hopes of reclaiming Florence as their city. Giovanni, the chubby boy appointed a cardinal at age thirteen, had ballooned into a massive man with extremely myopic eyes bulging in a fat red face, a snub nose, and a perpetually gaping mouth. His gigantic abdomen balanced on a pair of legs described as "ludicrously short and spindly." But the Medici cardinal's affable personality and generous disposition made up for his physical shortcomings.

In his years in exile Cardinal Giovanni de' Medici had established a power base in Rome, where his utter lack of faith in God or the Church in no way interfered with his ecclesiastical duties—nor did his clerical vows restrain his seemingly insatiable appetite for earthly pleasures of every sort. Cultured and capable, he ingratiated himself with the reigning

pope, Julius II, and began using his political leverage to lobby for a pardon from Florence for himself and his brother Giuliano.

As the political landscape shifted, Francesco del Giocondo may have allied himself with the clandestine group of Medici supporters in Florence. Then, in December of 1510, a plot to assassinate Gonfaloniere Soderini was uncovered. The alleged ringleader escaped; his father was exiled. Many blamed pro-Medici agitators for instigating the rebellion. Francesco would have had to tread carefully to avoid suspicion.

On April 22, 1511, the Signoria tackled a troubling civil and family matter: "the reprehensible habit, introduced here not long since, of giving large and excessive dowries." The situation had indeed gotten out of hand, with dowries soaring as high as 3,000 florins. An increasing number of families either had to marry a daughter beneath their station or consign her to a religious life. To prevent further "inconvenience and injury," a new law set a maximum of 1,600 florins on the dowries of every "daughter of a Florentine citizen."

This issue struck home in just about every household, including those of the Gherardini and del Giocondo. With no dowries, no suitors, and no acceptable place in society, two of Lisa's sisters had had no choice but to enter a convent. Joining their aunt (Antonmaria's sister), they took vows as Suor Camilla and Suor Alessandra (their birth names) in the Convent of San Domenico di Cafaggio (later known as San Domenico del Maglio), located in the open countryside between the church of Santissima Annunziata and the city walls. Its roster of nuns came mainly from families with noble bloodlines but less-than-notable means.

Francesco del Giocondo, a foresighted father, had set aside funds for a dowry for his oldest daughter, Camilla—1,000 florins for marriage, 200 florins for entry to a nunnery. Given his professional and political standing, along with Lisa's Gherardini pedigree, the girl should have attracted a reputable suitor. But in 1511, instead of negotiating a marriage alliance, Lisa and Francesco placed the twelve-year-old in the same Dominican convent as her aunts and great-aunt.

We do not know the reasons why. Perhaps Francesco could not ar-

range an advantageous union. Perhaps the market had closed him out. But the decision strikes me as more Lisa's than Francesco's. While his sons claimed his priority, Francesco would have trusted their mother to choose what was best for his daughters.

Struggling to comprehend Lisa's motivations, I walk to the former *chiostro* (cloister) of San Domenico, now the Centro Militare di Medicina Legale. No longer set in rural isolation, the compound sits on a quiet side street that seems distant from the grit and gridlock of modern Florence. A two-story stuccoed structure frames a walled courtyard sweet with birdsong and blossoms. Cats sun themselves on the grass. Butterflies flitter among the flowers. Standing in a shaded loggia, I could sense the unchanging rhythm of bygone days and imagine the black, sacred stillness of moonless nights.

On this once-hallowed ground, the Catholic in me could understand the magnetic tug of a tranquil life of prayer and contemplation. And the mother in me could understand how, in a world of unseen and unforeseeable dangers, I would want my daughter safe within these walls. Yet I kept thinking of the experiences beyond the cloister that Camilla would never have known—the caress of a husband, the miracle of a newborn baby, the embrace of a sleepy child.

Perhaps Lisa focused on another possibility. Once *fatta monaca* (made a nun), Camilla might attain profound spiritual fulfillment and a sense of peace and purpose transcending mere mortal concerns.

What did Camilla want? It didn't matter. Although the Church decreed that vows be made of a girl's own free will, the question of consent had lost all significance by the early sixteenth century. Parents were urged to bring daughters destined for a religious life to a convent as early as possible so the girls would never be exposed to the temptations of secular society.

"Before even venturing into the world," a chronicler wrote, "young girls entered the sepulchers where they would die." Most "took the veil" between the ages of nine and eleven and pronounced their final vows at twelve or thirteen.

Lisa's oldest daughter would never dress in an exquisite gown and ride in an exultant procession through the streets of Florence. Instead, Lisa would have braided Camilla's hair one last time and wrapped her in a plain gray wool cloak with a linen scarf around her head. By tradition, a girl's male relatives—her father and older brothers, in Camilla's case— quietly escorted her to her last earthly destination.

A wicker basket carried Camilla's *dote monastica* (monastic dowry): some basic house gowns, linings for chilly weather, washable undergarments, head scarves, aprons, handkerchiefs, slippers, shoes, towels, gloves, perhaps an ivory spoon for her personal use at the communal tables. Francesco would have supplied fabrics for the *tonaca* (habit) that Camilla would sew herself—plain wool of modest quality, in black and neutral colors, along with white linen for a wimple (a nun's headdress).

Once she pledged lifelong chastity, poverty, and obedience, Lisa's daughter would live in an unending cycle of daily devotion. From dawn until late into the night, she would pray—above all, for the city of Florence, which considered the intercession of its nuns "more powerful than two thousand horses." She would chant psalms and sing hymns. She would read inspirational texts. She would memorize Scripture. She would meditate on our Lord's Passion and Resurrection. She would tend the vegetables in the convent garden. She would sew simple unadorned gray wool smocks for winter and coarse linen shifts for summer. She would embroider vestments for clerics, altar linens for the church, and handkerchiefs for her family.

Her mother would have been thinking of Camilla every day and visiting the convent whenever possible—if only to glimpse her daughter through an altar grille at Mass. Whatever her motives for placing Camilla in San Domenico, Lisa would soon have reason to second-guess her decision.

In 1511, history once again upended Leonardo's life. Two opposing monarchs—Charles V, the "most Catholic" king of Spain, faced off on Italian soil against the "most Christian" King Louis XII of France. Joining the fray were the Venetian Republic, Germany, and Switzerland, with

Pope Julius II tacking among them. When this "Holy League" of enemies forced the French forces to retreat from Milan, Massimiliano Sforza, son of the late Duke Ludovico, prepared to reclaim his father's city.

In December, Leonardo and his assistants again packed whatever they could carry. The revered fifty-nine-year-old artist may not have feared for his life, but he knew that Milan would offer no future. A favorite of the despised French occupiers, however venerable, could expect no commissions, no benevolent patronage, no guaranteed income stream.

But where could Leonardo and his retinue go? Not back to Florence, with its petty bureaucrats and bitter stepbrothers. Not to Rome, where Michelangelo, barricaded within the Sistine Chapel, was creating a heavenly ceiling. Not to Venice, where Titian was gaining praise and patrons in the richest city-state in Italy.

The family of Leonardo's protégé Melzi welcomed the artist and his assistants to their country house, a handsome villa perched above a wide curve of the Adda River some twenty miles from Milan. Here the artist passed his days in the limbo of exile. He walked in the hills. He dissected animals and studied the workings of their hearts. He wrote and sketched. He analyzed the turbulent river currents. And he turned sixty.

A well-known sketch in Leonardo's notebooks from 1512 shows an aged and bearded man in profile, weary and contemplative, sitting on a rock with his hand resting on a walking stick. Some argue that this is a self-portrait, but the figure seems much older. The art critic Sir Kenneth Clark described the sketch as a "self-caricature," Leonardo's rueful depiction of himself as decrepit and disenchanted.

His pupils provide other images of the aging artist. In a red chalk profile dated around 1512 and attributed to Melzi, the sitter, generally presumed to be Leonardo at or almost sixty, remains strikingly handsome, features chiseled, mustache neatly combed, wavy hair tumbling onto his shoulders, beard bushy. It is the face of a sage, sculpted by the past but focused on the future.

On April 20, 1512, as Florence slept peacefully under a night sky spangled with stars, Giusto, the brawny young manager of the Convent of San Do-

menico's country properties, led three friends, one the brother of the Cardinal of Pavia, through the dark lanes to the nunnery. In silence, they scrambled up a ladder that Giusto had hidden nearby. On the second floor, four novices, hearts pounding and eyes gleaming, waited. One of the women adorned like a bride in exquisite gold ruffs was Lisa's younger sister, Suor Camilla, clearly not lacking in her forefathers' daring Gherardini spirit.

The men stayed with the women for three or four hours, unaware of an observer in the shadows. "They touched the breasts of the said nuns," the watcher reported in an anonymous denunciation placed in one of the municipal *tamburi*, "and handled . . . other things, for the sake of not detailing the obscenities committed."

The Florentine vice squad arrested Giusto and his three companions, who were sentenced and fined at a brief tribunal. The nuns, acquitted of any civil wrongdoing, faced the wrath of God and—even more terrifying—their Mother Superior.

We do not know their punishment. Prayers of penance, of course. A loss of privileges and dispensations. Perhaps rations of little more than gruel or bread and water. Silence so they could reflect on their transgressions. The most menial of chores. Isolation from others, including visits from their families. Suor Camilla might not have been allowed even the consoling company of her sister and her niece.

As Lisa Gherardini ventured into Florence's gossipy streets, she would have felt the curious stares and sensed the whispers in the air. She may have ached for the dishonor that her sixty-eight-year-old father, Antonmaria Gherardini, would have felt like a scourge. And Lisa may have worried about the stain her sister had brought on her own husband and children. But if she shed any tears—of anger or recrimination or sadness—she would have done so in private.

I think back to Lisa's distant cousin Margherita Datini, who faced the humiliation of two children sired by her husband with a servant and a slave. The betrayed wife had to dig deep to her noble core so she could walk among her neighbors in Prato with her head high. In Leonardo's portrait of Lisa Gherardini, I see a woman equally unflinching.

Soon a far greater threat overshadowed the scandal. In the summer of 1512, the fighting between French troops and the Spanish mercenar-

ies of Pope Julius II spread into Tuscany. When Florence remained loyal to France rather than pledging allegiance to him, Pope Julius II vowed to crush the recalcitrant republic and restore the family of his prized advisor, Cardinal Giovanni de' Medici, to power.

By August 2, 1512, rumors flew that Spanish troops, bankrolled in part by the cardinal, were marching on Florence. Panic swept the countryside. So many peasants thronged to enter the city gates that rows of carts and mules stretched for more than a mile. Within its mighty walls, the Commune cracked down on Medici sympathizers. Among those arrested in the last days of August was Francesco del Giocondo.

On August 29, the battle-hardened Spanish soldiers attacked nearby Prato. Florence sent some 3,000 of its militia to aid in its defense, but the volunteers, as the diarist Landucci reports, "all became timid as mice and could not hold out for a single day." The invaders raped, pillaged, and killed, slaughtering as many as 6,000 men, women, and children. Bodies were flung into ditches; severed limbs clogged the town wells. The bloodbath would go down as one of the most savage in history, "an appalling spectacle of horrors," as Machiavelli later described it.

News of the sack caused "great perturbation in the minds of men"— none more so than Gonfaloniere Soderini. When Medici supporters stormed the Palazzo Vecchio and demanded his resignation, he reportedly burst into tears and threatened to take his own life. Machiavelli arranged for a safe-conduct out of town but later denounced Soderini's behavior as so cowardly that at his death hell would deny him entrance and banish him to "the limbo of babies."

Florence, fearful that it might face the same fate as Prato, agreed to pay a hefty ransom of 60,000 florins and to reinstate the Medici. With less than a whimper, the Republic that had so proudly waved the banner of the red lily ceased to exist.

As September dawned in 1512, a thin man with lank dark hair and the family's signature nose slipped into the city he and his brothers had fled

eighteen years before. At age thirty-three, Giuliano de' Medici, already
weakened by tuberculosis, had shaved the beard he had grown in exile,
a symbol of aristocratic birth disdained by citizens of the Florentine
Republic.

Dressed in the traditional plain long Tuscan *lucco*, he headed not to
the Medici *palazzo* on Via Largo, but to the home of a family friend.
With every gesture of modesty and courtesy, Giuliano relayed a message:
The sons of Lorenzo Il Magnifico had returned, not as rulers, but as pri-
vate citizens.

This changed two weeks later, when his thirty-seven-year-old big
brother Cardinal Giovanni de' Medici arrived from Prato with 1,500 sol-
diers and a retinue befitting a prince of a realm rather than a religion. On
September 16, Giuliano de' Medici, backed by his brother's troops, seized
control of the Palazzo Vecchio in a transaction as bloodless and efficient
as a currency exchange at a Medici bank.

"The piazza was full of armed men," Landucci reports, "and all the
streets and outlets from it were barred with men at arms crying *'Palle!'* con-
tinually." La Vacca rang, summoning Florence's citizens. A decree was read
from the *ringhiera*, the raised platform in the Piazza della Signoria, dissolv-
ing the Great Council. The assemblage voted for a new governing body (the
"55 of 1512") made up of faithful Medici supporters handpicked by Cardi-
nal Giovanni and Giuliano de' Medici. The ranks of the new political elite,
which numbered some five hundred men by October 13, included Fran-
cesco del Giocondo, released from his brief detention as a political prisoner,
and his first cousin Paolo, named to a "scrutiny council" charged with elec-
tions and appointments for all public offices in Florence for the next year.

I learned about Francesco del Giocondo's political involvement from a
scholar who unearthed its historical documentation in an unlikely place:
a convent archive. Josephine Rogers Mariotti, an American who earned
an art history doctorate from the Università degli Studi di Firenze and is
director of the Associated Colleges of the Midwest's Florence program,
had been researching two paintings commissioned for Florence's Monas-
tero di Sant'Orsola.

Culling through the convent's records, Mariotti struck archival gold: an oversize leather-bound volume itemizing the expenses of Cardinal Giovanni de' Medici, one of the convent's patrons, beginning on September 16, 1512, the day that he and his brother regained control over their hometown. Dedicated to the omnipotent God; the glorious Virgin Mary, mother of Jesus; Saints Peter, Paul, and John the Baptist; Cosimo and Damian, the Medici patrons; and *"tutta la celestiale corte del paradiso"* (all the celestial court of paradise), the ledger provides a firsthand account of the second coming of the Medici into Florence.

From the moment of their return, the Medici brothers set out to win over the Florentines the way their father had: with bread and circuses and parades through the streets. As Giovanni's ledger attests, they bought wine by the dozens—in one case, hundreds—of barrels and hired trumpeters, musicians, and dancers from Pistoia, Arezzo, and other towns for exuberant celebrations of the city's "deliverance."

Nor was any expense spared in repairing and renovating the sacked Medici *palazzo.* The first priority was plumbing, with repairs to the wells and septic tanks. Then a small army of craftsmen—painters, sculptors, woodworkers, bricklayers, glassmakers, goldsmiths, drapers, upholsterers, and the best embroiderer of the age—set to work. A special commission charged with repossession of the family property threatened with the gallows anyone who didn't immediately return stolen Medici goods. "Many things were recovered," Landucci reported with his usual laconic pithiness.

The new rulers of fashion-fixated Florence required a new wardrobe. Stylish Giuliano, called "Il Magnifico" like his father, ordered black hose on September 16, the very day the brothers assumed power. Soon he was buying *braccia* (arm-length) after *braccia*—about twenty for a single robe—of the black velvet he favored for cloaks and mantles for himself and his retinue. *"I Giocondi setaiuoli"* (the del Giocondo silkmakers), as the account book records, started filling Medici orders on September 18.

Francesco del Giocondo became more than a supplier. On October 30, 1512, along with a select group of financial backers, he contributed 500

florins—the standard donation—to a total sum of 30,000 florins lent to the Monte, the fund that functioned as the city treasury. Many of his fellow donors came from the Medici *parentado*, including his former father-in-law, the long-lived and prolific Mariotto Rucellai. The following spring Francesco del Giocondo, wearing a ceremonial gold chain and crimson robe, would serve a two-month term in the highest of offices as a prior of the Signoria.

The great-grandson of the merry barrelmaker Iacopo had hitched his wagon to the brightest stars in Florence's political firmament.

Part IV

THE MEDICI TRIUMPHANT

(1513–1579)

Part IV

THE MEDICI TRIUMPHANT

(1537–1570)

Chapter 12

The Rise of the Lions

After growing up in the heyday of Medici glory, Lisa Gherardini would have remembered Lorenzo de' Medici's sons, especially Giuliano, the "sweet" boy born in 1479, her birth year. Perhaps she had wondered what had become of the doe-eyed gallant who once rode proudly through the streets of Florence. Just fifteen when his family was exiled, young Giuliano had found a warm welcome in the sophisticated court of Urbino, home of the artists Raphael and Bramante and one of the most civilized centers of the Renaissance world.

I first "met" Giuliano de' Medici in a literary masterpiece based on this refined court: *Il Libro del Cortegiano* (*The Book of the Courtier*) by Baldassare Castiglione. In an imagined debate, Giuliano, the epitome of a perfect gentleman, eloquently defends women as the equals of men in every arena, from philosophy to government.

In real life, this relatively minor Medici, an inveterate philanderer, strikes me as more of a player than a public defender of women's worth. Biographers portray Giuliano as "handsome, feckless, somewhat mystically inclined," a luxury-loving dilettante who dabbled in astrology and necromancy and indulged freely in sensual delights.

Leonardo most likely would have first met Giuliano de' Medici during one of his visits to Milan, where Duke Ludovico Sforza routinely introduced his celebrity genius-in-residence to distinguished guests. The lives of Giuliano and Leonardo, historians note, also may have intersected in Venice, where the exiled Medici was living when Leonardo stopped briefly in 1500 after the French conquest of Milan.

When Cardinal Giovanni de' Medici returned to his duties and his

decadent life in Rome, he entrusted the governance of Florence to his popular brother. As the new governor, Giuliano would surely have spent time with the family's political supporters, Francesco del Giocondo among them. Given the opportunity, the merchant might have regaled Giuliano, who shared the Medici passion for art as well as female beauty, with the story of how the legendary Leonardo had painted his wife's portrait (even if he was still awaiting its delivery).

Amid the fanfare of Medici-financed pageants and parties, Francesco del Giocondo could have introduced Giuliano to the model herself. After nearly two decades and six pregnancies, the thirty-four-year-old matron would no longer have resembled the coy, slim-hipped girl of their adolescence, but the Gherardini spirit might still have danced in Lisa's smile. I can imagine the courtly sophisticate and the gracious gentlewoman chatting about their childhoods or swapping anecdotes about Leonardo, who would soon come under Giuliano's wing.

In his bucolic refuge outside of Milan, Leonardo might not have heard of the assassination plot against Giuliano de' Medici that was uncovered in February 1513. One of the captured conspirators, bargaining for his life, produced a list of twenty leading citizens likely to support the rebels if they had succeeded. Among those named was Leonardo's former companion and colleague Niccolò Machiavelli, who was flung into jail and tortured with six excruciating drops from the dread *strappado*.

"I have borne them so straightforwardly that I love myself for it and consider myself more of a man than I believed I was," Machiavelli later wrote to a friend. But he also realized that any admission of guilt would have meant an immediate death sentence—the fate of two others charged in the conspiracy.

Begging Giuliano de' Medici, as town governor, for mercy, Machiavelli composed a poem that describes "the pain of six drops clawing into my back" and prison walls crawling with lice "so big and fat they seem like butterflies." If Giuliano ever saw the verse, he ignored it. Machiavelli remained in the "stomach-turning, suffocating stench" of his vermin-ridden cell.

News of a more momentous event would have traveled faster. On

February 21, 1513, Julius II, "*il Papa terribile*" (the dreadful Pope), a life-long nemesis of the Florentine Republic, died after ten years on the papal throne. Rome buried him in solemn ceremony but quickly moved on to the pressing business of choosing a new pontiff.

When the cardinals assembled in March, Giovanni de' Medici had to be carried to the conclave on a litter. The rotund prelate lay on his side because of the discomfort caused by a complaint that, as one chronicler delicately put it, involved "a part of the person that decency forbids one to mention."

The correct medical term is an anal fistula, caused by piles or hemorrhoids—not, as gossips claimed at the time, by vigorous sodomy. Rumors spread that Giovanni's lesions would not heal and might become gangrenous. The prospect of a brief pontificate—which many cardinals found appealing—helped win him some votes; political arm-twisting and promised favors clenched a majority. On March 11, St. Peter's Square echoed with shouts of "*Palle! Palle!*" The Medici balls had ascended to heaven's gate.

Giovanni de' Medici took the name of Leo X (Leone, the word for "lion" in Italian) to underscore his leonine qualities of courage and magnanimity and also, as citizens of Florence instantly grasped, to identify himself with his hometown's lions, real and symbolic. Francesco del Giocondo, who moved into the Palazzo Vecchio to serve as a prior for two months in the spring of 1513, might have been caught up in the city's delirious celebrations.

For four days after the announcement, pageant followed pageant. Bells clanged continuously. Cannons boomed. Vast floats, some painted by prominent artists such as Andrea del Sarto and Pontormo, rumbled through the streets. *Fuochi d'artificio* (fireworks) lit up the sky. Sweet white wine poured from rows of gilded barrels in the Piazza della Signoria. Cries of "*Papa Leone! Papa Leone!*" in praise of Pope Leo, the Lion Pope, echoed everywhere.

As part of its boundless exultation, the town granted amnesty to all prisoners. Blinking in the brightness of the day, Machiavelli limped past the jubilant crowds into lifelong exile on a small family property in the

countryside seven miles south of Florence. He would loathe every minute of his banishment.

"Caught in this way among the lice," the political mastermind wrote, "I wipe the mold from my brain and relive the feeling of being ill-treated by fate." That fall, drawing on the experience he had shared with Leonardo during Cesare Borgia's bloody campaign, he began a treatise that, as one of my college professors liked to quip, "put the science in political science." In a burst of inspired writing, Machiavelli finished *The Prince* by the end of 1513. (Although copies of the manuscript circulated for years, the book itself wasn't published until 1532.)

The author initially intended to dedicate the work to Giuliano de' Medici, a gesture that he hoped might ingratiate him to the new regime. But once again, fate didn't turn out the way he had hoped. The new Pope's brother had decamped for Rome.

Pope Leo X, the insatiable gourmand, greeted his new role with a characteristically hearty appetite. "God has given us the Papacy," he told Giuliano, appointed his Gonfaloniere della Chiesa (Defender of the Church), among other lofty titles. "Let us enjoy it." They undeniably did.

Suddenly, all roads from Florence led to Rome. Representatives of great families such as the Strozzi and Tornabuoni found well-paying sinecures in the papal chancery, its military, and other offices. At the beckoning of these wealthy patrons, men of genius flocked to the Eternal City in an astonishing concentration of talent.

After passing more than a third of his life in Milan, Leonardo joined the migration. His Medici patron was not the new Pope, however, but his sweetheart of a brother, Giuliano.

"I left Milan for Rome on 24 September 1513," Leonardo wrote on the opening page of a new notebook. With a small entourage that included Melzi and Salaì, he journeyed down the Via Emilia with crates containing the *Mona Lisa* and other works in progress, anatomy texts, notebooks, equipment, scientific instruments, furniture, clothing, books, and personal mementos.

According to a contemporary, Giuliano de' Medici welcomed Leo-

nardo "*piuttosto da fratello che da compagno*" (more like a brother than a friend). In addition to a stipend, he provided a suite of rooms in the Belvedere, part of the Apostolic Palace on the Vatican Hill, and hired an architect to design a workshop and living spaces for the esteemed artist and his retinue. Pope Leo himself commissioned a painting from Leonardo, who began by distilling certain herbs and oils to create a new form of varnish to put over the work when completed.

"This man will do nothing at all," the Pope exploded when he heard of Leonardo's tinkering, "since he is thinking of the end before he has even begun the work."

Rome didn't prove to be as hospitable a home for Leonardo as Milan had been. Younger artists—his old rival Michelangelo and Pope Leo's favorite, Raphael, among them—won the prize commissions. The "old man" dabbled in projects that included draining the marshes outside the city and creating a curved parabolic mirror that might function as a reflecting telescope. Never losing his love of practical jokes, Leonardo inflated bulls' intestines to create "transparent objects full of air" that scared members of the papal entourage. In letters to Giuliano he mainly complained about some German workers whom he suspected of trying to steal his secret mirror-making techniques.

⁓

Although there is no proof that Leonardo produced any new compositions while in Rome, some have speculated that he painted another portrait of a woman—perhaps the one that we know as the *Mona Lisa*.

One suggested subject was Pacifica Brandano, Giuliano de' Medici's mistress in Urbino, who gave birth to his illegitimate son Ippolito in 1511. After her death, Giuliano brought the boy to the home of his brother, then-Cardinal Giovanni de' Medici, in Rome. A recent theory speculates that Giuliano might have commissioned Leonardo to paint a portrait of an idealized maternal figure as a comfort for his motherless child. This sentimental notion has failed to convince historians, who note that Giuliano tended toward passionate rather than paternal pursuits. After one especially debauched three-day escapade with several women at the Palazzo Medici in Florence in 1514, he had to retreat to a thermal spa to recover.

Other nominees include several women who were living in Rome at the same time as Leonardo and Giuliano de' Medici. One, a witty Neapolitan widow named Isabella Gualanda, was a cousin of Cecilia Gallerani, the fetching mistress of Milan's Duke Ludovico, whom Leonardo painted in *Lady with an Ermine*. However, nothing links her with Giuliano or Leonardo.

Another attractive widow, Costanza d'Avalos del Balzo, inspired verses by the poet Enea Irpino da Parma, who refers to a portrait by Leonardo in a rapturous ode to her beauty. Adolfo Venturi, a prominent art historian in the early twentieth century, noting that her cheerful personality may have inspired the nickname "La Gioconda," identified this merry soul as Leonardo's sitter. But Costanza, nineteen years older than Giuliano, would have been in her mid-fifties by the time of Leonardo's stay in Rome.

Then there is the notorious "nude *Mona Lisa*," a curly-locked topless beauty. Several copies exist, although no one knows if Leonardo, or possibly Salaì, ever painted an original in Rome or elsewhere.

According to the theory I hear most often from art historians, Leonardo spent his years in Rome refining the portrait of Lisa Gherardini that he had begun in Florence. His painterly skills continued to evolve, and the most sophisticated brushwork on the *Mona Lisa*, particularly his gossamer glazes, dates to this period.

Did Leonardo, during the portrait's long metamorphosis, infuse his emotions into Lisa's visage, his reflections into her eyes, his perspective onto her lips? Did his portrait of a specific individual woman evolve into a more universal statement?

"Leonardo was onto something," Jeffrey Ruda, a professor of art history, comments when I sit in on his Renaissance art class on the campus of the University of California, Davis. "He saw that he could use this painting to demonstrate everything he had learned about portraiture and to convey everything he understood about being human."

This knowledge included an acute awareness of aging. Leonardo was feeling the bite of the "hard teeth of the years," as he wrote. Some of his exceptional vigor deserted him. His right side seemed weak, with a no-

ticeable tremor in his hand. His vision, which had been troubling him for decades, deteriorated. At times he relied on spectacles or goggles of some sort, tinted blue. Yet the irrepressible genius filled notebooks with more big ideas—a machine to produce rope, another to coin money for the Roman mint—along with apocalyptic images of great deluges. Still fascinated by the workings of the human body, he continued his anatomical studies at the Ospedale di Santo Spirito—until they drew Pope Leo's ire.

"The Pope has found out that I have skinned three corpses," Leonardo wrote after being forbidden to do more dissections. He appealed to Giuliano for help, but none was forthcoming. As Leonardo recorded in his notebook, at dawn on January 9, 1515, his patron departed from Rome to enter into a politically strategic marriage to a young French duchess, Filiberta (Philiberte) of Savoy.

She too crops up as a possible model for the *Mona Lisa*, even though the seventeen-year-old, described by a contemporary as "a thin girl with a pale, pinched face . . . almost a hunchback," seems an unlikely inspiration for the portrait that personifies Renaissance beauty.

In Florence, Francesco del Giocondo, although a relatively minor political player, may have aspired to *magnificenza*, the greatness expected of a prominent citizen. Beyond merely showing off his wealth with a fine house and fancy clothes, the entrepreneur became an art patron, with, as one critic puts it, "slightly above average aspirations."

When we meet for an *aperitivo* on Florence's chic Via dei Tornabuoni, Josephine Rogers Mariotti describes the clues that led to her documentation of Francesco del Giocondo's support for the arts. While researching two works by the artist Leonardo Malatesta that had originally hung in the Monastero di Sant'Orsola, she came across a coat of arms combining the *stemmi* (crests) of a husband and wife. Her curiosity piqued, she traced the origins of the emblems.

"The moment that I identified the families as the Gherardini and the del Giocondo, I knew the *stemma* could belong only to Lisa Gherardini and Francesco del Giocondo," Mariotti says. Sometime around 1515,

Francesco and Lisa del Giocondo became what she calls "assiduous pa-trons" of Sant'Orsola, one of Florence's most prestigious nunneries.

Founded in 1309 as a *satellite femminile* (female satellite) to the Basilica of San Lorenzo, Sant'Orsola, long favored by the Medici, boasted a ster-ling reputation as a place of both prayer and commerce. More than sixty nuns, along with boarding students and novices, alternated devotion with different types of labor. In large rooms equipped with elaborate looms, its industrious sisters—some of the "invisible hands" of the city's textile industry—wove cloth for household linens. Others produced fine gold and silver thread or embroidered vestments for local clerics, all under the supervision of sister-managers in charge of the different enterprises, who reported to the Mother Superior, the convent's chief executive.

In turbulent times, institutions like Sant'Orsola served as bastions that could safeguard the honor and well-being of Florentine daughters. Under flexible arrangements that lasted for months or years, many nun-neries took in boarders as young as five and provided them with a solid moral and intellectual education.

Entry into an elite convent like Sant'Orsola could be as fiercely com-petitive as admission to an Ivy League college. To be accepted as a nov-ice preparing for a religious life, a girl needed an impeccable background and parents who could underwrite her upkeep and extra expenses. The Mother established the amount on an individual basis, depending on the family's reputation and wealth.

Extra fees paid for creature comforts, such as a thick mattress and extra blankets, or for a *conversa* (a nun from a poor family who entered without a dowry) to act as a personal servant. A large enough donation could buy dispensations from many obligations. In exchange for an ad-ditional 200 florins, for example, Sant'Orsola's Mother exempted a daughter of the prominent Ricasoli clan from obeying convent rules and carrying out religious duties.

Sant'Orsola also operated an apothecary, popular among Florentine women, who could visit convents without a companion. Lisa, living just minutes away, did so regularly. A surviving ledger confirms her purchase

of a vial of distilled *acqua di chiocciole* (snails' water), both a cosmetic and a treatment for bronchial and digestive woes. However she may have used it, art historian Mariotti observes, the purchase testifies that "Lisa Gherardini was a woman who took care of herself."

I think of Lisa when I visit another centuries-old Florentine monastic apothecary, the Officina Profumo Farmaceutica di Santa Maria Novella, where I purchase a bottle of *acqua di rose* (rose water)—our "Mona Lisa scent," as my daughter calls it—that always makes me think of Lisa and her daughter Marietta.

Francesco del Giocondo's ability to provide a competitive dowry should have easily snagged an eligible suitor for his youngest daughter, but the couple—again, for reasons we may never fully fathom—opted for a religious life for her. According to Giuseppe Pallanti's research, Marietta may have entered Sant'Orsola—if only temporarily—around 1515, the year that her father began funding the paintings for its chapel. She would have been fifteen.

Another religious institution also benefited from Francesco del Giocondo's largesse: Santissima Annunziata. After years of supplying linens and loans to its Servite monks, Francesco acquired the ultimate religious status symbol: a crypt in a private chapel located behind the main altar. The great families of Florence viewed such sanctified spaces as both a testimony to earthly piety and a down payment of sorts on heavenly real estate in the hereafter.

Over time, Francesco commissioned a fresco with *La Storia de' Martiri* (history of the martyrs) by Antonio di Donnino (or Domino) Mazzieri for the wall and a painting of his patron St. Francis by the distinguished Florentine painter Domenico Puligo, a work that pleased him so much that he appropriated it for his home. Eventually, he arranged the transfer of his ancestors' remains from their tombs in Santa Maria Novella. His great-grandfather, the jovial barrelmaker Iacopo, could never have anticipated this upgrade in his final resting place.

Lisa's father, Antonmaria Gherardini, didn't fare as well in the changing times. Turning over management of his country properties to his son-

in-law, he earned the occasional honorarium as a witness or arbiter for Francesco and other businessmen. But Antonmaria and his family still kept bouncing from rental to rental, one house located in an alley behind Ser Piero da Vinci's family *palazzo*.

In 1515, no doubt at Lisa's urging, Francesco lent his father-in-law about 600 florins. When he couldn't repay the loan, Francesco harangued the aging aristocrat so mercilessly that Lisa's sister Ginevra reportedly renounced the small amount that might have gone toward her dowry to reimburse her brother-in-law for part of the debt. Francesco reluctantly wrote off the balance.

Once again, Lisa's predicament made me think of her Gherardini kinswoman Margherita Datini, whose impoverished mother and siblings constantly besieged her husband for money. Perhaps Lisa, like Margherita, championed her relatives' case with Francesco but privately chided them for asking too much.

———

Nothing would be too much, Giuliano de' Medici decreed, for his town's welcome of the first Florentine pope. Despite his worsening tuberculosis, Giuliano was determined that Florence would greet his visiting big brother with unmatched, unmatchable splendor. Leonardo, impresario extraordinaire, may have had a hand in the preparations, although biographers disagree on his role.

"Several thousand men labored for more than a month beforehand," the diarist Landucci writes, "working days and holidays alike" at a cost of 70,000 florins or more "for things of no duration."

On Friday, November 20, 1515, Lisa Gherardini and her children, ranging in age from thirteen to twenty-two, found themselves in a city transformed into a terrestrial paradise. Everywhere they looked they would have spied a new marvel: triumphal arches, a huge castle resting on twenty-two columns, statues of saints and ancient gods, an obelisk, screens decorated with allegorical figures, an immense tapestry covering the Duomo's partly finished facade. On this glorious day of days Francesco del Giocondo would have joined "all the chief citizens [who] went in procession to meet the Pope."

In bejeweled white robes and glittering tiara, Pope Leo entered the Porta Romana like a triumphant conqueror. Scarlet-clad cardinals and papal troops in gleaming armor with double-bladed axes marched behind him. Attendants tossed silver coins to the roaring crowds. Musicians played and sang verses of praise. In the Piazza San Felice, not far from the house where Lisa Gherardini was born, the decorations included an over-size portrait of Lorenzo Il Magnifico, inscribed in Latin with words that verged on blasphemy: THIS IS MY BELOVED SON—the phrase uttered from heaven by God the Father at the baptism of Christ. Tears flooded the pontiff's eyes.

The grand pageant following the procession—the Medici brothers' last Florentine extravaganza—spotlighted a young boy gilded from head to toe, standing on a pedestal, a symbol of the rebirth of the golden age of Florence. No sooner did the curtain fall than the boy collapsed and died, suffocated by the paint covering his body.

Leonardo may have remained in Florence to work on plans for a new *palazzo* for a Medici cousin, Lorenzo di Piero de' Medici, to be constructed opposite the family homestead, just a few blocks from the del Giocondo home. Might Leonardo have paid Lisa a visit? I relish the thought of the sixty-three-year-old artist and his thirty-six-year-old model reuniting more than a decade after Leonardo began her portrait, but there is no evidence that such an encounter ever took place.

With a stipend from Giuliano de' Medici to cover his expenses, Leonardo may have set off to Bologna with Pope Leo for a meeting with the new French king, Francis I (1494–1547). Not yet twenty, the boyish monarch stood six feet tall—a giant compared to most men of the time, with brawny shoulders, merry eyes, a powerful nose, and a penchant for charging into battle in gleaming armor, looking like a fairy-tale knight.

In the new regent's honor, Leonardo designed a special tribute: a clockwork lion that walked forward a few paces by means of an ingenious mechanism and opened its chest to reveal lilies in the place of its heart, a symbol of the friendship between the Lion Pope and the French King of the Lilies. "Violently enamored," as he later put it, of Leonardo's genius as

a great philosopher as well as an artist, King Francis invited him to come live in France. Leonardo hesitated.

His patron Giuliano de' Medici's condition was deteriorating. The Padre Santo (Holy Father) himself sent money to Sant'Orsola for prayers on his brother's behalf. For a while it seemed that the nuns' pious petitions might prevail. But Giuliano, shrinking to *pelle e ossa* (skin and bones), died on March 17, 1516. Baldassare Castiglione, who would immortalize him in his *Book of the Courtier*, eulogized Giuliano as a gentleman "whose goodness, nobility, and courtesy the world deserved to enjoy longer."

Francesco del Giocondo would have joined the mourners at Giuliano's stately funeral at the Basilica of San Lorenzo. Leonardo's grief ran deeper. Once again he had lost a friend, a patron, and a protector. On the day of Giuliano's death, in one of his most enigmatic sentences, the artist scrawled, "The medici created me, and the medici destroyed me." Because he failed to capitalize the *m*'s, no one is sure if he meant the Medici family or *medici* (doctors), whom he distrusted.

Although he yearned for a generous patron and stable sinecure, Leonardo might not have been eager to move to a foreign land. He had spent virtually his entire life between Florence and Milan, a distance of less than two hundred miles. Yet no place in Italy offered him refuge; no Italian patron sought his services. France's monarchs, in contrast, had showered him with such affection and so many tangible tokens of appreciation that he may already have felt like an adopted son.

In the autumn of 1516, at age sixty-four, Leonardo embarked on the longest journey of his life—a three-month trek from Rome to Florence to Milan, across the Alps to Lyon, and finally to Amboise. A train of mules toted his earthly possessions, the *Mona Lisa* among the crates of books, scientific instruments, clothes, and mirrors.

Leonardo found a final safe harbor in Clos Lucé, a handsome red brick and gray tufa manor, with an underground passage connecting it to King Francis's great château. When I recall visiting Amboise, I think of the gentle golden light of the surrounding countryside. I can picture

Leonardo in this glow, gazing out to a distant view of trees, turrets, and spires or wandering through the sprawling grounds.

"I shall continue," Leonardo wrote on the corner of a notebook page from this time. And so he did. In this serene setting he continued to think, advise, dictate, and teach. He worked on geometrical studies and designs for a new royal palace, studied the flow of the Loire, and lent his expertise to court theatricals. Some of the last drawings of Leonardo's life—whimsical sketches of cats, dragons, and fanciful animals—capture his enduring playfulness.

King Francis I, who considered Leonardo "a philosopher-magician of the visual world," came frequently to converse; visitors stopped by to pay respects. One of these encounters kindled a still-unsolved mystery about the lady in Leonardo's final portrait.

On October 10, 1517, Cardinal Luigi of Aragon, a wealthy and worldly prince of the Church who had stayed in Milan's old ducal palace during Leonardo's residence, arrived in Amboise with his chatty secretary, Antonio de Beatis, who kept a detailed journal of their trip. The sixty-five-year-old artist struck de Beatis as "an old man" no longer able to paint "with that sweetness that he used to."

During their visit, Leonardo led his guests into his studio and displayed three pictures: one of a young St. John the Baptist, another of the Madonna with the infant Jesus and St. Anne, and the third of "a certain Florentine lady, done from life at the *instanzia* [translated as "at the instigation, behest, encouragement, or request"] of the late Magnifico Giuliano de' Medici"—"*tutti perfettissimi*" (all completely finished and without flaw).

The next day at the royal castle at Blois, the Italian visitors viewed another Leonardo portrait "of a certain lady of Lombardy" (probably Duke Ludovico Sforza's mistress Lucrezia Crivelli)—"rather beautiful but in my opinion not as beautiful as Signora Gualanda," wrote de Beatis, referring, not to a portrait, but to Giuliano de' Medici's Neapolitan mistress Isabella Gualanda.

But if the "Florentine lady" was indeed Lisa Gherardini, why would

Leonardo say that Giuliano had "urged" him to paint her? Some specu-
late that Lisa must have been Giuliano's secret *amante* (lover)—a wholly
unsubstantiated claim that wove its way into fictional accounts of her life.
Others interpret the description as proof that the woman in the painting
is not Lisa at all.

I like the theory that art historian Josephine Rogers Mariotti ad-
vances in *Monna Lisa: La 'Gioconda' del Magnifico Giuliano*—her *libric-
cino* (little book), as she refers to the slim volume. Perhaps Giuliano, the
cosmopolitan courtier steeped in the platonic chivalry of Renaissance ro-
mance, asked Leonardo to complete his long-unfinished work as a trib-
ute to an ideal of feminine beauty—much like the portrait of Ginevra
de' Benci that the artist had painted for her admirer many years before.
Just as he might have in the Urbino court, cosmopolitan Giuliano, author
of amorous verses dedicated to idealized women, may have "instigated"
completion of the portrait as an immortal ode of praise.

Perhaps Giuliano had planned to keep the work himself. Perhaps he
thought of giving it to Francesco del Giocondo, his political ally and sup-
porter. The consumptive gallant may simply not have lived long enough
to claim possession.

Would Leonardo have parted with the portrait? Some speculate that
he had fallen in love with the image he had created. All we know is that
he always kept Lisa's portrait close and may have been adding a stroke
here and another there until the very end of his life. In his final years the
face of the serene *fiorentina* may have reminded Leonardo of a distant
time in a faraway city where he once was young and happy.

———

Lisa Gherardini would also have had reason to yearn for the happier days
of times long past. In January 1518, terrible news arrived from the Con-
vento di San Domenico di Cafaggio: Suor Beatrice, the name young Ca-
milla had taken when she pledged her life as a handmaiden of the Lord,
had passed into His hands. For her parents the shock may have hit before
the sorrow.

Their darling daughter—the sparkle-eyed baby, the prattling toddler,
the grinning sprite—was dead at age eighteen. The cause? Any of the

myriad perils, from pneumonia to plague, that snatched the lives even of the young and the cloistered.

The del Giocondo clan responded with what Giuseppe Pallanti terms *lo sbigottimento*—"dismay" or "consternation," although English doesn't capture as well as Italian the gut-wrenching force of the blow. The grieving family hung black woolen cloth from their windows and wrapped heavy funeral mantles around their shoulders. Mourners lit candles. A priest intoned the Mass for the Dead. The choir sang a solemn requiem. Suor Beatrice's body was laid to rest.

At age thirty-eight, Lisa Gherardini had lost three of the six children she had brought into the light to the Great Sea of death.

Chapter 13

The Great Sea

On my first trip to Florence many years ago, I climbed up to the ancient Basilica of San Miniato overlooking the town. Wandering through its cemetery, I was touched by the tombstones, some decorated with evocative statues of children and young maidens snatched by death. Beautiful faces, beautiful lives, all gone too soon.

Feeling melancholy as I descended the steep hill at twilight, I looked up to behold a crimson sunset above the *città d'arte* along the Arno. At that indelible moment, I came to understand something I couldn't quite express. Only recently did I find the words to capture this insight in one of Leonardo's notebooks: "Beauty in life perishes, not in art."

Was the imperishable beauty he had created a comfort to Leonardo at the end of his life?

In Vasari's vivid—perhaps overly so—account of Leonardo's last days, the artist studies Catholic teachings, repents, confesses his sins, and receives communion. On May 2, 1519, when the French monarch Francis I enters his chamber, Leonardo summons the strength to raise himself up on his bed to explain "what his sickness was and what the symptoms were." He then acknowledges "how much he had offended God by not working on his art as much as he should have." As Leonardo shudders in a final spasm, King Francis cradles his head and comforts him.

Historians have long been skeptical of this hyperbolic tale, especially after the discovery of an official royal document that placed the king some distance from Amboise the very next day. To me Leonardo's eleventh-hour conversion and cry of regret seem as dubious as the royal embrace.

In his will, Leonardo orchestrated his final exit: burial at the Church

of Saint-Florentin in Amboise, his coffin borne by the chaplains of the church, followed by the prior, curates, friars, and sixty poor men (compensated for their time) carrying tapers, while ten great candles burned and prayers were said for his soul. Leonardo left no instructions for his burial or tombstone.

Florence didn't receive word of the death until June 1, when his assistant Melzi notified Leonardo's half brothers. "He was like the best of fathers to me," he wrote. "As long as I have breath in my body I shall feel the sadness, for all time. He gave me every day the proofs of his most passionate and ardent affection."

At the time she heard the news, Lisa Gherardini probably had no idea what had become of her portrait. But I wonder: Did she weep when she heard of Leonardo's passing?

Perhaps Lisa was still shedding tears for the daughter she had lost the year before. God's will be done, she might have said a thousand times. But what was God's will for her youngest child, nineteen-year-old Marietta? We know that in 1519 the girl—past her prime as a bridal candidate—was living at the convent of Sant' Orsola. A ledger entry for July 14 records a payment of 18 florins received on behalf of "the daughter of Monna Lisa del Giocondo," perhaps to ensure some special comforts or privileges.

Ever since Camilla's death, Lisa herself may have spent more time at Sant'Orsola, worshiping in its chapel, attending novenas, vigils, and Masses, and making generous donations. Such "matronage," a common form of charity among Florence's upper-class married women, seems the only legitimate activity in which ladies could engage outside their homes, an extension of the love and care they gave their own families.

With her children grown and her household more sedate, Lisa may also have dispensed alms to the poor and visited the sick—good works that reflected well on a husband's civic reputation. But for Lisa, faith and charity may simply have offered a solace she could find nowhere else. The same might have proved true for her daughter.

In a solemn ceremony on October 20, 1521, Marietta del Giocondo, bride of Christ, donned a veil of white, accepted a ring of gold, and as-

sumed the name Suor Ludovica. In formal vows during a lilting High Mass on Christmas Eve a year later, the twenty-two-year-old swore life-long obedience, poverty, and chastity. Through all the days of her long life, she would pray in the chapel of Sant'Orsola before the paintings that her father had commissioned: one of her patron, San Ludovico; the other of his, San Francesco.

But that's not all Suor Ludovica would have done. After singing morning psalms, she might have worked the looms with other sisters or plied an embroidery needle through a brocaded vestment. Endowed with her father's business savvy, she became involved in managing convent properties; her name appears on several deeds in the Sant'Orsola archives.

The revelation of nuns' pursuit of what sound like jobs, if not careers, took me by surprise. As I probed into the research—much of it relatively recent—on women in convents, I discovered that the only female historians, accountants, entrepreneurs, pharmacists, and administrators of Renaissance Florence wore religious habits. Some nuns—a minority, to be sure—wrote chronicles, plays, and scholarly treatises; painted and illuminated devotional works; made heavenly music; and wielded considerable influence on local politics and commerce.

I found myself toying with a hypothetical question: Which would I have preferred? Marriage to a much older man I didn't know, whom I might or might not come to love? Sharing a home with live-in relatives? Decades of humdrum domesticity? The life-threatening prospects of pregnancy and birth? Given the choice—which Renaissance daughters were not—I might have seen advantages in taking the veil.

Lisa Gherardini, of course, is unlikely to have thought in such terms. But she would have taken comfort in the realization that her daughter Marietta, sheltered from the whims and wars of men, would live with dignity in a community of women in harmony with God's will. Or so she prayed.

Lisa herself may have progressed on her own spiritual journey. Like many devout women of the time, she may have increasingly woven religious practices into her daily life: prayers before the Madonna in her bedroom; morning Mass; inspirational readings; evening vespers; a Rosary before bed. Piety, which had brought serenity to Margherita Datini, Lisa's hot-blooded ancestress in Prato, might have soothed her soul as well.

In December 1521, at almost age forty-six, Leo X, the Medici Lion Pope, caught a chill while sitting by an open window on a cold winter night and died. So the Vatican announced, but many suspected poisoning by any of his numerous enemies. With the papal coffers drained by Leo's riotous excesses, the cardinals chose his diametric opposite: an ascetic Flemish scholar who holed up in a corner of the papal apartments and ate little but gruel.

The brief reign of Pope Adrian VI, so priggish that he threatened to whitewash Michelangelo's nude figures in the Sistine Chapel, ended within two years. The unpopular pontiff died of "kidney disease"—almost certainly a euphemism for poisoning, which had become an occupational hazard for the men who ascended to St. Peter's throne.

Medici boosters like Francesco del Giocondo would have prayed for the selection of Cardinal Giulio de' Medici (1478–1534), the illegitimate son of Lorenzo Il Magnifico's slain brother, Giuliano. But the conclave of cardinals deadlocked. Only after almost two months in uncleaned rooms putrid with the stench of sweat and age, with no fresh air or natural light and limited rations of bread, wine, and water, did the princes of the church finally settle on Giulio, who took the name Pope Clement VII.

"Rather morose and disagreeable," writes the historian Guicciardini, "reputed to be avaricious, by no means trustworthy, and naturally disinclined to do a kindness." Under Clement VII, Florence became, in effect, a satellite of Rome. Two illegitimate teenage Medici cousins—Ippolito, Giuliano de' Medici's son by his mistress in Urbino, and Alessandro, said to be the Pope's own bastard—took up residence in the family *palazzo*, with various officials charged with keeping the youths in check.

Francesco del Giocondo might have had a front-row seat on their high jinks. In 1525 the sixty-year-old once again assumed the long crimson robes, gold chain, and civic responsibilities of a prior and moved into the Palazzo Vecchio to serve his second two-month term on the Signoria. But he never stopped his relentless pursuit of profit. When a minor painter and sculptor named Maestro Valerio died owing him money, Francesco recouped the debt—and then some—by seizing possession of the artist's entire stock of works. In the uncertain times, he invested in what his Tus-

can great-grandfather had recognized as the only sure thing, real estate, and acquired more rural properties, including a former Strozzi estate.

Francesco's father-in-law, Antonmaria Gherardini, died around this time. His will, processed in 1526, revealed that the Gherardini, always determined to keep up appearances for the sake of family honor, had long been living beyond their means. In the coming years they would have to sell off more than half of their country assets to cover their debts. Eventually, only the ancient homestead in Cortine remained in the family's hands.

Lisa, ever the responsible big sister, would have worried about her impoverished siblings, especially after one of her brothers died, leaving a wife and children. Perhaps with some trepidation, she asked her husband if her relatives could move into the house next door on Via della Stufa. Francesco del Giocondo "knew it would not be a good arrangement," Giuseppe Pallanti reports drily, but he agreed—"above all to please his wife." He also may have slyly appropriated the widow's dowry for his own use.

Leonardo da Vinci's estate presented different problems. When an official court artist died, his works usually went to his patron. However, King Francis had granted Leonardo a special exemption allowing him to bequeath his possessions to whomever he chose. The artist left his notebooks and drawings to his assistant Melzi, a house and garden to his cherished Salaì, money to his stepbrothers, and gifts to various servants.

Several paintings, including the *Mona Lisa*, may have ended up with Salaì, who was killed in a violent altercation in Italy in 1524, just five years after his maestro's death. A probate inventory, discovered in the Milan archives in the early 1990s, listed twelve paintings in Salaì's possession, either Leonardo originals or excellent copies. A scribe initially identified one of two women's portraits as "*La Honda*," but then crossed this out and wrote "*La Ioconda*" (the Milanese spelling of *La Gioconda*)—another possible confirmation of "the Gioconda woman" as Leonardo's model.

King Francis I, who had probably coveted the portrait from first sight, wanted "her" at any price. He paid a staggering sum: an estimated 12,000 francs, the equivalent of almost $10 million today.

The French monarch also invested heavily in another costly pursuit: war with his archenemy, Charles V (1500–1558), ruler of Spain, Austria, and a few lesser duchies, who on several occasions challenged the French king to one-on-one combat. For years the two young, pugnacious, and egotistical monarchs moved armies like pawns across the Italian chessboard. Pope Clement VII, paralyzed by ambivalence, made the volatile situation worse by repeatedly shifting allegiance.

Rome paid the ultimate price for his vacillation. In 1527, a mutinous army of more than 25,000 Spanish soldiers and German mercenaries fighting for Charles V, unpaid and underfed, marched on the Eternal City. Before dawn on May 6, Romans awoke to the clang of warning bells and the crackling of gunfire. Wave after wave of half-crazed soldiers swept over its outmatched defenders and slaughtered everyone in their path—man or woman, old or young, priest or peasant. By the end of the unparalleled orgy of lust, violence, and wanton destruction, as many as half the population had fled or been cast into the Great Sea.

"In truth," the Dutch humanist Erasmus wrote, "this was rather the fall of a world than of a city."

Soon the same could be said of Florence. When news of the assault on Rome reached Florence, its citizens promptly escorted their young Medici leaders out of town. From their home on Via della Stufa, Francesco and Lisa del Giocondo could have heard the crowd's shouts and the crash of stone as Medici *palle* were stripped from buildings and flung to the pavement. A historian tells me that not a single Medici *stemma* (family crest) survived.

Another casualty in a pitched battle in the heart of Florence was Michelangelo's *David*. The Republican forces who had seized possession of the Palazzo Vecchio threw a bench from a window onto Medici loyalists attacking the building. It struck the town's prized symbol of freedom and broke its arm. When the fighting subsided, the future art historian Vasari, a young apprentice at the time, darted out of the besieged *palazzo* to retrieve the pieces. (After keeping them safe for years, Vasari finally repaired the mutilated sculpture in 1543.)

With the Medici again ousted, the Florentine Republic was reborn. The defiant citizens, excommunicated by the Pope, elected Jesus Christ

their Sovereign and posted a sign on the Palazzo Vecchio that read, "*Jesus Christus, Rex Fiorentini Popoli S.P. Decreto electus*" (Jesus Christ, King of the Florentine People, elected by Popular Decree). Scrawled on walls throughout town was the slogan "*Poveri ma liberi!*" (Poor but free!).

Francesco del Giocondo, who seemed always to have felt free to do as he pleased, never qualified as poor. As others sold off what they could in a panic, archival records show that in 1528 Francesco spent the whopping sum of almost 5,000 florins to enlarge his principal farm in Chianti. I asked several historians if he might have taken his family there to wait out the coming storm. No, they said, explaining that the countryside would soon become even more perilous than Florence itself.

Through memory books, I piece together what life might have been like for Lisa Gherardini during her hometown's darkest hours. An Italian mother to her core, the family matriarch, who turned fifty in 1529, would have gathered children, grandchildren, brothers, sisters, cousins, nieces, and nephews close and prepared for the worst. Stockpiling whatever supplies they could muster, her family would have planted vegetables on roofs and in courtyards. Eventually, they might have burned furniture, shutters, and doors as firewood to stay warm.

One of Lisa's cousins, Andrea Gherardini, descended from her great-uncle Antonio (her grandfather Noldo's brother), served as a captain in the citizens' militia known as the Marzoccheschi (sons of the Marzocco) and trained the town's youth to march and wage mock battles. In order to look older and more intimidating, the comely young Florentines grew beards and trimmed their shoulder-length locks. Like other citizens, Lisa and Francesco might have turned over gold necklaces and silver plates to melt into coins to buy arms for these defenders.

Above all, Florentines of all ages prayed, genuflecting twice a day by civic decree as the Angelus bells rang. Their preferred form of intercession was procession. As one diarist recorded, "the streets groaned under the weight" of daily parades of barefoot priors, *vecchioni* (old folks) limping slowly, and children dressed as angels—once accompanied by a gaggle of sheep, goats, and chickens smuggled through enemy lines. Historians

looking back on these ritual parades describe them as the "death march of the Republic."

Its demise came at the hands of the Medici pope. By the time Clement VII, disguised as a peddler, finally slipped out of Rome in December 1527, he had lost everything: money, influence, allies, and arms. But he swore never to give up the city his family had crowned with greatness, whatever devil he had to deal with—even his diabolical former enemy. In return for papal coronation as Holy Roman Emperor and other concessions, Charles V agreed to provide troops to reinstate the Medici in Florence. Within months a force of almost 40,000 massed on the hills surrounding the city.

"Get out your brocades, Florence!" the imperial troops taunted the town of textile makers. "We are coming to measure them with our pikestaffs."

The soldiers underestimated the defiant Florentines' grit—and their love of a grand symbolic gesture. On February 17, 1530, the del Giocondo family would have heard the trumpets blare for the town's traditional *calcio* match. Through the narrow streets to the large Piazza Santa Croce tramped squads of young men, fully decked in the livery of the teams known as the Bianchi (Whites) and the Verdi (Greens). To underscore Florentine disdain for the enemy, musicians played their instruments on the roof of Santa Croce. As the game began, a cannonball whistled over their heads and landed on the other side of the church. No one was injured, and the match resumed amid even greater clamor. Although the final score was quickly forgotten, all of Florence exulted in this triumph of the spirit.

The city held out for six more harrowing months. The cost of wheat soared to four times its normal price. As food rations dwindled, Florentines, weakened by starvation, began dying of plague and other rampant infections. Their only lifeline came from a brave, tough commander named Francesco Ferrucci, who repeatedly wove through the enemy camps to bring supplies. In the summer of 1530, under cover of darkness, Ferrucci led a group of men into the Tuscan countryside to recruit a volunteer army. Enemy forces ambushed them in the mountains above Pistoia. Ferrucci fought until mortally wounded. As an enemy commander lunged at him with a dagger, he gasped, "You are killing a dead man."

Something inside the Florentines died too. The city fathers estimated they had only about eight days of bread left for the starving population.

On August 12, 1530, Florentine delegates surrendered unconditionally. Despite assurances of clemency from the Pope, the invading troops murdered, pillaged, raped, and destroyed every vestige of the people's rule. The leader of the antipapal forces was tortured and killed. Scores of leading citizens, including Lisa's cousin Andrea Gherardini, were banished from Florence forever.

"Would that Florence had never existed!" Pope Clement VII was heard to exclaim. His wish almost came true. The city itself nearly drowned in a great sea of destruction.

Lisa and Francesco del Giocondo survived—testimony in itself to their resilience. According to tax documents from 1532, Francesco, sixty-seven, and Lisa, fifty-three, were living with their sons Bartolomeo and Piero, their wives, and several grandchildren on Via della Stufa. (There are no records of their son Andrea's fate.) All were coming to grips with what we might call a "new normal."

Florentine styles reflected the change. Emulating the young Marzoccheschi who had taken up arms during the siege, men of all ages, a diarist reports, "began to wear their hair short, everyone having formerly worn it long, onto their shoulders, without exception, and they now began to wear a beard."

Pope Clement VII installed his illegitimate son, Alessandro (1511–1537), a capricious, frizzy-haired lout, as governor. On May 1, 1532, the arrogant youth dismantled the republican institutions, including the 250-year-old Signoria on which Francesco del Giocondo had twice served. The newly proclaimed duke forced all Florentine men to turn over their weapons. La Vacca, the great bell, was thrown from its tower to smash to pieces in the Piazza della Signoria. Its crash reverberated in the hearts of Florence's citizens.

Despite the devastated economy, Francesco del Giocondo managed to hold on to a great deal of wealth. The white-haired hustler seems to have resumed his old practice of charging exorbitant exchange rates to re-

ligious orders. In 1536, at the age of seventy-one, he was hauled before an ecclesiastical court on a charge of usury.

Florence itself seemed to lose any moral compass. Duke Alessandro, the most sexually voracious of the Medici, preyed on Florentine wives, daughters, and nuns. His sordid reign ended with the betrayal of a companion-in-carousing, a distant cousin known as Lorenzino (little Lorenzo) for his small stature—later rechristened Lorenzaccio (nasty Lorenzo) for his evil acts.

When Alessandro's roving eye fell on a beautiful married woman of impeccable virtue, Lorenzino promised to arrange a tryst on the eve of the Epiphany in January 1537. Arriving at the rendezvous, Duke Alessandro undressed, lay down in bed, and fell asleep—only to awake when Lorenzino and a hired assassin burst into the room. Struggling to break free from Lorenzino's grip, Alessandro bit his cousin's finger to the bone before the assassin finished the Duke off with a knife thrust to his throat. By the time Alessandro's massacred body was discovered days later, the two assailants had escaped.

In the uproar that followed the assassination, the exiled Florentines seized the opportunity to try to reclaim power. A contingent of foot soldiers and knights marched toward the city but were vanquished by imperial forces. Among the leaders captured and hauled into prison was Lisa's cousin. Andrea Gherardini would meet the same brutal end as the rebellious ancestors I had read about in the state archives: He was *decapitato* (beheaded).

The Palleschi, as the Medici supporters called themselves, chose an unknown as the next ruler: eighteen-year-old Cosimo de' Medici (1519–1574), the son of a valiant mercenary known as Giovanni delle Bande Nere (John of the Black Bands), who had been killed a few years before. Under Cosimo's reign the Medici monarchy was born. It would endure until the lineage died out in the 1860s.

"These were a different breed of Medici," Florentine historian Fabrizio Ricciardelli remarks during a wide-ranging conversation in the Palazzo Spinelli, not far from Piazza Santa Croce.

"How?" I ask.

"If you go to the Vasari Corridor, you will understand," he says cryptically.

I join an evocative evening tour of the raised passageway, built in 1565 by Vasari at the behest of Duke Cosimo to connect the state offices in the Palazzo Vecchio with his home in the Pitti Palace. Hundreds of paintings, many artists' self-portraits, line the 10-foot-wide corridor, but I am drawn to the recessed windows, large and small, with their unique views of the river, the Ponte Vecchio, and the people milling below.

Peering from these vantage points, I understand Professor Ricciardelli's point: Lorenzo Il Magnifico had strolled the streets and sung and danced alongside his fellow Florentines. Cosimo and his descendants preferred to walk above their heads and look down on them with an arrogance that reminds me of the Gherardini and the tower-building magnates of centuries past.

In 1537 an aging and ailing Francesco del Giocondo prepared his final will and testament. Like all such official documents, it was written by a *notaio* in Latin. When I read the Italian and English translations, I sense Francesco's fondness for the woman who had shared his life. With great affection, he bequeaths to his "*dilectam uxorem*" (beloved wife) the farm that had served as her dowry and the clothes and jewels he had given her in their happiest moments, along with ample provisions for her remaining years. In addition to declaring his love, Francesco praises Lisa's "free-born" spirit.

The del Giocondo patriarch charged his daughter Suor Ludovica with caring for her mother's well-being and obliged her brothers to respect her choices. For Suor Ludovica, he arranged a monthly stipend to be paid directly to her so "the convent may not claim anything of it," along with monastic habits and shirts, linen and wool sheets, and all the fine Rheims linen she might need for her crisp white wimples. He named his sons Bartolomeo and Piero as his heirs, set aside dowries for their daughters, and exhorted his children to avoid all disagreements and to work at finding union, peace, and fraternal love. His trusted *notaio*, a colleague, and seven others, including a greengrocer, served as witnesses.

Francesco del Giocondo died in 1538 at age seventy-three. Wearing heavy mourning cloaks and carrying candles, the family gathered in the Martyrs Chapel of Santissima Annunziata. The Servite monks, who

knew Francesco well from his many years as their patron and supplier, assembled in full force to chant and pray. With incense wafting into the air, Lisa watched as the man who had shared her life for forty-three years was lowered into the crypt. Her husband's last request was for a lamp—its oil paid for by his heirs—that would burn in perpetuity above his tomb.

As was customary, Lisa's sons became her official protectors and providers. However, she exercised some of her newly acquired rights to assert control over the remaining years of her life. As was a widow's prerogative, Lisa turned over the property and possessions she had inherited from her husband to their daughter Suor Ludovica. This, I learned from Renaissance histories, was not unusual. When women of means passed on their assets, they were more likely than men to make bequests to other women and to institutions such as convents.

In 1539, Lisa's sons formally agreed that Bartolomeo would move out of the larger del Giocondo house on Via della Stufa, where their mother would remain with Piero and his family. Lisa had a different plan. In perhaps the only independent decision over her living arrangements that she ever made, the sixty-year-old relocated to the Monastero di Sant'Orsola, which took in widows for a fee of two florins a month. Perhaps, some speculate, Lisa became so frail or ill that she needed the nuns' care. Perhaps she didn't want to burden her son's family (although then as now, children and grandchildren warmly welcomed a *nonna*, or grandmother).

I credit Lisa's independent Gherardini spirit, which led her to end her days where she wanted—in a house of God, near her beloved daughter, sheltered from the cataclysms that had so often convulsed her city. She never left.

When Lisa Gherardini died at age sixty-three on July 15, 1542, the entire community of Sant'Orsola gathered at her funeral to mourn a cherished companion. At her request, she was buried, not in the del Giocondo crypt in Santissima Annunziata as her husband had directed, but at the convent.

Such arrangements also were not uncommon. "Privileged women, who perhaps alone in this society had the power to choose their place of burial, overwhelmingly preferred to lie in community with other women in churches or other ecclesiastical buildings," historian Margaret King re-

ports in *Women of the Renaissance*, "rather than to be buried with their husbands, their fathers, or other male members of their lineages."

Why? In not joining a husband in the family crypt, King theorizes, a woman refuted "all the past decisions of the male line." After a lifetime of being defined as a daughter, wife, and mother, a widow could finally assert her identity as an individual. A professor I know in Florence suggests another possible motive: Perhaps Renaissance women "had had enough of their husbands on earth."

Did Lisa Gherardini feel this way? My sense is that her final choice had more to do with her personal feelings and wishes than with her irascible husband. From the moment of her birth, Lisa had lived in the company of females—a *brigata* of godmothers, aunts, cousins, in-laws, friends, neighbors. Together they laughed and sang, danced and prayed, wept and comforted one another. Not even death could break the loving female bonds that had surrounded and supported her all the days of her life.

Lisa Gherardini, never anticipating that her face would enchant millions of men for centuries to come, chose to rest for eternity among sisters.

———

Bartolomeo and Piero del Giocondo could not hold on to the "huge legacy," as Giuseppe Pallanti characterizes it, that their father left them. Edged out by competitors in other countries, the silk merchants lost their best customers and fell behind on bills. As debts mounted, they started selling properties to pay creditors. Francesco's oldest son, Bartolomeo, who died on December 2, 1561, passed on to his son, Guaspari, a sizable inheritance along with a business in crisis.

Unable to keep the company afloat, even after bringing in a new partner, Guaspari del Giocondo declared bankruptcy in November 1564. A judge summoned him for questioning in the court of the Stinche, a dismal prison off Via Ghibellina where debtors served time as punishment for their financial failures. In these grim surroundings he confirmed his list of creditors—the best-known craftsmen, merchants, and bankers in Florence. The judge ordered Guaspari to remain in the city as he considered the case.

"Indifferent to his financial difficulties and with a good dose of ir-

responsibility," in Pallanti's description, the young man proceeded to indulge in a favorite pastime: gambling, a diversion that made his bad situation worse. In just a few hours of playing cards with friends, Guaspari lost a considerable sum. Unable to come up with cash, he wrote an IOU that he could not fulfill. His debtor went to the court and asked to be added to the list of del Giocondo creditors. The furious judge confiscated Guaspari's goods for auction and ordered announcements of the bankruptcy and public sale posted in the streets.

"The name of the del Giocondo family was on everyone's lips for six months," Pallanti reports. By the following April, Guaspari worked out an agreement to pay off two-thirds of the creditors so he could reclaim his goods and his freedom. But the stain on the family name lingered. Guaspari ended up working as a clerk for the friars at Santissima Annunziata, where he at least would have earned enough to keep his grandfather's votive lamp aglow. Francesco del Giocondo could never have anticipated how quickly the funds for his memorial light would run out.

Darkness now shrouds the chapel where his earthly remains rest. Rust has corroded the grimy votive lamp dangling from the ceiling. The altarpiece has faded beyond recognition. I peer inside the private confessional where Lisa Gherardini might have knelt to seek absolution. When my hand brushes against its wood frame, paint flakes onto my fingers.

The only surviving mention of Francesco's family name lies on a floor stone noting that the chapel, formerly of the "*familiae iucundi*" ("Giocondo family" in Latin), was transferred at some point to new owners with the name Anfortis. They too have evaporated into the past. All that remains is a spectral stillness that chills me even on a warm summer day.

Suor Ludovica, Lisa's youngest daughter, outlived her siblings and died at the venerable age of seventy-nine on April 8, 1579. She too was buried in Sant'Orsola.

~

On my most recent visit, the brutal ugliness of the dilapidated convent seems more oppressive than ever. I turn away from its grim walls and head across the Arno and up the steep hill to the cemetery of San Miniato. There, looking down on the city that Lisa Gherardini and Leonardo

had once called their own, I reflect on how each had died—one within its walls, one far from them.

Leonardo's genius glowed to the very end. For as long as they could, his fingers kept sketching; his eyes, observing; his agile brain, reflecting. "Even though he accomplished more by words than deeds," Vasari wrote, "his name and fame will never be extinguished." This has indeed proved true, but I wondered if the failures of his career—the uncast equestrian monument, the peeling *Last Supper*, the botched *Battle of Anghiari*, the scores of unfinished works—haunted him.

"*Dimmi se mai fu fatta alcuna cosa,*" Leonardo often scrawled in his notebooks. "Tell me if anything was ever done." To his impossibly high standards, nothing ever was. Time, the "destroyer of all things," would yield only to death, the "supreme evil." Once he wrote poignantly of the soul's fate: "It is with the greatest reluctance that it leaves the body, and I think that its sorrow and lamentations are not without cause."

Nowhere did Leonardo voice any belief in an afterlife. Art alone would endure. Painting, he observed, could "preserve the transient beauty of mortals and endow it with a permanence greater than the works of nature, for these are the slaves of time"—as was he.

At the end of her days Lisa Gherardini had no inkling of the immortality Leonardo had bequeathed on her portrait. But her regrets may have been few. With a life rooted in family and Florence, Lisa had watched youngsters grow, welcomed grandchildren, celebrated joys, mourned losses, and borne witness to history. As wife, mother, and muse, she had basked in golden hours. Ultimately, her spiritual journey may have lifted her beyond the pomp and possessions that Renaissance Florentines so voraciously craved to a higher plane and a greater peace.

When I think of Lisa's final moments, another quote from Leonardo comes to mind, a line written during his happiest years in Milan: "Just as a well-filled day brings blessed sleep, so a well-employed life brings a blessed death." At the hour of Lisa's death, the Holy Mother Mary, whom she would have worshipped all her life, may have blessed her with a gentle passage into the Great Sea of eternity.

Part V

THE MOST FAMOUS PAINTING IN THE WORLD

The Adventures of
Madame Lisa

Years ago, as my husband and I toured the French royal palace at Fontainebleau, about thirty-four miles outside of Paris, an unmistakable Texas twang echoed through filigreed halls that pushed ostentation to new levels of excess.

"This," the voice boomed, "is one hell of a goddamn château!"

The phrase became the punch line of our trip: Notre-Dame? One hell of a goddamn cathedral! The Arc de Triomphe? One hell of a goddamn arch!

When I learned that King Francis I, credited with bringing the Renaissance to France, had hung his newly acquired portrait of *La Joconde* in his private bath at Fontainebleau, I knew immediately that it would have been one hell of a goddamn lavatory.

In fact, the Appartement des Bains consisted of a six-room "bathing" suite complete with pool, steam room, gambling tables, and lounge. In this ultraexclusive men's club, Francis, his friends, courtiers, and their guests (often females other than royal wives) played cards, soaked, smoked, sweated, relaxed, and engaged in recreational pursuits of every type.

The painting may have taken up residence there sometime around 1525. Lisa Gherardini, then forty-six years old, would live another seventeen years. Did she ever learn of its whereabouts? One of her contemporaries did. Giorgio Vasari, the first to describe her portrait, lived in Florence off and on from 1524 to 1550.

I first encountered this remarkable Renaissance man—artist, archi-

tect, engineer, historian, author—years ago when I was researching my biography of the Italian language. The idea for his collection of life stories of Italian artists, I learned, grew out of a dinner conversation at the Palazzo Farnese in Rome around 1543 (shortly after Lisa Gherardini's death). The A-list guests, swapping reminiscences of the artistic giants who had beautified Italy, worried that their stories might soon be forgotten and lost forever. A learned bishop volunteered to compile a treatise, but he soon turned the project over to the boundlessly energetic Vasari.

In order to write the first book of art history, Vasari interviewed people who had known various painters and sculptors during their lives and seen their works firsthand. Although he started his research after the death of Lisa Gherardini and her husband, Vasari could have talked with their sons, not just about Leonardo, but also about lesser artists who had completed commissions for Francesco del Giocondo. In 1550, Bartolomeo and Piero, both in their fifties, would have read Vasari's account of Leonardo's life in the first edition of *Le Vite* (*The Lives*), which quickly became the talk of their art-obsessed town.

Did Vasari get the story of the *Mona Lisa* right? This depends on whom you ask. Over the centuries critics have challenged his dubious dating and florid embellishments, but the essay on Leonardo has largely held up.

"Think of Vasari writing about Leonardo like somebody today writing about the Beatles," historian Fabrizio Ricciardelli suggests when I seek his perspective. Even if Vasari never saw the *Mona Lisa*—just as a young author today would not have heard the Beatles perform live—plenty of eyewitnesses would have pounced on glaring errors. Vasari himself corrected many factual mistakes in an expanded second edition of *Le Vite* published in 1568, but only one in his essay on Leonardo: his initial identification of Ser Piero da Vinci as the artist's uncle rather than his father.

France's monarchs treated *La Joconde* as capriciously as they treated any other woman in the court. Some adored her; others ignored her. The portrait remained in the royal bathing suite until late in the sixteenth century, even though the steamy rooms were no place for a painted lady. Perhaps in an ill-fated attempt to repair decades of damage, a Dutch restorer

applied a thick coat of lacquer to the portrait. The varnish dulled the colors before fracturing into a web of threadlike fissures called *craquelure*. *Mona Lisa* has never since appeared without this veil.

By the beginning of the seventeenth century, the portrait had moved to the Cabinet des Tableaux, later called the Pavillon des Peintures (Pavilion of the Paintings) at Fontainebleau. Louis XIII (1601–1643) seems to have been so indifferent to *Mona Lisa*'s charms that in 1625 the young monarch considered swapping the painting in a two-for-one deal with King Charles I of England for a Titian and a Holbein. His ministers, arguing that one of Leonardo's best pictures should not leave France, talked him out of the exchange.

The portrait's reputation rebounded. In a 1642 inventory of the *Treasures and Marvels of the Royal Household of Fontainebleau*, Père Dan, Father Superior of its monastery, described the portrait of "a virtuous Italian lady . . . Mona Lissa [*sic*] commonly known as *La Joconde*" as the *"premier en estime, comme une merveille de la peinture"* (the most esteemed work in the royal collection, a marvel of painting).

The next regent smitten by the Italian lady was Louis XIV (1638–1715), a sophisticated art connoisseur. The Sun King ordered *La Joconde* transferred to the bedroom of his new palace at Versailles. There, during his long reign, she watched his lovers come—and invariably go—as Louis retired paramour after paramour to convents. Only *La Joconde* remained in his favor.

Louis XIV's official historian, André Félibien des Avaux, was equally enamored. "I have never seen anything more finished or expressive," he raved. "There is so much grace and so much sweetness in the eyes and the features of the face that it seems alive. One has the impression that this is indeed a woman who takes pleasure in being looked at."

After Louis XIV's death, *Mona Lisa* lost that pleasure. Like his ex-mistresses, her portrait ended up cloistered—in her case in the office of the Directeur des Batiments (Keeper of the Royal Buildings) in Versailles. But the fall from grace may have been fortuitous. France was careening toward revolution.

Although I had already concluded that fewer than six degrees of separation come between Leonardo, the *Mona Lisa*, and any conceivable topic, I did not anticipate a link to the French Revolution, Marie Antoinette, and Benjamin Franklin. I found one in the story of the so-called *Vernon Mona Lisa*.

According to this colorful account, the court of the ill-fated King Louis XVI (1754–1793) boasted two versions of the *Mona Lisa*—the poplar panel and a canvas painting that hung in the chambers of Queen Marie Antoinette (1755–1793). We don't know if the queen thought it was an original Leonardo, but she singled the painting out for special care.

Sometime before her grim encounter with the guillotine in 1793, Marie Antoinette reportedly entrusted the portrait to a young American named William Henry Vernon—perhaps for safekeeping, perhaps as a gift for helping to save the life of her son, the Dauphin of France and heir to the throne.

Vernon was the son of a shipbuilder in the colony of Rhode Island who had amassed a fortune trading in rum, slaves, and molasses. During the American Revolution, the senior Vernon, head of the Continental navy board, befriended men such as George Washington, John Adams, and the French Marquis de Lafayette. After the war, he dispatched his son to Paris to learn French and acquire some old-world polish.

Young Vernon fell so deeply under Paris's intoxicating spell that he became a pomaded regular at the court of King Louis XVI. When the American's princely lifestyle plunged him into debt, the youth asked Benjamin Franklin, ambassador to France at the time and another of his father's influential friends, for a loan. Fearing for the young man's future, Franklin wrote to the elder Vernon, urging him to rescue his son from a misspent life.

"He will inevitably be lost, if he is suffered to remain longer at Paris," Franklin warned. "I would recommend your making the voyage yourself to reclaim and bring him home with you."

The prodigal son defied his father's urgent pleas that he return home and ended up briefly imprisoned during the French Revolution. He later traveled to England and Russia before returning to Rhode Island in 1797 with chests of brocaded finery and a superb collection of paintings at-

tributed to Michelangelo, Murillo, van Dyck, and other masters. He called his favorite *The Nun*, "a finished piece by Leonardo de Vincy [*sic*]."

When he told his relatives that he had acquired the work from Marie Antoinette, they seem to have been more shocked than skeptical. Some spinster aunts considered the French queen so wicked that they allegedly burned letters she had written to their nephew.

Vernon hung *The Nun*, his most cherished possession, in his bedroom. Family members reported seeing him kneeling before it with tears in his eyes. After his death his heirs auctioned off Vernon's entire collection. A relative bought *The Nun*, which passed from generation to generation as a family heirloom before consignment to a bank vault, where it remains to this day.

~

After the revolution, the citizens of France claimed the priceless art in royal palaces as their own. A government commission selected the finest paintings for transfer to a section of the ancient palace of the Louvre, the new home for "the people's art." The *Mona Lisa*, one of the last works chosen, arrived in 1797 but did not remain long.

This time a conqueror took a fancy to her. In 1800, Napoleon Bonaparte (1769–1821) had the portrait he dubbed "Madame Lisa" placed in his bedroom in the Tuileries Palace. In time, the Emperor would become infatuated with a young Italian woman who bore a remarkable resemblance to the lady in the painting—a possible granddaughter, generations removed, of Lisa Gherardini.

When she tells me this bit of family lore, the dark eyes of Princess Natalia Guicciardini Strozzi, of the current generation of Gherardini descendants, sparkle.

"Her name was Teresa Guadagni," she says with a smile, "but Napoleon called her *'la belle italienne.'*"

Wondering how their paths might have crossed, I delve into an obscure chapter of French history. In 1805, after the Senate of France set up the First French Empire, Napoleon appointed his younger sister, her Imperial Highness Élisa, to rule over a large part of the Italian peninsula as Duchess of Lucca, Princess of Piombino, and Grand Duchess of Tuscany.

In 1807, *La Madame*, as her Italian subjects called her, set up the Institut Élisa, a school for noble-born girls created to produce well-educated, refined wives, and recruited the fairest of local aristocratic daughters to serve as "dames-in-waiting."

Among them was Teresa Guadagni, who was born in 1790 and probably joined the court as a teenager. She may have caught the Emperor's eye in Paris, which his sister visited regularly with her entourage. Despite Napoleon's ardent pursuit, Teresa resisted his advances. In 1810, Napoleon divorced his first wife, Josephine, and wed Marie-Louise Habsburg of Austria. Five years later he was defeated at Waterloo and exiled.

La Madame Élisa Bonaparte, arrested and briefly imprisoned, was allowed to stay in a country house near Trieste. Her former attendant Teresa Guadagni married an Italian count. Decades later her son Adolfo reportedly sold the portrait of Lisa Gherardini that had long been in the family to pay his debts. The Gherardini descendants have no idea what became of it.

As Napoleon's agents plundered Europe's museums and libraries, French scholars developed an Italian obsession of their own: Leonardo da Vinci. Milan's Ambrosiana Library alone relinquished fourteen volumes of drawings and writings, all in the painter's unmistakable mirror script. Conservators in the Louvre pounced on the pages and began classifying, studying, and copying.

As the unknown Leonardo—the scientist, the engineer, the naturalist, the universal genius—emerged from their research, he became a cult figure, celebrated less for his artworks, many unfinished, damaged, or lost, than for his restless, inquisitive, free-ranging "modern" mind. The French proudly claimed "Léonard de Vinci" as their own, an adopted son whose genius only they truly appreciated.

By 1815, "Madame Lisa" had returned to the Louvre, a place unlike any of her former residences. In its storied past, this medieval fortress had served as the setting for trials, coups, revolutions, hangings, assassinations, assaults, and royal weddings. For many years prostitutes plied their trade in its shadows. Artists worked and lived on the premises with their

families, hanging out laundry on clotheslines and cooking on open stoves in the courtyard. Napoleon reportedly ousted them for fear they would set fire to the palace.

After three hundred years as the exclusive property of a privileged few, the *Mona Lisa* moved into the public eye. At first she seemed just another pretty face. In 1840, experts calculating the market value of every painting in the Louvre set the worth of "*La Joconde*, wife of Francesco del Giocondo," at 90,000 francs—a relatively modest sum compared with 150,000 francs for Leonardo's *Virgin of the Rocks* and 600,000 francs for Raphael's *Holy Family*.

The portrait's fame spread mainly through copies by artists who set up easels in the Louvre and reproduced the works of great masters. Between 1851 and 1880 (when photography revolutionized the distribution of images), artists painted the *Mona Lisa* seventy-one times—an impressive number, but far less than works by other Italian artists such as Veronese and Titian.

Leonardo's lady did inspire one man's singular devotion. The great Italian engraver Luigi Calamatta dedicated twenty eye-straining years to the first exact engraving of the portrait. Copies of his immensely popular work, completed in 1857, spread Lisa's image throughout Europe.

The timing was perfect. The world was falling in love with love, and no place throbbed with more giddy infatuation than Paris. To the Romantics of the late nineteenth century, Lisa's became the face that launched a thousand fantasies. Suitors bearing flowers, poems, and impassioned notes climbed the grand staircase of the Louvre to gaze into her "limpid and burning eyes." Essayists agonized over Leonardo's *femme fatale*. Was she Madonna or whore? Mother or temptress? Seductress or seduced? Innocent or irresistible? What lay behind the magical woman's magical smile?

"Lovers, poets, dreamers go and die at her feet," a French curator wrote in 1861. He wasn't exaggerating. In 1852, the artist Luc Maspero threw himself from the fourth-floor window of his Paris hotel, leaving a farewell note that said, "For years I have grappled desperately with her smile. I prefer to die."

The art critic Théophile Gautier, smitten by "the sensuous, serpen-

tine mouth" that made viewers feel as timid as "schoolboys in the presence of a duchess," called *Mona Lisa* "the sphinx of beauty."

"Beware, *La Gioconda* is a dangerous picture," warned the stricken French historian Jules Michelet. "The painting attracts me, revolts me, consumes me. I go to her in spite of myself, as the bird to the serpent."

The English author Walter Pater took the Romantics' obsession to greater heights—or depths—in his influential book *The Renaissance*. "Hers is the head upon which all the ends of the world are come," he sighed, "a beauty wrought out from within upon the flesh, the deposit, little cell by cell, of strange thoughts and fantastic reveries and exquisite passions. . . . She is older than the rocks among which she sits; like the vampire, she has been dead many times, and learned the secret of the grave."

Drowning in torrents of purplish prose, I couldn't even recognize the Lisa Gherardini I had come to know in Florence. What would she have thought of the overwrought declarations? The virtuous, modest, principled Renaissance woman would have been horrified.

To restore my sense of *la donna vera*, I head to the Palazzo Strozzi, the architectural marvel begun in 1489 when Lisa was ten. It seems only fitting that this landmark should house the Biblioteca dell'Istituto Nazionale di Studi sul Rinascimento, a unique collection of writings from and about the Renaissance.

Its rooms, lined with books from floor to ceiling and lit by sunlight streaming from high beveled windows, smell like old leather and musty paper. My footsteps echo in the silence as I climb an open staircase to an upper-level balcony containing works on Leonardo.

Crouched in the narrow aisle, I browse through one worn book after another, not exactly sure what I am seeking. Then I spy a thin, pink-covered monograph titled *Leonardo da Vinci e La Gioconda*, published in Florence about a century ago as a gift (*in dono*) to buyers of an artistic reproduction of *La Gioconda* (price: 2 lire).

"*Interessantissimo!*" the back cover proclaims. Most interesting! And it is. Many of the factual statements about Lisa, such as the claim that she was a Neapolitan aristocrat, have since been disproved. But I discover in

its yellowed pages an excerpt from a novel by the Russian writer Dmitri Merejkowski, *Il Romanzo di Leonardo da Vinci*, an international bestseller translated into Italian around 1900.

At first I merely plod through Merejkowski's ponderous philosophizing. However, as I read his evocative descriptions of the interaction between Leonardo and Lisa, I wonder if I may have stumbled upon some of the deeper truths that only fiction can reveal.

In the Russian's narrative, Lisa does not sit passively and patiently as Leonardo reproduces her features. Rather, she works intensely to communicate the deepest and truest of feelings so his brush can capture the motions of her mind and the passions of her soul. As partners in the creative process, artist and model forge a bond so intimate that they understand each other almost without words.

Through what Merejkowski describes as their "profound and mystic caresses," Leonardo and Lisa bring forth "an immortal image of a new being . . . born of them both, even as a child is born of its father and mother." The process transforms Lisa, "the most ordinary of mortals," into "a changeling, a feminine double of Leonardo himself." This similarity has less to do with facial features than with the expression in the eyes and the smile. Especially the smile.

Their story does not end happily. Lisa leaves to travel with her husband to southern Italy. In a touching farewell scene, Leonardo grasps her hand and, for the first time, presses it to his mouth, as she brushes the top of his bent head with her lips. Lisa dies unexpectedly on the trip, and they never see each other again.

When a devastated Leonardo returns to his easel, he sees in the portrait the essence of Lisa Gherardini, as if he had stolen the spirit of the living woman to bestow upon her image. "The mystery of the universe," he concludes, "was the mystery of Mona Lisa."

In real life, ever stranger than fiction, the mystery deepened.

"*La Joconde, c'est partie!*" (The *Mona Lisa* is gone!) a guard at the Louvre gasped in horror on Tuesday, August 22, 1911. Only four iron hooks framed by a ghostly rectangular shape hung in her place on the wall. Since the mu-

seum was closed Mondays, no one had noticed her departure. The frame was found unmarred in a stairwell, as if the Florentine lady had emerged from it, in one chronicler's words, "as effortlessly as a woman stepped out of her petticoats."

In an instant *La Joconde* became the most wanted woman in the world, transformed from a missing masterpiece to a missing person. News of the sensational "*affaire de La Joconde*," traveling as fast as telegraph and cable could carry it, captivated millions, including many who had never heard of the portrait. Tabloids churned out reams of copy on the painting and its seductive model. The public responded as emotionally as they might to an abduction or kidnapping.

When the Louvre reopened on August 29, grieving Parisians lined up to view the blank space, which *Le Figaro* described as "an enormous, horrific, gaping void." Visitors in record numbers left flowers and wept. Guillaume Apollinaire, a flamboyant poet and cultural provocateur who had once called for the burning of the Louvre, was arrested as a suspect. The police hauled in his friend the Spanish painter Pablo Picasso, working in Paris at the time, for questioning.

Gone missing from the heart of Paris, the *Mona Lisa* popped up almost everywhere else. I can't help but think of the reports of its whereabouts as artistic Elvis sightings. The portrait was seen crossing the border into Switzerland, hopping a freight train for Holland, boarding a steamer for South America. One witness placed it in a private gallery in St. Petersburg; another, in an apartment in the Bronx. Long before the technology existed for her image to go viral, *Mona Lisa*'s smile—like the Cheshire cat's—seemed to materialize from thin air on kiosks, billboards, and magazine covers.

More than two years passed, and the hubbub died down. The Louvre removed the *Mona Lisa* from its catalogue and hung Raphael's portrait of the courtly author Baldassare Castiglione, the friend and admirer of Giuliano de' Medici, in her place.

Then, on November 29, 1913, Alfredo Geri, an antiques dealer with an upscale shop on Via Borgo Ognissanti in Florence, received a letter

postmarked from Paris and signed "Leonardo." The writer—and the unlikely perpetrator of "the heist of the century"—was an Italian named Vincenzo Peruggia, a thirty-two-year-old amateur painter who had occasionally worked as a handyman at the Louvre. Deftly removing the painting from the frame he had helped construct, he hid it under his coat and carried it out of the building.

"The stolen work of Leonardo da Vinci is in my possession," the note read. "It seems to belong to Italy since its painter was an Italian. My dream is to give back this masterpiece to the land from which it came and to the country that inspired it." Skeptical, Geri brought the letter to Giovanni Poggi, director of the Uffizi, who advised him to request a chance to inspect the painting in Florence before making an offer.

On December 10, a short, dark-complexioned man, not more than five feet three, with pomaded hair and a handlebar mustache waxed at the tips, checked in to the Albergo Tripoli-Italia, a shabby cut-rate hotel on Via Panzani not far from the train station in Florence. The hotel, renamed La Gioconda in honor of its sole claim to fame, has spruced up since then. In the cramped lobby I inquire about the room where *La Gioconda* was found. No. 20 is occupied, the weary-eyed desk clerk informs me, but I can walk up if I want.

On the way I imagine "Leonardo" leading portly Geri and dignified Poggi up the same steep stairs. On that distant day, the thief ushered them into his room and locked the door. Wordlessly dragging a wooden case from under the bed, he heaved it onto the rumpled sheets and dumped out woolen underwear, shirts, shoes, and other "wretched things," as Geri put it, to reveal a false bottom. Under it was a package bundled in red silk.

"To our amazed eyes, the divine *Gioconda* appeared intact and marvelously preserved," Geri reported. "We carried it to a window to compare it to a photograph we had brought with us. Poggi studied it and we had no doubt the painting was authentic." Closer examination would reveal a bruiselike discoloration on one cheek and a small scratch on her left shoulder. Otherwise the *Mona Lisa* was in remarkably good shape for a four-hundred-year-old who had spent two years in cheap rooms in Paris before hopping a train to Florence.

The Uffizi's Poggi insisted on taking the portrait back to his museum to compare it with other works by Leonardo. Peruggia, who expected the Italian government to pay him 500,000 lire—about $2.14 million today—for the "great service rendered," remained in his room. Within the hour, police hammered on his door. Waking from a nap, the clueless thief accompanied them without protest, confident that he soon would be released, rewarded, and hailed as a hero.

Diagnosed by a court psychiatrist as "mentally deficient," Peruggia embellished his story in repeated tellings. At first he claimed patriotism as his sole motive. But as he warmed to his tale, the art thief claimed that he had been "bewitched" by *la Gioconda*: "I fell victim to her smile and feasted my eyes on my treasure every evening, discovering each time new beauty and perversity in her. I fell in love with her."

At the trial on June 4, 1914, the French, embarrassed by their poor security and botched investigation, did not press for harsh punishment. His defenders portrayed Peruggia as a simple working stiff in a hostile country where he was mocked as a *"macaroni,"* his tools stolen and his wine salted. His initial sentence of a year and fifteen days was reduced to seven months and nine days. With time served, Peruggia was released immediately—so penniless that he turned his pockets inside out as he left the courthouse.

Peruggia's hometown of Dumenza in Lombardy welcomed him as a hero. During the First World War, he joined the Italian army and served honorably, then married, moved back to France, had a daughter, and opened a nursery in Haute-Savoie. He died on October 8, 1925, his forty-fourth birthday, of a heart attack.

Even today, theories persist that his theft was part of an elaborate scheme to pass off forged copies of the *Mona Lisa* as the stolen original. But in 1913, Italians were just happy to have their long-lost daughter home.

Although many in Florence hoped that "their" Lisa would remain in residence, the Italian government immediately began arrangements to deliver

the painting to the French—and to do so "with a solemnity worthy of Leonardo and a spirit of happiness worthy of *La Gioconda*'s smile." But for an exhilarating two weeks, *La Gioconda* was Italy's to enjoy.

On December 14, flanked by an honor guard and *carabinieri* in full dress uniform, Leonardo's lady, displayed in an ornate sixteenth-century frame, was carried through the corridors of the Uffizi in reverent silence. Soldiers saluted; men doffed their hats; women made the sign of the cross. *La Gioconda* was placed on a velvet-draped dais between two of Leonardo's earlier masterpieces, the *Annunciation* and the *Adoration of the Magi*. A crowd of more than 30,000 swept past the guards and mobbed the museum in a wild rush to see her.

After five days (the last reserved for schoolchildren and their teachers), *La Gioconda* traveled in a custom-fitted padded rosewood box in a private parlor car to Rome and a viewing by King Victor Emmanuel. On December 21, 1913, at a solemn ceremony befitting a coronation, *Mona Lisa* officially took up residence in the French embassy in the Palazzo Farnese. During her Roman holiday, the Queen of Italy, the Queen Mother, and the entire diplomatic corps came to call. *La Gioconda* then went on display for five days in the elegant Villa Borghese.

From Rome the painting traveled to Milan's Brera Gallery, which stayed open until midnight on her final night to accommodate a crowd of 60,000. A commemorative medal bore a likeness of Leonardo and an inscription: "May her divine smile ever shine." Then *La Gioconda* left Italy aboard a private railway car on the Milan–Paris express, never to return.

Paris welcomed back its adopted daughter with characteristic élan. Her image beamed from posters and banners. As an homage, society women adopted the "*La Joconde* look," dusting yellow powder on their faces and necks to suggest her golden complexion and immobilizing their facial muscles to mimic her smile. In Parisian cabarets, dancers dressed as *La Joconde* performed a saucy can-can.

After a thorough checkup by experts at the École des Beaux-Arts, art's most notorious woman was ready for her grand entrance. In grainy black-and-white photos in digitized newspapers of January 4, 1914, I see the ecstatic faces of Parisians lining the streets to cheer the portrait as it rode in a gala procession to the Louvre. In her first two days back on ex-

hibit, 120,000 visitors streamed to view *La Joconde*—so many that the museum temporarily set aside a gallery all her own.

But something beyond the painting's wild popularity had changed. The *Mona Lisa* had left the Louvre a work of art; she returned as public property, the first mass art icon. Anyone could say anything about her, do anything with her image, recast her in every possible way—and they did.

In 1919, Marcel Duchamp, who claimed that art could be made of anything (including a urinal), painted a mustache and a goatee on a monochrome postcard of the *Mona Lisa* and called it L.H.O.O.Q. (letters which, when spelled in French, sound like slang for "She's got a hot ass"). He was the first of a long string of twentieth-century artists—including Dalí, Léger, Magritte, Rauschenberg, and Andy Warhol—who couldn't resist taking liberties with Madame Lisa.

The *Mona Lisa* slipped out of sight again just before World War II. In 1939 the French spirited the painting to a series of safe houses, all equipped with central heating to keep the ambient temperature constant. Over the course of several years she was moved to the château at Amboise, adjacent to Leonardo's former home; the Abbey of Loc-Dieu; and the Ingres Museum in Montauban.

Even out of view, the *Mona Lisa* remained on people's lips. The British used a coded message—*La Joconde garde un sourire* (The *Mona Lisa* keeps her smile)—to contact the French Resistance. The portrait returned to the Louvre in October 1947, two years after the war's end.

Soon the world started singing her name. The songwriters Jay Livingston and Ray Evans composed a tune I still can't get out of my head. First sung by Nat King Cole in an eminently forgettable film called *Captain Carey USA*, "Mona Lisa" won the Academy Award for Best Original Song and became the top-selling record of 1950. Several generations of crooners—from Bing Crosby to Elvis Presley to Tom Jones to Michael Bublé—have since asked, "Are you warm, are you real, *Mona Lisa*? Or just a cold and lonely, lovely work of art."

The lovely work also came under attack. In 1956 a vandal threw acid at the lower part of the painting; later that year a young Bolivian flung a

rock, chipping a speck of pigment on the left elbow. Protective glass has kept the painting safe against more recent missiles, including a terra-cotta mug, purchased at the Louvre gift shop and heaved at the painting by a Russian woman distraught over being denied French citizenship. The attacks, art critics theorize, may stem from the same source as the adulation: the passion that Leonardo's painting provokes.

With the dawning of a new global age, the *Mona Lisa*, as France's cultural ambassador, began touring like a rock star. In 1962 two masters of politics and promotion—French president Charles de Gaulle and his minister of culture, André Malraux—orchestrated a high-profile journey. Despite strenuous objections from curators at the Louvre, Leonardo's lady sailed for the New World discovered by Columbus when Lisa Gherardini was a girl of thirteen.

The *Mona Lisa* traveled in style. With a $100 million insurance policy (today's equivalent: approximately $608 million), the portrait settled into her own first-class cabin on the S.S. *France*, with security guards on one side and nervous Louvre conservators on the other. Outfitted in a custom-made 350-pound airtight, floatable, temperature-and-humidity-controlled container constructed of steel alloy and padded with Styrofoam, she was without doubt the safest passenger on the luxury liner.

The director of the National Gallery of Art and a Secret Service contingent met the French delegation at the dock in New York. For the trip to Washington, D.C., the portrait rode in a modified ambulance padded with foam rubber. The National Gallery anticipated every need. Because of concern about changes in atmospheric pressure, its air-conditioning system was modified to simulate the very air *Mona Lisa* "breathed" in Paris.

President John F. Kennedy welcomed the illustrious visitor with honors usually reserved for a head of state. "The life of this painting," he noted, "spans the entire life of the New World. We citizens of nations unborn at the time of its creation are among the inheritors and protectors of the ideals which gave it birth." Visitors snaked in long lines down the National Mall to pay homage to "this great creation of the civilization which

we share, the beliefs which we protect, and the aspirations toward which we together strive."

The painting traveled to New York's Metropolitan Museum of Art for a sold-out, monthlong engagement. In a single week some 250,000 visitors came, each pausing, by *The New Yorker*'s estimates, an average of four seconds to gaze upon the work that had taken Leonardo so many years to create. By the end of *Mona Lisa*'s American tour, more than 1,600,000 people had laid eyes on the portrait.

Searching for coverage of the visit in the archives of *Life*, the most popular magazine of the day, I came upon another familiar face: the so-called *Vernon Mona Lisa*, which the family had become convinced was a Leonardo original. In 1964 the painting went on display at the Otis Art Institute in Los Angeles.

According to the *Life* report, the Vernons were willing to sell their heirloom—at an asking price of some $2.5 million. With no buyers, the *Vernon Mona Lisa* returned to its New Jersey bank vault. Experts have come to regard the painting as an excellent copy, probably painted by a seventeenth- or eighteenth-century French artist.

Once the French had their original *La Joconde* safely back in the Louvre, its curators swore she would never again leave their protective custody. But in 1974, *Mona Lisa* turned jet-setter, flying halfway around the world from Paris to Tokyo. To avoid any change in pressure during the flights, her aluminum travel case was encased in a protective steel container.

Tokyo went mad for *Mona Lisa*, displaying the portrait like a sacred relic and allowing each visitor ten seconds of one-on-one viewing. In Russia, visitors also flocked to view the portrait, but their responses were more muted. "A plain, sensible-looking woman," opined Communist leader Leonid Brezhnev.

~

These journeys capped what some call the "Frenchification" of *Mona Lisa*. No painting by a French artist could have matched her celebrity status, but at first I found it odd that France would send as a symbol of its artistic patrimony a portrait of an Italian lady by an Italian painter. Then I realized that the *Mona Lisa* had transcended geographical borders. Like

the Eiffel Tower, the Taj Mahal, or the Great Wall of China, the portrait had risen to the stratosphere of world wonders, something that everyone everywhere, from any country or culture, could appreciate.

Beginning in 2004, the year after her official five hundredth birthday, under the auspices of the Louvre and the Centre de Recherche et de Restauration des Musées de France, Madame Lisa underwent the most extensive battery of technological examinations ever performed on a painting. The goal, Louvre director Henri Loyrette explained, was "to lift part of the veil of mystery that covers this work."

In *Mona Lisa: Inside the Painting*, the oversize volume that details the findings, I peruse images of the *Mona Lisa* as she had never before been seen, including X-rays, infrared and multispectrum photographs, and ultraviolet fluorescence scans. In many, Lisa appears as a colorful abstraction or ghostly apparition, but I am captivated by an infrared reflectograph, which penetrates opaque pigments to reveal how the painting looked at an earlier stage.

Two full-page blowups provide "before" and "after" images of Lisa. In the reflectograph, her face appears stolid and square, her features heavy, her cheeks thick, the grain of her skin irregular. In a photograph of the finished painting, Lisa's face has rounded into an oval, with delicate features and gleaming skin. The astounding difference testifies to how Leonardo, with his multitude of brushstrokes, made Lisa beautiful. I imagine him as an old man, squinting at the portrait and leaning close to add yet another minuscule daub to his creation.

In another innovative evaluation, Parisian engineer Pascal Cotte, founder of Lumiere Technology, used an ultrapowerful "multispectral" camera to create a digitized image of the painting. Working with some 240,000,000 pixels, his team of experts removed—virtually, in every sense of the word—centuries of time-stained varnishes to reveal brighter colors, a more animated face, and a lusher background.

Photos made with conventional cameras of the *verso*, or back side, of the *Mona Lisa* portray a very different image: a humble, faded piece of wood. At the upper right is a centuries-old crack with some simple strips of tape crossing it in a T shape. Despite this fissure, experts consider the portrait, though darkened and dirty, in remarkably good shape.

The Louvre is determined to keep her that way. When spring comes to Paris and the air in the museum approximates ideal levels of heat and humidity, *Mona Lisa* is freed from her frame to undergo an annual checkup. More than two dozen analysts scrutinize the work, checking for everything from any expansion or contraction of the poplar panel to a return of the wood-eating deathwatch beetles that infected one of her earlier frames.

For the rest of the year, Madame Lisa hangs in splendid isolation in a remodeled chamber behind sheets of bulletproof, triple-laminated, non-reflective glass that maintain the temperature at a constant 55 degrees Fahrenheit. The most-visited attraction in the most-visited museum in the world regally greets a stream of visitors who bathe her in a continuous blitzkrieg of camera flashes. From all countries, speaking all languages, men, women, and children come for the simplest of reasons: to view the most famous painting in the world.

I was no different.

When I first saw the *Mona Lisa*, smaller and darker than I'd expected, on a breathless dash through the Louvre many years ago, I didn't know that Lisa Gherardini even existed. After a few moments of contemplation, my husband and I trudged on through what seemed like mile upon mile of masterpieces. Collapsing at the exit in a state of complete aesthetic exhaustion, I couldn't resist saying, "This is one hell of a goddamn museum!"

When I return for a more leisurely visit, "she" notices. Like many other visitors, I experience the unnerving sensation—an optical illusion, some say—of Lisa beholding me while I stare at her. Her gaze seems knowing; her eye, discerning. This is a woman who thinks, I realize, although she keeps her thoughts to herself.

Standing in front of the portrait, I "feel" as well as see *Mona Lisa*. What I sense is an appeal beyond mere beauty: Womanly wisdom. Sisterly warmth. Quiet strength. Tender compassion. Profound serenity. Sly wit. Just a smidgen of mischief. And, ah yes, mystery.

I smile back at her.

Chapter 15

The Last Smile

Whenever I return to Florence, I yearn for a place where I might honor the memory of its best-known daughter. There is none. Not rancid Via Sguazza, where Lisa Gherardini was born. Not nondescript Via della Stufa, where she lived most of her adult life. And certainly not the urban eyesore that her final resting place, the Monastero di Sant'Orsola, has become.

The convent where Lisa Gherardini passed her final days did not survive Napoleon's invasion and the deconsecration of thousands of religious institutions. Beginning in the 1800s, it underwent a series of transformations, from tobacco-processing plant to lecture hall for the University of Florence. In the 1980s, the city police department, planning to convert its structures into barracks, began excavations for a garage. Bulldozers pancaked several buildings, and land movers hauled bricks and stones, along with graves from a cemetery on the grounds, to a municipal landfill. When the city abandoned its plans for the site, Sant'Orsola deteriorated into a hulking, boarded-up, graffiti-smeared ruin.

In recent years, reporters from around the world have descended upon the abandoned convent in search of Lisa Gherardini—or rather, of her remains. A self-styled art detective named Silvano Vinceti, head of the official-sounding National Committee for the Promotion of Historic and Cultural Heritage, organized excavations of an underground crypt. In 2012, under the floodlights of dozens of international television crews, Vinceti dramatically announced the discovery of several skeletons stacked, as was the custom, one atop the other.

Do any of these bones belong to Lisa Gherardini? No one knows. Hundreds of women lived and died at Sant'Orsola over the centuries, and Lisa's body may have been among those dumped in the local landfill rather than interred in the chapel crypt.

~

Several years ago I spent an autumn day with Vinceti, a skinny, bald, fast-talking former television announcer and producer. When I asked what he thought were the odds of identifying Lisa's remains, he estimated 40 percent—without explanation of how he arrived at this figure. I'd put them considerably lower.

Carbon dating of the badly disintegrated bones could identify which skeletons, if any, date back to the sixteenth century. However, confirmation that any remains are indeed Lisa Gherardini's also requires DNA to match with a known blood relative.

The primary candidate was Lisa's oldest biological son, Piero, buried in Santissima Annunziata in 1569. In 2013 investigators lowered themselves into the subterranean chamber and broadcast spooky images of crumbling skeletons on a stark stone shelf. Some may belong to the family that took possession of the crypt after the del Giocondo; others may date back to the ancestors Francesco had transferred from Santa Maria Novella.

If they had been able to identify one skeleton as definitively that of Piero del Giocondo, scientists would have been able to compare his DNA to any samples they obtained from Sant' Orsola. A match would have confirmed if any bones belong to Lisa Gherardini. However, the analysts were unable to procure DNA for a definitive identification.

Italian art historians scoff at the entire endeavor, especially the ghoulish bringing up of bodies. "*Sgradevole, orrenda, e macabra* (Distasteful, horrible, and macabre)!" declared Antonio Paolucci, the esteemed director of the Vatican Museums. "*Lasciate in pace La Gioconda!*" (Leave *Mona Lisa* in peace!)

That's not likely to happen.

~

Neither the dubiousness of his quest nor the disdain of his critics fazes Vinceti, a self-taught art expert with an uncanny knack for generating publicity. In 2010 he announced, with global fanfare, the discovery of the remains of the artist Caravaggio—a finding that was immediately disputed by experts.

In 2011, the amateur sleuth, who has never had access to the original *Mona Lisa*, claimed that a digital copy reveals the letters *L* (perhaps for Lisa, he suggests) and *S* (perhaps for Leonardo's assistant Salaì) in the pupils of Lisa's eyes and the number 72 in the background. The Louvre, which has examined the painting with every known imaging technique, declared categorically that "no inscriptions, letters, or numbers" exist. Vinceti's rebuttal: The Louvre's curators are too embarrassed to admit they have been "really blind." (I too could discern nothing other than random scratches in the enlargements of digital copies of the painting that he showed me.)

In another claim, Vinceti declared that, as one newspaper put it, "Mona Lisa Was Really a Dude"—the alluring Salaì, who may have been Leonardo's lover as well as the model for *St. John the Baptist*. Vinceti bases this assertion on the similarities in the smiles of the figures in the two paintings, the hidden numbers, and a tangle of theories involving Kabbalah, an ancient Hebrew mystical school of thought.

Struggling to follow Vinceti's train of thought as well as his bullet-speed Italian, I have to force myself not to shake my head in incredulity. But theories of all sorts come with Leonardo territory.

Consider Lisa's ubiquitous smile. Dentists have blamed aching or missing teeth for her tight-lipped grin—although no proper Renaissance lady would have parted her lips in a public display of good cheer. Doctors have diagnosed deafness (which supposedly caused Leonardo's model to tip her head and smile expectantly), pregnancy (also blamed for Lisa's "swollen" fingers), an enlarged thyroid, fat deposits caused by high cholesterol, and a type of facial paralysis called Bell's palsy. The most scurrilous theory claims that Lisa smiled with closed lips because mercury, a treatment for venereal disease, had damaged her teeth.

More recently, neuroscientists have chimed in with their observations. Because of our optical wiring, one explains, we may be better able to see Lisa's smile with a sideways glance than with a straight-on stare. Others claim that "random noise" in the path from retina to visual cortex influences whether or not we detect an upturned mouth. But is the expression on Lisa's face a smile or a smirk? In a computerized analysis, "emotion recognition" software appraised Lisa's smile as 83 percent happy, 9 percent disgusted, 6 percent fearful, about 2 percent angry, and less than 1 percent neutral.

"Neutral" would not apply in the smallest of degrees to the advocates of various "contenders for the seat on the loggia," as an art historian categorizes the many *Mona Lisa* wannabes. It doesn't matter if the proposed candidates happen to be too old, too young, too ugly, or too preposterous. Their proponents contend, in prose often punctuated with entire battalions of exclamation points, that they alone have uncovered the unmistakable, unshakable truth about Leonardo's muse—in skull measurements, in embroidery knots, or in plots as intricate as *The Da Vinci Code*'s.

Yet the heated debates about the origins of Lisa's smile and the true identity of the woman in Leonardo's portrait pale in comparison with the controversy over whether more than one *Mona Lisa* exists.

Artists may have begun copying the *Mona Lisa* while Leonardo was still working on the painting. Some of the estimated sixty to seventy reproductions in existence are such exact clones that they have duped even learned authorities. Sir Joshua Reynolds (1723–1792), the distinguished artist, collector, and first president of Great Britain's Royal Academy of Arts, was so convinced of the authenticity of the *Mona Lisa* he received in exchange for one of his self-portraits that he argued that the Louvre painting was a fake.

One of the oldest known copies made its way to Madrid's Prado Museum. At some point an artist painted the background black, perhaps to match other portraits displayed nearby. A few years ago a skillful restorer laboriously removed the dark coating to reveal bright colors, a richly detailed background, and a fetching young model (whose face bears no

resemblance to the *Mona Lisa*'s). Studies with sophisticated imaging techniques reveal the same shifts in the model's position that appear under the surface of the Louvre painting.

This Lisa, like several other copies, may bear more resemblance than the lady in the Louvre to the description provided by Giorgio Vasari in his biographical essay on Leonardo. In words that practically caress Lisa's face, he praised eyes with "that luster and watery sheen which are always seen in life, and around them all those rosy and pearly tints, as well as the lashes" and eyebrows that "could not be more natural." Her "beautiful nostrils, rosy and tender, appear to be alive." The mouth, "united by the red of its lips to the flesh-tints of the face, seems to be not colors but flesh."

Some experts blame the discrepancy between Vasari's description and the actual *Mona Lisa* on the dulling of the paints and varnishes over time or on the less-than-reliable eyewitnesses who described the masterpiece to him. Others suggest a different possibility, too provocative not to consider.

Leonardo, according to this scenario, may have painted another portrait of Lisa—not a complete work, but her face and parts of her figure, leaving assistants to finish the rest. At some point he may have presented this work to Lisa and Francesco del Giocondo. If so, this might have been the painting that Giorgio Vasari himself saw in Florence and described in minute detail.

The two–*Mona Lisa* theory has been around a long time. In 1584, in his *Treatise on Painting*, the Florentine artist and chronicler Giovanni Paolo Lomazzo, a supposed acquaintance of Leonardo's longtime secretary Melzi, wrote that "the two most beautiful and important portraits by Leonardo are the *Mona Lisa* and the *Gioconda*."

We know that one of these works ended up in the Louvre. If the other one existed, where did it go?

❧

Great Britain is one guess, although no one can supply the when, where, and how of its transport. In 1913, a certain Earl Brownlow in Somerset discreetly let it be known that he might be willing to part with a purported Leonardo that had long been in his family's possession. Hugh

Blaker (1873–1936), a dapper British painter and art dealer searching for years for the almost mythical "second" *Mona Lisa*, was eager to see it.

As soon as he beheld the portrait in the aristocrat's stately home, Blaker later reported, he was sure it was a Leonardo. Heart pounding, he struggled to disguise his excitement as he negotiated its purchase "for a modest sum." The art dealer brought the prized work to his home and studio in Isleworth, just outside London, where it became known as the *Isleworth Mona Lisa*.

"The *Mona Lisa* is perfectly beautiful . . ." Blaker wrote to his sister Jane. "I think there is big money in it. I am sure it was done in Leonardo's studio before the Louvre picture was finished as the background is entirely different and two columns, of which the bases are just showing in the original (sic!), run up each side of the painting. . . . Therefore it is NOT A COPY as we understand the term. . . . It is indeed a capture."

With war clouds gathering over Europe, Blaker shipped his newly acquired treasure to safety in Boston's Museum of Fine Arts, where it hung in the administrative offices. In 1922, John Eyre, Blaker's father-in-law and a respected art collector, took the portrait to Italy for assessment by some of the leading Leonardo experts of the time.

"*Che bella! Che bella! Che bella!*" one enthused. "The best *Mona Lisa* I have seen except the Louvre," said another. Most agreed that Leonardo may have painted the face and hair, while another artist or artists completed the throat, hands, and background. Despite these endorsements, all based on "connoisseurship," or subjective appraisal, Eyre and his son-in-law never succeeded in establishing the portrait as a genuine Leonardo.

"I leave her intrinsic beauty and enigmatic smile to bewitch and puzzle her admirers," Eyre wrote as "an old and ailing man."

"Bewitch" she did. In 1936, a British art enthusiast, Henry F. Pulitzer, walked into the private Leicester Galleries in Isleworth, took one glance at the painting, and lost his heart. "This is the story of a great love which has not changed in thirty years since I first met the lady," Pulitzer wrote in his book, *Where Is the Mona Lisa?*, self-published in 1966.

The Leonardo aficionado had seen every known work by the artist

and assembled a vast library on every facet of his life. Like a pilgrim, Pulitzer returned frequently to the Louvre to spend hours in front of Leonardo's great lady. But, he confessed, it "failed miserably to evoke in me the joy and deep satisfaction I had felt in front of the *Mona Lisa* in the Leicester Galleries."

Pulitzer, through what he calls "a most improbable combination of circumstances," managed to purchase the *Isleworth Mona Lisa* in the 1960s. A "Swiss syndicate" underwrote part of the investment. To come up with his share, Pulitzer had to sell his grand house in Kensington, all of its furnishings, and many of its paintings.

"To realize this dream," he wrote, "no sacrifice was too much."

Pulitzer hung the painting in his drawing room and, according to a long-term companion, "practically lived in that room, even had his meals there, just so he could be with his *Mona Lisa*." Although the art world never overcame its skepticism, Pulitzer remained a believer to the end.

"I may not be here on earth when the final verdict is passed," he wrote. "That is of no importance. . . . A great work of art continues eternally in giving joy and happiness to others who come after me." But for decades after his death, no one could take any delight in Pulitzer's adored lady, locked away in a bank vault in Switzerland.

Then along came a twenty-first-century version of Snow White's prince. The privately funded Mona Lisa Foundation, which promotes research on the painting it has renamed the *Earlier Version*, set out to revive Pulitzer's sleeping beauty, not with a kiss, but with cutting-edge technology that its directors hoped would prove what had so long seemed unprovable: that Leonardo had painted this portrait as well as the Louvre's *grande dame*.

Over the course of several years, at a cost of an estimated $1 million, international experts evaluated the *Mona Lisa*'s "younger sister" with techniques similar to those that the Louvre portrait has undergone, including X-rays, multispectral digitization, and high-definition imagery. None of their findings, according to the Mona Lisa Foundation, could "disprove a Leonardo authorship . . . or lead one to doubt Leonardo's

hand." Yet all but one of the experts stopped short of deeming the portrait a Leonardo.

The exception was John Asmus, an American art diagnostician at the University of California, San Diego, who has studied the Louvre portrait as well as the *Earlier Version*. Scaling the two portraits—the Foundation's somewhat larger than the Louvre's, with columns on either side—to size, he found similarities he considers too precise to be coincidental in their geometry (the underlying triangles, elliptical outlines, and proportions), their histograms ("fingerprints" of light and dark shading), and the frequency of brushstrokes, measured in pixels. Subsequent tests by other experts have confirmed the geometrical similarities and demonstrated that the canvas itself dates from the late 1400s.

Academicians remain unconvinced. "So much is wrong—the dress, the hair, the background landscape," commented Martin Kemp, an emeritus professor at Oxford University and a leading Leonardo scholar. The artist rarely painted on canvas. The landscape lacks "atmospheric subtlety." The head "does not capture the profound elusiveness of the original." And the apparent age difference? "If her face appears younger," said Kemp, "it is simply because the copyist painted it that way."

Although the *Earlier Version* may be a copy—and the skeptics outnumber the believers, certainly in scholarly circles—I find her a charming one. The younger Lisa beams with a girlish glow, her face slimmer, her smile fuller, her eyes dancing with anticipation of the future gleaming before her. And she isn't staying in the shadows. The Mona Lisa Foundation has launched a yearlong global tour, beginning in the Far East, to let "the people" judge for themselves.

The people, in the most literal of senses, have already spoken. "Their" *Mona Lisa*, unframed and unfettered, reigns supreme as the queen of kitsch, caricatured, cannibalized, morphed, manipulated, multiplied, and mocked in countless spoofs. She has appeared in sunglasses, hair curlers, a burka, a kimono, a sari, a nose ring, Mickey Mouse ears, black boots, a Santa hat, a see-through blouse, and in nothing at all. The intrepid beauty has straddled a motorcycle and a mule, flashed her under-

wear, skateboarded, skied, smoked a joint, and engaged in a kinky array of X-rated activities.

What is it about this painting, more so than any other, that makes people want to transform it into something sensational, shocking, surreal, or just plain silly? I first mulled this question years ago when I was staying at the Hotel Monna Lisa on Borgo Pinti, a former fourteenth-century convent in central Florence. Every morning I would sip a cappuccino in a salon decorated with variations on the portrait: *Mona Lisa* smoking, *Mona Lisa* topless, *Mona Lisa* blond, *Mona Lisa* in Cubist form, *Mona Lisa* with Frank Zappa's bearded face.

The *Mona*s just keep coming. An exhibit at the Modern Eden Gallery in San Francisco in 2013 featured a roundup of recent spinoffs, including *Cona Lisa* (Lisa as a Conehead), *Mona Llama* (all animal from the neck up), *Mona Kahlo Frida Lisa* (complete with unibrow), *Mona Pagliaccio* (in clown face), and *Unicorn Mona* (with a little horn right in the middle of her forehead).

Illustrators never seem to tire of "Monalizing" famous faces, from Mao Tse-tung (*La Joconde Rouge*) to Hillary Clinton (and Monica Lewinsky) to President Barack Obama. But artists aren't the only ones who can't keep their hands off the Renaissance lady. She has shown up in Ray Bradbury's science fiction, Bob Dylan's lyrics, movies like *Mona Lisa Smile* (with Julia Roberts's megawatt grin), the Looney Tunes *Louvre Come Back to Me*, and a *Simpsons* episode featuring "Moanin' Lisa." "I feel like the frame that gets to hold the *Mona Lisa*," croons country singer Brad Paisley in a recent ballad. "And I don't care if that's all I ever do."

Hucksters have harnessed Leonardo's lady to sell toothpaste ("Mona Lisa discovers Rembrandt!"), deodorant (a brand called Old Masters), condoms (Gioconda Liquid Latex), cigars in Holland, rum in Martinique, matches in Argentina, milk in California (from a cow named Moo-na Lisa), and mouse pads, caps, candy, sugar bowls, magnets, drawer pulls, shower curtains, throw pillows, and coloring books just about everywhere. Not long ago an ad for a new "vaginal replenishment" product popped up on my computer screen. Its name: Mona Lisa.

In 2013, NASA, in its first test of a laser system for interplanetary communication, selected *Mona Lisa*'s image to transmit to the moon.

Why not? She's been everywhere and done everything else. Admirers have reproduced her face in toast, yarn, pasta, LEGOs, jelly beans, jewels, coffee cups, spools, and just about every other conceivable medium.

An iconic image, not a real woman, inspires the many forms of *Mona Lisa* mania. We can blame—or credit—Leonardo for its insane popularity. The painting is just that good, beyond all superlatives. But others also catapulted this particular work of genius to global notoriety: the king who brought its creator to France, the monarchs who enshrined the portrait in their bedrooms, the Romantics who raved about it, the painters who copied it, the thief who stole it, the legions who have manipulated it, the millions who have visited it.

Yet none of these would have come into play if not for *una donna vera* named Lisa Gherardini. Finally, her hometown is paying tribute to her existence.

Lisa Gherardini's childhood neighborhood in the Oltrarno has launched an annual celebration of June 15, her birthday, as "Monna Lisa Day." In her honor, banners flutter overhead. Artists display paintings inspired by her portrait. Musicians perform. Everyone dances in the local piazza. On Via Sguazza, a plaque now marks the place where Lisa was born and describes her return as a cause of *"gioia per lei e i fiorentini tutti"* (joy for her and all Florentines).

"It's about time," I thought when I first heard of the long overdue recognition of Florence's all-but-forgotten daughter. Yet "she" never left. Whenever I've visited the city over the last two decades, I have always managed to find her—in one form or another.

Once I watched a young Italian, his black curls pulled into a ponytail, create a billboard-sized *Mona Lisa* in chalk on the pavement of a pedestrian-only street. Tee-shirted tourists licked cones of gelato as he deftly outlined her figure and shaded her contours in vibrant hues. With the ease of a thousand repetitions, his fingers kept moving as he told me that, of all the masterpieces he paints to earn a few euro, she is his favorite.

"Perchè?" I asked. Why?

"*La Gioconda vive!*" (*Mona Lisa* lives!) the street artist replied.

So does her *giocondità*. My dictionary translates this archaic term as "cheerfulness," but I prefer an art historian's far more poetic definition as "the state of the soul when it is content or serene." It is this spirit—always female and forever Florentine—that I look for when I return to Lisa Gherardini's hometown.

Early one morning as I walk along the Arno, I pause to wait for a traffic light to change. Gazing ahead, I see a bright dot in the distance moving toward me. As I keep watching, I realize that it is a young woman on a bicycle, but distinctly unlike any of the other Italian cyclists whirring along the busy street.

She is dressed head to toe in white—a creamy sheath dress with chiffon spaghetti straps, white open-toed shoes with four-inch heels, a pearl ankle bracelet, a gossamer scarf tossed loosely over her shoulders. Long curls that Leonardo would have delighted in painting bounce gently on her shoulders. Perfectly balanced, she pedals without any obvious effort. Something in her grace, her classic beauty, her otherworldly aura enthralls me.

In one smooth movement, the slender woman descends to walk her bicycle across the wide street. We approach each other from opposite sides of the crosswalk. Our eyes meet briefly and then, demure as a Renaissance maiden, she glances away. I walk a few steps and then turn around to catch a final glimpse. She has done the same. Then I see it.

A tiny smile plays around her lips.

The smile of *una donna vera*. The smile of a *Mona Lisa*.

EPILOGUE

Mona Lisa Gherardini del Giocondo no longer is invisible in her home-town. A plaque now marks the site on Via Sguazza where Lisa was born and notes the joy that her return to "the places of her childhood" has brought to all Florentines. "Monna Lisa Day" on June 15 has become an annual celebration of the arts in her old neighborhood in the Oltrarno.

Florentines are campaigning to restore the long-abandoned convent of Sant'Orsola, where Lisa died and was buried in 1542. A plan sponsored by local businesses includes a residence for foreign students, restaurants, shops, and a cultural museum. For the first time in decades, community leaders say they feel "*una fiammella di speranza*" (a flicker of hope) that life will return to the gutted structure.

I got a preview of Sant'Orsola's possible future during a three-day open house featuring poetry readings, concerts, and art exhibits. One of the organizers described the mammoth ruin as both "horrible and mag-nificent." It is indeed both. But despite the horror of pancaked staircases and piles of debris, I was captivated by traces of magnificence in Sant'Or-sola's frescoed walls, elegant columns, and tranquil inner courtyards.

While the media focused on a controversial quest over the last few years to identify Mona Lisa's remains in Sant'Orsola's crypt, a quieter search was underway. As detailed in *The Three Mona Lisas*, art historian Rab Hatfield has uncovered compelling new evidence that Mona Lisa Gherardini del Giocondo was indeed Leonardo's model.

No one may have been more surprised by the results of his sleuthing than Hatfield himself. When I first met the retired professor at a cafe in the Piazza San Marco several years ago, he warned that I "would hate" what he had to say: He was "99.9 percent certain" that Leonardo's model was not Lisa Gherardini.

"Well," I replied after a deep breath, "if that's so, I'll tell the story of the greatest case of mistaken identity in the history of art."

A few months later, I received an e-mail from Professor Hatfield with news he described as "exciting but also very embarrassing." Almost at the end of his research, he had unearthed an "astonishing letter" that convinced him that "we probably do see Mona Lisa in the portrait after all."

The letter reveals that five centuries ago—just as today—men couldn't resist the beguiling Mona Lisa. On September 26, 1515, three years after the Medici had returned to power after a long political exile, the nobleman Filippo Strozzi wrote to his brother-in-law Lorenzo di Piero de' Medici, grandson of Lorenzo Il Magnifico and Captain General of the Florentine army. He couldn't wait until his friend's return to the city to share an anecdote that he knew Lorenzo would "get the same pleasure out of" that he had.

Francesco del Giocondo, Lisa's opportunistic husband, had come to Filippo Strozzi to report some sizzling gossip that his nineteen-year-old son Piero had heard. According to the racy rumor, two of the mightiest men in Florence—Filippo himself and his friend Lorenzo di Piero de' Medici—had "tempted . . . Mona Lisa in her honor." When the thirty-six-year-old mother of six rejected their advances, the outraged suitors vowed to take their revenge by bringing about her husband's ruin.

Francesco approached Filippo Strozzi, not with righteous anger over the insult to his wife's virtue, but with abject apologies for her disrespect. The obsequious merchant floridly affirmed his loyalty to the Medici, declaring that he "would not refuse to shed his own blood" for them.

Amused by Francesco's fawning, Filippo told the merchant that he had never paid any attention to "his women," although he confessed that he would have "sooner thought about the males." The young Lorenzo de' Medici, thirteen years Lisa's junior, had already personally reassured her that he bore her husband no ill will when he met with her in a *capannucia* (a word that translates as a "little hut," although Hatfield suggests that it could also describe a cozy little "love nest"). Reassured, Francesco left his meeting with Filippo "all contented and satisfied."

The incident affirms the art historian Giorgio Vasari's description of Lisa as *bellissima* (most beautiful). Even in her thirties, she attracted the attention, albeit unwanted, of much younger men. Lisa's refusal testifies to her virtue, but the dual propositions raise questions: Why would two rich and influential men who could have seduced any fetching *fiorentina*

pursue a mature matron like Mona Lisa? Did they—or those who believed they had done so—have reason to assume she'd acquiesce?

Perhaps. Lisa's reputation may have suffered because of the scandalous behavior of her younger sister Camilla, a nun at the convent of San Domenico di Cafaggio. Along with three other novices, she was publicly denounced in 1512 for participating in what Hatfield describes as "an orgy" with four young swains who had climbed over the nunnery's walls for a nighttime rendezvous.

Lisa also may have been tainted by the disdain of many—including Filippo Strozzi—for her unscrupulous husband. Although Francesco del Giocondo inherited a sizable fortune, his greed never abated. Over the years he traded in cloth, leather, iron, gold, wax, wine, salt, cattle—and high-interest loans. If his creditors couldn't pay back him back, the Renaissance loan shark seized their assets.

Although there is no record of the transaction, Hatfield speculates that Leonardo delivered the portrait of Mona Lisa to her husband before leaving Florence—for Milan and eventually Rome. At some point, Francesco del Giocondo may have proffered the masterwork as a gift either to young Lorenzo or to his far more influential uncle Giuliano de' Medici in Rome. Famed for his courtly grace and amorous escapades, the brother of Pope Leo X may have long admired Lisa from afar as what Hatfield calls his "unattainable Lady on a Pedestal."

When Guiliano de' Medici became Leonardo's patron in 1513, he may have requested that the artist rework the portrait of Mona Lisa. During his years in Rome, Leonardo applied transparent glazes that softened her features and adorned her with long reddish tresses (since faded into brown). After Giuliano's death in 1516, Leonardo brought the portrait with him to France, where he joined the service of King Francis I, his final patron. Despite failing eyesight and a weakened arm, the aging artist may have continued adding feathery brushstrokes to Lisa's image until the very end of his life.

Hers may have been the last portrait Leonardo touched; her smile, the last that he perfected. And although mystery may always swirl around the *Mona Lisa*, one thing remains certain: Five centuries after a genius immortalized her, the world cannot stop looking at the woman whom everyone recognizes—and whom we are finally getting to know.

ACKNOWLEDGMENTS

"The people of Florence are like their *palazzi:* Their exteriors seem cold and formidable, but inside you find the most wonderful treasures."

When Natalia Guicciardini Strozzi shared this observation, I smiled. I couldn't agree more, but I relished hearing these words from a descendant of Lisa Gherardini, the woman we know as "Mona Lisa." After several years of pursuing her life story, I am profoundly grateful to many people in Florence who shared the treasures of their knowledge, insight, and friendship with me.

I start with two men who share the same last name: Pallanti. Our family friend, Dr. Stefano Pallanti, whose roots in Florence date back to Dante's time, introduced me to Giuseppe Pallanti (not a relation, it turns out), whose archival research has revealed long-unknown facts about Lisa's birth, life, and death. I thank him for generously sharing his time, observations, and most recent unpublished findings with me.

The greatest gift that Ludovica Sebregondi and her husband, Mario Ruffini, have given me is their friendship. One of its unexpected consequences was the discovery that they live in the very same building where Lisa Gherardini's mother had grown up more than five centuries earlier. A professor of art history, a curator, and an author, Ludovica was a constant source of inspiration, information, guidance, and knowledge. Two of the exhibits she shepherded—*Virtù d'Amore* at the Galleria dell'Accademia in 2010 and *Denaro e Bellezza* at the Palazzo Strozzi in 2011—were seminal in my understanding of the families and fortunes of Renaissance Florence.

Several scholars brought this golden period to life for me. Historian Lisa Kaborycha of the University of California, Berkeley, guided me through the State Archives of Florence, answered my questions, and vetted chapters in my final manuscript. Kristin Stasiowski of Kent State University, another of my manuscript readers, infused our every conversa-

tion with her thorough knowledge of Renaissance Florence, her spot-on instincts as a writer and educator, and her unmitigated enthusiasm.

This project introduced me to a dream team of art history professors. I am deeply indebted to Rab Hatfield of Syracuse University in Florence, who dedicated an enormous amount of time to reviewing my manuscript and educating me about facets of art history I might never have grasped. Without his astute guidance and unparalleled knowledge, I would have made many fundamental errors.

Professors Mario Cianchi of the Accademia di Belle Arti, Giovanna Giusti of the Uffizi Gallery, Gary Radke of Syracuse University, Gert Jan van der Sman of the Dutch University Institute for Art History, and Helen Manner Watterson and Mary Beckinsale of Studio Art Centers International (SACI) all contributed to my education in Renaissance art. I thank Jeffrey Ruda of the University of California, Davis, for inviting me to his art history class and for his insights into Leonardo's work.

I owe my understanding and appreciation of Renaissance women to a bevy of scholars. Angela Bianchini, an esteemed author, graciously welcomed me into her home and shared her sage perspective on the women of Lisa Gherardini's time. Sara Matthews-Grieco of Syracuse University in Florence provided invaluable insights on women, families, and sexuality. Gigliola Sacerdoti Mariani, a professor emerita at the University of Florence, shared the great pleasure of her company as well as her wisdom. Monsignor Timothy Verdon, director of the Museo dell'Opera di Santa Maria del Fiore in Florence, provided a context for understanding the evolution of Leonardo's art. I thank Josephine Rogers Mariotti, director of the Associated Colleges of the Midwest program in Florence, for filling in missing pages on the role of Lisa Gherardini's husband in Florentine political life.

Historian Fabrizio Ricciardelli, director of Kent State's Palazzo dei Cerchi, deepened my understanding of important economic and social trends in Renaissance Florence. Sabine Pretsch of the Antico Setificio Fiorentino introduced me to the history of Florentine silk. I feel a personal debt of gratitude to historian Gene Brucker, a professor emeritus at the University of California, Berkeley, whose books served as my syllabus for a self-taught course in Renaissance history. Valeria della Valle, a dis-

tinguished author and *professoressa* at La Sapienza in Rome, clarified the linguistic issues that came up in my research and provided guidance on the final manuscript.

Contessa Simonetta Brandolini d'Adda, president of the Friends of Florence, was a generous source of information, contacts, and encouragement. I am grateful for the help of Stefano U. Baldassarri of the Institute at Palazzo Rucellai and Contessa Oliva Rucellai in locating genealogical records for the Rucellai family. I appreciate Silvano Vinceti's time in describing his efforts to exhume and identify the skeleton of Lisa Gherardini.

I thank Gianni Nunziante for welcoming us to his magnificent villa at Vignamaggio, the former home of the Gherardini. The delightful visit proved invaluable in tracing the family's history. Giuliano da Empoli, Florence's former cultural minister, was instrumental in introducing me to Lisa Gherardini's descendants. I cherished the opportunity to meet the charming Natalia and Irina Guicciardini Strozzi, and I thank them for sharing the story of their family's centuries-long link to Lisa Gherardini. I am grateful to Domenico Savini for explaining how he traced their lineage through the centuries.

I appreciate Principessa Giorgiana Corsini's gracious hospitality and the delight of meeting three generations of her family, and I thank dear Cristina Fornari for introducing us and her husband, Alain, for sending me background articles from the European press. Others also graced my times in Italy with special joys, including Andrea and Lorenzo Fasola Bologna and their lovely wives, Robert Sciò and the staff at Il Pellicano, Alessandro Camponeschi and his team, the poet Elisa Biagini, Michael Brod and Gabrielle Maria Taylor of Villa Tornabuoni, Nicoletta Maraschio and Domenico de Martino of the Accademia della Crusca, Susan Salas of Pepperdine University, and Cristina Anzilotti of Sarah Lawrence's Florence program.

I extend fond appreciation to Daniel Forman and Maria Rita Bellini of the Antica Torre di Via Tornabuoni. The wonderful Antonella Fabiano and Annalisa Camilli always make me feel at home at the Palazzo Magnani Feroni. I thank Anna Rostron of Windows on Italy and Pat Byrne of Italy Perfect for their assistance in finding charming apartments

during my longer stays. The d'Ambrosio brothers—Crescenzo, Simone, and Andrea, the Italian sons I never had—were, as always, utterly reliable and absolutely invaluable.

This project would never have taken wing if not for my agent and cherished friend Joy Harris (truly *una gioia*), who has nurtured my development as a writer over many years. I could not have written this book without her; I might not even have dared to try. I have long owed a special debt to Adam Reid, an unsung hero, for his thoroughness, efficiency, and hard work.

Alessandra Bastagni played a unique role in this book's history—first as its acquiring editor and then as a developmental consultant. I so appreciate her invaluable help in telling Lisa Gherardini's story as clearly and cogently as possible. *Grazie infinite.*

The editorial team at Simon & Schuster has made me feel welcome and valued. Trish Todd, the gracious epitome of publishing professionalism, has truly become a godmother to this *Mona Lisa*. I had wondered how anyone could conjure up an original image of such a ubiquitous painting, but art director Michael Accordino created a stunning jacket that captures Lisa's soul and setting. Paul Dippolito matched its elegance with his stylish interior design.

I appreciate Gypsy da Silva's and Lisa Healy's expert guidance through the editing process. I am deeply grateful to Fred Wiemer, copy editor extraordinaire, and Anna Jardine. And I thank marketing specialist Andrea DeWerd and publicist Sarah Reidy for shepherding this *Mona Lisa*'s voyage into the world. My thanks also go to Jennifer Weidman for her legal vetting and Molly Lindley for her cheerful assistance. You all have my admiration and appreciation.

Closer to home, I thank Valentina Medda, my Italian-language guardian angel, for her assistance; Elisabetta Nelsen of San Francisco State University for putting me in touch with sources in Florence; and Debra Turner for the inspirational image of the *Mona Lisa*. It's a joy to work with my website gurus at xuni.com, the endlessly creative Madeira James and Jen Forbus. Yolanda Cossio, Aileen Berg, Nedah Rose, and the rest of my textbook team at Cengage Learning have been a constant source of support. I appreciate the encouragement of Rhonda Anderson, Mary

Sherman, and other dear friends and the *Bella Lingua* fans and Facebook friends who have formed such a warm virtual community.

Years ago I showed a one-page proposal for this book to the person whose opinion I value most: my husband, Bob. From the moment he read it, he has provided unquestioning, unbounded support—whether that meant joining me on research forays in Italy or reading draft after countless draft. As always, he has been the best of partners, husbands, and men. Our multitalented daughter, Julia, the sunshine of my soul, provided assistance of every type, from research to fabulous food to photography. *Ti voglio tanto bene!*

A tutti, grazie di cuore!

MONA LISA TIMELINE

1444: Birth of Antonmaria di Noldo Gherardini, Lisa's father.

1449: Birth of Lorenzo de' Medici.

1452: Birth of Leonardo da Vinci.

1465: Birth of Francesco del Giocondo, future husband of Lisa Gherardini.

1469: Lorenzo de' Medici assumes power in Florence.

1476: Antonmaria Gherardini marries for the third time, to Lucrezia da Caccia (after two wives die in childbirth).

1478: Pazzi conspiracy and attempted assassination of Lorenzo de' Medici.

 Florence at war with the papacy and Naples.

1479: Birth of Lisa to Antonmaria Gherardini and his wife, Lucrezia.

1480: Lorenzo de' Medici brokers a peace with Naples and Pope Sixtus IV.

1480–1520: Forty members of the del Giocondo family serve in the Florentine government.

1482: Leonardo leaves Florence and moves to Milan.

1491: Francesco del Giocondo marries his first wife, Camilla Rucellai.

1492: Lorenzo de' Medici dies; son Piero assumes power.

 Christopher Columbus discovers the New World.

1493: Birth of Francesco del Giocondo's son Bartolomeo.

1494:　Francesco del Giocondo's first wife, Camilla, dies.

Florence ousts Piero de' Medici and ends Medici rule.

French troops under King Charles VIII invade Italy and surround Florence.

Fra Girolamo Savonarola, a Dominican friar, assumes greater influence in Florence.

1495:　Wedding of Lisa Gherardini and Francesco del Giocondo.

1496:　Birth of Lisa's son Piero del Giocondo.

1497:　Birth of Lisa's daughter Piera del Giocondo.

1498:　Execution of Savonarola.

1499:　Death of Lisa's daughter Piera del Giocondo.

Birth of Lisa's daughter Camilla del Giocondo.

France occupies Milan; Leonardo flees.

1500:　Leonardo returns to Florence.

Birth of Lisa's daughter Marietta del Giocondo.

1502:　Leonardo works as military engineer for Cesare Borgia.

Birth of Lisa's son Andrea del Giocondo.

1503:　Leonardo works on a portrait of Lisa Gherardini.

Michelangelo's *David* installed in the Piazza della Signoria.

Leonardo receives a commission to paint the Battle of Anghiari in the Palazzo Vecchio.

1504:　Death of Leonardo's father, Ser Piero da Vinci.

1506:　Leonardo summoned to Milan to complete a long-disputed work.

1507:　Birth of Lisa's son Giocondo del Giocondo, who dies a month later.

1512:　Lisa Gherardini's younger sister Suor Camilla accused of engaging in "obscene acts" with men within the walls of her convent.

Francesco del Giocondo briefly jailed as a Medici loyalist.

Lorenzo's sons Cardinal Giovanni de' Medici and Giuliano de' Medici reclaim power in Florence.

End of the Florentine Republic.

1513: Cardinal Giovanni de' Medici is voted Pope; takes name Leo X.

Francesco del Giocondo serves as a prior of the Florence Signoria.

1514: Leonardo moves to Rome and works under the patronage of Giuliano de' Medici.

1516: Death of Giuliano de' Medici.

King Francis I of France becomes Leonardo's patron.

Leonardo moves to France.

1518: Death of Lisa's oldest daughter Camilla (Suor Beatrice).

1519: Death of Leonardo in France.

1521: Lisa's youngest daughter, Marietta, takes vows as a nun (Suor Ludovica).

1523: Giulio de' Medici becomes Pope Clement VII.

1525: Francesco del Giocondo serves a second term as a prior of the Signoria.

1527: Sack of Rome.

Rebirth of the Florentine Republic.

1530: Siege of Florence and fall of the Florentine Republic.

Return of the Medici to power.

1538: Death of Francesco del Giocondo and burial in a private chapel at Santissima Annunziata.

1540: Lisa Gherardini goes to live in the Monastero di Sant'Orsola.

1542: Death of Lisa Gherardini and burial at Sant'Orsola.

PRINCIPAL CHARACTERS

Gherardini Family

Pelliccia Gherardini da Vignamaggio (dates unknown), convicted of treason for plotting to overthrow the Florentine government in 1360, sentenced to death and forced into exile; eventually had the charges against him dropped.

Dianora Gherardini Bandini, daughter of Pelliccia Gherardini; wife of Domenico Bandini, who was executed as a traitor in 1360; mother of seven, including her youngest daughter, Margherita.

Margherita Bandini Datini (1360–1423), Dianora Gherardini's daughter; married Francesco di Marco Datini, the successful "merchant of Prato," in 1376. Her letters provide the most comprehensive account of the lives of women of her time.

Noldo Gherardini (1402–1479), Lisa's grandfather, moved the family to Florence from Chianti.

Antonmaria Gherardini (1444–c. 1525), Noldo's son and father of Lisa, married three times (in 1465, 1473, and 1476) and arranged her marriage to Francesco del Giocondo.

Lisa Gherardini (1479–1542), daughter of Antonmaria, wife of Francesco del Giocondo, mother of six biological children and a stepson, model for the famous portrait by Leonardo.

Camilla Gherardini, Lisa's younger sister, forced to enter a convent for lack of a dowry.

del Giocondo Family

Iacopo (nicknamed Giocondo), born around 1357, a jovial barrelmaker who invested in real estate and earned enough to catapult the family out of the working class.

Bartolomeo del Giocondo, grandson of Iacopo and father of Francesco, a successful silkmaker who moved out of the family homestead into a house on Via della Stufa.

Francesco del Giocondo (1465–1538), who worked in his family's silk business and pursued other entrepreneurial ventures; married twice (to Camilla Rucellai in 1491 and Lisa Gherardini in 1495); fathered seven children; served in various government councils in Florence; and is believed to have commissioned Leonardo's portrait of his wife.

Medici Family

Lorenzo de' Medici (1449–1492), called Il Magnifico, took power as Florence's untitled prince in 1469 and ushered in a period of prosperity and civic celebration.

Piero de' Medici (1472–1503), Lorenzo's oldest son, who succeeded his father but was forced to flee Florence in 1494.

Giovanni de' Medici (1475–1521), Lorenzo's second son, who was appointed a cardinal at age thirteen and became Pope Leo X in 1513.

Giuliano de' Medici (1479–1516), youngest son of Lorenzo de' Medici, politically allied with Francesco del Giocondo, and patron of Leonardo da Vinci from 1513 to 1516.

Giulio de' Medici (1478–1534), illegitimate son of Lorenzo de' Medici's slain brother, Giuliano, who became Pope Clement VII in 1523 and headed the Church during the calamitous Sack of Rome in 1527 and the Siege of Florence in 1530.

da Vinci Family and Entourage

Ser Piero da Vinci (1427–1504), father of Leonardo (illegitimate) and eleven other children, a well-connected legal professional in Florence.

Leonardo da Vinci (1452–1519), an incomparable artist trained in Florence who spent a third of his life working in Milan; creator of masterpieces such as *The Last Supper* and the *Mona Lisa*; spent his final years in France under the patronage of King Francis I.

Salaì (Gian Giacomo Caprotti da Oreno) (1480–1524), a mischievous beautiful boy who joined Leonardo's household at age ten and remained a part of it until the end of the artist's life.

Francesco Melzi (1491–1570), another handsome young man who came into Leonardo's household in 1507 and remained his lifelong assistant and secretary.

Others

Duke Ludovico Sforza (1452–1508), seized control of Milan from the legitimate heir and assembled a glittering court of artists and scholars, including Leonardo; ousted in 1499 and later imprisoned by the French.

Cesare Borgia (1475–1507), illegitimate son of the Spaniard Pope Alexander VI, a ruthless commander who set out to conquer central Italy in his father's name and who hired Leonardo as a military engineer in 1502.

Niccolò Machiavelli (1469–1527), a career bureaucrat in the Florentine government; collaborated with Leonardo on a project for rerouting the Arno River; best known as author of *The Prince*.

Michelangelo Buonarroti (1475–1564), a Florentine considered the preeminent sculptor of his time, earned early fame for his statue *David*, commissioned to create a mural in the same hall as Leonardo in the Palazzo Vecchio.

King Charles VIII of France (1470–1498), invaded Italy in 1494 and briefly occupied Florence in his march to claim the throne of Naples.

King Louis XII of France (1462–1515), invaded Italy in 1499 to seize control of Milan, later became one of Leonardo's patrons.

King Francis I of France (1494–1547), a dynamic young monarch who became Leonardo's patron and settled the artist in a château in the Loire Valley for the last years of his life.

NOTES

1: Una Donna Vera (*A Real Woman*)

PAGE

1 *One evening during a dinner at her home:* Ludovica Sebregondi, *coordinamento scientifico ed editoriale* at the Palazzo Strozzi, is a *professoressa* of art history at the University of Florence and the author of numerous books on Italian art.

1 *Monna, spelled with two n's in contemporary Italian: Monna* seems to have long been the more common spelling, but *mona* is not an Anglicism or misspelling. According to Manlio Cortelazzo and Michele Cortelazzo's *L'Etimologico Minore, mona* dates back to the thirteenth century. Vasari refers to "Mona Lisa" in his *Lives of the Artists,* but its use was already becoming obsolete in sixteenth-century Florence, according to art historian Rab Hatfield of Syracuse University in Florence. *Monna* is the correct spelling in contemporary Italian. As Ludovica Sebregondi informs me, *mona* is considered a *parolaccia* (bad word) in the Veneto.

2 *Curiosity leads me, via a typically Italian network:* Giuseppe Pallanti's archival discoveries about Lisa Gherardini, published in 2006 in Italian as *La Vera Identità della Gioconda* and in English as *Mona Lisa Revealed,* served as the most comprehensive and reliable source of documentation on Lisa Gherardini and her husband, Francesco del Giocondo. Over the last few years Dottor Pallanti has generously shared with me more recent unpublished findings, including newly confirmed dates for the births of Lisa Gherardini's six children as well as for the brief life of her daughter Piera. Through conversations and correspondence, he also provided invaluable insights into Lisa Gherardini and her family and corrected many widely circulated inaccuracies, such as the assertion that her husband had two previous wives.

3 *Descended from ancient nobles, she was born and baptized in Florence in 1479:* Gene Brucker lists the Gherardini among the city's "most illustrious families" in *Florence: The Golden Age, 1138–1737.*

3 *Lisa's life spanned the most tumultuous chapters in the history of Florence:* The extensive works (itemized in the bibliography) of Professor Gene Brucker of the University of California, Berkeley, the dean of Renaissance Florence historians, constituted my syllabus for Florentine history. I also drew on Christo-

pher Duggan's *A Concise History of Italy*, David Gilmour's *The Pursuit of Italy*, and Lisa Kaborycha's *A Short History of Renaissance Italy*.

3 *"Inhabit her neighborhoods," an art historian advises me*: I thank Josephine Rogers Mariotti for this wise counsel.

5 *I kneel to trace the Latin words* "familiae iucundi": The stone in the Martyrs Chapel behind the main altar of Santissima Annunziata, inserted in 1738, reads: "Olim familiae iucundi, nunc de anfortis" (once family Giocondo, now family Anforti). I have posted a photograph of the inscription on my website, www.monalisabook.com.

6 *He wrote like no one else, in his inimitable "mirror script"*: I've seen estimates of 5,000 to 7,000 pages collected from Leonardo's notebooks; there may be thousands more still unfound.

6 *He rode like a champion, so strong that a biographer*: Vasari claimed that Leonardo could bend a horseshoe with one hand.

7 *Sometimes admired, often feared, never loved*: Brucker enumerates Florentine "vices" in *Florence: The Golden Age, 1138–1737*.

7 *Even its native sons derided their hometown*: Agnolo Acciaiuoli described Florence as "a paradise inhabited by devils" in a letter to Filippo Strozzi.

7 *In Milan, where he spent more than a third of his life*: For my research on Leonardo da Vinci, I turned to his notebooks and many biographies, including Serge Bramly's *Leonardo: The Artist and the Man*, Fritjof Capra's *The Science of Leonardo*, Charles Nicholl's *Leonardo da Vinci: Flights of Mind*, Martin Kemp's *Leonardo*, Carlo Pedretti's *Leonardo: Art and Science*, Sherwin Nuland's *Leonardo da Vinci*, Giorgio Vasari's *Le Vite*, and Frank Zöllner's *Leonardo da Vinci*.

9 *Yet the evidence that Lisa Gherardini was indeed Leonardo's model*: Frank Zöllner's article on "Leonardo's Portrait of Mona Lisa del Giocondo" (in *Gazette des Beaux-Arts* 121 [1993]: 115–138) provides detailed analysis of the evidence for Lisa Gherardini as Leonardo's model.

9 *But it wasn't until 2007 that genealogist Domenico Savini*: His chart of Lisa's descendants can be found online in an article in Italian and English at http://www.prestigefoodwine.com/Monna_Lisa.pdf.

9 *Skirting this self-proclaimed "medieval Manhattan"*: The website for the Guicciardini Strozzi winery, with stunning photos of the estate and text in Italian and English, is www.guicciardinistrozzi.it.

2: Fires of the Heart

PAGE

16 *I begin my quest by exchanging my passport for the oldest book*: My archival sources for the millennia of Gherardini history include a family memory book, Niccolò Gherardini, *Memorie Domestiche di Niccolò Gherardini, 1585–1596*;

Eugenio Gamurrini's "*Famiglia Gherardina*," in: *Istoria Genealogica delle Famiglie Nobili Toscane et Umbre*; and Galvani's *Sommario Storico delle Famiglie Celebri Toscane Compilato da D. Tiribilli-Giuliani*. I also drew on material on the Gherardini and the Aeneas legend in *Medieval Italy: An Encyclopedia*, vol. 1, *A–K*, which states that the first record of the Gherardini in Florence dates to the year 910.

17 *As I learn from the oldest chronicles of Florence*: In reconstructing Florence's past, I drew on early histories, primarily Giovanni Villani's *Nuova Cronica* and Francesco Guicciardini's *The History of Italy* and *The History of Florence*. More recent sources include Lisa Kaborycha's *A Short History of Renaissance Italy*, Herlihy and Klapisch-Zuber's *Tuscans and Their Families*, Baldassarri and Saiber's *Images of Quattrocento Florence*, R. W. B. Lewis's *The City of Florence*, and, in addition to his books, Brucker's essay "Florentine Voices from the 'Catasto,' 1427–1480," in *I Tatti Studies: Essays in the Renaissance*.

20 *In a history of Florence, I come upon a sketch*: A drawing of the Gherardini magnates' Florence tower appears on p. 38 in Brucker's *Florence: The Golden Age*. Each of the four quarters of the city was divided into four *gonfaloni*, or neighborhood districts.

21 *In addition to swashbuckling warriors*: Villani lists the Gherardini among the noble families of San Piero Scheraggio in 1250 in his *Nuova Cronica*. Beginning in 1293, the Gherardini appear on "*la lista dei Grandi fiorentini*," compiled by the Podestà of Florence, cited by Christiane Klapisch-Zuber in *Ritorno alla Politica*. This volume, along with Gene Brucker's *Florence: The Golden Age, 1138–1737* and Carol Lansing's *The Florentine Magnates*, provided details of Florence in the magnate era.

21 *The newly rich* popolo grasso: The *popolo minuto*, chronically underfed, were smaller in stature as well as resources.

23 *When they weren't attacking other magnates*: Klapisch-Zuber is the historian who described the Gherardini as warlike and uncivilized troublemakers.

25 *Their leader, Cavaliere Gherarduccio Gherardini*: A photograph of the *antico sepolcro cavalleresco* (ancient knightly tomb) can be found at http://effigiesand brasses.com/monuments/gherarduccio_de_gherardini/.

25 *On a crisp fall day, my husband and I*: Information about Villa Vignamaggio, including a photo gallery, is available at http://www.vignamaggio.it.

26 *More than a few descended into the ranks*: The historian was David Herlihy.

26 *The Gherardini, singled out by historians*: The quoted material comes from Brucker's *Florentine Politics and Society, 1343–1378*.

26 *As I labored through a scholarly history*: The history that describes the Gherardini's hatred of one another is Klapisch-Zuber's *Ritorno alla Politica*.

27 *Before they could act, one of the plotters*: Salvestro de' Medici was the great-uncle of Cosimo the Elder, who would establish Medici dominion over Florence in the fifteenth century.

28 *On the wall of its* cantina: The name Amidio Gherardini, as I read it on a copy
 of the original letter, also is spelled Amido, Amideo, and Amadio in various
 documents—typical of a time when literacy was limited and spelling arbi-
 trary. The estate, advertised as the "birthplace of Mona Lisa," was sold in 2014;
 the listing price was 50 million euro (about $63 million).

29 *During his long life, Datini copied:* The historian Barbara Tuchman describes
 Margherita Datini as "rebellious and singularly outspoken" in her introduc-
 tion to Iris Origo's *The Merchant of Prato.*

29 *In their pages:* In *Letters to Francesco Datini,* published in 2012, Carolyn James
 and Antonio Pagliaro provided the first translation of almost all of Margheri-
 ta's letters into English.

3: A Voice Without a Face

PAGE

30 *The Datini come alive only in the words they wrote:* The description of this "ar-
 chival treasure trove" comes from Iris Origo's *The Merchant of Prato.*

31 *Reading many of their letters in Iris Origo's landmark* The Merchant of Prato:
 This volume also provided essential background and insights into the lives of
 Margherita Datini and her husband.

31 *a state of angst he called* malinconia: I base my discussion of *malinconia* and
 other Italian words throughout the text on *L'Etimologico Minore* (Manlio
 Cortelazzo and Michele Cortelazzo, eds.) and counsel from Italian scholars,
 first and foremost Professoressa Valeria della Valle of Sapienza University in
 Rome, author of numerous books on the Italian language.

32 *In this thriving trade center:* In addition to the previously cited histories, Indro
 Montanelli and Roberto Gervaso's *Italy in the Golden Centuries* vividly de-
 scribes Avignon during the exiled papacy.

35 *Almost as soon as he unpacked:* In addition to *The Merchant of Prato,* I also
 gleaned useful insights into the couple's life from Angela Bianchini's account
 in *Alessandra e Lucrezia* and from the essays of Ann Crabb.

35 *With her spouse away, Margherita:* Ann Crabb refers to Margherita as such in
 her essay "Gaining Honor as Husband's Deputy: Margherita Datini, 1376–
 1410," in *Early Modern Women* 3 (2008).

37 *A few months after the birth of her husband's illegitimate son:* Ann Crabb's "If I
 Could Write," in *Renaissance Quarterly,* details Margherita Datini's efforts to
 learn to write.

41 *I imagine Margherita, reconciled at age thirty-eight:* Byrne and Congdon's
 "Mothering in the Casa Datini," in the *Journal of Medieval History,* discusses
 the children who came to live in Margherita Datini's home.

43 *As the fifteenth century unfolded:* The quote on Florence's splendors comes

from Dati's *Storie di Firenze*; the description of Florence as a blazing sun, from Herlihy and Klapisch-Zuber's *Tuscans and Their Families*.

44 *His other properties went to his oldest son:* I've seen various spellings for Lisa's father's name, including Antonio Maria. Antonmaria is used by contemporary biographers.

44 *Neither ancient nor aristocratic, another Tuscan family:* Leonardo's great-grandfather, Ser Piero da Vinci, was invested as a *notaio* in 1360 and served as *notaio* to the Florence Signoria.

46 *Among the many families in Florence's thriving thread trade:* Pallanti's *La Vera Identità della Gioconda* was my source for the detailed history of the del Giocondo family.

47 *In a town whose residents quaffed 70,000 quarts of wine a day:* The estimate of the amount of wine Florentines consumed comes from Franco Franceschi's chapter "The Merchant-Bankers of 15th-Century Florence," in Ludovica Sebregondi and Tim Parks's *Money and Beauty*. Villani stated that around 1338 some 5.9 million gallons of wine entered the city yearly, with an additional 1.2 million gallons in times of abundance.

4: "Who Would Be Happy . . ."

49 *On February 7, 1468, nineteen-year-old Lorenzo de' Medici:* From a wealth of material on the lives of the Medici, I relied most on Franco Cesati's *The Medici*; J. R. Hale's *Florence and the Medici*; Christopher Hibbert's *The Rise and Fall of the House of Medici*; Dale Kent's *Cosimo de' Medici and the Florentine Renaissance*; Paul Strathern's *The Medici: Godfathers of the Renaissance*; and Miles Unger's *Magnifico*.

51 *Traders hauled leather from Córdoba:* I found differing estimates of the population of Florence in the fifteenth century, but most ranged from 50,000 to 60,000.

51 *Life was short, just thirty-five to forty years on average:* The estimate of Florentine life expectancy comes from Herlihy and Klapisch-Zuber, who report that the average life span was thirty-five, slightly more for men, slightly less for women.

51 *"Who would be happy, let him be":* The translation of *"Chi vuole essere lieto, sia"* is mine.

53 *And here he would develop the habit of carrying a* libriccino: Of the various spellings for Leonardo's "little book," my authoritative source, Professoressa Valeria della Valle, informs me that *"libriccino"* is historically correct.

54 *Not long afterward, the twenty-year-old scrawled a rare expression:* Contento is the modern Italian form of *chontento*, which Leonardo used.

55 *In 1473, Antonmaria's eye turned*: In addition to Luigi Passerini's *Genealogia e Storia della Famiglia Rucellai*, I found extensive discussion of the Rucellai's marriage alliances and kinship bonds in Francis William Kent's *Household and Lineage in Renaissance Florence: The Family Life of the Capponi, Ginori, and Rucellai* and Brucker's *Florence: The Golden Age*.

57 *But their all-too-fleeting joy soon turned to sorrow*: Angela Bianchini offers an interesting insight into Florentines' response to the tragic early deaths of so many of their daughters in childbirth: They viewed them as part of "the price one paid" for the glory and beauty of their city.

57 *"I am so oppressed by grief and pain"*: The grieving widower was Giovanni Tornabuoni, quoted in Gert Jan van der Sman's *Lorenzo and Giovanna*.

58 *"The highest citizens who govern the state"*: The quotation about silk merchants' children comes from Brucker's *Florence: The Golden Age*.

59 *Like only a few women of her day*: The line of Ginevra de' Benci's poetry that I translated from the Italian reads, "*Chiego merzede, e sono alpestro tigre.*"

60 *But as I learned more about Ginevra*: In addition to general sources on Leonardo's works, the essays by Mary Garrard on Ginevra de' Benci provided a fascinating feminist perspective.

61 *Within a few years the prospering notaio*: Giuseppe Pallanti tells me that the da Vinci *palazzo* was only 30 meters—about 33 yards—from the home of Lisa's grandparents on Via Ghibellina.

62 *Sex between men was so common*: Michael Rocke's *Forbidden Friendships* provides the most comprehensive discussion of homosexuality in the Renaissance, including the statistics cited. As Rocke explains, Florentine men, who typically postponed marriage until age thirty or later, engaged in all sorts of sexual activity, homosexual as well as heterosexual, in their youth. Rocke mentions a sixteen-year-old boy named Priore Gherardini, a probable relative of Lisa Gherardini, also descended from the old magnates, who regularly participated in homosexual liaisons, bragged that the laws were not intended for people of his noble status, and threatened to kill anyone who dared offend him or his lovers.

64 *On the morning of April 26, 1478*: I drew on several detailed accounts of the Pazzi conspiracy, including Miles Unger's *Magnifico*, Christopher Hibbert's *The Rise and Fall of the House of Medici*, and Lauro Martines's *April Blood*.

66 *Sixtus IV decided that it was time to topple*: Brucker's *Florence: The Golden Age* describes the plunder of Chianti.

66 *Unless a father could provide a dowry*: My sources for the discussion of girls' dowries include Julius Kirshner and Anthony Molho's "The Dowry Fund and the Marriage Market in Early Quattrocento Florence," in the *Journal of Modern History*; Brucker's *Living on the Edge in Leonardo's Florence* (also the source of the quote from the chronicler Giovanni Cambi); and Margaret King's

Women of the Renaissance (the source of the estimate that in sixteenth-century Florence as many as half of the women from elite families resided in convents). Klapisch-Zuber is the historian who stated that the "best people" did not house unmarried daughters older than twenty under their roofs.

67 *Once convents had been reserved:* The cleric who referred to girls in convents as "the scum and vomit of the world," cited by David Herlihy, was Bernardino of Siena.

5: Daughter of the Renaissance

71 *On a mid-June day in 1479:* Louis Haas provides a detailed account of birth (including the bathing of a newborn in warm white wine) and baptism in *The Renaissance Man and His Children.*

72 *To Florentine Catholics, who baptized all newborns here:* The custom of baptizing all Catholic infants in the Baptistery continued until at least 1965, according to Michael Levey in *Florence: A Portrait.*

73 *Although Lisa's baptism has been well documented:* I found Lisa Gherardini's baptismal record at http://archivio.operaduomo.fi.it.

74 *Lisa's addition to the rolls of Florentine citizens:* Historians cite numerous examples of the use of beans in Florentine accounting transactions, including votes on artistic commissions, such as the completion of the Duomo's cupola, and on death sentences for criminals (with black beans, of course). According to Charles Nicholl, in *Leonardi da Vinci: Flights of Mind*, Leonardo was inducted into the Confraternity of St. John in Florence by a majority of 41 black beans to 2 white beans.

75 *I catch up on the news:* Luca Landucci's pithy and pointed observations of Florence come from an English translation of his diaries published in 1927.

77 *The young artist had grown:* This description of Leonardo's appearance comes from the *Anonimo Gaddiano*, a book written around 1540 by an unknown author, once in the Gaddi, or Magliabechi, collection.

78 *Il Moro (the Moor), as burly, big-chinned Sforza was nicknamed:* I have seen estimates as high as 120,000 for Milan's population, but 80,000 is more widely quoted.

79 *He proposed completion of a stunning memorial:* Rab Hatfield of Syracuse University in Florence informs me that the equestrian monument commissioned by Duke Ludovico Sforza of Milan was initially entrusted to Antonio del Pollaiuolo, who conceived the idea of a rearing horse.

80 *In 1483, at age four, Lisa became a big sister:* My source for the names of Lisa's siblings is Giuseppe Pallanti.

82 *Like other Florentines, she would have learned to tell time by church bells:* The

bells of La Badia Fiorentina, for instance, signaled the beginning and end of the artisans' workday.

83 *When excavation for the Strozzi palazzo:* Descriptions of children tossing coins and medals into the foundations of the Palazzo Strozzi appear in various family memory books. A trader named Tribaldo de' Rossi had his son toss in damask roses. "You will remember this, won't you?" he asked the boy. "Yes," the four-year-old solemnly replied.

83 *"Whoever is not a merchant":* The quote on merchants from Gregorio Dati appears in Brucker's *Renaissance Florence.*

84 *Florentine silk, epitomizing the elegance:* Franco Franceschi provides the evaluation of the silk industry in his chapter "The Merchant-Bankers of 15th-Century Florence," in Ludovia Sebregondi and Tim Parks's *Money and Beauty.*

84 *Curious about what the del Giocondo silk shops might have looked like:* Patrizia Pietrogrande's *Antico Setificio Fiorentino,* a beautifully illustrated history of silk making in Florence, was my major source of information on Florentine cloth. Carole Collier Frick's *Dressing Renaissance Florence* provided a wealth of information on Florentine fashions, including statistics on cloth production and the amounts used in gowns.

85 *A lady's gown, falling in deep folds:* I found various measurements for "*braccia*": 21.6 inches in Florence and 23.4 inches in Milan in one of Leonardo's notebooks.

86 *And so he embarked:* This historian was Domenico Laurenza.

87 *As with his portrait of the self-proclaimed tigress:* Among the articles that offered background on Leonardo's portrait of Cecilia Gallerani were Janice Shell and Grazioso Sironi's "Cecilia Gallerani: Leonardo's *Lady with an Ermine*" and David Alan Brown's "Leonardo and the Ladies with the Ermine and the Book."

88 *With her right hand, in a curiously suggestive gesture:* The Greek for "ermine" is ερμίνα, which I've seen spelled as *gale, galle, gallee,* and *galay*—all somewhat similar to "Gallerani."

88 *The city of artistic geniuses:* The historian who described Florence as among the more unlucky places in western Europe to be born female and who quoted Marsilio Ficino is Dale Kent in her chapter on "Women in Renaissance Florence," in David Alan Brown's *Virtue and Beauty.*

89 *Scholars, looking back on history:* A History of Women: Renaissance and Enlightenment Paradoxes, edited by Natalie Zemon Davis and Arlette Farge, offered rich insights into women's lives. Additional historical background came from Herlihy and Klapisch-Zuber's *Tuscans and Their Families,* Kaborycha's *A Short History of Renaissance Italy,* Margaret King's *Women of the Renaissance,* Claudio Paolini's *Virtù d'Amore,* and Ludovica Sebregondi and Tim Parks's *Money and Beauty.* My understanding of women's lives in Renaissance Flor-

ence also was enriched by Joan Kelly-Gadol, who asked "Did Women Have a Renaissance?" and Natalie Tomas, particularly her chapter "Did Women Have a Space?" in *Renaissance Florence: A Social History*.

89 *Even if little changed in their social condition*: David Herlihy was the historian who made this observation.

89 *At the suggestion of a mutual friend*: During her long and illustrious career, Bianchini has written prizewinning novels, short stories, literary criticism, historical works, and radio and television scripts. A basic summary can be found at http://en.wikipedia.org/wiki/Angela_Bianchini.

6: Money and Beauty

PAGE

93 *The festivities mark the opening*: The catalogue for the exhibit *Denaro e Bellezza* (Money and Beauty), presented at the Palazzo Strozzi from September 17, 2011, to January 22, 2012, along with the exhibit itself and the commentaries by cocurators Ludovica Sebregondi and Tim Parks, enlightened me about the interwoven connections between Florentine commerce and creativity.

93 *For centuries the shiny coin*: Historian Fabrizio Ricciardelli estimates that one gold florin in Lisa Gherardini's day would be the equivalent, depending on exchange rates, of 100 to 110 euro or roughly (at an exchange rate of $1.35) $135 to $148. A 1,000-florin dowry, then, would translate into 100,000 euro or $135,000; a 2,000-florin dowry, to 200,000 euro or $270,000.

94 *A father deposited an amount*: Julius Kirshner and Anthony Molho provided the estimate I used for how much money would accrue over different time periods in their in-depth analysis of Florentine dowries, which is also my source for the quotes on girls who chose a religious life. They also calculated that about half of the wealthiest households in Florence invested in the dowry fund. I also drew on Margaret King's *Women of the Renaissance* and Richard Goldthwaite's *Private Wealth in Renaissance Florence*.

96 *A popular treatise listed thirty-three female "perfections"*: The quote on women's beauties comes from Sara Matthews-Grieco's chapter "The Body, Appearance, and Sexuality," in Davis and Farge, *A History of Women: Renaissance and Enlightenment Paradoxes*.

97 *A French researcher*: The French engineer Pascal Cotte, head of Lumiere Technology, used a multispectral camera to digitize the *Mona Lisa* and detect her single surviving brow hair.

98 *In a nineteenth-century genealogy, I find a Rucellai family tree*: The Rucellai genealogy that I consulted was Passerini's *Genealogia e Storia della Famiglia Rucellai*. I found additional information on Mariotto Rucellai in Francis Kent's *Household and Lineage in Renaissance Florence*.

108 *"If you sound your trumpets"*: I translated his exhortation from the Italian: *"Se suonerete le vostre trombe, noi suoneremo le nostre campane."*

108 *After decades of the prosperity and peace*: I drew insights into Florence at the end of the fifteenth century from Brucker's *Living on the Edge in Leonardo's Florence* and *Renaissance Florence*.

7: The Business of Marriage

Then, as now, there was great variation in courtships and weddings. I convey some of the most likely possibilities for Lisa Gherardini and Francesco del Giocondo.

PAGE

111 *The dowry, the sine qua non of the deal*: Frederick Hartt, in "Leonardo and the Second Florentine Republic," calculated that a dowry typically diminished the net worth of a bride's kin by about 14 percent while boosting a groom's by 23 percent.

111 *Perhaps, like the Prato merchant*: Francesco del Giocondo's "marrying up" socially was not uncommon. Hartt refers to this as the "gentrification of the bourgeois."

112 *"A marriage without a dowry"*: This quote comes from Klapisch-Zuber, who also provided extensive documentation of other aspects of Renaissance family finances and weddings in *Women, Family, and Ritual in Renaissance Italy*.

113 *Francesco, with a Florentine's hypersensitivity*: Kirshner and Molho, in their article on dowries, comment that many widowers "were willing to accept a smaller dowry in exchange for a wife and mother for their dependent children." They also note that "real property, when possible, did not travel with a wife to her husband and his family, but remained with her father, brothers, and male kin."

113 *Compared to the high dowries*: Giuseppe Pallanti provided the estimates of the value of the San Silvestro farm and its furnishings.

114 *I got my first sense of its elaborate variations*: The exhibition at the Galleria dell'Accademia in 2010 and its catalogue provided a wealth of background information. Also informative were Deborah Krohn's "Weddings in the Italian Renaissance" and "Marriage as a Key to Understanding the Past," in *Art and Love in Renaissance Italy*.

117 *The practice developed of the groom's bestowing a* contra-donora: Klapisch-Zuber estimated the value of dowries and counterdowries in *Women, Family, and Ritual in Renaissance Italy*.

118 *Her wedding was the single biggest event*: I found detailed descriptions of courtship and wedding preparations and rituals in Claudio Paolini's *Virtù d'Amore*, Herlihy and Klapisch-Zuber's *Tuscans and Their Families*, and scholarly ar-

ticles such as Brucia Witthoft's "Marriage Rituals and Marriage Chests in Quattrocento Florence."

118 *Lisa's dress would have been the most stylish she had ever worn:* Carole Collier Frick's *Dressing Renaissance Florence* supplied in-depth information on wedding clothing, including the bride's trousseau and countertrousseau and wedding gown.

119 *It wasn't until 1563:* Katherine McIver states in her reviews of *Art and Love in Renaissance Italy* and *Love and Marriage in Renaissance Florence*, in *Renaissance Quarterly*, that no systematized requirements for a proper wedding existed before the Council of Trent.

121 *Not surprisingly, many a wedding night:* I found the description and woodcut of a tearful wedding night in Ludovica Sebregondi's chapter *"Rituali di Nozze nella Firenze Rinascimentale"* (Wedding Rituals in Renaissance Florence) in Claudio Paolini's *Virtù d'Amore.*

121 *That day or the next:* Klapisch-Zuber provides a detailed background on "the ring game" and on dowry payments in *Women, Family, and Ritual in Renaissance Italy.*

122 *Dowries were paid only after a marriage was consummated:* Kirshner and Molho's "The Dowry Fund and the Marriage Market in Early Quattrocento Florence" was my source for when dowries were paid.

122 *Although he might have rued the loss:* I base my perspective on Antonmaria Gherardini getting the better bargain on insights gleaned from Herlihy and Klapisch-Zuber's *Tuscans and Their Families.*

8: The Merchant's Wife

I drew on a large number of sources to re-create life as Lisa Gherardini would have known it in Renaissance Florence, including Elizabeth Cohen and Thomas Cohen's *Daily Life in Renaissance Italy,* William Connell's *Society and Individual in Renaissance Florence,* Elizabeth Currie's *Inside the Renaissance House,* Trevor Dean and K. J. P. Lowe's *Marriage in Italy: 1300–1650,* Jacqueline Musacchio's *The Art and Ritual of Childbirth in Renaissance Italy,* and Richard Trexler's *Public Life in Renaissance Florence* and *Power and Independence in Renaissance Florence.*

PAGE

123 *For brides from financially strapped households:* The historian was J. H. Plumb in *The Italian Renaissance.*

124 *Thanks to the countertrousseau she received from her husband:* My key sources on Florentine fashion were Frick's *Dressing Renaissance Florence,* Jacqueline Herald's *Renaissance Dress in Italy, 1400–1500,* and Cesare Vecellio's *Vecellio's Renaissance Costume Book.*

127 *The former was reserved primarily for educated and affluent:* Richard Trexler was the historian who described the view of Florentine hypersexed male youths as "idiots" incapable of responsibility.

129 *Prototypes of self-help manuals:* Rudolph Bell's delightful and erudite *How to Do It* proffered a trove of advice on the most intimate details of married life in the Renaissance. Haas's *The Renaissance Man and His Children* describes many aspects of birth and newborn care.

131 *With or without erotic:* I confirmed the birth date of Lisa Gherardini's first child, Piero Zanobi, in the digital archives of the Florence Duomo.

134 *His cousin Bartolomeo:* Giuseppe Pallanti documented Bartolomeo del Giocondo's purchases of jewelry for his wife at the birth of each of their children.

134 *Fra Girolamo Savonarola, grandson of the physician and author:* Among the most vivid accounts of Savonarola's final years is Christopher Hibbert's in *The Rise and Fall of the House of Medici.*

138 *As the fifteenth century lurched through its final years:* Giuseppe Pallanti confirmed the dates of the brief life of Piera del Giocondo.

139 *Transferring his life's savings to the bank at Santa Maria Nuova:* According to biographer Charles Nicholl, Leonardo's savings amounted to 600 florins.

139 *"A defeated man nearing fifty":* The biographer was Jacob Bronowski, in his essay on the artist in J. H. Plumb's *The Italian Renaissance.*

9: New Beginnings

PAGE

143 *In the early years:* Various art historians, including Frank Zöllner, postulate that Santissima Annunziata was the place where Leonardo could have met Francesco del Giocondo. This also is Giuseppe Pallanti's belief.

144 *The town where artists reigned like rockstars:* I drew on Frederick Hartt's "Leonardo and the Second Florentine Republic" to understand more about the early years of the sixteenth century when Leonardo returned to Florence.

145 *Catching his breath:* After learning of an alleged Leonardo studio at Santissima Annunziata, I tracked down a report on its discovery in *The New York Times:* Jason Horowitz's "A da Vinci Complex? Call It a Hypothesis," January 15, 2005.

146 *In 1502, during Leonardo's residence:* Giuseppe Pallanti provided the dates of Leonardo's residence and the births of Lisa's children.

149 *The two may have first met in Milan in 1499:* The sources I found most useful on the history of the Borgias were Michael Mallett's *The Borgias,* Christopher Hibbert's *The Borgias and Their Enemies,* and Sarah Bradford's *Lucrezia Borgia.*

149 *As the diarist Landucci reports:* Elizabeth Lev's *The Tigress of Forlì* captures the passion and pageantry of Caterina Sforza's life.

150 *Some have argued*: Magdalena Soest, a German scholar, has argued that Cate-
rina Sforza was the model for Leonardo's portrait on the basis of similarities
in the facial features, hair, and pose that she sees with a 1487 portrait by the
artist Lorenzo di Credi, one of Leonardo's colleagues.

The arguments that Caterina Sforza may have been the model for the
Mona Lisa were debated at an international roundtable on the 500th anniver-
sary of her death, on May 16, 2009, at Forlì. I thank my friend Ludovica Se-
bregondi for a copy of the proceedings of the *tavola rotonda* (roundtable): "*Il
Volto di Caterina. L'Identità e la Suggestione.*"

150 *To Leonardo, indifferent to his patrons' political agendas*: Frederick Hartt de-
scribes Leonardo as being "as apolitical as he was areligious (at least in an
orthodox Christian sense)" and asserts that he had no compunction about
working for Cesare Borgia.

151 *In October 1502, the priors of the Florentine Signoria*: Maurizio Viroli's *Niccolò's
Smile* and Ross King's *Machiavelli: Philosopher of Power* provided keen insights
into the famous political strategist. Paul Strathern wove an interesting tapes-
try of three extraordinary men—Leonardo, Machiavelli, and Cesare Borgia—
in *The Artist, the Philosopher, and the Warrior.*

10: *The Portrait in Progress*

In addition to the cited art history texts, I drew on numerous scholarly articles as
background for this chapter. Among the most helpful were Sir Kenneth Clark's "*Mona
Lisa*," a lecture at the Victoria and Albert Museum; Jack Greenstein's "Leonardo,
Mona Lisa, and *La Gioconda*: Reviewing the Evidence"; Z. Filipczak's "New Light
on *Mona Lisa*: Leonardo's Optical Knowledge and His Choice of Lighting"; Gustav
Kobbé's "The Smile of the Mona Lisa"; Edward Olszewski's "How Leonardo Invented
Sfumato"; Diogo Queiros-Conde's "The Turbulent Structure of '*Sfumato*' within
Mona Lisa"; and Webster Smith's "Observations on the *Mona Lisa* Landscape."

PAGE

159 *According to beneath-the-surface scans*: The studies of the *Mona Lisa* by the
Center of Research and Restoration of the Museums of France yielded the
findings about the gossamer veil, the bonnet at the nape of the neck, and other
details obscured by centuries of grime and discolored lacquers.

159 *Although he dressed his Madonnas*: The scholar was Monsignor Timothy Ver-
don, who shared his insights during an interview in Florence.

159 *Leonardo stripped Lisa of all embellishments*: In "Leonardo and the Second
Florentine Republic," Frederick Hartt notes that Leonardo "habitually drew
women's hands without rings." Lisa holds herself upright, as did Ghirlandaio's

maidens, Hartt comments, but whereas they display their wealth in elaborate hair and dress and their piety in the form of a prayerbook and rosary, she dresses "with sobriety and moderation, in materials whose essential quality is revealed only in the artful artlessness of their crinkled folds."

160 *Some commentators have categorized this as a guarnello:* Art historian Rab Hatfield pointed out to me the missing hem and other reasons why Lisa's veil could not be considered a *guarnello.*

162 *Michelangelo Buonarroti (1475–1564), twenty-three years Leonardo's junior:* My sources on Michelangelo include John Spike's *Young Michelangelo,* George Bull's *Michelangelo: A Biography,* and Ross King's *Michelangelo and the Pope's Ceiling.*

164 *A manuscript expert named Armin Schlechter:* The marginal note was reported in *Handschriften des Mittelalters* (2007).

165 *The only portrait Ugolino might have seen on Leonardo's easel was Lisa's:* Biographer Charles Nicholl was my source for this observation.

170 *Michelangelo's acclaimed David:* In *The Wealth of Michelangelo,* Rab Hatfield presents detailed documentation of the fortune that Michelangelo accumulated over his long career, making him the richest artist up to that time.

171 *The engineer in Leonardo, as avid as his inner artist:* Fortune Is a River, by Roger Masters, provided background on the doomed attempt to change the course of the Arno.

173 *In 1506, Raphael produced another copycat composition:* Maddalena Strozzi Doni would give birth to four sons. All were named Giovanni Battista, and all died soon after birth.

175 *Payments for various materials continued through October:* According to Zöllner's article on the portrait, Leonardo received his first substantial payment of 35 florins in May 1503 and monthly payments of 15 florins for at least a year, perhaps as long as until February 1505.

175 *An English translation of* The Lives of the Artists: According to Professoressa Valeria della Valle, *penare* remains in use today to describe struggling to complete a job as one would wish.

176 *For each square yard that Michelangelo covered:* R. A. Scotti makes this comparison in *Vanished Smile.*

11: Family Matters

PAGE

180 *In 1507, the year Lisa turned twenty-eight, she discovered:* Giuseppe Pallanti confirmed the brief life span of Giocondo del Giocondo.

183 *On the verso, the rougher opposite side:* Several biographers make note of the

lips in Leonardo's notebooks from around 1508. Charles Nicholl describes them as "almost exactly the smile of the Mona Lisa."

185 *On April 22, 1511, the Signoria tackled:* In *Tuscans and Their Families,* Herlihy and Klapisch-Zuber describe dowry inflation, the Monte delle Doti, girls' lack of choice, and the reality that "even wealthy girls with dowries had to take husbands of lower social rank."

185 *With no dowries, no suitors:* Richard Trexler characterized the nuns at San Domenico di Cafaggio as "girls from families whose father or brothers were not generally counted among those with a central economic role in the city." As a result of the limited number of marriages among many elite families, as Brucker notes in *Living on the Edge in Leonardo's Florence,* "most of these lineages were biologically extinct by the nineteenth century."

186 *"Before even venturing into the world":* The volumes that provided background on Florentine convents and their residents include Richard Trexler's *The Children of Renaissance Florence,* K. J. P. Lowe's *Nuns' Chronicles and Convent Culture in Renaissance and Counter-Reformation Italy,* and Sister Giustina Niccolini's *The Chronicle of Le Murate.*

186 *Most "took the veil" between ages nine and eleven:* My sources for the age at which girls entered convents and pledged their final vows were Klapisch-Zuber in *Women, Family, and Ritual in Renaissance Italy* and Trexler in *The Children of Renaissance Florence.*

187 *A wicker basket carried Camilla's dote monastica:* The description of a *dote monastica* (monastic dowry) comes from Frick, *Dressing Renaissance Florence.*

187 *Once she pledged lifelong chastity, poverty, and obedience:* I gained great insight into convent life from Sharon Strocchia's scholarly treatise "Taken into Custody: Girls and Convent Guardianship in Renaissance Florence," in *Renaissance Studies.*

188 *On April 20, 1512, as Florence slept peacefully:* Giuseppe Pallanti uncovered the documents detailing the "obscenities" committed by Suor Camilla at the Convent of San Domenico.

190 *By August 2, 1512, rumors flew:* Brucker's *Renaissance Florence* informed my description of this period in its history.

191 *I learned about Francesco del Giocondo's political involvement:* Josephine Rogers Mariotti's archival discoveries include a ledger of Cardinal Giovanni de' Medici. Her essay "Selections from a Ledger of Cardinal Giovanni de' Medici, 1512–1513" in *Nuovi Studi, Rivista di Arte Antica e Moderna,* records a marginal notation in the State Archives of Florence stating that Francesco del Giocondo was chosen "dei 55 nel 1512" (one of the 55 of 1512), his contribution of 500 gold florins, and the appointment of his cousin Paolo to the scrutiny council of 200, charged with elections and appointments.

12: The Rise of the Lions

197 *Biographers portray Giuliano as "handsome, feckless":* This description comes from Nicholl's *Leonardo da Vinci: Flights of Mind.* In *Florence: A Portrait,* Michael Levey describes him as "private and thoughtful."

197 *When Cardinal Giovanni de' Medici returned to his duties:* Various histories of the Medici family detail the return of Lorenzo de' Medici's sons to power in Florence. I drew on several, including Christopher Hibbert's *The Rise and Fall of the House of Medici,* Paul Strathern's *The Medici: Godfathers of the Renaissance,* and Vespasiano da Bisticci's *Renaissance Princes, Popes, and Prelates* (New York: Harper Torchbooks, 1963).

201 *One suggested subject was Pacifica Brandano:* Roberto Zapperi makes the case for her as Leonardo's model in *Monna Lisa Addio: La Vera Storia della Gioconda* (Rome: Le Lettere, 2013).

203 *In Florence, Francesco del Giocondo:* Frank Zöllner characterizes Francesco del Giocondo's aspirations as "slightly above average" in his article "Leonardo's Portrait of Mona Lisa del Giocondo," in *Gazette des Beaux-Arts.*

203 *While researching two works by the artist Leonardo Malatesta:* The paintings that Josephine Rogers Mariotti was studying are now in Casa Vasari, a museum that honors Giorgio Vasari in his hometown of Arezzo.

204 *Sant'Orsola also operated an apothecary:* Sharon Strocchia's "The Nun Apothecaries of Renaissance Florence" documents that Cosimo de' Medici purchased pills at Sant'Orsola and that respectable women could shop at convent pharmacies without companions and without jeopardizing their reputations.

205 *Another religious institution also benefited:* Jonathan Katz Nelson's "Memorial Chapels in Churches: The Privatization and Transformation of Sacred Spaces," in *Renaissance Florence: A Social History,* provided insight into the significance of these chapels. Frank Zöllner reports a major refurbishment of the Martyrs Chapel in Santissima Annunziata in 1526.

209 *King Francis I, who considered Leonardo "a philosopher-magician":* Martin Kemp describes Francis I's near-reverence for Leonardo in "Late Leonardo: Problems and Implications" and contrasts it with Pope Leo X's impatience with the artist.

210 *I like the theory that art historian Josephine Rogers Mariotti advances:* Her book was a major source for my discussion of Giuliano de' Medici and his possible role in the completion of the *Mona Lisa.*

13: The Great Sea

213 *A ledger entry for July 14:* Giuseppe Pallanti has documented this payment to Sant'Orsola.

213 *Ever since Camilla's death:* Among various scholarly discussions of the faith of Renaissance women, I found those of Lisa Kaborycha, Margaret King, and Christiane Klapisch-Zuber most enlightening.

214 *The revelation of nuns' pursuit of what sound like jobs:* Previously cited sources, particularly Sandra Strocchia's research, discuss the various occupations of women in convents.

215 *But he never stopped his relentless pursuit of profit:* Leonardo biographers Frank Zöllner and Charles Nicholl report Francesco del Giocondo's taking possession of an artist's property and works to repay a debt.

216 *King Francis I, who had probably coveted the portrait from first sight:* Martin Kemp is one of several sources to estimate the amount King Francis I paid as 12,000 francs.

218 *Through memory books, I piece together:* I drew on previously cited historical sources to reconstruct the years of the Siege of Florence. My source for Clement VII's comment "Would that Florence never existed!" is J. R. Hale's *Florence and the Medici.*

220 *(There are no records of their son Andrea's fate):* The last reference that I found to Lisa's son Andrea, born in 1502, tracks him to 1524.

221 *Among the leaders captured:* My source for the imprisonment and execution of Lisa's cousin Andrea Gherardini in 1537 is Gene Brucker's *Florence: The Golden Age.*

222 *In 1537 an aging and ailing Francesco del Giocondo:* I base my comments on Pallanti's Italian and English translations of Francesco del Giocondo's will. The key phrase in Latin reads: *"et attento qualiter se gessit prefata domina Lisa erga dictum testatorem ingenue et tanquam mulier ingenua."*

222 *He named his sons Bartolomeo and Piero as his heirs:* According to Zöllner's article on Leonardo's portrait, Francesco left 1,440 florins as a dowry for Cassandra, the daughter of his son Piero.

223 *This, I learned from Renaissance histories, was not unusual:* Margaret King discusses widows' disposition of their inheritances and their preferred burial sites in *Women of the Renaissance.*

226 *Leonardo's genius glowed to the very end:* Martin Kemp writes that Leonardo's "fertile and centrifugal intellect" survived into his final years, during which he plumbed old obsessions "ever more profoundly" and generated fresh ideas "with almost undiminished fertility" in "Late Leonardo: Problems and Implications."

14: The Adventures of Madame Lisa

PAGE

229 *The painting may have taken up residence there sometime around 1525*: Donald Sassoon's "*Mona Lisa: The Best-Known Girl in the Whole Wide World*," in *History Workshop Journal*, provides a succinct but comprehensive summary of the painting's "life." I also drew on his books *Leonardo and the Mona Lisa Story* and *Becoming Mona Lisa*, and on Roy McMullen's *Mona Lisa: The Picture and the Myth*.

235 *"Lovers, poets, dreamers go and die at her feet"*: He was Charles Clement, a former deputy keeper at the Musée Napoléon.

236 *Then I spy a thin, pink-covered monograph*: It was published by the Unione Editrice Artistica Italiana di Firenze in 1914.

237 *"La Joconde, c'est partie!"*: Several entertaining volumes recount the theft of the *Mona Lisa*, including R. A. Scotti's *Vanished Smile*, Seymour Reit's *The Day They Stole the Mona Lisa*, and Noah Charney's *The Thefts of the Mona Lisa*.

242 *In 1919, Marcel Duchamp*: Antoinette LaFarge's "The Bearded Lady and the Shaven Man: Mona Lisa, Meet 'Mona/Leo,'" in *Leonardo*, presents an interesting perspective on the artistic spoofs of the *Mona Lisa*.

245 *Beginning in 2004, the year after her official five hundredth birthday*: Jean-Pierre Mohen et al., *Mona Lisa: Inside the Painting*, an oversize volume with excellent reproductions, documents the findings of the high-tech studies performed on the *Mona Lisa*. A video on the digitizing of the *Mona Lisa* can be viewed at www.lumiere-technology.com.

15: The Last Smile

PAGE

247 *In recent years, reporters from around the world*: The international press has reported extensively on Silvano Vinceti's crusade to exhume the skeleton of Lisa Gherardini. An excellent roundup can be found at http://www.huffington post.com/2012/09/17/skeleton-presumed-to-be-m_n_1889865.html.

249 *The most scurrilous theory*: I found an interesting summary of opinions from a century ago on Lisa's smile in Kobbé's "The Smile of the *Mona Lisa*" in *The Lotus Magazine*.

250 *"Neutral" would not apply in the smallest of degrees*: I found arguments in support of at least half a dozen candidates for the "real" Mona Lisa. In one of the most impassioned, a German historian living in Australia, Maike Vogt-Lüerssen, has contended that symbols in the embroidered neckline of the portrait identify the sitter as Isabella d'Aragona, the wife of Gian Galeazzo Maria

Sforza, rightful heir to the throne of Milan and nephew of Leonardo's patron Duke Ludovico. On her website (www.kleio.org), she further contends that Isabella was Leonardo's "great love and wife" and that he painted their likenesses as two of the apostles in *The Last Supper*. Jack Greenstein's "Leonardo, *Mona Lisa*, and *La Gioconda*: Reviewing the Evidence," in *Artibus et Historiae*, analyzes Zöllner's arguments as well as other theories. The Mona Lisa Foundation's *Mona Lisa: Leonardo's Earlier Version* also summarizes the suggested candidates and the refuting evidence.

Several scientists have investigated the optics of Lisa's smile. My sources included Isabel Bohrn's "*Mona Lisa*'s Smile—Perception or Deception?" in *Psychological Science* and Margaret Livingstone's "Is It Warm? Is It Real? Or Just Low Spatial Frequency?" in *Science*.

252 "*The* Mona Lisa *is perfectly beautiful*": Blaker's letter appears in Henry Pulitzer's self-published book, *Where Is the Mona Lisa?*

252 *In 1936, a British art enthusiast, Henry F. Pulitzer*: Pulitzer explained his fascination with the *Mona Lisa* and his quest to prove the authenticity of his copy in his self-published volume, *Where Is the Mona Lisa?* John Eyre published his case for the painting's authenticity in *Monograph on Leonardo da Vinci's Mona Lisa* (London: Greve & Co., 1915).

253 *Then along came a twenty-first-century version of Snow White's prince*: The arguments for the existence of a second *Mona Lisa*, as well as discourses on a wide array of related topics, appear in *Mona Lisa: Leonardo's Earlier Version*. Its publisher, the Mona Lisa Foundation, posts regular updates on its website, http://monalisa.org/.

257 *So does her* giocondità: According to Professoressa della Valle, *giocondità* is not widely used today, but it translates as "*gioia serena e spensierata*" (serene and carefree joy). Paul Barolsky eloquently defined *giocondità* in his essay "Mona Lisa Explained," in *Source: Notes in the History of Art*.

BIBLIOGRAPHY

Ajmar-Wollheim, Marta, and Flora Dennis, eds. *At Home in Renaissance Italy* (exhibition catalog). London: V&A Publications, 2006.

Alberti, Leon Battista. *The Family in Renaissance Florence.* Translated by Renée Neu Watkins. Prospect Heights, Ill.: Waveland Press, 1994.

Baldassarri, Stefano, and Arielle Saiber, eds. *Images of Quattrocento Florence.* New Haven, Conn.: Yale University Press, 2000.

Barber, Barrington. *Through the Eyes of Leonardo da Vinci.* New York: Gramercy Books, 2004.

Bargellini, Piero. "The Ladies in the Life of Lorenzo de' Medici." In *The Medici Women.* Edited by Franco Cardini. (*Politics and History* 13). Translated by Stephanie Johnson. Florence: Arnaud, 2003.

Barolsky, Paul. "Mona Lisa Explained." *Source: Notes in the History of Art* 13, no. 2 (Winter 1994): 15–16.

Bayer, Andrea Jane, ed. *Art and Love in Renaissance Italy.* New Haven, Conn.: Yale University Press, 2009.

Bell, Rudolph. *How to Do It: Guides to Good Living for Renaissance Italians.* Chicago: University of Chicago Press, 1999.

Bianchini, Angela. *Alessandra e Lucrezia: Destini Femminili nella Firenze del Quattrocento.* Milan: Arnoldo Mondadori, 2006.

Boase, T. S. R. *Giorgio Vasari: The Man and the Book.* Princeton, N.J.: Princeton University Press, 1979.

Bohrn, Isabel, et al. "*Mona Lisa's* Smile—Perception or Deception?" *Psychological Science* 21 (2010): 378.

Bradford, Sarah. *Lucrezia Borgia.* New York: Penguin, 2004.

Bramly, Serge. *Leonardo: The Artist and the Man.* New York: Penguin, 1992.

———. *Mona Lisa.* New York: Assouline, 2004.

Brown, David Alan. *Virtue and Beauty: Leonardo's Ginevra de' Benci and Renaissance Portraits of Women.* Washington, D.C.: National Gallery of Art, 2002.

———. "Leonardo and the Ladies with the Ermine and the Book." *Artibus et Historiae* 11, no. 22 (1990): 47–61.

Brucker, Gene. *Living on the Edge in Leonardo's Florence.* Berkeley: University of California Press, 2005.

———. *The Society of Renaissance Florence.* Toronto: University of Toronto Press, 2001.

————. *Florence: The Golden Age, 1138–1737*. Berkeley: University of California Press, 1998.

————. *Giovanni and Lusanna: Love and Marriage in Renaissance Florence*. Berkeley: University of California Press, 1986.

————. *The Civic World of Renaissance Florence*. Princeton, N.J.: Princeton University Press, 1977.

————. *Renaissance Florence*. Berkeley: University of California Press, 1969.

————. *Florentine Politics and Society, 1343–1378*. Princeton, N.J.: Princeton University Press, 1962.

————. "Florentine Voices from the 'Catasto,' 1427–1480." *I Tatti Studies: Essays in the Renaissance* 5 (1993): 11–32.

————. "Florence and Venice in the Renaissance." *American Historical Review* 88, no. 3 (June 1983): 599–616.

————., ed. *Two Memoirs of Renaissance Florence: The Diaries of Buonaccorso Pitti and Gregorio Dati*. Prospect Heights, Ill.: Waveland Press, 1967.

Bull, George. *Michelangelo: A Biography*. New York: St. Martin's Griffin, 1995.

Burckhardt, Jacob. *The Civilization of the Renaissance in Italy*. New York: Penguin Classics, 1990.

Burke, Jill. "Agostino Vespucci's Marginal Notes About Leonardo da Vinci in Heidelberg." *Leonardo da Vinci Society Newsletter*, no. 30 (May 2008): 3–4.

Byrne, Joseph, and Eleanor Congdon. "Mothering in the Casa Datini." *Journal of Medieval History* 25, no. 1 (1999): 35–86.

Capra, Fritjof. *The Science of Leonardo: Inside the Mind of the Great Genius of the Renaissance*. New York: Anchor, 2008.

Cardini, Franco, ed. *The Medici Women. (Politics and History* 13). Translated by Stephanie Johnson. Florence: Arnaud, 2003.

Cesati, Franco. *The Medici*. Florence: Mandragora, 1999.

Charney, Noah. *The Thefts of the Mona Lisa*. Amelia, Italy.: ARCA Publications, 2011.

Ciprandi, Silvano. *L'Enigma di un Sorriso*. Milan: Società Dante Alighieri, 2012.

Clark, Kenneth. *Leonardo da Vinci*. London: Penguin, 1993.

————. "Mona Lisa." *The Burlington Magazine* 115, no. 840 (March 1973): 144–150.

Cohen, Elizabeth, and Thomas Cohen. *Daily Life in Renaissance Italy*. Westport, Conn.: Greenwood, 2001.

Condivi, Ascanio. *The Life of Michelangelo*. University Park: Pennsylvania State University Press, 2000.

Connell, William. *Society and Individual in Renaissance Florence*. Berkeley: University of California Press, 2002.

Cortelazzo, Manlio, and Michele Cortelazzo. *L'Etimologico Minore*. Bologna: Zanichelli, 2004.

Crabb, Ann. "'If I Could Write': Margherita Datini and Letter Writing, 1385–1410." *Renaissance Quarterly* 60, no. 4 (Winter 2007): 1170–1206.

Crum, Roger, and John Paoletti, eds. *Renaissance Florence: A Social History.* Cambridge: Cambridge University Press, 2008.

Currie, Elizabeth. *Inside the Renaissance House.* London: Victoria & Albert Museum, 1986.

Datini, Margherita. *Letters to Francesco Datini.* Translated by Carolyn James and Antonio Pagliaro. Toronto: Center for Reformation and Renaissance Studies, 2012.

da Vinci, Leonardo. *The Notebooks of Leonardo da Vinci.* 2 vols. New York: Dover, 1970.

Davis, Natalie Zemon, and Arlette Farge, eds. *A History of Women: Renaissance and Enlightenment Paradoxes.* Cambridge, Mass.: Harvard University Press, 1993.

Dean, Trevor, and K. J. P. Lowe, eds. *Marriage in Italy: 1300–1650.* Cambridge: Cambridge University Press, 1988.

Duggan, Christopher. *A Concise History of Italy.* Cambridge: Cambridge University Press, 2004.

Emison, Patricia. *Leonardo.* London: Phaidon Press, 2011.

Farago, Claire. "Leonardo's Battle of Anghiari: A Study in the Exchange Between Theory and Practice." *The Art Bulletin* 76, no. 2 (June 1994): 301–330.

Ferraresi, Augusto. *Leonardo da Vinci e La Gioconda.* Florence: Unione Editrice Artistica Italiana, 1914.

Filipczak, Z. "New Light on *Mona Lisa*: Leonardo's Optical Knowledge and His Choice of Lighting." *The Art Bulletin* 59, no. 4 (Dec. 1977): 518–523.

Franklin, David, ed. *Leonardo da Vinci, Michelangelo and the Renaissance in Florence.* Ottawa: National Gallery of Art, 2005.

Frick, Carole Collier. *Dressing Renaissance Florence.* Baltimore: Johns Hopkins University Press, 2002.

Galvani, Francesco. *Sommario Storico delle Famiglie Celebri Toscane Compilato da D. Tiribilli-Giuliani, Riveduto dal Cav. L. Passerini. http://books.google.com/books? id=zVEBAAAAQAAJ&printsec=frontcover&dg=Sommario+Storico+delle+ Famiglie+Celebri+Toscane&hl=en&sa=X&ei=o58DU_ruM6qR2wW950CID Q&ved=oCC4Q6AEwAA#v=onepage&q=Sommario%20Storico%20delle%20 Famiglie%20Celebri%20Toscane&f=false.*

Gamurrini, Eugenio. "Famiglia Gherardina." In *Istoria Genealogica delle Famiglie Nobili Toscane et Umbre,* Vol. II. Florence, 1671, 111–138.

Garrard, Mary D. "Leonardo da Vinci: Female Portraits, Female Nature." In *The Expanding Discourse: Feminism and Art History.* Edited by Norma Broude and Mary D. Garrard. New York: Icon Editions, 1992.

———. "Who Was Ginevra de' Benci? Leonardo's Portrait and Its Sitter Recontextualized." *Artibus et Historiae* 27, no. 53 (2006): 23–56.

Gherardini, Niccolò. *Memorie Domestiche di Niccolò Gherardini, 1585–1596.* ASF Manoscritti Vari, 288.

"I Gherardini del Contado Fiorentino." In *Miscellanea Storica della Valdelsa,*

Vol. 15. http://books.google.com/books?id=Ztw4AAMAAJ&pg=PA186 &dq=Miscellanea+Storica+della+Valdelsa+vol+15&hl=en&sa=X&ei =c50DU5GaNsOS2QWMooDoBw&ved=0CCsQ6AEwAA#v=onepage &q=Gherardini&f=false.

Gilmour, David. *The Pursuit of Italy*. New York: Farrar, Straus & Giroux, 2011.

Goffen, Rona. *Renaissance Rivals*. New Haven, Conn.: Yale University Press, 2002.

Goldthwaite, Richard. *Private Wealth in Renaissance Florence*. Princeton, N.J.: Princeton University Press, 1968.

Greenstein, Jack. "Leonardo, *Mona Lisa*, and *La Gioconda*: Reviewing the Evidence." *Artibus et Historiae* 25, no. 50 (2004): 17–38.

Gregory, Heather. *Selected Letters of Alessandra Strozzi*. Berkeley: University of California Press, 1997.

Guicciardini, Francesco. *The History of Florence*. New York: Harper Torchbooks, 1970.

———. *The History of Italy*. Princeton: Princeton University Press, 1969.

Gundle, Stephen. *Bellissima: Feminine Beauty and the Idea of Italy*. New Haven, Conn.: Yale University Press, 2007.

Haas, Louis. *The Renaissance Man and His Children*. New York: St. Martin's, 1998.

Hale, J. R. *Florence and the Medici*. London: Phoenix, 2001.

Hartt, Frederick. "Leonardo and the Second Florentine Republic." *Journal of the Walters Art Gallery* 44 (1985): 95–116.

Hatfield, Rab. *The Wealth of Michelangelo*. Rome: Edizioni di Storia e Letteratura, 2002.

Herald, Jacqueline. *Renaissance Dress in Italy, 1400–1500*. London: Bell & Hyman, 1981.

Herlihy, David, and Christiane Klapisch-Zuber. *Tuscans and Their Families: A Study of the Florentine Catasto of 1427*. New Haven, Conn.: Yale University Press, 1985.

Hibbert, Christopher. *The Borgias and Their Enemies, 1431–1519*. New York: Harcourt, 2008.

———. *The Rise and Fall of the House of Medici*. New York: Penguin, 1979.

Jones, Jonathan. *The Lost Battles*. New York: Knopf, 2012.

Kaborycha, Lisa. *A Short History of Renaissance Italy*. San Francisco: Pearson, 2010.

Kelly-Gadol, Joan. "Did Women Have a Renaissance?" In *Becoming Visible: Women in European History*. Edited by Renate Bridenthal and Claudia Koonz. Boston: Houghton Mifflin, 1977.

Kemp, Martin. *Leonardo da Vinci: The Marvelous Works of Nature and Man*. Oxford: Oxford University Press, 2006.

———. *Leonardo*. Oxford: Oxford University Press, 2004.

———. "Late Leonardo: Problems and Implications." *Art Journal* 46, no. 2, "Old-Age Style" (Summer 1987): 94–102.

Kent, Dale. *Cosimo de' Medici and the Florentine Renaissance*. New Haven, Conn.: Yale University Press, 2000.

———. "Women in Renaissance Florence." In *Virtue and Beauty* (exhibition catalog; David Alan Brown, ed.). Princeton, N.J.: Princeton University Press, 2001.

Kent, Francis William. *Household and Lineage in Renaissance Florence: The Family Life of the Capponi, Ginori, and Rucellai.* Princeton, N.J.: Princeton University Press, 1977.

King, Margaret. *Women of the Renaissance.* Chicago: University of Chicago Press, 1991.

King, Ross. *Leonardo and the Last Supper.* New York: Walker, 2012.

———. *Machiavelli: Philosopher of Power.* New York: Harper Perennial, 2007.

———. *Michelangelo and the Pope's Ceiling.* New York: Penguin, 2003.

Kirshner, Julius, and Anthony Molho. "The Dowry Fund and the Marriage Market in Early Quattrocento Florence." *Journal of Modern History* 49, no. 3 (1978): 403–438.

Klapisch-Zuber, Christiane. *Ritorno alla Politica: I Magnati Fiorentine 1340–1440.* Rome: Viella, 2009.

———. *Women, Family, and Ritual in Renaissance Italy.* Chicago: University of Chicago Press, 1985.

———., ed. *A History of Women in the West.* Vol. II, *Silences of the Middle Ages.* Cambridge, Mass.: Harvard University Press, 1995.

Klein, Stefano. *Leonardo's Legacy.* New York: Da Capo, 2008.

Kleinhenz, Christopher, et al. *Medieval Italy: An Encyclopedia.* Vol. 1, *A–K.* London: Routledge, 2004.

Kobbé, Gustav. "The Smile of the *Mona Lisa.*" *Lotus Magazine* 8, no. 2 (November 1916): 67–74.

Krohn, Deborah. "Marriage as a Key to Understanding the Past." In *Art and Love in Renaissance Italy.* Edited by Andrea Bayer. New York: Metropolitan Museum of Art, 2008.

———. "Weddings in the Italian Renaissance." In *Heilbrunn Timeline of Art History.* New York: Metropolitan Museum of Art, 2000.

LaFarge, Antoinette. "The Bearded Lady and the Shaven Man: Mona Lisa, Meet 'Mona/Leo.'" *Leonardo* 29, no. 5, Fourth Annual New York Digital Salon (1996): 379–383.

Landucci, Luca. *Florentine Diary from 1450 to 1516,* continued by an anonymous writer till 1542. Translated by Alice de Rosen Jervis. New York: Dutton, 1927.

Lansing, Carol. *The Florentine Magnates.* Princeton, N.J.: Princeton University Press, 1991.

Lester, Toby. *Da Vinci's Ghost.* New York: Free Press, 2012.

Lev, Elizabeth. *The Tigress of Forlì.* Boston: Houghton Mifflin Harcourt, 2011.

Levey, Michael. *Florence: A Portrait.* Cambridge, Mass.: Harvard University Press, 1998.

Lewis, R. W. B. *The City of Florence.* New York: Farrar, Straus & Giroux, 1995.

Livingstone, Margaret S. "Is It Warm? Is It Real? Or Just Low Spatial Frequency?" *Science* 290 (2001): 1299.

Lorenzo Il Magnifico. *Opere.* Vol. 1. Edited by Attilio Simioni. Bari: G. Latera & Figli, 1913.

Lowe, K. J. P. *Nuns' Chronicles and Convent Culture in Renaissance and Counter-Reformation Italy.* Cambridge: Cambridge University Press, 2003.

McCarthy, Mary. *The Stones of Florence.* San Diego: Harcourt, 1963.

McIver, Katherine. "Art and Love in Renaissance Italy and *Love and Marriage in Renaissance Florence.*" *Renaissance Quarterly* 62, no. 3 (Fall 2009): 918–921.

McMullen, Roy. *Mona Lisa: The Picture and the Myth.* New York: Da Capo, 1977.

Mallett, Michael. *The Borgias.* New York: Barnes & Noble, 1969.

Mariotti, Josephine Rogers. *Monna Lisa: La 'Gioconda' del Magnifico Giuliano.* Florence: Edizioni Polistampa, 2009.

———. "Selections from a Ledger of Cardinal Giovanni de' Medici, 1512–1513." *Nuovi Studi: Rivista di Arte Antica e Moderna,* 2003.

Martines, Lauro. *April Blood.* Oxford: Oxford University Press, 2004.

Masters, Roger. *Fortune Is a River.* New York: Free Press, 1998.

Matthews-Grieco, Sara. "The Body, Appearance, and Sexuality." In *A History of Women: Renaissance and Enlightenment Paradoxes.* Edited by Natalie Zemon Davis and Arlette Farge. Cambridge, Mass.: Harvard University Press, 1993.

Merejkowski, Dmitri. *The Romance of Leonardo da Vinci.* Garden City, N.Y.: Garden City Publishing, 1928.

Miscellanea Storica della Valdelsa. Vols. 9–10. http://books.google.com/books?id=CcdDAAAAYAAJ&printsec=frontcover&dg=Miscellanea+Storica+della+Valdelsa&hl=en&sa=X&ei=ZKADU-TyLqfR2wW-xIDYDw&ved=0CCkQ6AEwAA#v=onepage&q=vol%209&f=false.

Mohen, Jean-Pierre, et al. *Mona Lisa: Inside the Painting.* New York: Abrams, 2006.

Mona Lisa Foundation. *Mona Lisa: Leonardo's Earlier Version.* Zurich: Mona Lisa Foundation, 2012.

Montanelli, Indro, and Roberto Gervaso. *Italy in the Golden Centuries.* Translated by Mihaly Csikszentmihalyi. Chicago: Henry Regnery, 1967.

Musacchio, Jacqueline. *The Art and Ritual of Childbirth in Renaissance Italy.* New Haven, Conn.: Yale University Press, 1999.

Nelson, Jonathan Katz. "Memorial Chapels in Churches: The Privatization and Transformation of Sacred Spaces." In *Renaissance Florence: A Social History.* Edited by Roger Crum and John Paoletti. Cambridge: Cambridge University Press, 2008.

Niccolini, Sister Giustina. *The Chronicle of Le Murate.* Toronto: Iter Inc., 2011.

Nicholl, Charles. *Leonardo da Vinci: Flights of Mind.* New York: Penguin, 2005.

Noel, Gerard. *The Renaissance Popes.* New York: Carroll & Graf, 2006.

Nuland, Sherwin. *Leonardo da Vinci.* New York: Penguin, 2005.

Olszewski, Edward. "How Leonardo Invented *Sfumato.*" *Source: Notes in the History of Art* 31, no. 1 (Fall 2011): 4–9.

Origo, Iris. *The Merchant of Prato.* Boston: Nonpareil Books, 1986.

Pallanti, Giuseppe. *La Vera Identità della Gioconda.* Milan: Skira Editore, 2006.

————. *Mona Lisa Revealed*. Milan: Skira Editore, 2006.

Paoletti, John, and Gary Radke. *Art in Renaissance Italy*. Upper Saddle River, N.J.: Pearson Prentice Hall, 2005.

Paolini, Claudio, et al. *Virtù d'Amore*. Florence: Giunti, 2010.

Parks, Tim. *Medici Money*. London: Profile Books, 2005.

Passerini, Luigi. *Genealogia e Storia della Famiglia Rucellai*. Florence: Galileiana, 1861.

Pedretti, Carlo. *Leonardo: Art and Science*. Cobham, U.K.: TAJ Books, 2004.

Pietrogrande, Patrizia. *Antico Setificio Fiorentino*. Florence: Le Lettere, 2011.

Plumb, J. H. *The Italian Renaissance*. New York: American Heritage, 2001.

Pulitzer, Henry. *Where Is the Mona Lisa?* London: The Pulitzer Press, 1966.

Queiros-Conde, Diogo. "The Turbulent Structure of 'Sfumato' within Mona Lisa." *Leonardo* 37, no. 3 (2004): 223–228.

"Quel Sorriso, Eterno Mistero." http://www.prestigefoodwine.com/Monna_Lisa .pdf.

Reit, Seymour. *The Day They Stole the Mona Lisa*. New York: Summit Books, 1981.

Rocke, Michael. *Forbidden Friendships: Homosexuality and Male Culture in Renaissance Florence*. New York: Oxford University Press, 1966.

Rubin, P. L., and Alison Wright. *Renaissance Florence: The Art of the 1470s*. London: National Gallery Publications, 1999.

Rubinstein, Nicolai, ed. *Florentine Studies: Politics and Society in Renaissance Florence*. Evanston, Ill.: Northwestern University Press, 1968.

Sachs, Hannelore. *The Renaissance Woman*. New York: McGraw-Hill, 1971.

Sassoon, Donald. *Becoming Mona Lisa*. New York: Mariner Books, 2003.

————. *Leonardo and the Mona Lisa Story*. New York: Overlook Press, 2006.

————. "Mona Lisa: The Best-Known Girl in the Whole Wide World." *History Workshop Journal*, no. 51 (2001): 1–18.

Scotti, R. A. *Vanished Smile*. New York: Vintage, 2009.

Sebregondi, Ludovica, and Tim Parks. *Money and Beauty: Bankers, Botticelli, and the Bonfire of the Vanities*. Florence: Giunti, 2011.

————. eds. "Commentaries from the Exhibition *Denaro e Bellezza*." Florence: Palazzo Strozzi, September 17, 2011–January 22, 2012.

Shell, Janice, and Grazioso Sironi. "Cecilia Gallerani: Leonardo's *Lady with an Ermine*." *Artibus et Historiae* 13, no. 25 (1992): 47–66.

Smith, Webster. "Observations on the *Mona Lisa* Landscape." *The Art Bulletin* 67, no. 2 (June 1985): 183.

Spadolini, Giovanni. *A Short History of Florence*. Translated by Robert Learmonth. Florence: Le Monnier, 1992.

Spike, John. *Young Michelangelo: The Path to the Sistine*. New York: Vendome Press, 2010.

Strathern, Paul. *The Artist, the Philosopher, and the Warrior*. New York: Bantam, 2009.

————. *The Medici: Godfathers of the Renaissance*. London: Pimlico, 2005.

Strocchia, Sharon. "The Nun Apothecaries of Renaissance Florence: Marketing Medicines in the Convent." *Renaissance Studies* 25, no. 5 (2011): 1–21.

———. "Taken into Custody: Girls and Convent Guardianship in Renaissance Florence." *Renaissance Studies* 17, no. 2 (2003): 177–200.

Tinagli, Paola. *Women in Italian Renaissance Art: Gender, Representation, Identity.* Manchester: Manchester University Press, 1997.

Tomas, Natalie. "Did Women Have a Space?" In *Renaissance Florence: A Social History.* Edited by Roger Crum and John Paoletti. Cambridge: Cambridge University Press, 2008.

———. *The Medici Women.* Hampshire, U.K.: Ashgate Publishing, 2003.

Trexler, Richard. *Power and Independence in Renaissance Florence.* Vol. I, *The Children of Renaissance Florence.* Vol. II, *The Women of Renaissance Florence.* Vol. III, *The Workers of Renaissance Florence.* Binghamton, N.Y.: Medieval & Renaissance Texts and Studies, 1993.

———. *Public Life in Renaissance Florence.* New York: Academic Press, 1980.

Unger, Miles. *Magnifico.* New York: Simon & Schuster, 2008.

Uzielli, Gustavo. *La Leggenda dei Tre Valdelsani, Conquistatori dell'Irlanda.* http://books.google.com/books?id=W5MRAAAAYAAJ.

Van der Sman, Gert Jan. *Lorenzo and Giovanna.* Florence: Mandragora, 2010.

Vasari, Giorgio. *The Lives of the Artists.* Translated by Julia Conaway Bondanella and Peter Bondanella. New York: Oxford University Press, 1991.

Vecellio, Cesare. *Vecellio's Renaissance Costume Book.* New York: Dover, 1977.

Vespasiano da Bisticci. *Renaissance Princes, Popes, and Prelates.* New York: Harper Torchbooks, 1963.

Villani, Giovanni. *Nuova Cronica,* Vol. II (Libri IX–XI). Parma: Fondazione Pietro Bembo, 1991.

Viroli, Maurizio. *Niccolò's Smile.* New York: Hill & Wang, 2000.

Walker, Paul Robert. *The Feud That Sparked the Renaissance.* New York: William Morrow, 2002.

Welch, Evelyn. "Art on the Edge: Hair and Hands in Renaissance Italy." *Renaissance Studies* 23, no. 3 (June 2009): 241–268.

Winspeare, Massimo. *The Medici: The Golden Age of Collecting.* Livorno: Sillabe, 2000.

Witthoft, Brucia. "Marriage Rituals and Marriage Chests in Quattrocento Florence." *Artibus et Historiae* 3, no. 5 (1982): 43–59.

Zöllner, Frank. *Leonardo da Vinci: The Complete Paintings and Drawings.* Cologne: Taschen, 2012.

———. *Leonardo da Vinci.* Cologne: Taschen, 2005.

———. "Leonardo's Portrait of Mona Lisa del Giocondo." In *Gazette des Beaux-Arts* 121 (1993): S. 115–138. (Reprinted in Claire J. Farago, ed. *Leonardo da Vinci: Selected Scholarship.* New York: Garland Publishing, 1999, Bd. III, S. 243–266.)

INDEX

Page numbers beginning with 273 refer to endnotes.

ABOUT THE AUTHOR

Dianne Hales is a widely published and honored author and journalist. Her most recent trade book was the bestselling *La Bella Lingua: My Love Affair with Italian, the World's Most Enchanting Language*, for which the president of Italy awarded her an honorary knighthood, with the title of *Cavaliere dell'Ordine della Stella della Solidarietà Italiana* (Knight of the Order of the Star of Italian Solidarity).

In addition to writing trade and text books, Dianne Hales has served as a contributing editor for *Parade, Ladies' Home Journal, American Health,* and *Working Mother,* and has written more than a thousand articles for national publications, including *Family Circle, Glamour, Good Housekeeping, Mademoiselle, McCall's, The New York Times, Reader's Digest, Redbook, Seventeen, The Washington Post,* and *Woman's Day.*

A graduate of the Columbia University Graduate School of Journalism, Dianne is one of the few journalists to be honored with national awards for excellence in magazine writing by both the American Psychiatric Association and the American Psychological Association. Her writing awards include an EMMA (Exceptional Media Merit Award) for health reporting from the National Women's Political Caucus and Radcliffe College, a National Mature Media Award, and commendations from various organizations, including the California Psychiatric Society, the National Easter Seal Society, and the New York Public Library.

Dianne, who lives in the San Francisco Bay Area, is the wife of Dr. Robert E. Hales, chair of psychiatry at the University of California, Davis, and the mother of Julia Hales.